WORTHY MONUMENTS

WORTHY MONUMENTS

Art Museums and the Politics of Culture
in Nineteenth-Century France

. . .

Daniel J. Sherman

Harvard University Press
Cambridge, Massachusetts
London, England
1989

Publication of this book has been aided by a grant
from the Andrew W. Mellon Foundation

This book is printed on acid-free paper, and its binding materials
have been chosen for strength and durability

Library of Congress Cataloging-in-Publication Data

Sherman, Daniel J.
 Worthy monuments : art museums and the politics of culture in
nineteenth-century France / Daniel J. Sherman.
 p. cm.
 Bibliography: p.
 Includes index.
 ISBN 0-674-96230-3 (alk. paper)
 1. Art museums—France—History—19th century. 2. Art and state—
 France. 3. France—Cultural policy. I. Title.
N2010.S57 1989 88-7939
708.4—dc19 CIP

For my parents

Acknowledgments

Inasmuch as this book presents a historical critique of institutional culture, it may seem odd to offer the customary thanks, which often seem to invoke cultural institutions almost in ritual fashion. Irony is not a bad trope with which to start, but these acknowledgments are intended as more than mere ritual: not only heartfelt, they also serve to situate both the book and its author within the context that shaped them. I was fortunate to enjoy institutional support that enabled me to work as I chose, beginning with the Department of History at Yale University. I am particularly grateful to Professors John Merriman, Peter Gay, and Robert L. Herbert, for their wise counsel and continual encouragement: their openness to new approaches that straddle the usual disciplinary boundaries made a study of this kind possible. I also wish to thank the institutions that supported my research and writing: the French-American Foundation, New York, for a Tocqueville Fellowship, 1982–83; the Social Science Research Council and the American Council of Learned Societies, for an International Doctoral Research Fellowship, 1982–1984, with funds provided by the Ford Foundation and the National Endowment for the Humanities; the Camargo Foundation, Cassis, France, where I was a Resident Fellow in the fall of 1983; and the Mrs. Giles Whiting Foundation, for a Whiting Fellowship in the Humanities, 1984–85. A research grant from the American Philosophical Society in the summer of 1986 supported additional post-doctoral research.

In France I received a warm welcome and willing assistance from curators and archivists throughout the country; sharing my ideas and questions with them enlivened my research with an extraordinary sense of scholarly community and shared discovery. My thanks, first, to François Bergot of the Musée des Beaux-Arts,

Rouen; Monique Richard of the Musée des Beaux-Arts and Marie-Thérèse Degroise of the Archives Municipales, Dijon; and Henri Wytenhove of the Musée des Beaux-Arts, Marseilles, who gave me free access to uncatalogued and normally inaccessible archives. I am also grateful to Brigitte Labat-Poussin, Archives Nationales; Jean-Paul Avisseau, Archives Municipales de Bordeaux; Hélène Avisseau, Archives Départementales de la Gironde; Gilberte Martin-Méry and Olivier Le Bihan, Musée des Beaux-Arts, Bordeaux; Mlle. Peytout, Bibliothèque Municipale de Bordeaux; Pierre Georgel, Musée des Beaux-Arts, Dijon (now at the Musée Picasso, Paris); Arnaud Ramière de Fortanier, Archives Municipales de Marseille; Mme. Lebeltel, Archives Municipales de Rouen; Vivienne Miguet, Archives Départementales de la Seine-Maritime; Marie-Pierre Foissy-Aufrère, Musée des Beaux-Arts, Rouen (now at the Musée Calvet, Avignon). The extraordinary generosity, both professional and personal, of Marie Jeune, also at the Musée des Beaux-Arts, Rouen, deserves special mention, and continues to astonish me.

The Library of Congress and the Center for European Studies at Harvard University provided stimulating and supportive environments for two major periods of writing; my thanks to Abby Collins at the Center and to Sarah Pritchard of the Reference Division and Bruce Martin and the Study Facilities staff at the Library. A number of friends and colleagues on both sides of the Atlantic provided tips, forwarded photocopies, shared insights, or simply listened at crucial moments, sustaining my enthusiasm with their kindness and generosity. To all of them a warm and grateful *salut fraternel,* particularly David Barquist, Marjorie Beale, Barry Bergdoll, Anne and John Boris, Laird Boswell, Anne and Alain Cornet-Vernet, Robert Dietle, Laura Frader, Ellen Ginsberg, Brian Ladd, Philippe Le Villain, Patricia Mainardi, David Myers, Dominique Poulot, Aron Rodrigue, and Nicole Villa. I have benefited immensely from the searching questions of Anne Higonnet, who with Judy Coffin invited me to present my central thesis in *Radical History Review* (no. 38, 1987, pp. 38–58; © MARHO: The Radical Historians' Organization, 1987); my thanks to the editors of that journal and to *Historical Reflections/Réflexions Historiques* for allowing me to reprint passages that first appeared in their pages (vol. 15, 1988, pp. 337–359). Katherine Auspitz, Louis Cooper, and Philip Nord have read the entire manuscript in various versions, and their enthusiasm and their critical suggestions have been indispensable.

In the final stages of its preparation, this book had the good fortune to come under the expert guidance of Aida Donald, Elizabeth Suttell, and Elizabeth Gretz of Harvard University Press. The reader as well as the author has reason to be grateful for their sagacity, tact, and patience. My very warm thanks as well to Nathaniel Trumbull, for his invaluable last-minute checking, to Jan and Nancy Brumm for the loan of their house in Provence, where correcting copy was almost a pleasure, and to the Van der Heijdens, for their hospitality and their typewriter.

My deepest thanks go to four people whose presence in my life and my work is such as to defy characterization, let alone acknowledgment. J. B. Ross more than anyone is responsible for my belief in the possibilities of history as a life-enhancing activity; like so many others, I count myself fortunate to have been able to learn from her practice of it, at once wise and humane. Stanley Hoffmann, brilliant teacher and generous friend, has been both support and inspiration at every step of my career. He introduced me to the study of French history, spurred my pursuit of it, and has, by encouragement and by example, given me reason to continue. Finally, not even those who know my parents, Stanley M. Sherman and Claire Richter Sherman, could comprehend how much they have given me. My father, an architect and critic, and my mother, an art historian, introduced me to the pleasures of museums and of scholarship, taught me how to look at cities and at works of art, and gave me the tools to think critically—and that, like my dedication, was just the beginning.

<div align="right">

Paris/Seillans
September 1988

</div>

Contents

Introduction 1

PART I THE MUSEUM AND THE STATE 11

1 *The State and the Uses of Patronage: The Envoi System* 16
2 *Inspectors, Inspections, and Norms* 55

PART II THE MUSEUM AND THE CITY 91

3 *Museums in Formation, 1791–1850* 97
4 *Museums in Transition, 1850–1870* 121
5 *Museums in Construction, 1860–1890* 154
6 *The Museum and the Institution of Culture, 1870–1914* 192

Conclusion 239

Abbreviations 249
Bibliography 251
Notes 264
Index 331

Illustrations

1. Léon Cogniet, *Tintoretto Painting His Dead Daughter.*
Bordeaux, Musée des Beaux-Arts. 135
2. Jean-François Millet, *Woman Feeding Her Child (La
bouillie).* Marseilles, Musée des Beaux-Arts. 142
3. William-Adolphe Bouguereau, *The Return of Tobias.*
Dijon, Musée des Beaux-Arts. 146
4. Jean-Pierre Alexandre Antigna, *Mirror of the Woods.*
Bordeaux, Musée des Beaux-Arts. 148
5. Palais de Longchamp, Marseilles: Musée des Beaux-Arts
from the central arcade. Photograph by the author. 164
6. Jules Cavelier, *La Durance.* Marseilles, Musée des
Beaux-Arts. From a postcard, ca. 1914. 178
7. Musée des Beaux-Arts, Bordeaux: North wing.
Photograph by the author. 181
8. Musée des Beaux-Arts, Rouen: Main entrance.
Photograph by the author. 182
9. Musée des Beaux-Arts, Marseilles: North side of the main
stairway. Photograph by the author. 184
10. Pierre Puvis de Chavannes, *Marseilles, Greek Colony.*
Marseilles, Musée des Beaux-Arts. 186
11. Pierre Puvis de Chavannes, *Marseilles, Gateway to the
Orient.* Marseilles, Musée des Beaux-Arts. 186
12. Pierre Puvis de Chavannes, *Inter Artes et Naturam.*
Rouen, Musée des Beaux-Arts. Photograph: Lauros-
Giraudon, Paris. 188–189
13. Carolus Duran, *Danaë.* Bordeaux, Musée des Beaux-Arts. 199
14. Etienne Tournès, *Young Woman Undressing.* Bordeaux,
Musée des Beaux-Arts. 201

15. Alfred Smith, *Quais of Bordeaux, Evening*. Bordeaux,
Musée des Beaux-Arts. *202*
16. Charles Fréchon, *Spring Leaves*. Rouen, Musée des
Beaux-Arts. *203*
17. Luigi Loir, *Flood Tide of the Seine, Paris*. Rouen, Musée
des Beaux-Arts. *204*
18. Pierre-Paul Prud'hon, *Portrait of Georges Anthony*. Dijon,
Musée des Beaux-Arts. *206*
19. Charles Angrand, *The Rouen Museum in 1880*. Private
collection. Photograph: Musée des Beaux-Arts, Rouen. *214*
20. Emmanuel Benner, *Bathers*. Rouen, Musée des Beaux-Arts. *222*

Introduction

Along with its continued proliferation as an institution, and surely not coincidental to it, the art museum has become one of the most broadly resonant metaphors of our culture. A music critic seeking to highlight an opera company's isolation from contemporary musical composition calls it "the Met Museum of Opera," and goes on to ask, "what kind of museum will it be? Will the exhibits be mounted with real care and thought? Will the permanent collection be rotated endlessly, or will there be discriminating fresh looks at our opera heritage? Will the treasures on display be protected from deterioration (or, when necessary, restored by expert hands)?"[1] A scholar reviewing the latest volume in a massive historical biography finds it "not merely, as the cliché has it, a monument . . . [but] a museum of historical scholarship, a vast, neoclassical museum in which the informed visitor can walk for days with profit and delight, though the casual visitor may soon be lost."[2] Writers wishing to signal their concern with characters who live in the past, or whose lives revolve around fragmented, objectified chunks of memory, entitle their novels *Museum Pieces*. We have imaginary museums, "McMuseums," and even secret museums, the subjects of this last ranging from caricature to the constitution of pornography as a cultural tradition in its own right.[3]

Such metaphors associate the museum with the past rather than the present, with sterility and decay rather than creativity, with mystification rather than elucidation. They demonstrate, moreover, the museum's fundamental connection to the forms and structures of social organization: its image is inseparable from those of the people who have built it, who use it, or who feel alienated from it. Indeed, Georges Bataille has gone so far as to observe that "the halls and art objects are but the container, whose content is formed by

I

the visitors. It is the content that distinguishes a museum from a private collection. A museum is like a lung of a great city; each Sunday the crowd flows like blood into the museum and emerges purified and fresh . . . It is interesting to observe the flow of visitors visibly driven by the desire to resemble the celestial visions ravishing to their eyes."[4] John Berger describes arguably the same phenomenon in blunter, angrier, but still metaphorical terms: "the majority takes it as axiomatic that the museums are full of holy relics which refer to a mystery which excludes them: the mystery of unaccountable wealth. Or, to put this another way, they believe that original masterpieces belong to the preserve (both materially and spiritually) of the rich."[5]

Yet if these texts demonstrate the pervasiveness of the image of the museum, they also exemplify its largely intuitive, instinctual, and, in its original meaning, sensational character. The very familiarity of the image, indeed, conceals a surprising lack of agreement about the institution, not only among specialists but by the public at large. From the Grand Louvre project and the new Orsay in Paris to the proposed Whitney and Guggenheim additions in New York, museums provoke controversy. Passionate in their rhetoric, sweeping, provocative, often sophisticated in their argumentation, such debates nevertheless tend to perpetuate themselves along familiar lines, without any apparent potential for resolution. Every city seems to want a museum, but without any consensus on such essential elements as the appropriate architectural frame, the relationship between entertainment and education in the museum's purposes, or even the nature of the public the museum is called upon to serve.[6]

Such uncertainty about the present often reflects, and in many ways can be regarded as a consequence of, a lack of awareness of the past. If, in other words, we have little idea of where the museum is going (and still less of where it ought to go), that may be because we have so little sense of where it has come from or of the course it has followed. Past accounts of the history of the art museum have opened a number of suggestive lines of inquiry, but for various reasons they have failed to come together into a coherent body of analysis. They may for convenience be divided into three categories: the anecdotal, the schematic, and the contextual. By far the largest category, the anecdotal might also be called the political, in deference to the kind of historical writing it most clearly resembles. In these chronicles directors serve as rulers, curators play the parts of generals and politicians, and art dealers of either honest or, more

usually, deceitful diplomats. In particular, as works of art assume the role of territories, auctions and other avenues of acquisition are recounted in the language of battle, alternately colorful and soberly strategic. The politics of the museum thus takes on the familiar features in which we normally encounter politics *tout court,* as a mix of personalities, petty concerns, and grand issues (the last addressed only by a few visionaries), all against a fairly distant backdrop of prevailing "ideas."[7] Such works have the virtue of providing essential information about certain signposts of the museum's development, but they leave unexamined its connection to larger issues.

In contrast, establishing such connections constitutes the principal objective of more schematic studies. Whereas the anecdotal chroniclers tend to produce expansive, often weighty tomes, the schematists generally favor brief, pungent articles, at most short monographs. Here the museum becomes objectified as part of a larger pattern of historical development, typically, as for example in the path-breaking contributions of Carol Duncan and Alan Wallach, one involving the exertion of bourgeois authority in and over the modern nation-state.[8] The details of museums' histories, collecting practices, and spatial arrangements fit neatly into the overall pattern; the parts cohere. In recuperating and deconstructing the museum's effective construction as an ideological system, such accounts clearly point to the source of much of the disquiet they provoke. This acuteness, however, often comes at the expense of specificity and, indeed, of any sense of historical development.[9]

Historians concerned with placing museums in a broader context, of whom Neil Harris is the pioneering example, obviously seek to recover such specificity. They analyze the museum in relation to comparable phenomena and practices at various phases of its development, notably, for Harris, modes of installation and display in department stores.[10] In this way the constituent parts of the museum emerge as aspects of the particular historical situation that gave them meaning. Yet the museum's own modes of signification rarely benefit from the same scrutiny or level of analysis. Each of these historical methods has its uses, but none can by itself provide an account of the art museum that adequately connects its past to its present. In this book, then, I attempt to combine aspects of all three: a sense of color, detail, and narrative flow, an awareness of structural and ideological implications, and a sensitivity to the broader social and cultural contexts in which museums emerged and developed.

The histories of museums in various countries in Europe and

America have enough in common to make a comparative treatment of them not only practicable but welcome.[11] But comparative studies run the risk of passing too lightly over the particularities of national cultures, surely one of the most significant factors, both ideologically and contextually, in the formation of museums. Of the various nations available for special examination in this light, none calls more insistently for attention than France. For not only does France have the strongest claim to have given birth to the art museum as a public institution; in the nineteenth century it both proclaimed itself the inheritor and embodiment of classical civilization and occupied an acknowledged position at the center of the art world. Even in other countries, the resonances that museums now possess arguably owe something to elements, discursive as well as practical, that in their origins were peculiarly French.[12]

Yet national culture alone defined neither museums' context nor their own enterprise. Clearly we can construct a plausible, cogent, and theoretically sophisticated model for the museum's development on the basis of the great national museums; if we grant New York's Metropolitan Museum this status, Duncan and Wallach have essentially created such a model. But for France, where the Louvre and its various adjuncts were almost exclusively the work of the state, a focus on the national level would exclude the other political and social forces, here operating largely outside the national capital, that contributed to shaping the museum. From the point of view simply of the museum as an institution, some of the most important questions take us outside Paris. The most obvious of these questions are not the least interesting: How and why did communities and groups outside the center feel the need to appropriate an institutional form created by the state? How did they adapt it to their own purposes? How, in turn, did such adaptations affect the original form? To the extent, for example, that museums' practices and meanings came to be embodied in building types specifically devised for the purpose, the Louvre and its sister institution for contemporary art, the Luxembourg, hardly offer the best examples for analysis. Both were converted from their original palatial functions, and both were subject to considerable criticism late in the century for their inadequacy as museums.

Though it may seem incongruous with respect to a culture and a polity as centered in the capital city as that of nineteenth-century France, an exploration of museums in the French provinces comes

at the confluence of two fruitful lines of research. On the one hand, a number of recent studies have illuminated the dynamics of elite culture and politics in major provincial cities and showed the subtle interplay of national and regional factors in their development.[13] On the other hand, scholars have also presented searching and provocative analyses of various domains, from the professional to the institutional, of bourgeois culture in the nineteenth century.[14] This book joins in their interrogation of the notion of this period as "the bourgeois century" in an effort to identify and to understand the uses, forms, and purposes of culture both for bourgeois elites and for the whole society.[15] We do not lack theoretical constructions for the discourses and institutions of this culture. Barthes's notion of mythology, Gramsci's cultural hegemony, and Bourdieu's cultural capital, in particular, offer a powerful analytical framework for understanding bourgeois culture. Together they make clear how ruling elites derive power from the sphere of high culture they define, use culture to legitimate their domination of the whole society, and mask the historical constructedness of their work in a mode of signification that makes it seem natural or inevitable.[16] Yet the most effective use of this framework demands the specificity and the fullness of particular historical situations: we need a sense of process, of dynamics, of the ways in which culture served whatever purposes historians and theorists now ascribe to it. Surely institutions that local elites, bourgeois by anyone's measure, organized and identified as cultural have much to teach us in this regard.

The national and local dimensions of French museums are of course intertwined, not least at the level of sources. The inspection reports of the state Fine Arts Administration provide some of the most detailed information available about museums as local institutions in the nineteenth century, while it is impossible to judge the nature and effectiveness of the state's cultural policy without surveying the responses to it in local archives. Nonetheless, there are compelling reasons for considering the national and the local separately, beginning with assumptions about the state's cultural predominance that permeate not only French history but French historiography. The following passage, published in 1840 in a short-lived journal called *L'art en province,* could as plausibly be dated in the 1960s, possibly with the substitution of the word "regions" for "provinces": "The provinces have completely faded away. Paris has received all the attention and all the affection of the government.

Everything has been done by Paris and for Paris; all of France is reduced to the capital. The provinces have accepted this humiliation without a word of protest: they have been taken in tow by the capital, and have been content to copy its deeds and its manners."[17]

The assumption that the best must always be in Paris, and that the capital casts its shadow over all aspects of French high culture, is one of the nineteenth century's most persistent legacies to the twentieth. In this light the availability of the museum as a cultural domain for cities to mold in their own image demands explanation: it cannot be understood without a prior consideration of the role of the state and of its limits. Thus the book begins with the state, its policy, and its action involving provincial museums in the nineteenth century.

The state's role in the affairs of provincial museums consisted of two major elements. By depositing large quantities of works of art in major provincial cities during the Napoleonic era, the state compelled, without itself either organizing or supervising, the creation of museums. This single act of patronage, carried out in stages between 1801 and 1811, had so many benefits that successive regimes made it a regular practice; the practice in turn became so essential to the functioning of the state's cultural patronage that it became a self-contained, self-perpetuating system. Chapter 1 examines this system with an eye to its most notable paradox, that the principal link between the state and provincial museums had so little concern for museums as distinct institutions. The state demonstrated its own awareness of this paradox in organizing regular inspections of provincial museums, the subject of Chapter 2. Inspections clearly provided a way for the state to articulate and communicate its vision of museums' purposes and methods. Yet, and despite the state's desire to use inspectors as the basis for increased intervention, inspectors could do no more than fill an essentially discursive role. Not only did the state's other practices of patronage place special constraints on its relations with provincial museums, but other, local agencies had by the last quarter of the century arrogated to themselves the institutional field in which the government wished to operate.

Local claims over provincial museums emerged neither instantaneously nor in simple consequence of the state's perceived absence. Municipal investment in the development of art museums had its own causes and followed its own dynamic. Part II, on the museum and the city, treats that dynamic as proper to a level of experience

largely distinct, if not autonomous, from that of the state. In beginning this account, Chapter 3 doubles back to the period of the Revolution, whose upheavals set the basic terms for the museum enterprise in both Paris and the provinces. It then continues through what might be called the formative stage of provincial museums (roughly to 1850), although the metaphor of "infancy" perhaps better conveys the uncertainty of its outcome. At its inception an undifferentiated hybrid of various related forms, chiefly the art school, the museum in the period covered by Chapter 4 began, slowly and with many false starts, to emerge as a distinct institution. Administrative reforms, the growth of tourism, and an emergent provincial art public all played a part in this development, but the precise character of the institution remained to be determined. "Worthy monuments" needed a signifier that was palpable, not just conceptual; Chapter 5 examines the processes through which major provincial cities gave the visible form of a new building type to the institution, impressing it with the stamp of their own self-conceptions and conceptions of culture. Finally, Chapter 6 offers an analysis of the basic elements of the museum—acquisitions, administration, installation—in the changed context of the consolidated institution. It then situates visitors in the museum, both spatially and in terms of the social and aesthetic values used to constitute them as a public.

In a sense, Part II provides the contours, the shadings, and above all the details of a picture the state saw only in blurred outline, through its own telescopic perspective. In order to facilitate consideration of the full range of sociopolitical issues that had a bearing on museums, the local terrain investigated here has a particular set of limits: it consists of four major regional centers, Bordeaux, Dijon, Marseilles, and Rouen. Of the four, both Marseilles and Rouen combined industrial and commercial activities, but with very different trajectories: Marseilles's industrial base grew out of the dramatic expansion of its port, whereas the port of Rouen developed to counter the mid-century downturn in its textile industry. Bordeaux's almost purely commercial economy, in contrast, underwent a slow but irreversible decline over the course of the nineteenth century. Dijon, a secondary commercial and administrative center with a rich cultural tradition, enjoyed reasonably consistent prosperity throughout the century.[18] Notwithstanding these particularities, which ensure the diversity appropriate to a sample group, all of

these cities possessed the complexity of social relations, political conflicts, and cultural activities that distinguished the urban from the rural in nineteenth-century France.[19]

The terrain thus defined has significance both for the museum and for a broadened understanding of French history. The museum is fundamentally an urban institution; that it can also arise in small towns and even (of late) in rural areas does not vitiate this essential urbanity, rooted in the museum's historical origins and in the nature and purposes of artistic production in the nineteenth century. The museum derives its image at least in part from its urban setting, in the sense that the city shapes and gives meaning to the museum's distinctive practices, so it is above all in this context that the museum's development needs to be situated. Until recently, however, the prevailing account of modern French history has neglected the major provincial cities almost to the point of exclusion and relied on a simple dichotomy that identifies Paris as the only true city and equates the rest of the country, "la province," with "la France profonde," the rural hinterland. A number of frameworks have been brought to bear on French history in the nineteenth century: class conflict and bourgeois dominance, the persistence of political conflict around the ideas of the Revolution, the acculturation of the periphery to the concepts of nation and Republic. In all of these processes, the role and importance of provincial cities grew enormously over the course of the century, so that greater attention to these cities can only add depth and nuance to our understanding of the evolving nation.

Ultimately this book does not aim either to posit some new, overarching schema of French history or to construct new models for the development of the museum. Neither, however, can it accept the purely empirical role of recounting the emergence of some narrowly defined institutional type. In recent historical scholarship, the term "culture" generally denotes both the common beliefs and values of a group or groups and their external signifiers. Historians have been at pains to identify and explicate the cultural dimensions of discourses and processes in the political and social spheres, formerly assumed to operate, with or without a materialist base, according to their own autonomous dynamics.[20] Cultural historians, even those concerned with the domains their subjects themselves defined as cultural, cannot take part in this rethinking without a sensitivity to the ways in which such domains are bound up with

structures of authority, domination, and exchange. Clearly the institutions and their progenitors discussed in this book claimed a kind of moral autonomy for the activities they called cultural. To make such a claim the basis for historical analysis, however, whether implicitly or explicitly, effectively returns to the reductive notion of culture as "reflection"—reflective, that is, of processes largely external to it.[21] Not only historically blinkered, such a notion, as Mary Douglas makes clear, also misses much of the power that institutions like museums exercise.

In her challenging book *How Institutions Think,* Douglas argues that institutions, which she defines as "legitimized social groupings," play an essential role in cognition. The creation of institutions, she believes, answers a fundamental human need for order and coherence in the world of social interaction. Institutions found their authority on analogies that attribute their own organizational structures to natural or metaphysical arrangements rather than to social convention. They serve their ordering purposes by encoding information, creating categories, and setting boundaries that "systematically direct individual memory and channel our perceptions into forms compatible with the relations they authorize." Though Douglas rejects theories that find these practices characteristic only of modern or advanced societies, she agrees with Foucault, Ian Hacking, and others that the modern age (Hacking emphasizes the nineteenth century) has seen an unprecedented proliferation of institutionally produced labels and categories, labels that "stabilize the flux of social life and even create to some extent the realities to which they apply."[22] As an anthropologist, Douglas is concerned mainly with categories of individual people, but her extremely suggestive insights also illuminate the way cultural institutions classify dimensions of *collective* experience on behalf of their creators.

Thus the museum cannot be regarded simply as a reflection of class relations, political transformations, ideological debates: these were as much its raw materials and its building blocks as were works of art and monumental spaces, in which, indeed, class, politics, and ideology are themselves inscribed. The museum's social and political implications, however, involve more than the clarity and coherence of theoretical constructs: they also result from a concrete historical process. Douglas makes clear what is at stake in reconstructing that process when she reminds us that institutions have an interest in effacing the complexity of their history and replacing it

with a sanitized version that serves their own purposes; this, indeed, is one of the principal aims Barthes attributes to mythologies.[23] Cultural history, then, has above all the task of recovering both the constraints and the sense of possibility that framed and impelled the development of the museum in all its particularities. This is, of course, no simple matter: indeed its very essence may be said to lie in its complexity.

Every historian engages in constructing a dialogue between the past and the present, but historians and others constantly confronted with the contingent and variable determinants of culture may be particularly conscious of the limitations of our perspectives. However fine the sense of possibility afforded by hindsight, however acute the awareness of constraints not admitted in the past, these cannot take absolute precedence, or assume total authority, over those of our subjects. In both structure and method, this book is informed by the conviction that cultural history needs to be as broad in its sympathy as it is rigorous in analysis. It ought, in the words of Thomas Nipperdey, "to give back to past generations what they once possessed, what every present possesses: the fullness of the possible future, the uncertainty, the freedom, the finiteness, the contradictoriness."[24] If we put aside the comforting abstractions of argument, whether historical or theoretical, we recognize museums above all as places, places where people come into contact with the visible manifestations of culture, with the various instruments and symbols of power and status, and with each other. They thus constitute an ideal locus for an effort to come to terms with the complexity of our own culture, an effort that, as museums are the first to demonstrate, we can only accomplish by first confronting the complexity of culture in the past.

THE MUSEUM
AND THE STATE

The national museums are a very rich, very heterogeneous mass, poorly installed and poorly organized, adequately meeting neither of their two goals, pleasure or instruction. They are a faithful image of France itself over the past hundred years, encamped amidst the ruins of the ancien régime, while attempting simultaneously to fashion out of them a new social order, carrying out this enterprise with admirable energy and perseverance, but periodically blocked and forced to compromise, undertaking much, rarely finishing anything, but always hoping—hoping to bring together the results of this chaotic labor, to calm minds and unite wills in a free country.

—Gustave Larroumet,
L'art et l'Etat en France, 1895

THOUGH IT CONTINUES and appropriates many of the activities associated with private and princely collecting and display, the art museum sets itself apart from them through its deliberate and self-conscious identification with the public sphere.[1] In the long run the museum, like any institution, derives its essential character from the particular political, social, and cultural instances that control it, but this development is a contingent process. The quality of being public, in contrast, with all it implies, is fundamental, inescapable, and in that sense determining. The art museum *could* be many things, but it *had* to be public. That is why any consideration of the art museum in France must begin with the state, because however peripheral in geographical terms the space in question, in France its constitution as public comes from the center, which is to say, from the state.

As opposed to the various regimes that have incarnated it over the course of the last two centuries, the state has maintained its continuity through its administrative apparatus. Whatever the policy in which the state has couched its support of museums, that support not only has had to pass through the structures of bureaucracy but also has assumed meaning as part of a bureaucratic discourse. Bureaucracy is, of course, by no means ideologically innocent, but it operates in a mode distinct from the particular representations that have traditionally framed the study of cultural politics. Its principal cultural purpose was simply to testify to the state's presence in that domain. From time to time certain regimes, notably the Third Republic, attempted to build on this foundation and to cast museums in a mold more closely tied to their own conceptions of culture and their own visions of cultural policy.[2] That in this effort they largely failed has to do, ironically enough, with their mastery of existing bureaucratic strategies.

The initial, and principal, means through which the state manifested its presence in the life of provincial art museums consisted of artifacts, for the most part painting and sculpture. The character of these works varied widely over the course of the century, but in general they educed a conscious association with the tradition of an autonomous high art rather than with contemporary political ideas.

It would be only a mild exaggeration to say that the state attached less importance to the pictures themselves than to the labels on them that said "Don de l'Empereur" (gift of the Emperor) or later, more modestly but no less clearly, "Dépôt de l'Etat" (deposit of the State). But, just as the transmission of objects predated the institution and continued to follow its own logic, the objects themselves had limited use at those times when the state attempted to reform institutions.

Envois, as the works the state sent to the provinces came to be known, came freighted with the assumptions behind their acquisition: their display in a public institution allowed the state to associate itself with the prestige of artistic tradition while playing down its involvement in the cultural marketplace. Although remaining the state's property, envois were effectively on permanent loan to the institutions receiving them; as such, they helped shape the character of museum installations and also influenced the acquisitions that museums made independently of the state. In other respects, however, their symbolic value operated within a very narrow field, delimited by notions of patrimony, benevolent authority, and the autonomous "cultural." Athough this signification took place in museums, they were not its primary target or concern.

When the state wished to involve itself more actively in the purposes of the museum, it needed a mode of representation at once more flexible and more insistent. Again following the logic of administration, the state chose for this function the multiple role of dispenser of standards, technical expert, and regulator. In this way it could stake its claim to authority over the museum on every basis other than its ultimate power in a centralized political order, hardly of great relevance for institutions it had played only a peripheral role in defining. This kind of authority, while signified in the written forms beloved of bureaucrats, was best embodied in their physical representatives, the inspectors. There is an irony here, for though inspectors derived their official powers, such as they were, from the state, the state was in effect laying claim to the authority—artistic, intellectual, and technical—that they possessed, not the reverse.

In the end, however, the inspectors could do little more than serve as living counterparts to the envois, not because they similarly lacked flexibility and drive, but because they lacked any means other than the envois to put these qualities into play. The story of the state's inspectors of provincial museums derives much of its interest

from the remarkable, and in many cases quite fruitful, coincidence of their standards and values with those of the local elites who built and developed the museum. But in terms of the implementation of state cultural policy, inspectors' actual presence in provincial museums was as one-dimensional as the envois that preceded and, both literally and figuratively, surrounded them.

From the point of view of policy, Part I tells a story of cross-purposes, contradictions, and missed opportunities. But the state's connection to provincial museums cannot be considered only as a matter of cultural policy. The emergence of the museum as an institution involves the construction of a complex of meanings, signified in various ways, and their attachment in various ways to a particular kind of public space. Whatever the trajectory of its own attitudes and priorities, the state clearly played a part in this construction. For not only its claim to authority over cultural institutions but its patronage practices profoundly influenced the strategies of those who actually sought cultural authority in the provinces. In the history of provincial art museums, the state had a monopoly neither on discourse nor on practice, but it did have to show, through both its presence and its absence, in what ways and to what extent the museum was available for local elites to shape in their own image. If, then, the state did not have the last word on what museums would become in France, it clearly had the first.

· · · CHAPTER I · · ·

The State and the Uses of Patronage:
The Envoi System

The State and the Arts: Patronage and Purchases

Political regimes since antiquity have seen in the visual arts an opportunity for legitimation and self-glorification. Their investment in artistic production has thus reflected the ideological benefit they have expected to derive from it. New to the eighteenth century, however, was the view that art could also convey some moral value to the nation as a whole, independent of, though of course not incidental to, the distinct political or ideological purposes of a particular regime. Though by the middle of the nineteenth century it had taken on a life of its own, the state's practice of sending works of art to the provinces clearly had its roots in this moralistic and utilitarian conception of the fine arts. Indeed the notion of the arts as elevating, uplifting, and educational forces for the whole community, not merely for a narrow elite, received expression in various political contexts in the eighteenth century. Obviously this view had different significances for mid-century philosophes, notably Diderot, for monarchist reformers in the 1770s, well represented in the cultural sphere by Louis XVI's Surintendant des Bâtiments, the Comte d'Angiviller, and for radical critics in the 1780s. Without excluding the possibility of ideological particularity in state-supported art, which of course it received in generous measure during the Revolution, the idea of a moral and useful art owed much of its appeal throughout the nineteenth century to its apparent political neutrality and consequent almost infinite adaptability.[1]

But the malleability of its intellectual roots does not alone explain the extraordinary growth and persistence of the envoi system. The attention span and interests of various regimes with respect to the visual arts varied considerably over the course of the nineteenth century. The two Napoleons, concerned primarily with subject matter,

took little interest in questions of taste; Louis-Philippe and his family projected a keen sense of the politics of style and artistic schools onto their patronage. The two empires, as well as the Restoration, thus encouraged work of an overtly political, dynastic, and in some cases religious character. The July Monarchy and the Third Republic, in contrast, reserved explicit ideological statements for other fields and in the visual arts attempted to mask their purposes in apparently more neutral images of heroic or virtuous action from either ancient or more recent French history.[2] But whatever the program, one underlying principle remained constant: that the arts, when flourishing, contributed to both the moral prestige and the material prosperity of France, and that the government therefore had a clear and definite responsibility to support and promote them.[3] Not surprisingly, this principle found its most natural embodiment, not in works of art or in the various aesthetic categories—styles, schools, traditions—that critics use to classify them, but in the practices and institutions of patronage.

A number of figures active in the arts in the early Third Republic maintained that only a democracy could provide the conditions necessary for the ideal relationship between the state and cultural production, which one defined as "l'art libre sous l'Etat protecteur" (free art under the protection of the state).[4] Yet in practice successive regimes, whether monarchical or republican, differed little in the means they used to support the arts: education; preservation; direct "encouragement," through commissions and purchases; and diffusion, which covered such practices as subsidies of theaters and musical performances, the organization of exhibitions, and assistance to various kinds of cultural institutions.[5] Though on one level means toward the broad, general end of promoting the arts, each of these practices effectively created a more limited aim, gradually attracting to itself a distinct terminology, justification, and set of procedures. Such compartmentalization would eventually lead critics to accuse the state of a blurred and narrow vision, of nourishing individual trees while losing sight of the forest. Such charges reflect the effectiveness of the fine arts bureaucracy as an administrative apparatus largely the product of the Revolution. Although occasionally revitalized by bursts of republican ideology, notably in the early Third Republic, this apparatus, like most bureaucracies, eventually devised its own standards of efficiency, largely independent of its ostensibly guiding ideological purposes.[6]

In theory, the envoi system fulfilled, depending on the circum-

stances, one or two of the overall aims of the state's involvement in culture, encouragement and diffusion, and by extension a third, education. Originally, as proposed by the interior minister, Jean-Antoine Chaptal, and promulgated in a consular decree of 14 fructidor year 9 (1 September 1801), the system emphasized diffusion, since the government of the Consulate sent out chiefly old master paintings it had accumulated in foreign conquests or from the former royal collections.[7] As the century progressed, however, and particularly from the Second Empire on, the aim of encouragement came to occupy a dominant position in the system, subordinating the broader purposes of Napoleon's edict to the state's pressing need to find repositories for the vast numbers of works it was purchasing from living artists. Rhetorically, the distinctly pedagogical function attributed to the provincial museums receiving envois remained, but in fact the system's raison d'être had come to lie in practical considerations attendant on the state's direct promotion of artistic production. The state's ever-increasing reliance on the art market as the site of this activity thus had important consequences for provincial museums, not least in the sheer copiousness of the supply of works they were called upon to house.

The state's practice of purchasing works from the Paris salons went back to the ancien régime, though prior to the Revolution works so acquired had entered the monarch's personal collection; public museums dated only from 1791. Official purchases continued through the Restoration and the July Monarchy, their beneficiaries including Delacroix and Paul Delaroche as well as David and Ingres. Yet purchases by no means constituted the centerpiece of the state's patronage of the arts in this period: until the 1850s commissions claimed the lion's share of the state's spending on works of art. Provincial museums, in the period between 1815 and 1848, accordingly tended to receive large-scale historical scenes commissioned by the government and bearing some connection to local history.[8] Before 1870, except during the Second Republic, money for purchases and indeed for most fine arts spending came from the budget of the royal or imperial household, though Louis-Philippe and to a larger extent Napoleon III left the actual choice of works of art to their fine arts officials.[9]

Beyond their symbolic importance, moreover, acquisitions represented an increasingly significant proportion of the funds the state was spending on works of art (see Table 1).[10] From 1858 to 1863,

Table 1. Cost of works of art commissioned and purchased by the government, 1858–1876 (in thousands of francs)

Year	Sculptures Commis-sions	Purchases	Paintings Commis-sions	Purchases	Purchases as percent of total value
1858	140	43	300	80	21.0
1859	245	22	269	76	22.0
1860	260	35	275	63	18.6
1861	106	30	330	90	21.4
1862	98	20	250	100	28.5
1863	162	240	400	355	47.0
1864	65	145	300	450	60.0
1865	220	50	230	300	56.6
1866	50	16	200	230	53.4
1867	155	130	240	245	50.5
1869	84.4	136	284.7	350	55.1
1870	0	20	80	6.5	(No Salon purchases)
1871	26	130	40	180	81.8
1872	7	15	70	72	50.7
1873	18.7	41	134.5	60	30.8
1874	40	89.3	60	234.2	79.6
1875	92	50	75	210	73.7
1876	35	19	62	105	62.8

Source: Archives Nationales, AD[XVIIIF] 673, 691, 772, 791, 811, 833, 855, 904, 914, 925, 962, 963, 1001, 1020, and 1042: for the Second Empire, *Compte rendu par le Ministre d'Etat* (or, from 1863, *de la Maison de l'Empereur et des Beaux-Arts*), *Compte définitif des dépenses ordinaires et des dépenses extraordinaires de l'exercice* [year]; for the Third Republic (data provided for purposes of comparison), Ministère de l'Instruction Publique et des Beaux-Arts, *Compte définitif des dépenses de l'exercice* [year]. AD[XVIIIF] 874, with accounts for 1868, was missing from the Archives Nationales, possibly because it was published in 1870.

the first five-year period for which ministerial accounts detail the works acquired and distributed, purchases represented less than a quarter of the sum expended on paintings (22.3 percent), purchased sculpture even less (15 percent). But from 1863 to 1869, purchases amounted to over half the expenditures on paintings (53.8 percent), while purchases of sculpture had climbed to 49.3 percent of the total.[11] Several factors might account for this shift, chief among

them the considerable rise in the number of works exhibited at the Salons.

An official state exhibition dating back to the seventeenth century, the Salon presented works by living artists for a period ranging from a few weeks to three months. Whether biennial, as during the Restoration (1815–1830), or annual, as throughout the July Monarchy (1830–1848) and Third Republic (after 1870), until late in the nineteenth century the Salon was the dominant event in the Paris art world. Yet as early as the 1840s many critics and other observers had begun taking note of the dramatic increase in the size of Salons and in the number of works submitted. The exposition, they complained, had become a huge picture bazaar rather than a showcase for the best in contemporary art. This change in the character of the Salon corresponded to the emergence of alternative outlets for the sale of art, including dealers and small-scale private patronage, all developments scholars have traced to the appearance of a substantial bourgeois art market.[12] Both highly respected mainstream artists like Ingres, who did not exhibit at the Salon after 1834, and more innovative and controversial figures like Jean-François Millet took advantage of new commercial avenues outside the Salon, thus contributing in part to the decline in the overall quality of Salon exhibits that many critics perceived.[13]

But the vast expansion of the Salons, which can be documented in the number of works exhibited from 1800 to 1870 (see Table 2),[14]

Table 2. Number of works in Salons from the Consulate to the Second Empire

Period	Smallest Salon	Largest Salon	Average
1800–1815	705	1,442	1,025
Restoration	1,100	2,371	1,762
July Monarchy	1,597	3,318	2,271
1850s	1,757	5,129	3,326
1860–1870	2,745	5,434	3,780
Second Empire (overall)			3,598

Source: Averages compiled from figures in J. J. Guiffrey, *Table générale des artistes ayant exposé aux Salons du XVIII siècle, suivie d'une table de la Bibliographie des Salons, précédée de notes sur les anciennes expositions et d'une liste raisonnée des Salons de 1801 à 1873* (Paris: J. Baur, 1873), pp. lxv–lxxii.

posed a considerable challenge to the regime that organized them and that continued to characterize their exhibits in terms of artistic quality rather than of market value. The relationship between state patronage and the art market is a complex one that has yet to receive the sustained scholarly consideration it merits. Clearly, however, the dramatic increase in state purchasing can only be understood in the context of the burgeoning private art market. In many ways the Second Empire as a regime associated itself with the values of speculative capitalism, and it effectively came to measure its own role as a patron in terms of the sums of money others were spending on art.[15] Yet for the state to have used this standard of comparison openly would have compromised the prestige it wished to derive from visual culture; hence the need to exhibit its purchases as the fruits of enlightened patronage rather than of vigorous speculation or naked political calculation.

The most prestigious destination for works of art purchased by the state was the Musée du Luxembourg. When still a royal residence, the Luxembourg had housed the first public exhibition of works from the royal collections in the 1770s; it had served as the museum of contemporary French art since 1818. The Louvre did not display works by living artists: the rules varied from time to time, but at least five and for most of the nineteenth century ten years had to elapse between the time of an artist's death and the transferral of his or her works from the Luxembourg to the Louvre. Thus the Luxembourg represented the apex of official recognition for practicing artists.[16] Artists, of course, spared no effort to reach this summit. One sculptor, obviously angling for a spot in the Luxembourg, deeply offended the mayor of Grenoble by suggesting that the museum there could not suitably accommodate his work (the city got it anyway). Usually, however, municipal officials showed a greater sensitivity to the exigencies of artists' careers: in 1866 the mayor of Dijon expressed the hope that a recently purchased painting by Louis Boulanger, then the director of the Dijon museum, would go to the Luxembourg, but said that if it did not the city would be happy to receive it, which it eventually did.[17] Much later, the painter Victor Gilbert wrote almost casually to Bordeaux officials that he would have preferred that his *Jeweller* hang in the Luxembourg, but if it had to go to the provinces, he was pleased that Bordeaux would get it. His correspondents did not appear offended, nor did their counterparts in a similar instance in Rouen.[18]

The difficulty, obviously, was that the Luxembourg could not

possibly accommodate anything like a substantial portion of the works the state was buying, especially as the number of those purchases increased. In 1860 the Luxembourg housed 168 paintings and drawings and 31 pieces of sculpture. In 1863 the Fine Arts Administration sent an additional 29 paintings to the museum, but in the meantime it had purchased 145 paintings, and never again in the Second Empire would it purchase fewer than 115 paintings annually (see Table 3).[19]

Even had the Luxembourg had more room, for ideological reasons it could hardly have taken a larger proportion of Salon purchases. Curators often cited the Luxembourg's character as a "musée de passage," but each work's *passage* generally lasted a generation or

Table 3. Destinations of paintings acquired by the government, 1858–1876

Year	Commissions					Purchases					Percent of purchases to provincial museums
	Total	MN	Ch	PB	MP	Total	MN	Ch	PB	MP	
1858	173	9	69	76	19	33	2	6	4	21	63.6
1859	174	4	81	78	25	20	0	0	5	15	75.0
1860	168	4	79	73	12	23	2	4	3	13	56.5
1861	190	6	64	116	4	16	5	3	4	4	25.0
1862	173	2	54	76	34	26	1	4	1	21	80.8
1863	231	9	94	101	27	103	33	10	5	55	53.4
1864	207	3	69	101	34	142	22	10	1	109	76.8
1865	165	2	65	89	9	125	0	11	0	114	91.2
1866	159	1	83	69	6	123	0	13	2	108	87.8
1867	158	4	81	71	2	115	0	11	12	91	79.1
1869	252	1	94	144	13	145	3	15	5	122	84.1
1870	101	0	37	63	1	4	0	3	1	0	(Wartime)
1871	32	0	24	2	6	91	1	3	0	84	92.3
1872	63	0	61	1	1	33	0	2	2	29	87.9
1873	132	0	109	18	6	26	0	6	3	16	61.5
1874	61	0	0	48	12	132	0	20	2	109	82.6
1875	38	1	24	2	11	101	0	31	5	65	64.4
1876	41	0	23	9	9	114	0	87	15	12	10.5

Source: See Table 1.

Abbreviations: MN, national museums (principally Luxembourg); Ch, churches; PB, public buildings (e.g., prefectures, city halls); MP, provincial museums.

more: the museum was meant to provide a sort of visual summary of the greatest achievements of the contemporary French school. A commission made up of curators from the Louvre as well as the Luxembourg's lone curator generally selected the works the state wished to purchase at the beginning of the Salon. This practice effectively gave the state the right of first refusal, and it also gave the Salon's organizers the opportunity to publicize the government's choices by hanging them in choice locations and by affixing special labels denoting official endorsement.[20] The Luxembourg itself, however, represented a higher level of recognition, one clearly and deliberately insulated from the market atmosphere of the Salon. Though occasionally a short exhibition of the state's purchases might be held after the close of the Salon, it always took place in the Salon exhibition galleries themselves. There was no Luxembourg biennial, much less annual: that was not its role.

The exiguity of the Luxembourg did not actually become a cause célèbre until late in the century, when parliamentary critics noted that the stifling heat and overcrowding posed a serious risk of deterioration to the works of art, but knowledgeable observers were well aware of its limitations by the 1860s.[21] The *Chronique des arts et de la curiosité* observed in 1863 that "there is no museum in Europe more unfit than the Luxembourg to house paintings; most of its rooms, narrow and poorly lit, refuse *absolutely* to accommodate large canvases." Philippe de Chennevières, curator of the Luxembourg from 1861 to 1873 before becoming director of fine arts, commented on "the overly tight space . . . the Gallery and Vernet Rooms were bursting from year to year because of the crowding, and we were inevitably constricted by the stairway of the Senate and by its meeting rooms." Charles Blanc, Chennevières's predecessor as fine arts director, wrote simply in 1872, "The Luxembourg is overloaded, completely overloaded."[22]

Expanding Salons, substantial and increasing state Salon purchases, a national showcase for contemporary art with no room for expansion: all these signs of change in the art world in the mid-nineteenth century provoked considerable comment, and often vigorous criticism of the state. The Second Empire had, after all, openly invested both in the art market and in the prestige attached to art. Moreover, it insistently made claims to authority, not directly over artists and their work but over the terms of artistic production, and used the visual arts as a kind of leitmotif to exemplify its

political and ideological programs. Thus the regime of Napoleon III became an inevitable target of blame for whatever critics found wrong in the art world and in the state's responses to it.[23]

The Second Empire polemic over state patronage had one notable peculiarity. Essentially concerned with market practices and institutions, both sides nonetheless framed their argument in terms of artistic quality or merit, which, as the critics in their more sober moments would surely have conceded, ruling elites have never been able to secure on their own. It is hardly coincidental, then, that the practice of shipping works of art to the provinces first reached systematic proportions during the Second Empire. In the context of this perpetual contestation, such a practice had one inestimable advantage: it removed from the Paris arena the works of art around which the debate (misleadingly) revolved. Out of sight was not quite out of mind, but it was clearly peripheral; Paris was the only place where the state's critics could claim that aesthetic quality mattered.[24] The envoi system did come in for occasional murmurs of rather routine criticism, but this involved a different, and for Parisians altogether less fascinating, charge against the regime, not autocracy but over-centralization. Although hardly the kind of utility that the eighteenth century had attributed to the fine arts, the type of disposal service that envois thus provided was in many ways inscribed in the practice of distribution from the beginning. In the multiplicity of its investments, the state's notions of utility almost invariably came to focus on immediate practical needs rather than on the ideological purposes a particular practice had originally been intended to serve. Yet precisely this bureaucratic focus endowed the envoi system with a longevity, and a resistance to change, that politics alone could never have provided it.

Envois: The Workings of the System

Whatever the cultural value attached to them, works of art have in common with other commodities their materiality as objects, not least in their occupation of space. On one level, indeed, and arguably the most important, the decree of 14 fructidor year 9 represented a highly practical solution to a massive storage problem. From 1794 to 1810 an enormous number of works of art reached Paris in the wake of Napoleon's military conquests, through means as diverse as outright plunder in Belgium and the Netherlands,

formal agreement (the Treaty of Tolentino) in Italy, and in Germany, the single-minded efforts of Dominique Vivant-Denon, the dynamic director of the Louvre and Napoleon's cultural major-domo.[25] More than five hundred paintings from Italy alone, probably a similar number from the Low Countries, and twice that many from Germany entered France in this way, though the allies reclaimed a respectable proportion of them in 1815. The booty also included cartloads of sculptures, among them Venice's prized bronze horses and Lion of St. Mark, and numerous books, manuscripts, scientific instruments, and works in such media as glass, ceramics, and precious stones.[26]

Most of these works, following a celebratory pageant to the greater glory of France, went to the Louvre, renamed the Musée Napoléon in 1803. But that institution also had to accommodate works of art from former monasteries and churches, and moreover was closed for reconstruction for long periods of time between 1793, when it first opened to the public, and 1810.[27] Chaptal's report to Napoleon of 13 fructidor, the day before the decree, duly cited Paris' obligation to share its artistic treasures with the provinces, as well as the benefits envois could provide to provincial education and taste, but it began with the physical situation: "The immense gallery open to the public cannot accommodate more than half of the master-pieces belonging to the nation. There are over a thousand further pictures at Versailles and six or seven hundred in storage at the Louvre, for lack either of space to hang them or of necessary restoration."[28] The first envois carried out in accordance with the fructidor decree disposed of over eight hundred paintings; as Chaptal could easily have anticipated, the dispersal also saved the government considerable expense for repairs and restorations: beginning a pattern that would last throughout the century, it charged the cities involved for the necessary work.[29]

Although hardly unusual in its combination of practicality and noble-sounding rhetoric, the decree of 14 fructidor managed to merge them with notable subtlety and political skill. Like all masterful political strokes, the envoi system as Napoleon constituted it served multiple purposes, while appearing to serve only, or primarily, the most noble and politically popular. Obviously the state could not simply have kept its surplus of masterpieces hidden away in storage; it had attached too great a symbolic value to them for that.[30] It could, however, have confined the dispersal of works to the

subsidiary galleries of Versailles and the Luxembourg, which had yet to receive distinct missions or characters, or sent them back to the churches that, following the Concordat of 1802, were clamoring for the restitution or replacement of art they had lost in the previous decade.[31] The brilliance of the decree of fructidor consisted in going one step further, to the facile generation of a kind of factitious, stage-set decentralization, or the appearance of decentralization without the reality.

Chaptal, of course, couched his proposal in the careful, if somewhat condescending, terms appropriate to a conscientious decentralizer. He observed that "the landmarks of painting cannot be distributed indiscriminately all over France"; they could be useful only in cities "where existing knowledge would make them valuable, and where a large population and natural predispositions could presage success in training students." Yet the apparently last-minute changes the report went through before reaching this statesmanlike sonority give the lie to the impression of conscientiousness. The first report had included only four cities in the state's largesse (Brussels, Lyons, Toulouse, and Bordeaux), the first version of the decree five (these plus Rennes). In the final version of the decree, the one actually signed by Napoleon, the word "huit" is scratched out and the number "15" written over it, with the final list of cities written in the margin.[32] A year later, on 16 fructidor 10 (3 September 1802), Chaptal reported that two additional cities, Tours and Montpellier, were demanding that they be included in the state's benefaction. Noting that they met the criteria he had established, and above all that they were suitably far removed from the cities already chosen, he recommended granting the request, and a decree of the same date did so.[33]

For Chaptal and his master, obviously, expanding the pool of recipients merely increased the decree's political benefit. The inclusion of three cities in annexed territories (Brussels, Mainz, and Geneva) and the early addition of Rennes in Brittany, a region of dubious loyalty, make clear the real nature of the regime's "sensitivity" to local interests.[34] In the context of a new, highly centralized style of authority, the cities concerned were hardly likely to interpret the state's generosity as genuinely decentralizing in spirit, but as long as they evinced suitably humble gratitude in accepting the works, the state was equally unlikely to care. For the regime decentralization had never been more than a convenient rationale, and it

did not bother to enforce the fructidor decree's provision that "the paintings will not be sent until the city has established, at its own expense, a gallery suitable to receive them."[35] The envoi system served one primary purpose, the disposition of pictures, and the Napoleonic regime contented itself with the simplest benefits, both political and practical, it thus provided. Though its successors sometimes tried to do more, the simplicity of the system's principle and the facility of its practice not only proved hard to resist but made the difficulties of expanding envois into an effective instrument of cultural policy look all the more formidable and all the less worth overcoming.

The regimes that followed the Empire had a number of occasions to use provincial art museums as convenient repositories for works they had acquired but, for reasons involving either national politics or the narrower but equally contentious politics of the art world, did not wish to keep in Paris. One such case, reasonably well known, involves Gustave Courbet's *After Dinner at Ornans,* one of his early realist works and both a critical and popular success at the Salon of 1849. The Fine Arts Administration, in keeping with the reformist principles of its director, Charles Blanc, and the director of the Louvre, Philippe-Auguste Jeanron, bought the painting for three thousand francs. But, after several months' reflection, they apparently decided that Courbet's art represented too radical a departure even for them and sent the painting to Lille, an important provincial museum but hardly the Luxembourg.[36]

On a far larger scale, provincial museums provided Napoleon III thirteen years later with a way of extricating himself from a contentious artistic imbroglio he had himself created. In 1861 the emperor had spent 4.8 million francs to purchase the lion's share of the vast and distinguished collection of a bankrupt Roman functionary and archeologist named Giampietro Campana. The following year the collection, including over six hundred Italian primitive and Renaissance paintings as well as classical and more recent sculpture, ceramics, jewelry, and decorative arts, went on view at the Palais de l'Industrie, the Louvre having no room for them. Napoleon III gave the museum his own name and intended it to serve as a "musée de l'art industriel," to provide inspiration and models for artists and craftsmen. But the head of the fine arts bureaucracy, the Comte de Nieuwerkerke, and the Louvre's curatorial staff viewed the new museum as a threat to their authority and to the primacy of the

Louvre. They opposed it with such vehemence that the emperor quickly thought better of his plan and canceled the project. Following an outburst of public indignation that included both Ingres and Delacroix, and under pressure from the Académie des Beaux-Arts, the Louvre agreed to keep a number of the paintings. The bulk, however, went to provincial museums, in the greatest windfall they had received since the original envois. The Louvre's director, Frédéric Reiset, carried out the distribution hastily, indiscriminately, and, most authorities agree, with considerable vindictiveness (cutting up triptychs, for example, and sending different panels to different parts of the country). As a result, when the national museum administration decided to reassemble the collection following World War II, it required over twenty years and much travail to do so.[37]

The distribution of works from the Campana collection, of course, resulted from an unusual if not unique conjunction of circumstances. Yet an examination of the overall pattern of Second Empire envois, that ever-growing pool of Salon acquisitions that the Luxembourg could not accommodate, reveals a similar order of priorities. Though not individually as dramatic as the Campana affair, certain regular features of the envoi system of the period suggest that the government cared much more about disposing of works of art than it did about the institutions that received them. In the first place, the government had a disconcerting tendency to send works to museums that did not exist. The town of Apt, in the Vaucluse, received a painting in the 1860s, but an inspector in 1879 found that the city's envois were hung in the city council chamber, which was never open to the public. The inspector emphasized that "the *museum* in Apt, for which no one in the town is responsible, is not close to becoming a museum."[38] Inspectors also found that a number of towns that had received paintings during the Second Empire, sometimes in substantial numbers, kept their works dispersed around their town halls, without "any organization as a museum." Senlis, in the Oise, which had received two envois in the 1860s, had by 1879 gotten no further than choosing a site for a museum.[39] Nor did the state make such envois completely unconsciously: in 1863 the government arts service agreed to allow an envoi to hang in the city hall of Brest until the city constructed a museum. It did not request, nor did it receive, any commitment to a precise timetable for this construction.[40]

Phantom museums may have received only a very small proportion of the Second Empire's envois, but the government showed little more concern about the conditions of museums that did exist. In 1851 the Interior Ministry sent out a circular asking certain basic questions about the conditions of collections and museums, and around 1863 the arts bureaucracy began asking for copies of provincial museum catalogues or inventories, but officials seem to have done little with whatever information they acquired.[41] The Grenoble museum received nine envois in the 1850s and twenty-two, including nine from the Campana collection, in the 1860s, but one 1859 visitor said that on a cloudy day "it becomes impossible to see a single painting, and it is not long before this gloom becomes highly sinister."[42] Bordeaux could boast of fifteen envois in the fifties and twenty-three, including eight from Campana, in the sixties, despite experiencing a serious museum fire in 1862. It housed its collections in galleries a local observer described as "incommodes et obscures."[43]

After 1850, the government also evinced little interest in the subject matter of the works it was acquiring, certainly not to the extent of assigning paintings to the museums that might most logically have wanted them. It would be difficult, moreover, to construe this randomness in terms of a policy to inculcate patriotic feelings in various regions by showing them other parts of the nation to which all belonged. In addition to the lack of any documentary evidence for such a plan, there were simply too many exceptions. One group of exceptions involved resort areas or sites particularly popular with artists, like those of Brittany or Barbizon. Thus the state sent Saint-Malô a depiction of itself as well as a scene of the neighboring Breton department of Morbihan, Melun a work entitled *Fontainebleau Landscape,* and Pau five watercolors of the nearby resort of Biarritz. Whereas Chambéry, in the newly annexed Savoie departments, received landscapes of Neuilly and of Cannes, historical scenes, which might be considered a natural way to promote loyalty in peripheral areas or in those with a rebellious past, also tended to go to the places where the original events had occurred. *Joan of Arc Going to the Torture,* for example, was sent to Rouen in 1867, and *The Body of Charles the Bold Discovered on the Morrow of the Battle of Nancy* went to Nancy in 1865.[44] Although the idea of provincial museums displaying works of regional interest was very much in the

air during the Second Empire,[45] the whole business bears the hall-marks of absent-mindedness much more than of concerted policy.

The government used the simplest possible criteria in determining the number and destinations of envois. It obviously wished the system to appear fair, and its patronage therefore had to reach all communities in France with any pretension to urban status (and the statistical definition of urbanity included any *commune* with a population of two thousand or more), in reasonable proportion to their importance and to that of their museums. The Fine Arts Administration generally ignored requests for special treatment, except from towns that claimed they had been overlooked. When, for example, the Calais museum commission observed "with pain" that its institution did not appear on the *Journal officiel* list of envoi recipients for 1864, the Fine Arts ministry (since the previous year attached to the Imperial Household) replied that it would consider it the following year, if the museum sent along a catalogue. The catalogue duly sent, the museum received its first painting the next year.[46] In 1852 the minister of state informed a number of influential officials, including the minister of the navy, that the government could not consider Bordeaux's request for a painting by Jean-Léon Gérôme until after the close of the Salon at the beginning of August. Though by the early sixties the state was billing envois as a commemoration of the emperor's birthday, the timing remained the same.[47] Napoleon's fête, conveniently, fell on 15 August, giving his arts administrators just enough time to sort out their purchases, though hardly enough to ponder them.

The state also observed in its distribution a strict hierarchy of museums, based roughly on the museum's size and on the size and importance of the cities to which they belonged. Virtually an exact proportional relationship obtained between the mean number of paintings sent to a museum and the state's categorization of it, whether "of the first order," "of secondary importance," "of tertiary importance," or "in formation" (see Table 4).[48] Specific requests from cities might enable them to secure a particular choice, but they could not alter the numerical distribution. Nor, conversely, did a major city need to show any interest in envois in order to receive them. Among class 1 museums, Rouen received eight envois in the 1850s without requesting a single one; Bordeaux made two requests but received seven envois; Marseilles put in five requests but received ten works, not significantly more than the others. In

Table 4. Mean number of paintings sent to provincial museums, subdivided by category of museum, 1800–1914

Period	All museums	Class 1[a]	Class 2	Class 3	Class 4	Class 5	Class 6
Before 1815	32.0	46.0	12.8	3.0	0.0	2.0	0.0
Restoration	4.4	9.0	2.1	2.6	1.0	0.0	1.0
July Monarchy	3.7	6.0	4.8	2.67	0.0	1.0	0.0
Second Republic	2.2	3.2	1.9	1.8	0.0	0.0	0.0
1851–1860	4.3	8.5	5.1	3.3	0.5	0.0	1.5
1861–1870	5.5	9.4	6.6	5.1	1.7	1.5	1.0
Campana distribution	6.1	10.8	5.2	4.9	1.0	0.0	0.0
1871–1880	3.8	10.6	5.8	3.4	2.2	1.0	2.1
Louvre reserves, 1872	7.6	17.5	12.1	6.5	3.2	1.67	2.67
1881–1890	2.8	7.9	3.8	2.7	2.5	1.3	0.5
1891–1900	2.5	7.7	3.8	2.4	1.5	1.3	0.9
1901–1914	3.97	12.1	6.1	3.5	3.6	2.4	0.7

Source: Data in cahiers, AN, F^{21} 4500, 4909, 4910. Means obtained through computerized analysis of the raw data, using the Statistical Analysis System (SAS). Figures for classes 4, 5, and 6 from before 1870 based on an insignificant number of cases.

a. Categories from Charles Blanc, Directeur des Beaux-Arts to Ministre de l'Instruction Publique et des Beaux-Arts, August 1872, reprinted in *CAC* 10 (1872): 334–337. Class 1: "collections de la première catégorie" (16 museums); Class 2: "28 musées de deuxième ordre"; Class 3: "musées de troisième catégorie" (117 museums); Class 4: "musées en voie de formation," i.e., 45 museums founded between 1870 and 1879; Class 5: 58 museums founded after 1879; Class 6: 27 museums for which no information on founding is available, either in the cahiers themselves or in Germaine Barnaud, *Répertoire des musées et collections publiques de France* (Paris: Réunion des Musées Nationaux, 1982). Blanc himself listed only the museums he included in the first two categories.

the sixties Rouen received thirty-four works, including fifteen from the Campana collection, on the strength of two requests; Bordeaux received twenty-three, eight from Campana, on the strength of three. Nor did the interest of Roanne, a class 3 museum, evinced in a request in the 1850s, make any difference to its status: it received only two envois.[49]

Even the intervention of political figures, whether deputies, senators, or influential ministers, could not change the basic lines of policy. Only politicians who understood both the purposes and the workings of the envoi system were likely to get anything for their constituencies or home towns. An astute deputy from Alsace warned the mayor of Colmar in 1851 that time was much too short

for him to obtain everything he had requested, and advised him to ask only for what the government could easily provide, an already purchased painting by an Alsatian artist.[50] Requests of this kind, indeed, could simplify the distribution process for a bureaucracy largely unconcerned with either details or consequences. In 1865 an embarrassed artist wrote Nieuwerkerke to thank the government for purchasing his bas-relief, but said that, as the recipient of a city scholarship, and not dreaming that the state might want the work, he had already sent it to Bordeaux. The state responded by regularizing this "envoi" with an official decree, and that was that.[51] Such minor diversions in no way disrupted the course of the mighty river of art the Second Empire kept flowing.

The advent of the Third Republic brought changes in tone, but few changes in substance, to the envoi system. In part this continuity grew out of the desire, even the anxiety of early leaders of the Republic to prove the new regime as generous and enlightened a patron of culture as its predecessors. The idea of patronage on behalf of a royal or imperial household had disappeared, but the state Fine Arts Administration, installed since the fall of the Empire in the Ministry of Public Instruction, carried out old practices of patronage without either questioning them or having to justify them to their new political masters. As one republican city official in Bordeaux put it, "the Republic should, like monarchies, encourage the arts; it must therefore follow the old tradition."[52]

But even after the difficulties and hesitations of the "République des ducs," even after the firm establishment of a Republic based on republican principles and governed by republican leaders, the nature of cultural policy in general, and of the envoi system in particular, remained largely unaltered. The instability of the parliamentary regime as it emerged in the late 1870s and 1880s militated against strong action or even reflection from the executive. It left a great deal of authority in the hands of an expanding bureaucracy, whose habits, not irrevocably but in the absence of external pressure, tended toward the preservation, even ossification, of preexisting norms and procedures.[53] Whatever its action in other domains, the Third Republic brought little such pressure to bear on the envoi system, at least in terms of any new ideological purpose. Despite the state's attempt to portray envois as part of a distinctly republican emphasis on instruction and enlightenment, the primary imperative remained the disposal of works of art. By 1870 the envoi system had

come to function according to its own logic, one understood by both its administrators and its ostensible beneficiaries. But even beyond this practical level, its focus, and for the state its raison d'être, never shifted from the works being transmitted to the needs of their recipients.

The first note struck by the Third Republic in the realm of provincial museums could not have been more in harmony with the practices of the Second Empire. In 1872, in response to queries from several deputies, Minister of Public Instruction Jules Simon announced that the government would carry out a plan, formulated just before the collapse of the Second Empire, to distribute to provincial museums a number of works from the Louvre's storage areas.[54] As Simon's report initiating the distribution makes clear, the project had originated not in response to popular demand but to deal with a familiar preoccupation: "The previous government had recognized that, even after the completion of the Louvre, it would be impossible to display in the old and new galleries of the national museums [i.e., Versailles and the Luxembourg as well as the Louvre] all the treasures they possessed, and which had for a number of years been increasing considerably, as much through the administration's purchases as through private gifts." Though working with "scrupulous care" to preserve the integrity of the state's collections, Simon continued, a commission appointed in 1869 had "nevertheless" determined that the Louvre could safely part with over four thousand objects, including one thousand paintings.[55] The government naturally observed a strict hierarchy of museums in distributing these works: in preparing this distribution Charles Blanc formalized the unofficial classification of museums long in use by the state.[56]

In his report on the Louvre reserves plan, Blanc had offered a paean to "the aspirations of the provinces and the increasingly active interest they are taking in all kinds of artistic advances." Simon took up the cry in praising "the sacrifices a number of French cities have made to create museums, and to enrich those they already possess."[57] But another project Blanc undertook during his brief tenure as the Third Republic's first director of fine arts (1870–1873), probably the one closest to his heart, makes clear how little interest he took in the distinct needs and purposes of provincial museums. In 1872 Blanc began organizing a "Musée des Copies," or as he called it, a "Musée Européen," which was to display copies of great works

from the Western tradition since the beginnings of the Renaissance. The idea for such a museum, intended to instruct not only artists and craftsmen but the general public as well, did not originate with Blanc; he may have gotten it from his close friend Adolphe Thiers. But Blanc's manifestly democratizing aims raised too many hackles during the museum's few months of existence in the Palais de l'Industrie, and Chennevières closed it when he succeeded Blanc late in 1873, sending the museum's contents to the Ecole des Beaux-Arts.[58]

Driven by his vision, Blanc had spared no trouble or expense in his feverish efforts to organize the museum. He commissioned well-known artists, including Antoine Vollon and Léon Bonnat, to execute copies, and he used all the means at his disposal to obtain the copies he desired from the collections of various provincial museums. Neither in Dijon, where Blanc could rely on the help of his friend Célestin Nanteuil, a painter and director of the Dijon museum, nor in Marseilles, which he visited personally and where he had to deal with a wily deputy named Alexandre Clapier, did officials have much trouble persuading Blanc to raise his offers. But Blanc's attitude toward provincial museums emerges very clearly throughout the entire affair as a mixture of impatience, condescension, and contempt. At one point he wrote to Nanteuil, "I think the lot that should soon be sent you is ample compensation; anyway it's as ample as I'd promised."[59] And, though officials in Marseilles had made clear from the beginning that they would not regard contemporary Salon works as adequate compensation for the museum's only Ingres, a copy of Raphael's *Mercury,* Blanc later denied that he had suggested a state purchase of another Ingres copy, a fragment after Poussin's *Eliezer and Rebecca,* as a replacement.[60] Obviously Blanc persisted in regarding provincial museums as repositories from which the state could pick and choose at will, of so little importance as collections in their own right that the latest showy Salon "machine" would suffice to fill any gaps.

Charles Blanc may have been particularly unscrupulous, and exceptionally transparent, in the pursuit of his ends, but his attitude toward provincial museums was by no means unique. In the 1874 discussion of the fine arts budget, one deputy proposed that provincial museums, in exchange for future envois and for works from the Louvre distribution, be required to send to Paris works that would fill in gaps in the national collections.[61] The state might not have

gotten away with such a maneuver, which undoubtedly would have provoked considerable resistance. That it did not even try, however, indicates how little the Fine Arts Administration even connected envois with provincial museums as institutions, in terms either of costs or of benefits.[62]

True, the Republic's arts administrators did succeed in eliminating the most serious anomalies from the envoi system. The government still managed, in the 1870s, to send works to towns without museums, including Mont-de-Marsan, Montélimar, Pont-Audémer, St. Gaudens, and Vervins, true backwaters that even the Second Empire had contrived to ignore.[63] But the institution of regular inspections of provincial museums in the 1880s at least succeeded in eliminating this most extreme irregularity. Beginning in the 1880s as well, the subject matter of envois generally had more to do with the localities receiving them, and not simply in areas popular with artists. Perpignan received *Sunset, near Perpignan* in 1896 and *The Têt, at Perpignan* in 1910; Rouen, which in the 1860s had received *Souvenir of the Dauphiné,* an area far removed from Normandy, received *Banks of the Seine* in 1888, Evariste Luminais' *The Enervés of Jumièges* in 1912, and a watercolor of *The Rue des Arpents, Rouen,* in 1913. Cities in more picturesque areas, particularly those frequented by tourists and artists, continued to receive particularly heavy loads of regional scenes: the state sent no fewer than nineteen scenes of Brittany to the museum in Quimper between 1879 and 1914.[64] Although this new tidiness in assigning envois clearly reflects the practical adaptation of a bureaucracy to increasing numbers both of works and of potential recipients, it hardly signaled any profound shift in policy.

The regular inspections the government initiated in 1879, however, and which accompanied the elaboration of new standards for museum facilities, were at least intended to indicate a new policy. From an administrative point of view, as will be discussed in Chapter 2, both inspections and standards represented chiefly an attempt to provide envois with some kind of official rationale; nonetheless, in placing considerable emphasis on municipal effort, they did much to change the tone of the envoi process. Long practiced in the art of telling Paris what it wanted to hear, local officials quickly learned to couch their requests for specific works of art in terms appropriate to this new era of standards. The key word was *sacrifices,*

a term both broader and more specific than the English and encompassing the concepts of effort and initiative as well as of financial investment.[65]

The future president Sadi-Carnot, as a deputy from the Côte d'Or and minister of finance, wrote to the director of fine arts in 1885, "The Museum of Dijon, as you doubtless know, is already highly important, and the city has undertaken many *sacrifices* for it."[66] "As for the *sacrifice* that the city of Marseilles makes for its museum," the director of that institution wrote in 1883, "I can say that in the last year it devoted the sum of 24,000 francs to the purchase of sculpture and painting." In 1880 the mayor of Rouen described the cost of the new museum the city was constructing as "an enormous *sacrifice,* and one that testifies to the concern of the city of Rouen for everything that can contribute to the progress of the arts."[67] Ideally, a city's actions could literally put words in the mouths of the state's representatives, as when the chief inspector of provincial museums, Roger Marx, responded to "the very meritorious effort of M. Auquier, newly named curator of the Marseilles museum," with the recommendation of an envoi.[68]

As all parties knew, the state hardly needed an incentive to send works of art to the provinces, but it obviously jumped at the chance to respond to one when it could. In pretending that envois represented a reward for some government-stimulated *sacrifices,* however ill-defined, the state was creating an amiable and harmless, if somewhat hollow, game, in which most provincial cities could play along without much difficulty. Logically, however, the state's new norms would also have entailed sanctions for museums that did not comply with them. Yet the Bordeaux museum received thirty envois in the 1870s, including fourteen from the Louvre reserves, even though it had experienced two serious fires in the previous decade. This total compared favorably with those of two other class 1 museums, Lyons (twenty-nine works, eight from the Louvre reserves) and Montpellier (nineteen and seven), both of which could boast a wholly acceptable rating in the 1879 inspection.[69] Beginning in the 1880s, inspectors repeatedly called to the government's attention the serious risks of fire that ground-floor shops and warehouses posed to the museum in Dijon, but the number of its envois (twelve in the 1880s, thirty-five in the 1890s) compared favorably with those sent to other class 1 museums with better ratings.[70]

What accounts for this apparent laxity toward major museums?

In the first place, the government could threaten to withhold envois from small museums with impunity (though in point of fact it rarely did so). Since small towns all over France were constantly creating new museums, then requesting works from Paris to fill them, the state did not lack potential recipients for the least prestigious and cheapest works it acquired. In 1884 a deputy named Hippolyte Gomot described the typical circumstances surrounding the creation of a new museum in a small town: "A mayor wants to endow the city he governs with a new institution: he chooses an empty room in the town hall, has the word 'Musée' written in large letters over the pediment of the door, names a commission, then sends the minister of fine arts a duly endorsed letter. In general, that is enough; the museum is immediately put in the third class, because there is no fourth class, and, every two or three years, receives a work of art from the State."[71] Though not entirely accurate—a "fourth class" did exist, precisely for museums in their early stages, and by the mid-eighties the state was exercising considerably more caution than previously in sending works to new museums—this rather cynical account gets most of the essentials right and shows how widely the state's practices were understood.

Recently created or minor museums, however, would normally receive only two or three envois per decade in any case (see Table 4): in 1884 the director of fine arts explained the assignment of a painting to Rouen on the grounds that few museums had room for a work of this size, whereas Rouen's new building did.[72] Only the most important museums, and not all of those, could accommodate the more prestigious, and often very large, works at the top of the purchase list; thus the administration could not afford to question them too closely, particularly since most major museums were acquiring works of art independently, through purchases, gifts, and bequests. Paradoxically, then, the more envois a museum normally accounted for, the less it had to worry about the government's standards. Not only did independent acquisitions redound to a city's credit in the *sacrifices* column, they also made envois of contemporary art less and less important in major provincial collections.

Despite its greater efficiency and mastery of detail, the Fine Arts Administration of the Third Republic did little to alter the essential priorities and distribution processes of the envoi system. Continuity in policy reflected above all the regime's overwhelming preoccupation, which amounted almost to a fetish, with the principle of "dis-

tributive justice" in its relations with the provinces.[73] Thus an equitable distribution of works of art, based on the importance of individual cities, had an even higher value than it had in the Second Empire. "I could not accord the city of Rouen as large a share as you would like," the Minister of Public Instruction wrote the mayor in 1872, "without prompting complaints from cities of the same importance which would not be included in the annual distribution."[74] The curator of the Dijon museum received a similar response in person when, in the company of an influential senator, he visited the director of fine arts in 1892 with a number of requests.[75] The state also took into account its support for other municipal art projects: subsidies for the construction of important sculptural monuments, which some cities liked to erect in great numbers, usually meant fewer envois.[76]

Nor could provincial museums easily impose their own ideas of fairness on the government. In 1879 an anonymous fine arts official responded with incredulity to a claim from the mayor of Marseilles that his city had been overlooked in recent years. The official marked the offending passage with two large question marks and an exclamation point, and wrote in the margin, "*24* paintings or sculptures since 1871—of which *five* have been sent this year alone—it is the most consistently favored museum."[77] As subject to bureaucratic confusion as any agency, the Fine Arts Administration nevertheless had little trouble keeping track of its own generosity.

The basic schema from which the government derived its conception of equity remained a simple one: a glance at Table 4 reveals that the strong relationship between the mean number of paintings sent to a museum and the museum's "importance," expressed as a category, persisted in the Third Republic. Clearly this ordering continued to serve the state's basic need to dispose of works of art, which was indeed inscribed in the notion of distributive justice. At the top of the pyramid, the Luxembourg continued to have first claim on the government's purchases, and even important museums could see a promised envoi reclaimed and replaced with a substitute because the Luxembourg expressed an interest in it.[78] Nevertheless, the government's hierarchy placed the most important, "class 1" provincial museums on virtually the same footing as the Luxembourg, and this arrangement was virtually impervious to outside influence. Thus, for example, when in 1886 a senator requested that a painting already promised to Dijon be sent to the Luxembourg,

the ministry refused, telling him that "the institution in question can be considered one of the most important of our provincial museums and one of the most visited."[79]

Between 1870 and 1890 the government sent to provincial museums works by a substantial number of artists also represented in the Luxembourg, including the painters Emile Breton (Grenoble), Jean-Jacques Henner (Lille, Lyons in joint purchase), and Léon Lhermitte (Amiens), and the sculptors A.-E. Carrier-Belleuse and Emmanuel Fremiet. This overlap resulted from a number of factors, notably the Luxembourg's rule of displaying no more than three works by a single artist at one time and support for many artists in their provincial home towns. The relationship between the Luxembourg and the major provincial museums followed no particular chronological pattern. Some artists entered the Luxembourg only after the state had first sent their works to the provinces; others, like Adrien-Louis Demont, saw works sent to provincial museums only after they reached or approached the Luxembourg's limit.[80] The hierarchy was an approximate one, but it had no need of precision: encompassing not only notions of the relative standing of most museums and artists but also the expectations these reputations engendered, its bottom line was expediency. An internal memorandum in 1890 said that a recently purchased painting, which had won a prize at an exhibition in Antwerp, could appropriately go only to a first-rank museum like Bordeaux or Marseilles; it went to the latter.[81]

At the same time that it perpetuated the old hierarchy, moreover, the government created new ones. In response both to increasing public interest in the decorative and graphic arts and to parliamentary calls for the government to promote them, envois from the late 1880s on included increasing numbers of prints, ceramics, Sèvres porcelain, and even glass.[82] But the old, much decried prejudice against the so-called minor arts persisted, and prints and objets d'art went above all to smaller museums (see Table 5). Museums of the first rank continued to garner a disproportionate share of works in the more costly and more prestigious media, painting and sculpture. This was only one reason for the general discontent that the envoi system provoked at the turn of the century, in Paris and the provinces alike. The sources and nature of that discontent go beyond the workings of the system, however; they involve the peculiar duality of envois, both instruments of policy and works of art.

Table 5. Painting and sculpture in relation to all envois, by category of museum, 1871–1914

	1871–1880	1881–1890	1891–1900	1901–1914
All envois	1,237[a]	1,114	1,335	2,238
Painting and sculpture	1,127	942	800	1,193
Painting and sculpture as percent of envois				
All museums	91.1	92.3	75.7	56.0
Class 1	98.3	94.8	71.2	74.2
Class 2	95.5	97.8	77.7	57.4
Class 3	90.2	96.0	78.8	54.8
Class 4	80.1	89.6	84.8	63.9
Classes 5 and 6	92.8	81.6	64.7	38.0

Source: Data in cahiers, AN, F²¹ 4500, 4909, 4910.
a. Does not include envois from the Louvre reserves.

Envois as Policy and as Art

If only because of their continued usefulness, by the end of the nineteenth century provincial museums had come to occupy an important and distinct niche in the Fine Arts Administration's sense of its constituencies. In 1896, the fine arts director, Henry Roujon, responded tartly to a request from the director of the Louvre for surplus sculpture to fill some of the empty pedestals in the Tuileries Gardens. Pointing out that each year the national museums had first refusal on all the government's purchases, Roujon struck a note that would have been unthinkable fifteen or twenty years before: "Since the Fine Arts Administration receives an ever-increasing number of requests from the departments and municipalities for works of art, to which it has the duty to respond favorably to as large an extent as possible, it would be absolutely unfair for the Louvre to be always, and exclusively, favored."[83]

What then, of the increasing criticism the envoi system was provoking in the quarter century prior to 1914? Obviously it did not result exclusively from the priorities of the Fine Arts Administration but from the relationship of those priorities to the political and administrative context in which the state's patronage practices had become lodged. The envoi system suffered from three principal problems in this period. First, the transparency both of the gov-

ernment's purpose and of its methods had the effect of banalizing its generosity, so that recipients of envois at best took them for granted, at worst viewed them with barely disguised contempt. Second, the system had virtually no flexibility; its rigid timetable and the massiveness of its scale admitted little variation and provided virtually no scope for reform. Finally, the practice of envois was based on a view of a traditional, stable market situation dominated by a large-scale exhibition under official or semiofficial sponsorship. Always problematic, by the end of the nineteenth century the state's market practices placed it in a position of acute vulnerability to critical attack.

Even during the Second Empire, of course, the state's insistence on the centrality of the Salon had had its disingenuous side: for all the state's lofty pronouncements about artistic progress, it knew that the Salon, in its pretensions to quality, was facing severe challenges from the private art market. But even after it got out of the business of organizing Salons in 1880, the state never formally renounced its attachment to the large exhibition, with the result that by the end of the century its practices of purchase and distribution had become seriously maladapted to market conditions. Like political controversies in the art world of the Second Empire, both the responses to and the consequences of these problems were often refracted through the discourse of artistic merit or quality. Thus envois have tended to appear in historical accounts as evidence of the state's attachment to a sterile and desiccated *pompiérisme,* an art of forgotten historical references and empty gestures, large enough in scale to attract the attention of the Salon audience; the only alternative view presents them as the pathetic tools of an inadequately conceived policy of decentralization. But envois cannot be properly understood in terms solely of policy *or* of art: from every point of view, and especially with regard to provincial museums, their significance and their reputation derive from the unique conjuncture they effected between the two.

Although invariably fulsome, the somewhat formulaic phrases in which local officials routinely thanked Paris officials for envois indicate how little credit the government was accruing from sending them. Occasionally these messages even hinted at a certain hesitation, as though the city were straining to find something nice to say about its new treasures: "These paintings are already installed and given over to the admiration of the public, which does not tire

of praising the accomplished brushwork, correct and severe, of M. Vibert, and the richly southern and harmonious color of M. Ferrandiz's canvas." The draft of this 1864 letter, in the Bordeaux city archives, indeed shows that the mayor's description of his compatriots' reactions went through several versions, and with good reason, for they were anything but enthusiastic. After explaining his failure to obtain a more desirable envoi from the government, the president of the Bordeaux artistic society wrote to a friend in the city government: "As far as the Ferrandiz goes, well, all right. But the Vibert—fie! we really must protest this barbarism! If only we didn't have to seem pleased with such generosity! I deplore the minister's decision to grant our museum two works of such little interest."[84]

In the 1890s Emile Vallet, the curator of the Bordeaux museum, made frank assessments of new envois in reports to the mayor on insurance valuations. They ranged from "although the landscape is not one of M. Auguin's best, it is still an estimable work, stamped with an elevated feeling for nature," to "without any outstanding merit, as without any overly apparent faults," to "a little pedestrian."[85] Museums also complained about the size of works the state expected them to display. In 1877 Marseilles actually refused the offer of a huge (sixteen by twenty-five feet) Roman martyrdom scene by Joseph-Désiré Court on the grounds of space. The curator, in suggesting this pretext (the museum did in fact have room), observed that the museum already contained twenty-one paintings "surpassing ordinary dimensions," of which the largest, an 1873 envoi by A.-B. Glaize called *The Pillory,* measured an extraordinary sixteen by thirty-four feet, "without this quantity of painting being, for the most part, matched by quality."[86] It is not surprising that the inspections instituted soon thereafter devoted so much attention to the availability of space in the various provincial museums.

Though they may have grumbled about particular objects, most provincial museums continued to request envois regularly. Pierre Angrand has chronicled these requests in detail; though regional scenes and works by local artists were probably the most popular (and also the most easily granted), it would be difficult to place them into neat categories of subject matter or style.[87] Perhaps because cities obtained the works they really wanted in other ways, chiefly by buying them, they seem to have made a distinction between envois and their normal acquisitions, and their requests bespeak a

level of expectation largely devoid of gratitude. When the govern-
ment promised Dijon some envois in compensation for the substan-
tial death duties it had had to pay on an important bequest, the
mayor responded that this was hardly what he had in mind. "That
[the sending of works of art] is a favor your Administration has
accustomed us to receive each year," he wrote the minister, "and I
am not afraid to add that the importance of our Museum and of our
Art School fully justifies it."[88] More significant criticisms came
from Paris observers of the entire envoi system, and they date back,
as the previously quoted comments of Edmond About remind us,
to the end of the Second Empire. Not a partisan of provincial
museums, Louis de Ronchaud still conceded in 1885 that "very
often, it must be recognized, [the state's] gifts are not made to
develop the taste of visitors, nor to reveal in them some secret voca-
tion [for the arts]." Most such observers had no illusions about the
reasons for this paucity of envois of distinction: "One can say,"
commented the writer and deputy Fernand Engerand, with more
than a touch of irony, "that the State has made provincial museums
into the ordinary discharge sites for its official purchases, which,
it seems, are supposed to promote the development of the arts."
In 1895 Gustave Larroumet, onetime director of fine arts, stated,
"almost everything that enters [the Luxembourg] is worthy of
admission. But the envois to the provinces!"[89]

Beyond the lack of interest or gratitude it prompted, a second
weakness of the envoi system was that it lacked the capacity to adapt
to the needs and orientations of particular institutions. The only sig-
nificant innovation in the quarter century prior to 1914 involved a
limited supplementation of envois with state subsidies for purchases
by individual cities. This practice, at last, allowed for a certain mea-
sure of local initiative in the matter of envois. The state, however,
initiated a significant proportion of these joint purchases itself, usu-
ally proposing them to a city to which the artist or subject matter of
the work concerned might have special connections. Joint purchases
also represented, at least potentially, a considerable savings for the
state's acquisitions budget, and both on this count and as an encour-
agement to local cultural action they received high praise.[90]

Often, however, a museum might request the assistance of the
state in carrying out a large-scale project, typically the addition of a
gallery or galleries containing casts of the works of an important
sculptor with local roots. Marseilles, for example, wished to honor

the seventeenth-century master Pierre Puget, Dijon its native son François Rude, creator of the so-called Marseillaise figure on the Arc de Triomphe. In such circumstances whatever assistance the government could offer almost invariably proved inadequate to the city's purpose. The Fine Arts Administration usually cited budgetary restrictions and occasionally the uncooperativeness of the (technically subordinate, but virtually autonomous) national museum or Louvre administration.[91] But these obstacles, though hardly imaginary, represented only minor parts of a more overarching problem, the continued centering of the envoi system on the state's purchases, which themselves still focused on the annual art exhibitions. Only a fundamental change in the state's method of acquiring works of art could have transformed its primary means of aiding provincial museums.

The state could not ignore the diminution in the importance of the Salon: it had, after all, played a significant role in that development. In 1880 Jules Ferry's undersecretary for fine arts, Edmond Turquet, ended the government's responsibility for organizing the Salon. The government compelled the exhibiting artists to constitute themselves as the Société des Artistes Français and in this capacity to take charge of the exhibition. By this action, although the Salon continued to use the government-owned exhibition hall, the Palais de l'Industrie, the Fine Arts Administration invalidated any claim the Salon might make to "official" status. Thus when a splinter group of disgruntled artists, without any common aesthetic program, broke away from the Société des Artistes in 1890 to found a new Société Nationale des Beaux-Arts, the government felt bound to make purchases at this new salon as well.[92] A few years later Gustave Larroumet fretted that "in a few years there will be twenty of them [salons], and we will see, we or our successors, the end of the salons through their multiplication." But the comments of a number of parliamentary observers around the turn of the century bespeak a serene and unblinking recognition that salons were already something of an anachronism.[93] Meanwhile, the government, bewildered, perhaps even troubled, but stubbornly true to its principles, dutifully began to spread its purchases over all the major Paris exhibitions, including the Salon d'Automne and other avant-garde exhibitions.[94]

In this respect the government was simply adhering to the "impartial" stance that both parliamentary and critical opinion pre-

scribed for it. In his report on the 1891 fine arts budget, Antonin Proust put forward the view that in its purchases "the state has the duty to encourage the representation of the contemporary scene [*choses actuelles*]." But most observers agreed rather with the strict impartiality proclaimed by Léon Bourgeois, then minister of public instruction and fine arts, in discussing the same budget: "Just as there is no longer a state religion or a 'reason of state,' there is not and there ought not to be a state art (Hear hear!) or a state taste." Bourgeois maintained that the government encouraged its purchasing commissions to evaluate the works they considered only on the basis of merit and originality.[95] Both defenders and critics of the government in subsequent years approved this intention; they differed chiefly on the effectiveness of the means chosen to achieve it.[96]

Critics of the government's purchases made a number of proposals to ensure the impartiality of the process as well as to rationalize and broaden it. Suggestions included annual traveling exhibitions of the state's purchases; they would give the public an opportunity to evaluate these works prior to their definitive assignment to museums and other institutions. The artist-turned-politician Henri Dujardin-Beaumetz instituted such expositions on becoming undersecretary of state for fine arts in 1905, but only in Paris. Another idea he had put forth as a deputy, that exhibiting artists be allowed to vote on works for state purchase, met with some skepticism and never bore fruit. Nor did the administration under his direction do much to expand its purchasing to exhibitions outside of Paris.[97] Other deputies also called for a ban on solicitations for purchase by artists or by deputies themselves, a suggestion unlikely to get very far in an electoral system that placed so much emphasis on constituent services. A few went so far as to suggest that the state completely overhaul the purchasing process and assign specific sums to acquisitions for the national museums, for provincial museums, and for works by promising young artists.[98]

The concern with "younger" artists was a prevalent one: it was the obvious subtext to an 1885 article in which the critic and connoisseur Louis de Ronchaud wrote that ideally the government should buy only works that did not attract other buyers, that presented special difficulties to the public's appreciation, or in which an obviously talented artist still showed some hesitations or uncertainties.[99] In practice, however, the government made its choices chiefly among artists who had gained a certain measure of popular and

critical recognition. This reflected the biases of the Salon, where young or controversial artists often found their works, if accepted, "skied" or hung in positions that made them virtually invisible. All of de Ronchaud's criteria would obviously have applied to the impressionists, the most prominent group victimized by Salon practices. In the period before their first group exhibition of 1874, Monet, Pissarro, Sisley, and Renoir were still submitting works to the Salon. But in 1874 Pissarro was forty-four, Sisley thirty-five, Monet thirty-four, and Renoir thirty-three; in that same year only 35 of the 184 artists represented in the Luxembourg were under forty-five years of age, and only 12 were under thirty-five.[100]

Though perceiving the systemic deficiencies in the state's purchasing procedures, proposals that the state allocate more of its resources to the encouragement of younger artists thus did not get to the heart of the problem, the government's continued reliance on the salons as the site of its purchases. Arguably as early as the mid-1870s, certainly by the late 1880s, the government had effectively isolated itself from the cutting edge of the art market. For by the time they might normally have expected state purchases as due recognition of their mature efforts, the leaders of the impressionist movement had essentially opted out of the salon market. The impressionists, at this stage of their development, attached some importance to the principle of independence from the official or (after 1880) established artistic system. They also had considerable success, as did many more accepted artists, in devising and working through alternative methods of exhibiting and selling their works, particularly group shows and private dealers.[101]

Most artists who had such possibilities available would have done, and did do, the same; small group shows offered better exposure and publicity than the salons, which can explain the appeal of the impressionist shows to reasonably successful artists like Jean-François Raffaelli and Giuseppe de Nittis, who sympathized only partially with impressionist theories and techniques. A continuing relationship with a dealer could provide a release from the pressures and uncertainties of the Salon scene, and artists of all stripes, including acknowledged leaders of the Academy like Bouguereau and Gérôme, availed themselves of such opportunities, including that of sales abroad. If the state did not venture into the private art market, except for death sales and important auctions, the causes of its avoidance lay not only in bureaucratic sloth but also in sheer prac-

ticality: most dealers charged more than it was willing to pay.[102] Thus a reallocation of resources more radical, more thoughtful, and more comprehensive than contemporary critics envisioned would have been necessary to rejuvenate the state's purchasing and diversify the pool of envois.

Changes in the art market in the last quarter of the nineteenth century and the state's obvious but nonetheless puzzling inability to keep up with them generated nothing so much as confusion. In their bewilderment, critics naturally seized on the consequences they could perceive rather than the processes that befuddled them. They returned to the kinds of harsh attacks on the government's taste that had been common since the July Monarchy, but with a new political twist. In a parliamentary system that brought local loyalties rather than party ties to the fore, envois, as a link between center and periphery, could hardly avoid scrutiny. In this way envois ceased to provide the government with a refuge from the discourse of "quality" and instead became one of its principal points of reference.

Although he could have been discussing almost anything, the deputy Gomot was talking about envois when he charged in 1884:

> We have gotten to the point where quantity has replaced quality in the choice of paintings and sculptures: mediocre artists, commendable, I am willing to admit—and perhaps also recommended—have been substituted for artists who had long and justly possessed the favor of the public and had proved themselves.
>
> If such a tendency were to become more marked, art in our provinces would suffer a rapid decline.[103]

"As for me," cried another deputy, Edouard Aynard, in 1890, "I consider detestable this practice of treating a provincial museum as something negligible, of the lowest rank on the artistic ladder . . . what we need is not secondary works but works of real value." Quoting Aynard in 1894, Baron Demarçay added, "As for the State's gifts, you know them, you know what is sent; it is not the best of what there is among the acquisitions."[104] The 1906 reporter on the fine arts budget, Charles Couyba, used less euphemistic language, at the same time drawing a clear contrast with works he felt the state should have been buying: "Those same commissions that endowed our provincial museums with such insipid, such conventional paintings, did they not also exclude impressionism, of which French art is so proud today?"[105]

From such comments it was but a small step to comprehensive attacks on the government's past exclusion of "independent" artists, notably the 1910 budget report by Joseph Paul-Boncour, later published as a book under the title *Art et démocratie*. "Always and traditionally," Paul-Boncour wrote, "the State, in its commissions and in its purchases as in its teaching, has been enfeoffed to the Institut and to academic art."[106] As Pierre Vaisse observes, the essentials of this argument have changed little since Paul-Boncour's day; it needs reexamination for the way it associates provincial museums with one of art history's losing causes.[107]

In a sense, the accusation that the state acted as a stooge for the Academy brings the argument about quality full circle. An essentially aesthetic antipathy, that is, a dislike of the objects acquired (and regret over those not acquired), here feels the need to frame itself as the critique of an institution and of a practice. Yet the historical evidence poses a problem: after 1848, when it lost its monopoly over Salon juries, the Académie des Beaux-Arts had virtually no institutional link to the purchasing and distribution arm of the state cultural apparatus. Thus, in order to show the state's subservience to some monolithic entity called "the Academy," evidence of an essentially aesthetic order must be relied upon. The object, of course, is to demonstrate that "official" and "academic" art, notwithstanding the insistence both of late nineteenth-century officials and of more recent scholarship on distinguishing between them, can rightfully be considered one and the same thing.[108]

Certainly academic instruction exercised considerable influence over nineteenth-century painting, but it provides far too broad a foundation for a monolith. As the Academy's most careful historian, Albert Boime, has observed, this influence consisted chiefly of an outlook and a set of general principles involving careful draftsmanship, a "dutifully finished surface," and an appeal to the mind rather than to the emotions. It did not, then, entail an emphasis on particular kinds of subjects, still less a common body of "stylistic" referents. This kind of influence allowed for considerable diversity even among the Academy's members in the Third Republic (they included a number of artists, like Vollon and Jules Breton, whose work focused on contemporary themes), to say nothing of their often fiercely independent students.[109] In the face of such diversity, many critics present an essentially genealogical notion of the academic, identifying it with both the subject matter ("history paint-

ing") and the style (neoclassicism) of the most prominent artists to whom the origins of academicism can plausibly be imputed, David and Ingres.[110]

Yet even in the July Monarchy history paintings never represented a majority of envois (see Table 6).[111] With the exception of the 1870s, when the new Republic was probably trying to revive national spirit after the disasters of 1870–1871, history painting as a proportion of the total pool declined continuously, its greatest drops occurring in the 1880s and after 1900. Landscape remained roughly constant at about a third of the total throughout the latter half of the century, while genre, apart from a slight drop in the 1870s, consistently rose from just over a tenth of envois in 1850 to nearly a third in 1900. From 1850 on, landscape and genre together always represented a majority of the paintings provincial museums received, and by the first decade of the twentieth century they accounted for over three-quarters of them. These figures rely on the system of classification in use in the nineteenth century; as such they may even under-estimate the importance of genre. For genre's triumph, as recent scholarship has argued, was twofold. First, as the anecdotal sup-planted the heroic, so genre invaded other categories, notably his-tory painting.[112] Beyond such changes in definition, the envoi pool

Table 6. Subject matter of painting envois, as percent of total pool, 1830–1914

Period	History	Landscape	Genre	Portraits	Still lifes
July Monarchy	40.5	26.0	10.4	4.0	1.7
Second Republic	35.1	29.9	10.4	2.6	2.6
1851–1860	28.2	33.6	22.6	1.8	4.6
1861–1870	35.9	29.4	28.7	3.7	1.7
1871–1880	40.2	30.1	25.3	1.5	1.9
1881–1890	26.7	33.2	31.3	2.1	3.5
1891–1900	26.6	29.5	31.0	5.5	4.8
1901–1914	12.5	36.8	37.5	5.2	7.8

Source: Data in cahiers, Archives Nationales, F²¹ 4500, 4909, 4910. The number of paintings considered is as follows: July Monarchy, 173; Second Republic, 77; 1850s, 283; 1860s, 463; 1870s, 475; 1880s, 374; 1890s, 271; 1901–1914, 557. These figures do not include envois from the Louvre reserves, works that at one time hung in the Luxembourg, or joint purchases (and thus do not sum to 100). They consist, in other words, entirely of the state's current purchases at the Salons.

confirms other indices of a second, purely numerical shift, namely the growing importance of genre scenes at the expense of history painting.[113]

An analysis of subject matter does not, of course, say much about style. But whatever the stylistic character of individual envois, even if one were to make the dubious assumption that it was relatively uniform, they do not, as a body, conform to the standard image of academic art. If a certain broadly shared aesthetic and a number of common stylistic traits can be discerned in the Third Republic's purchases, they reflect neither a stultified academicism nor a radical spirit of innovation. Rather the art favored by the government represented a cautious middle road, typically involving watered-down versions of such initially radical developments as realism and impressionism. In its very diversity this official art exemplified the efforts of mainstream artists and their bourgeois public to assimilate, and to appropriate for their own purposes, the crucial departures in perception and representation that challenged French society in the latter half of the nineteenth century.[114]

Certainly the government, which continued to fund the Ecole des Beaux-Arts, also had a stake in the kind of polished, highly finished works produced by its graduates and by the anonymous mass of artists who saw in them a means of achieving prominence through success in the Salon and other traditional venues.[115] But in addition to the praise they elicited from many deputies, the impressionists and their successors also had their appreciators, and even champions, in the halls of the Fine Arts Administration. Roger Marx, who became chief inspector of departmental museums in the early 1890s, organized the fine arts section of the Exposition Universelle of 1900, including an entire section devoted to the impressionists; even critics of the government paid tribute to his advanced views and support for the avant-garde. Georges Lafenestre, who occupied a series of powerful positions in the Fine Arts Administration, may have been, as Vaisse says, more conservative in his views than Marx, but he had nothing but praise for the impressionists in an 1899 book entitled *Artistes et amateurs*.[116]

Although the Fine Arts Administration was perfectly capable of making aesthetic distinctions, what differentiated the Gilberts and Lapostolets from the Monets and Degas was not their adherence to any particular artistic school but their conformity to the traditional (which is to say antiquated) rules of the marketplace that the state

practiced. Two of the impressionists who returned to the salon in the late 1880s, Sisley and Renoir, had works purchased by the state, and the government had a more than respectable record with the next generation of the avant-garde.[117] To characterize the state's purchasing practices as, in Charles Rosen and Henri Zerner's term, "flagrant critical confusion" conflates intentions with results.[118] Obviously any assemblage of objects for posterity becomes a critical statement in the long run, after the fact of collection. But the governments of the Third Republic did not intend their purchases to signal a primarily critical judgment. The state aimed, simply and explicitly, to support in as equitable a manner as possible the work of all meritorious artists who, over a number of years, exhibited in recognized forums. The greatest deficiency of this policy lay in its failure to discern the ways in which manners of artistic production, exhibition practices, and marketing strategies were bound up with each other. The state did not see, in other words, that a preference for a kind of exhibition practice could, for a time, effectively constitute discrimination against a particular kind of production. With the exception of some of those at the turn of the century, however, few of the state's critics have proved any more sensitive to these relationships.

The process through which the state purchased and distributed works of art mirrored with almost uncanny faithfulness the political structures of the Third Republic. With its multiple layers of commissions and subcommissions, its appearance of openness to outside influences that could in reality change only details, and its virtually unalterable schedule and order of priorities, the system did not allow much range to the aesthetic preferences of individual functionaries. They had a well-defined task to perform, and they carried it out conscientiously according to principles and procedures that had little to do with art or with critical discourse.[119] As a result, the works provincial museums received, considered both in the aggregate and as individual works of art, strongly support the state's claim that, far from being beholden to the Academy, it was only trying to amass a representative survey of the art of the day.

The state only abandoned salon purchases in the wake of World War I, when inflation, austerity, and the constraints of reconstruction left it little choice. Envois did not cease, but they became more infrequent, almost exclusively (with the exception of joint purchases) the product of the national museum reserves and, in

the main, more tailored to the strengths and needs of individual museums. Not long after the Great War, when the gaps in the state's purchasing policies loomed larger than they had before, one provincial mayor asked wistfully if the state had any impressionist paintings it could send from the Luxembourg.[120] At the time the envoi system was at its height, however, few in the provinces would have found fault with the state's eye. In 1895 a new, young, and forward-looking curator in Marseilles communicated his desiderata to Paris on an inspection form. His list included two unabashed modernists, Monet and Eugène Carrière, but consisted for the most part of artists the state itself was favoring: Jean Dagnan-Bouveret, Alfred Roll, Albert Besnard, and Vollon, all mainstream realists, Auguste Pointelin, another landscape artist heavily influenced by impressionism, Jean-Charles Cazin and Edmond Aman-Jean.[121] If the state for the most part chose, to use Boime's term, art of the *juste milieu,* that choice corresponded to the temper of the age, and provincial cities, though also acquiring a number of impressionist works, had endorsed it in their purchases, both in collaboration with the state and independently.[122]

Late in the nineteenth century, however, the state began to devote valiant efforts to reclaiming the work of artists it had previously passed over, from the realists to the impressionists. This effort took three principal forms: encouraging gifts and bequests of private collections to the state, such as those of Etienne Moreau-Nélaton in 1907 and of Isaac de Camondo in 1911, supporting public subscription campaigns to acquire major works for the nation, notably Manet's *Olympia* in 1890 and Courbet's *Studio* in 1919, and, of course, purchases.[123] The results of this enterprise can be evaluated on many levels, but its greatest consequence for provincial museums stemmed from the profound shift in attitude it signaled. Whatever their importance for the subsequent history of art, independent artists had never represented anything approaching a dominant proportion of the working artists of their time. The state's effective decision to devote increasing attention and a growing share of its resources to recovering their work amounted to considerably more than a simple overhaul or diversification of its purchasing practices. No longer was the government content to amass a broad sample of work available in certain recognized channels: it now engaged itself to appropriate work from a group or tradition essentially constituted by critical discourse. In so doing, the state in effect accepted

the implication of its patronage in critical judgment on matters of
"quality." But because this shift occurred as a practical matter, car-
ried out in the context of other administrative mutations, its funda-
mental importance went unproclaimed. Nothing served to indicate
that the critical mantle the state assumed early in the twentieth cen-
tury was a new one, at a far remove from the kind of authority it
had hitherto claimed to exercise in cultural matters.

This is not to say that the state had kept the notion of critically
determined "quality" out of its conception of the museum, only
that it had previously confined its official and rhetorical investment
in this discourse to the Louvre and other museums of past art.
"Oeuvre de mérite," the most common accolade bestowed on the
state's purchases of contemporary art, meant simply that: an accom-
plished work in terms of commonly accepted standards. Although
some of its representatives may have had such pretensions, the state
in its plenitude was not in the business either of certifying genius or
of sniffing out masterpieces; its refusal to make such claims, indeed,
explains why it scrupulously distinguished between the Louvre and
the Luxembourg. Admitting the applicability of both particular and
relative notions of quality to the world of contemporary art, how-
ever, had implications not only for the Luxembourg but for the
institutions most closely identified with it, provincial art museums.
By implicitly admitting the faultiness of its earlier practices of pur-
chasing and distribution, the state saddled its earlier beneficiaries
with an image of inferiority. This was particularly true of provincial
museums, which would benefit only marginally, if at all, from the
state's belated change of directions. Ultimately, then, the state's
greatest disservice to provincial museums consisted not of depriving
them of art of a certain quality but of adopting particular notions of
quality, divorcing them from their social context, and in this reified
form fixing them in the prevailing image of the museum in such a
way as to imply that they had always been there.

The ultimate abandonment of envois of contemporary purchased
art, however, on another level represented the culmination of a long
process on the part of the state. Although the critical discourse of
quality became affixed to envois only quite late in the day, since
early in the Third Republic the state had been facing mounting evi-
dence that envois were no longer serving their original purposes.
Added to the critique of the state's patronage, the Third Republic's
desire to make the arts educational in specifically useful ways made

envois as the sole instrument of state cultural policy in provincial museums untenable. To reinsert its purposes into the notion of what the museum should be, and not simply to retain its presence therein, the state needed representatives more adaptable, as well as more voluble, than works of art. Since administrators had the responsibility of finding such an instrument, they naturally chose for this purpose a version of themselves, the inspectors of provincial museums. Competent and well-intentioned men, these inspectors obviously had no say over the complex of practices into which they were entering. Had they started with a tabula rasa, however, one may doubt whether they would have chosen to inscribe it with the envoi system.

CHAPTER 2

Inspectors, Inspections, and Norms

The Patchwork Bureaucracy

In February 1879 the fine arts director, Eugène Guillaume, submitted a report to his ministerial superior proposing the first comprehensive inspection of provincial museums. Both Guillaume's report and the introduction of legislation in 1878 by the minister, Agénor Bardoux, made it clear that the state intended inspections to tighten its supervision of, and expand its influence over, provincial museums. But Guillaume placed his greatest stress on the state's interest in preserving the works of art it had entrusted to provincial museums and, by extension, preserving the national artistic patrimony as a whole. According to Guillaume, a number of serious fires in provincial museums, including the two in Bordeaux (1862 and 1870) and one the previous year in Moulins, had aroused the administration's concern and convinced it of the need to obtain better information on conditions in provincial museums.[1] The actual desire to reform provincial museums, in the interests of national arts education, clearly represented an innovation of the Third Republic. But the state perceived the preservation of envois, works of art that remained its property, as its highest priority, and thus had to accord it at least rhetorical precedence.

Successive regimes had not showered their largesse on provincial museums without attempting to amass some information about them. As early as 1813, when the city of Rouen requested the state's assistance in paying its curator's salary, the minister of the interior had asked for information on the number of paintings in the new museum and the titles of those of particular note. In 1817 the Interior Ministry requested a catalogue of the city's collections from Montpellier, and on learning that the works were displayed in the

city hall, expressed the hope that "they are arranged in such a way that artists can study them. It is only in this intention that the establishment of a museum takes place."[2] In addition, beginning early in the Restoration, various well-connected *notables* received the resonant title of Inspector of Departmental Museums, and on occasion cities received word of an impending visit from such a personage, as did Marseilles in 1821.[3] But the lone inspector had no administrative link to the state arts bureaucracy, and sporadic personal efforts notwithstanding, the position was generally regarded as a sinecure.[4]

On occasion the government made a more systematic attempt to investigate the conditions of provincial museums. In 1851 a circular sent to prefects asked about the circumstances and conditions of museums in their departments, and similar information was sought twenty-eight years later; throughout the 1860s, officials in Paris requested catalogues from museums seeking envois.[5] Despite the political turbulence of 1851 and the shifting of the fine arts bureaucracy among four different ministries during the Second Empire, some information probably filtered into Paris from these inquiries.[6] The state's seemingly congenital inability to gather and absorb information about provincial museums had its roots in causes beyond the purely administrative.

First, though the state had never surrendered ownership of the works of art it sent to the provinces, its legal authority over the museums that received them remained rather murky. Guillaume's report cited only two legislative precedents. First, two revolutionary decrees of brumaire and frimaire year 3 (October–December 1794) held local officials responsible for the deterioration of local art treasures and forbade the storage of any valuable collections near gunpowder works. In addition, a set of royal ordinances of 1839 gave the state certain vague rights of supervision over collections of books and medals.[7] The decree of frimaire year 3 was generally interpreted as applying to any risk of fire, and as for the 1839 ordinances, Guillaume argued that "in the intent of the legislation, [they] obviously extend to other collections of works of art," though one of his successors later contested this interpretation.[8] In other words, very little in the legislative or administrative code either encouraged or facilitated the accumulation of information about provincial museums.

This problem, however, the state could have circumvented had it wanted to, and indeed it was about to do so in 1879. More impor-

tant, governments prior to the Third Republic, and particularly that of the Second Empire, simply lacked the will to confront the bad news about provincial museums. The nature of its patronage practices had kept the state from inquiring too closely into the conditions of the recipient institutions on which those practices depended. Louis-Napoleon Bonaparte had quickly quashed the one serious attempt to bring local museums under closer supervision, Ledru-Rollin's creation in 1848 of a four-man Inspectorate of Provincial Museums.[9] But by 1879, without in any fundamental way questioning the orientation or workings of the envoi system, the government nonetheless thought not only that it could face the news about provincial museums, but that it had to. What had changed? The state had never lacked evidence of the uncertain, even perilous conditions in which many provincial establishments housed works of art: examples had abounded, in both number and drama (for example, the Bordeaux fires), for years. In this as in so many other domains, notoriety alone cannot explain the state's gradual sensitization to the problem. That process, the necessary prelude to action, had its roots in the particular political context of the 1870s.

Guillaume's proposal coincided with the events marking the end of a period of transition that had begun with the so-called 16 mai crisis of 1877. The parliamentary elections in the summer of 1877 had established the primacy of the Assembly over the President. They represented a repudiation of the monarchist head of state, Marshal MacMahon, who had (on 16 May 1877) dissolved the Assembly after the resignation of his republican prime minister, Jules Simon. After a republican victory in the senatorial elections of January 1879, MacMahon himself resigned; his successor, Jules Grévy, installed a new cabinet under the republican Richard Waddington, with Jules Ferry receiving his first appointment as minister of public instruction and fine arts. Under Ferry, the director of fine arts became an undersecretary of state, and Guillaume was replaced by a republican deputy, Edmond Turquet. But the period of transition during which Guillaume's proposal had germinated involved ideology as well as people, and in few areas was the ideological shift as crucial as in that of education and culture.

The early Third Republic's belief in the importance of state-controlled lay education, though often associated with Ferry, the father of the Republic's essential education laws, in fact constituted an important principle for most early republican leaders.[10] Changes

in the conception of the state's role in culture were less dramatic, but the republicans' view of culture shared with their new philosophy of education a certain moral tone, an unblinking seriousness of purpose. In this view, the arts continued to play a key role in maintaining national prestige, particularly in international forums like the Expositions Universelles, one of which the new Republic, imitating its imperial predecessor, had already held in 1878. Yet this was to be prestige with a difference, demonstrating the superior progress of an unshackled, newly free people, in which the talents of the individual reflected the liberty of all, not the glory of a ruler or of a dynasty. Certainly the state had a responsibility to support artistic creation, but no longer as an exalted patron bestowing favors on humble subjects. Rather, creation would be the product of dignified workers at complete liberty to express themselves in whatever ways might satisfy them and please the public; the state would merely choose the best representatives of this creative output. Certainly the state would continue to distribute works of art to museums all over the country, not as gratuitous tokens of a sovereign's magnificence, but rather in a serious vein that would educate and uplift the public with the highest examples of the nation's cultural achievements.[11]

Whatever its long-term impact on cultural policy (limited in the matter of envois), in the short run the advent of republican ideology seems to have conveyed a new sense of possibility to those who had long advocated various kinds of cultural reform. Philippe de Chennevières, Blanc's successor (and Guillaume's predecessor) as fine arts director from 1873 to 1878, had long taken a keen interest in the preservation both of art treasures and of artistic traditions in the provinces. As a minor functionary at the Louvre in 1848, he sent a petition to the provisional government calling for, among other things, the incorporation of provincial museums in a national "service de centralisation et de contrôle," ideas he elaborated in an *Essai sur la réorganisation des arts en province* published in 1852. During the Second Empire, when as a protégé of Nieuwerkerke his main responsibility was the organization of the Salons, his ardor for centralizing reform clearly cooled. In an 1865 article on provincial museums in the *Gazette des beaux-arts,* Chennevières made little mention of reforms and implied that the state could, and should, do no more than provide museums with envois.[12]

The establishment of another republic, together, perhaps, with the ardent republicanism of many of his officials, seems to have turned

Chennevières, notwithstanding his legitimist sympathies, once again in a reformist direction. As director his efforts to encourage and support cultural activity in the provinces included the first congress of local artistic societies (which became a regular meeting with its own publication) and two massive publishing programs, the *Inventaire des richesses de l'art de la France* and the *Archives de l'art français*.[13] None of the obituary tributes to Chennevières, however, suggests that he originated the idea of organized inspections of provincial museums, and Guillaume's proposal bears the hallmarks of a different spirit. For Chennevières the value of information about provincial museums lay in the promotion of scholarship, like his own early studies of provincial painters. He wrote at one point, "I am in no way a centralizer," and seems always to have viewed encouragement rather than *contrôle* (supervision) as the appropriate role for the state. Ultimately, all of Chennevières's interest in the provinces, including a lingering taste for decentralization he did little to put into practice, can be traced to his romantic legitimism, with its typical nostalgia for an ancien régime France of autonomous provinces that never really existed.[14]

Eugène Guillaume, on the other hand, who succeeded Chennevières in 1878, represented a very different set of attitudes. Though himself a conservative, Guillaume was much more pedagogical and pragmatic in orientation than his predecessor. A prominent sculptor, he had served as director of the French Academy in Rome, and on the basis of his service in the Fine Arts Administration could claim to be the father of the Inspection de l'Enseignement du Dessin.[15] Thus his strong interest in artistic education and his confidence in the efficacy of state intervention dovetailed nicely with the concerns of the republicans; his inspection project resulted not from any single factor but from a unique conjunction of personality, ideology, and political circumstance. The change of government and Guillaume's departure in February 1879 thus caused only a few weeks' delay in the project. In the months that followed the Fine Arts Administration proceeded with its plans, albeit in a somewhat haphazard fashion.

Guillaume had already nominated, and Bardoux appointed, three inspectors, whom the former praised for their youthful energy, competence, and "independence." In the end only two of these men, Henri Houssaye, the son of Arsène who, at thirty-one, had already made a name for himself as a writer (he was later elected to the

Académie Française), and the critic Arthur Baignières, made a substantial contribution to the inspection. Just as it relied on the usual channels of personal patronage,[16] the ministry assigned them to districts in a notably unscientific fashion, dividing the country into zones named for the Paris railway stations.[17] After receiving their formal instructions from Turquet in late April 1879, the inspectors began their work in late spring. Houssaye completed his assignment in two extensive tours, one in July and August and one in November, eventually submitting fifty-six reports, while Baignières, working more sporadically, took over a year to complete fifty.[18]

As anticipated in Guillaume's proposal, in November 1879 Undersecretary of State Turquet asked Houssaye to draw up a general report on provincial art museums.[19] Houssaye strongly favored increased state intervention in the affairs of provincial museums.[20] At the conclusion of an article in the *Revue des deux mondes,* with a touch of journalistic exaggeration he might not have risked in an official report, he explained that he had not mentioned the state in discussing the running of provincial museums because "the state has no part in it." In both report and article, however, Houssaye made clear his firm belief that "the interest of the museums imperatively requires the state's supervision [*contrôle*]."[21] Predictably, this *contrôle* would begin with legislation establishing the state's competence in regard to museums, to end what Houssaye called the "inconceivable anomaly" of there being a statute for libraries (the 1839 ordinances) and none for museums.[22]

But statutes, for Houssaye, represented only a beginning. He strongly recommended the institution of regular inspections of provincial museums, if initially only on the basis of the law of frimaire, which he interpreted as applying to all forms of deterioration of works of art. He saw inspections, moreover, as coming in the wake of a ministerial circular to be sent to museum and local officials. This circular would spell out official responsibilities, particularly with regard to the objects in their care, over which, whatever their provenance, Houssaye wanted the state to claim ultimate proprietary authority. Houssaye also made several subsidiary recommendations: that prefectoral appointments of museum curators be subject to ministerial approval, and that the distribution of works of art to the provinces be conducted far more carefully and systematically, to the exclusion of "museums that are under construction or repair, museums whose cities take no interest in them, and above all of

museums that do not exist."[23] Even Houssaye's urgings, and those of the 1881 reporter, could not move the projected new statute for provincial museums out of the clogged maze of the Paris bureaucracy.[24] But on other fronts Houssaye's report marked the beginning of a major bureaucratization of the state's relations with provincial art museums.

The first signs of the state's new attitude came, unsurprisingly, in the realm of envois, always its central concern with regard to provincial museums. In the summer of 1881, the administration intimated to a number of cities that it would base future decisions on the allocation of envois at least in part on the information it was gathering about provincial museums.[25] At this stage municipalities could hardly anticipate that changes in the envoi system would ultimately involve tone far more than substance. Thus a simple change in the wording of the envoi decrees that began early in 1882 considerably alarmed some local officials. In the context of its apparent new seriousness, the state's declaration that envois came "à titre de dépôt" (by virtue of deposit, that is, *not* as a gift) seemed to signal a radical shift in its patronage practices. It must even have seemed possible that a system based in theory on generosity, in practice on pressing need, and thus in any case without conditions, might suddenly come with strings attached.

The director of fine arts, Albert Kaempfen, denying that the phrase signified any innovation, said that the state intended only to clarify and to safeguard its proprietary rights. Yet his explanation, in response to an inquiry from the museum in Saint-Dizier (Haute-Marne), could only have deepened local concerns. Kaempfen claimed (although the archival evidence does not support this) that the *dépôt* phrasing, used in all decrees since the beginning of the year 1882, simply revived an older formula that had fallen into disuse. "In light of the numerous abuses of which we had been made aware," he wrote, the administration thought it desirable to revive the usage, "in order to affirm the state's rights of ownership and supervision [*contrôle*]." The director went on to say that the state intended in future to be able to recall its envois to Paris for short periods without fear of obstruction, presumably for restoration or for temporary exhibitions, but that works deposited would not be reclaimed definitively unless "their preservation seemed threatened."[26] This was small consolation for museums where "abuses" had been pointed out: for all its obliqueness, the state's intent must have been quite

clear. Cities could not yet know how little inclined the state would be to carry out this threat.

If, moreover, the new official wording concerned only the state's own envois, the government had already stated its claim to authority over all works in public collections. That claim came in the ministerial circular recommended by Houssaye and duly issued by Turquet in April 1881.[27] Among other things, the circular quoted extensively from the law of frimaire year 3 forbidding the storage of books or works of art near saltpeter workshops; it also took a swipe at Louis-Napoleon for abolishing Ledru-Rollin's inspectorate. Recalling the provisions of the 1852 decree on prefectoral appointments, Turquet implied that some of the abuses the inspectors had found, including poorly guarded or badly arranged collections, lack of catalogues, and faulty restorations, stemmed from irregular appointments. The circular concluded with a ringing affirmation of the state's authority: "There is here, Monsieur le Préfet, a public interest that the government has the right to protect; as for the state's right of intervention, it could not be contested, for it follows naturally from the origin of the departmental museums and appears conspicuously at every moment of their history." For the benefit of those to whom this right did not appear at all conspicuous, the circular mentioned the ministry's intended new statute for provincial museums, but it added that, before presenting it, the government wanted further information. So the prefects, using the forms printed for the original inspection, were to send in their own reports on museums in their departments.[28]

But the state's new attitude toward provincial museums hardly allowed it to revert to the old, indirect, and unreliable means of gathering information about them. To give substance to its emerging standards and to give force to its affirmations that it had both a right and a duty to intervene in the affairs of provincial museums, the government had, as Guillaume and Houssaye had realized, to continue its inspections. How these inspections would be organized and to what extent their findings could be integrated into the processes of policy and decision making could be determined later. In 1881, therefore, the Fine Arts Administration commissioned at least four ad hoc inspections of museums in various areas, entrusting all of them to local figures, including two museum curators. These inspections had no discernible rationale other than requests for patronage jobs, and most included museums already covered in

1879–1880.[29] But despite their haphazard character, the successor inspections of 1881 and subsequent years could produce substantial results. In December 1881, for example, Emile Cardon submitted a report containing detailed observations on eight important museums in the North and in eastern Normandy, as well as pages of penetrating comments on the problems common to all of them.[30]

As the inspections proceeded, the state's confidence grew, and all hesitation about the government's right to conduct such inspections disappeared.[31] By the mid-eighties inspections of provincial museums seem to have become almost a fashion among bureaucrats: in the summer of 1885 a functionary of the Fine Arts Administration named Armand Dayot wrote to Turquet, once again undersecretary, from the beach resort in Normandy where he was vacationing, offering to visit and report on the nearby museums of Coutances and Cherbourg.[32] At the same time, the idea of inspections was receiving support in parliamentary circles: in 1884 the deputy Gomot, who had earlier described the envoi system in such scathingly realistic terms, criticized the government for not organizing serious, regular inspections of provincial museums. Echoing Houssaye, Gomot declared that an inspector could serve a number of useful purposes in a museum: "He could enlighten curators on the classification of paintings and of objets d'art, and on how a catalogue is drawn up. He could also—and this is very important—inform the Fine Arts Administration about the *sacrifices* cities are undertaking . . . This is information the Fine Arts Administration does not have . . . The remedy would be easy to carry out; in my view, it is this. The administration should ask for floor plans of all museums, have inventories drawn up, according to serious standards; finally, it should have museums inspected."[33] This last suggestion prompted cheers from Gomot's colleagues.

In January 1887, on the recommendation of Kaempfen, the minister created an Inspection des Musées des Départements. Neither Kaempfen's report nor the ministerial circular informing mayors of the new inspectorate specified exactly how or how often it would operate, but it did distinguish between the "Inspection" itself, as an administrative entity, and the first *enquête* or investigation it was about to carry out.[34] Rather than having to assemble and pay a whole new corps of inspectors, however, the administration simply added provincial museums to the responsibilities of an existing corps, the Inspection de l'Enseignement du Dessin. The government had estab-

lished this agency in 1879 as part of a program to develop artistic instruction in primary and secondary schools, and to improve it in specialized art schools; it now received a new name, Inspection de l'Enseignement du Dessin et des Musées.[35]

As early as 1882, the Inspection de l'Enseignement du Dessin had a staff of twelve field inspectors. Most of the inspectors were artists—painters, sculptors, and graphic artists—a few were architects; all worked only part-time for the government. By 1885 they shared a salary appropriation of forty-two thousand francs per year (between three and four thousand each, depending on seniority), plus expense money for their tours totaling seventeen thousand francs.[36] The addition of provincial museums to inspectors' responsibilities brought no augmentation in either budget or personnel, but it did create several bureaucratic complications for them, notably having to report to two different inspectors general, themselves officials of two different divisions of the Fine Arts Administration. "This assignment to two different offices," observed Georges Berger in his report on the 1897 fine arts budget, "facilitates neither the work of the administration nor that of the inspectors."[37] But from the administration's point of view, as Kaempfen had declared and as Berger recognized, this arrangement had certain advantages. In particular, it simplified contacts with the local authorities and institutions under inspection.[38]

The daunting work load inspectors had to face posed a more serious problem for the efficiency of the service. A detailed list of the nine inspection districts in 1905 reveals that each inspector had to evaluate programs in an average of 154 institutions per year. Of these fewer than 20 percent were museums; the bulk were art education courses in lycées, collèges, teacher training colleges, and art schools.[39] In principle the inspectors were to visit all the institutions in their districts each February or March. Their reports on schools would thus reach the ministry in time for the drafting of the budget; those on museums could be considered prior to the main exhibition purchase season in late spring. In fact, however, some institutions could not be visited annually, and many received only cursory inspections. "It cannot be otherwise," wrote Berger in 1900, "for the inspectors must have the requisite time to draft their reports to the central administration and to correspond with the [institutions] in their charge."[40] Berger went on to observe that on the low salaries it paid the inspectors, the administration "could not perpetually keep them away from their personal occupations."[41]

Although various reporters had for ten years been lamenting the low pay accorded this corps of inspectors, Berger went to the heart of the matter when he implied that the administration was unwilling to spend the money to maintain a staff of full-time inspectors.[42] The administration may have assumed, with typical circularity, that artists with their own careers were inherently more distinguished than those completely dependent on a government salary; still, the reliance on moonlighting artists could lead to certain anomalies. In 1909 the Rouen museum requested and received the envoi of a painting by Paul Steck, the inspector for that district, out of how finely meshed a complex of motives one can only imagine.[43] Whatever its limitations, nonetheless, the Inspection des Musées des Départements clearly provided the government with more reliable and more regular information on provincial museums than it had ever previously received. In the process, the overworked, underpaid men of the inspectorate also did more than anyone else to articulate the state's vision of the ideal museum in the nineteenth century, both in its straightforward outline and its subtle, often shifting, but no less essential details.

Searching for the Ideal Museum:
The State's Museological Standards

The framework of the inspectors' investigations and the questions they were asking reflected both the state's practical concern for the security and preservation of its envois and its more general interest in the purposes and utility of provincial art museums. This framework, which remained much the same up to the eve of World War I, emerges most clearly from the printed forms the administration drew up, beginning with the first inspection in 1879.[44] The formulation of ostensibly objective categories through which the arrangements of particular institutions could be evaluated marks an important passage in the emergence of the museum as an institution. It evokes Michel Foucault's sense of a "mutation" within Western culture at the end of the eighteenth century that accorded "the pure forms of knowledge . . . autonomy and sovereignty in relation to all empirical knowledge."[45] A museum could no longer be considered solely on its own terms or in comparison only to similar institutions nearby: it had to measure up to standards for *the* museum, even if they effectively operated on a sliding scale. The state's categories and hierarchy derive their interest chiefly from this common

discourse of standards, which it shared with the class formed by its most elite educational institutions. Indeed, the state's role in establishing and perpetuating this discourse can hardly be distinguished from that of the bourgeois elites who most often embodied it, and the values of the inspectors who represented its interests came from the same mold.[46]

The first state questionnaire explicitly applying external standards to provincial museums asked about the date and circumstances of the museum's founding, its status (municipal or departmental), administrative structure, number and salaries of personnel, days open, and hours. The form also included sections on the museum's resources and annual budget, the existence of catalogues, inventories, and labels for the exhibited objects, and, in considerable detail, the number of works possessed in every medium. A page was devoted to the museum's "installation": whether it was housed independently or with other collections or municipal agencies and in what type of building, the risks of fire as specified in the regulations of frimaire year 3 (misidentified as brumaire year 7), the number of rooms and their condition, the state of the collections, and any possible improvements. The form left a final page blank for the inspector's comments.

The state's notion of a "real" museum as one accessible to the public dated back virtually to the original envois, as the 1817 Interior Ministry inquiry concerning the museum in Montpellier makes clear. But in that case the state had focused narrowly on artists' access to the museum, whereas in 1879 Undersecretary Turquet linked the state's interest in enforcing basic standards to the belief, elsewhere trumpeted as particularly republican, in the general instructional purposes of the fine arts.[47] In a letter to the inspectors of 23 April, Turquet wrote: "I should also remind you that a museum is recognized as such, and is entitled to the Administration's support, only if it is a truly public collection, with free access at certain fixed days and times, and which, as a consequence, can promote the development of public instruction and taste."[48] In this context, the 1879 inspection form set out a fairly broad agenda for the inspectors to cover, although it included neither the number or character of visits to museums nor the aesthetic interest or quality of museum collections.

In 1883 the Fine Arts Administration began writing to prefects in departments where inspection reports had indicated some "anoma-

lies" in the running of one or more art museums. These letters set out five basic standards all museums were expected to meet. The criteria closely parallel the sections of the 1879 inspection form. Each museum had to have, first, legal status as a municipal or departmental entity; second, an installation in an "isolated" facility in conformity with fire and security regulations; third, a curator regularly appointed by the prefect on presentation by the mayor; fourth, a current inventory and a printed catalogue "presenting a seasoned and methodical classification of the works"; and finally, regular opening hours, with special times set aside for artists.[49]

The requirement of a safe and secure building grew out of the state's position as the "conscientious owner" of the many works it had sent out for the "enjoyment" of provincial cities.[50] Confirmation of legal status and regular curatorial appointments, the Fine Arts Administration insisted, simply ensured it occasional, pro forma access to information about provincial museums. On the latter point, the prefectoral naming of curators under an 1852 decree was a formality of which the administration was notified but in which it rarely interfered. Indeed, the administration never took a consistent position on whether it wished simply to be informed of these appointments, to be consulted about them, or actually to approve them; it took an active role in curatorial appointments only rarely, when local officials, faced with a number of influential candidates, passed the decision up to Paris.[51] The government, obviously, had an essential need of information for both its goals: narrowly, to ensure the preservation of works of art; more broadly, to raise the calibre of provincial museums and hence enhance their usefulness to the public. The standards for catalogues and public access clearly conveyed this latter purpose.

These same considerations remained paramount in the forms prepared after 1887 for the Inspection des Musées des Départements. The questionnaires ranged in style from the relatively casual 1890 form, which provided tables for museum budgets and staffs, then left two pages blank for the remaining information, to the meticulous, almost compulsively subdivided 1895 form. That questionnaire contained such headings as "Titre II. Bâtiments; 1. Construction, 2. Mesures de Sécurité; 3. Mesures de Salubrité," with as many as six specific points per category. It also asked for a detailed list of all envois and all other works that had entered the collection since 1887, including dimensions, type of frame, and state of preservation. All

the forms, however, continued to emphasize the conditions of the museum building and the installation of the collection, the size and competence of the staff, including both curators and guards, the degree of access, and the quality of catalogues and labels. After about 1905, its concerns firmly ingrained in inspectors' consciousness, the administration adopted a very short form designed to present the most essential information as clearly as possible; many reports in this period were also submitted as prose accounts on ordinary ministerial stationery.[52]

In the 1890s the state's broader effort to raise standards in provincial museums took on increasing importance. Inspectors commented frequently on the quality of museum collections and on potential areas of improvement. The 1895 inspection form, for the first time, included questions about the number of visitors, educational programs, and connections of museums to local artistic societies and expositions.[53] The inspectorate also contrived to make clear, in subtle but unmistakable ways, that its operations involved not only information-gathering but also *contrôle,* that is, supervision and, by extension, intervention. Its simplest means of doing so was to divide forms into spaces in which local officials provided information and adjacent areas, ranging from columns to full pages, in which inspectors commented on the accuracy and significance of this information.[54] Even an uninterrupted succession of *"exacts"* ("correct") sufficed to put provincial museums in their place in the cultural hierarchy.

The state's vision of the ideal museum emerged not only from ostensibly abstract standards but also from the attitudes, beliefs, and prejudices of its representatives. As agents of the bureaucracy, the inspectors might have been expected to evince a Paris-oriented, rigidly hierarchical attitude toward institutions in the provinces.[55] Occasionally the inspectors betrayed at least a tinge of the Parisian mind-set, as had Houssaye in writing of the museum in Blois, "Royal installation. Worthy of the Louvre."[56] But such references are rare: most inspectors did not expect every provincial museum to constitute a miniature Louvre. Indeed in many respects the Louvre provided a poor example for the provinces. Overcrowded and with notoriously lax security, by the turn of the century it was prompting cries of despair from the press: "Will it be said that the Louvre cannot be saved and that the authorities are defaulting on the most elementary of their duties? Those hitherto most confident are, with

concern and indignation, beginning to wonder."[57] Thus the standards that governed evaluations of provincial museums had to be largely independent of those applied to the national collections.

Important museums in large cities were probably rated more favorably, on average, than their smaller, more remote cousins, because of their higher budgets and larger buildings. But size alone held little virtue for the inspectors, and they could judge harshly those museums that seemed to have little but their size to recommend them. In 1902, observing a leaky ceiling, fallen plaster, an unsteady floor, and poorly secured windows in the Musée Fabre, an inspector declared that "the current buildings are neither well constructed nor sufficiently large, and thus are unworthy of the Montpellier museum."[58] In a similar vein, after twenty years of reports on the serious risk of fire in the Lyons museum (from both the heating system and an embalming laboratory connected with the natural history museum) an inspector in 1907 called the museum's facilities flatly "inadequate."[59] In contrast, inspectors displayed a marked predilection for well-run small museums, and they seem to have shown more indulgence toward them. In 1880 Baignières described the Musée Vivenel in Compiègne as "a valuable source of information on both the fine and the decorative arts . . . exceptional," even though its annual budget amounted to only five hundred francs, and not all its objects were labeled.[60]

Nor did inspectors have a fixed notion of the nature or quality of collections that museums ought to possess. In 1879, impressed by the Greuze collection in Tournus, the artist's native town, Houssaye wrote: "It would be of the greatest value to the history of art for each small town to have in this way an almost purely local museum, devoted to one master of the French school. That is the goal that all small museums, which because of their modest resources cannot acquire first-rate originals, should try to attain."[61] Even in larger towns, like Saint-Etienne and Lyons, inspectors favored, and in some cases directly encouraged, special installations devoted to local artists. Wrote one inspector of the Galerie des Peintres Lyonnais in Lyons, "it would be extremely desirable if this example were followed, and all the major cities of France made an effort to bring out the personal characteristics of their painters."[62] The 1895 inspection form even included a special question, "Are the works of artists from the region grouped together?"[63] Such observations make clear the hierarchical and centripetal ordering out of which the state's

standards for museums emerged, with Paris both at the center and at the top. Yet they also reveal a tolerance of diversity as well as a certain sensitivity to the connections between museums and local cultural traditions.

Whatever their flexibility about size or the nature of museum collections, inspectors clearly worked with the image of an ideal museum in mind. Such a museum, to judge from the tenor of inspection reports, had to go beyond the basic criteria of adequately protecting and presenting works of art; it had in some way to signal its potential for enlightening the public. On the rare occasions when they found such a museum, inspectors could barely restrain their enthusiasm. An 1895 report called the Grenoble museum "a museum in the desired conditions": a well-guarded, adequately heated and ventilated building, an annual budget of over ten thousand francs, an active advisory board and a highly competent curator, an up-to-date (1892) catalogue and informative labels, and between seventy and eighty thousand visitors per year. "It is," the report declared, "a true museum."[64]

Naturally, inspectors spent far less time rhapsodizing about ideal museums than they did evaluating those that fell considerably short of the ideal. For the most part their comments focused on those most basic concerns, the condition of the museum building and other factors affecting the presentation of works of art. Often these concerns loomed so large that they rendered moot the issue of a museum's broader cultural or educational role. Beyond obvious pedagogical gaps like the lack of catalogues, an inspector could consider issues of interpretation only when a museum was not in imminent risk of burning down or its collections of rotting from humidity, when it had room to hang its envois, light for the public to see them by, and guards to make sure they remained there. When such essentials were lacking, the inspectors could hardly bother about methodically arranged catalogues or special installations for local artists.

Of the three major physical deficiencies that occupied most of the inspectors' attention—lack of space, fire hazards, and humidity or other structural or environmental defects—none could lead more swiftly to a curtailment of envois than insufficient space. In 1895 an astute inspector, J.-M. Bayard de la Vingtrie, observed that the disposition of space in the building housing the museum and library of Tonnerre (Yonne), which did not allow enough room for library

storage, would lead inevitably to an encroachment on the museum's space. "From now on," he concluded, "this museum, to which no extension is possible, can be stricken from the list of those eligible to receive new works from the state."[65]

Inspectors took as dim a view of overcrowded conditions in important museums as in lesser ones, particularly when these supposed showpieces consigned envois to storage. Following reports of severe overcrowding in Nantes, and on the inspector's recommendation, the minister threatened in 1890 to exclude Nantes from future envois and to reclaim some of those already sent if the city did not proceed with plans to construct a new museum building.[66] In Nancy, the mayor had seemed responsive to criticisms in 1884 of overcrowding in the museum but had pleaded a lack of funds to remedy the situation. The inspector, Jules Pillet, therefore suggested in 1887 that the Fine Arts Administration adopt a more subtle strategy: to promise an envoi of sculpture but to withhold it until the city began work on an addition to the museum. The extension did go forward, and in 1890 Pillet, though he would have preferred an entirely new building, pronounced it a great improvement.[67] Pillet's caveat, alas, proved all too well founded: less than twenty years later another inspector had to decry the severe shortage of display space in the Nancy museum.[68]

The risk of fire, naturally, preoccupied inspectors a great deal. Not only did much of their statutory authority derive from the frimaire decree on fire safety, which the 1879 and 1895 inspection forms cited specifically; the conflagrations that did occur received a great deal of publicity and aroused widespread public concern.[69] In fact, both the government and the public may have been exaggerating the risks: inspectors in 1879 found fire hazards worth noting in less than 15 percent of the museums they surveyed.[70] Yet in 1896, when a Caen newspaper wanted to use the city art museum as a vehicle through which to criticize the municipal government, it inevitably mentioned the fire hazards posed by surrounding buildings and an unsafe heating system. The inspector who looked into the matter concluded reassuringly (and perhaps somewhat overconfidently, in view of the fire that occurred ten years later) that the reports overstated the dangers. Nevertheless, the alacrity with which the administration responded to the press report shows how little room to maneuver it felt it had in such matters.[71] Officials may still have been wondering whether firmer action on their part to

correct irregularities in the Verdun museum might have prevented a serious fire there in 1894.[72]

The root of the fire problem lay not in any unusual concentration of flammable materials in art museums but in museums' proximity to other buildings housing such materials. Of the 82 museums inspected in 1879–1880 for which some information is available, only just over a quarter occupied separate, distinct buildings of their own, some of them together with a library or other collection. Of the rest, about half shared space with other municipal "services" in the town hall; the remainder found some kind of refuge in schools, courthouses, post offices, or other public buildings.[73] The situation improved somewhat over the next three decades: some cities, including Rouen, Bordeaux, Lille, and Nantes, constructed new buildings for their museums, and others constructed new school and other buildings to relieve crowding and fire risks in museums. But the basic problem persisted. Few museums violated the actual wording of the frimaire decree as clearly as Dijon and Saint-Lô, both situated above leased storage areas containing flammable goods, chiefly spirits (cities claimed they could not break the warehouse leases).[74] But a number of museums shared buildings with schools and thus faced risks ranging from poorly ventilated school kitchens (Valence) to chemistry experiments (Pau, Saint-Etienne) to the lighting of candles and fires by resident teachers (Châlon-sur-Saône, Tulle). In such cases, inspectors could do little except urge the city to move more quickly to transfer the school elsewhere, a matter obviously beyond their competence. At the same time they firmly cautioned the administration against sending envois of any value to the museums concerned.[75] Only rarely did the administration have a chance to play a more positive role, as for example when it consulted extensively with a responsive city government in Vesoul (Haute-Saône) about plans to convert an old market building into a museum.[76]

While fire hazards, no matter how seriously the administration took them, posed only a potential threat to museum collections, other structural deficiencies were doing actual damage to works of art. As such they constituted a kind of subtext to inspectors' continued urgings that cities somehow find the money to build new museums or at least to renovate or expand existing structures. At times, these urgings look like an automatic reflex of the bureaucracy's image of the ideal museum. In 1887, for example, Pillet

suggested that an old residence recently purchased by the city of Saint-Dié would provide an admirable home for the museum: "The stairway of the house is of monumental proportions and would provide a fine entrance to the museum."[77] But the inspectors' reaction to humid conditions in a number of museums gave a certain urgency, and a practical basis, to their exhortations.

In 1879, to take a particularly flagrant instance, Houssaye described the conditions in the old Toulouse museum as "detestable" and observed ominously that "changes in temperature stretch and strain the canvases on their frames to the point of tearing them and destroying their distinctive features. Paintings are flaking and crumbling, marble sculptures are splitting, plasters shattering." At the same time, he ascribed the dampness in the Tarbes museum to "pluvial infiltrations occurring in the roof," and under the rubric "improvements" he suggested only that the roof be fixed.[78] In 1901, a vicious right-wing press attack on the city government in Nîmes, touching peripherally on the museum, prompted a visit from the inspector Lucien Charvet. The press reports had alarmed the administration because, like those in Caen and Nevers, they had focused on the supposed deterioration of works of art; as usual, Charvet found them exaggerated. He did, however, observe that: "Water does not run down the walls, but, the day of my visit, one breathed a humid atmosphere, a consequence of the lack of cellars; the cement paving is full of wet slabs that the heating is no match for. And this heating itself only produces a vapor that attaches itself to the surface of the paintings, which is regrettable."[79] Even though the museum building was only just over a decade old, Charvet proposed a prompt reconstruction, "without hesitation, without procrastination, and before next winter"; the city took his advice.[80]

The administration made manifest its concern for the preservation of works of art in one other area, the question of the restoration (i.e., conservation) of paintings. On no other question, in fact, did the administration make clearer its pervasive lack of confidence in the competence of local curators, which was usually only an undercurrent in inspection reports.[81] The state in principle advocated the authority of a single curator, and in a number of places had to fight for it. In small towns it had to combat the tendency to entrust curatorial responsibilities to officials who had other duties, which in practice often meant no curator at all; in some cities it struggled against the subordination of the curator to some kind of advisory

board.[82] But the administration had a more serious problem: it simply did not have the capacity to produce curators who could meet its standards. It thus evinced enormous trepidation about the possible efforts of local artists and curators to restore envois on their own.

An 1890 ministerial circular to prefects, which began with a stern affirmation of the state's ultimate authority over curatorial appointments, explained the state's concern about restorations: "[Efforts to restore or clean paintings without prior consultation of the Fine Arts Administration] have been either too hasty or carried out by inexperienced artists, and have resulted in irreparable damage to certain works. You will insist . . . that such incidents do not recur, and that the Administration be consulted in the future about the measures to be taken in regard to any painting granted by the state whose condition leaves something to be desired."[83] Though the issue of restorations did not arise as frequently as did some others, it never lost its capacity to provoke the administration. Sharply critical accounts of incompetent restorations in Nancy ("one day these successive restorations will completely obscure the work of the master"), both in the press and in inspection reports, led to a threat from Roger Marx to cut off future envois; the curator merely denied that he had done any work on envois.[84]

But regardless of the time inspectors had to spend cajoling municipalities into attending to the mere necessities of a museum's existence, much more than this lay between Houssaye's "not close to becoming a museum," applied to Gap in 1879, and the accolade of "a true museum" accorded Grenoble in 1895.[85] Standards of excellence were both vaguer and more exacting than those for adequacy; they emerge as a kind of hidden agenda of the inspection forms and reports, unspoken but understood. The vocabulary of this agenda reflects, perhaps deliberately, the indefinable nature of what Paris was looking for: its key words were "goût" (taste), "tenu" (roughly, appearance), "ordre," "méthode." A museum could, for example, subject itself to severe criticism for lack of a catalogue, but a catalogue alone was not enough. "The catalogue is inadequate," Baignières declared of the Le Havre museum in 1879. "It does not list the dimensions of the canvases and follows neither an alphabetical order nor a classification by national school."[86] Inspectors also took a dim view of museums that did not provide full and accurate labels to inform the casual visitor. Two different

inspectors, in 1887 and 1895, indignantly reported that the museum in Poitiers had actually removed labels to boost sales of its catalogue. Yet again labels alone were not enough: reports on Nancy in 1902 and 1909 called the labels there misleading and inaccurate.[87]

The inspectors did on the whole make clear what they were looking for, though often only by implication. In 1890 Bouchet-Doumenq praised the catalogue in Marseilles as "very careful and very scholarly"; an inspector in Montpellier the same year seemed impressed that the curator was planning to include facsimiles of artists' signatures in the next edition of his catalogue.[88] Precision, care, scholarship: these were the characteristics the administration was seeking, and it was prepared to take concrete steps to encourage them. The administration made frequent use of the fifteen thousand francs allotted to provincial museums in its annual budgets (twenty thousand francs beginning in 1901) to subsidize the publication of catalogues. Ultimately aiming for uniformity, the administration naturally conditioned its assistance on the observance of its standards. In 1885 the director of fine arts sent the museum in Semur (Côte d'Or) a copy of the Amiens museum catalogue, "which could serve as a model and guide in the drafting and arrangement of the catalogue."[89] In 1890, again offering a subsidy, the Amiens catalogue as a model, and assistance in checking attributions, the director wrote the mayor of Nîmes, "It would be desirable for the catalogues of provincial museums to be drawn up as much as possible according to the same schema."[90] A perusal of provincial museum catalogues from the late nineteenth century indeed reveals a remarkable similarity, though whether through casual emulation or as a result of the Fine Arts Administration's efforts cannot be determined with any certainty.

If the inspectors sought order and clarity in catalogues and labels, they sought them even more in the installation of the works of art themselves, where, in addition, they looked for evidence of taste and a certain kind of pedagogical spirit. With regard to installation as well, in probably the majority of cases the inspectors had to deal with problems of the most basic sort: overcrowding, which usually meant paintings hung too high to be seen as well as too close together to be appreciated, and, in that pre-electric age, lack of sufficient light (in 1887 Charvet wrote of the Saint-Etienne museum, "even on the brightest day a certain obscurity, unfavorable to the paintings, reigns there").[91] As was the case with catalogues, how-

ever, merely satisfying the basic requirements did not win the inspectors' approbation. In a detailed special report on museums in Normandy and in the North that he submitted in 1881, Emile Cardon paid tribute to the newly completed museum building in Rouen: "The galleries, tastefully decorated, evenly enough lit from above, are lofty and spacious," though he felt perhaps too uniformly so. But he had significant reservations about the arrangement of the paintings, which he criticized for lacking a "methodical order," for not separating contemporary from older works, and for not clearly distinguishing between works of the different national schools.[92] A quarter of a century later, another inspector, though describing the museum as "spacious and well installed," also noted that the arrangement of the collections needed to be improved, "to make the public's perusal of them more educational."[93]

Indeed the administration regarded the quality of a museum's installation as crucial in determining whether it qualified as a "true museum." Noting that the randomness of its installation gave the museum in Roanne "something of the appearance of a store," Charvet declared: "If a museum does not, through its methodical arrangement, facilitate general instruction, if it is nothing but a place where objects of artistic or historical interest or curiosities are assembled, it cannot attain precisely that elevated goal that the curator has so well detailed in the preface to his inventory."[94] By contrast, consider the description of the model, the "true museum," Grenoble in 1895: "The galleries are bright, lit from above, beautifully laid out, well decorated. The paintings are arranged by national schools, and present the history of art from the fifteenth century on through works of a high order."[95]

The terms in which inspectors praised installations reflect an assumption that something in the work of the cultivated curator would automatically appeal to other cultivated people. It is difficult to know exactly what Bouchet-Doumenq meant in describing the installations in Nice in 1890 and in Vendôme (Loir-et-Cher) in 1895 as "tasteful," though in Nice the flowers in the courtyard may have impressed him. What, too, did Andrieu have in mind in 1887 when he said that the collections in Soissons (Aisne) were well installed but ought to be more "decorative"?[96] Occasionally inspectors hinted at, if not what that indefinable element consisted of, at least how it might be conveyed. Charvet, for example, liked the Soissons curator's idea of tinting the walls of his sculpture galleries with a reddish-brown wash, which made the sculptures easier to see.[97]

Clearly this quest for that indefinable entity most commonly labeled "taste" occupied an essential place in the inspectorate's construction of the ideal museum. In one respect, however, this element may have brought inspectors into conflict with their narrower and more clearly mandated concern for the conditions of works of art. Nothing, either in the instructions they received or in the questionnaires that structured their investigations, ever directed inspectors to involve themselves in issues of artistic quality. Senior officials of the inspection, indeed, evinced little interest in questions relating to specific works of art—attributions, for example—unless they involved their physical condition.[98] But administrators could not reasonably have required the inspectors, who all had artistic training, to refrain from commenting on the aesthetic value of the collections they were seeing. Inspectors were occasionally generous, more often harsh. In 1887 Charvet called the collections of the relatively new museum in Paray-le-Monial, in the Loire Valley, "of the least importance from the standpoint of art," and Hirsch said of the paintings in the Saintes museum, "very few are worthy of note."[99]

The normal remedy for such situations, of course, was envois, and inspectors often recommended them. Sometimes, however, inspectors troubled by the poor quality of what they were seeing resembled someone whose right hand does not know what the left is doing. To improve the quality, not of collections themselves, but of the museographical experience they provided, they sometimes proposed an *épuration,* literally a purification or purge. Noting that the museum in Bordeaux, at the time (1887) only five years in its new building, was nearly full, Hirsch observed, "in the premodern painting gallery, it would be easy to remedy this lack of space, with an eye to future gifts or acquisitions, by removing certain paintings that are either of absolutely no interest, or else actually poor." Charvet suggested a similar measure in Grenoble the same year, delicately using the word *éloignant* (distancing) to describe what would happen to the lesser works.[100] In Reims, Pillet wrote with simultaneous dismissiveness and approbation, the museum had relegated minor works to "a kind of secondary museum, or storage area, which will, however, be open to the public," although the curator was billing this space as a "musée Rémois" and devoting it to the works of local artists.[101]

Coming from men capable of criticizing museums for the mere existence of a storage area, these ideas might seem at the very least incongruous. Charvet, however, could have cited his responsibility

to see that the state's envois were on view, and might have claimed that he would never propose an *épuration* involving envois. Inspectors might also have observed that they were willing to tolerate placing envois in reserve areas, whether open to the public or (as was more usual) closed, as an occasional practical necessity. But too many curators used them as, in Fernand Engerand's words, "a kind of dump where, all too often, they sequester any painting that shocks their aesthetic."[102] Yet these kinds of distinctions obscure an important evolution in the inspectors' thinking. In the reports of Houssaye, by no means an undiscriminating person, one senses a view that vaunted exhibition in itself and that considered a display of anything less than a complete collection as somehow deficient.[103] His successors, by contrast, though not entirely free of this perspective, seem to have been moving toward a different ideal, one considerably more open to variation.

Houssaye would not, of course, have eschewed those ill-defined but to inspectors quite obvious qualities of taste, order, and method. But in attaching such importance to these ideas, and in linking them to the even more subjective notion of artistic quality, the administration's most visible representatives were fundamentally altering the state's image of the ideal museum. If their notions of cultivation and taste struck a responsive chord in many provincial cities and signaled the commonality of their outlook with that of local elites, they may also have been setting a standard increasingly difficult for museums in smaller centers to attain. How effective inspectors would be in building on both their broader ideal and their specific programs depended, of course, not only on their standards of classification but on the practical ways they defined their roles in the provinces. Ultimately, too, their practical roles could be deployed only within the sphere of action defined by the state they represented. For the logic of inspection went beyond the dialogue with the provinces that inspectors could establish on their own. If, as it intended, inspections were to change the very terms of that dialogue, the state had to channel the information they provided in the direction of reform.

The Elusive Solution: From Inspection to Reform

Writing in 1880, Houssaye had set forth a glowing vision of the role inspectors could play not only for the state but for the provinces as well: "These inspectors would see to the observation of the law of

brumaire [i.e., frimaire year 3], would offer their opinion on the
hanging of paintings and their advice on the drawing up of cata-
logues. They would keep the administration informed about the
conditions and needs of museums, which every day alters. They
would attend to the annual distribution of envois. They would be
the advocates of the administration in the provinces and the advo-
cates of the provinces in Paris."[104] "Personally, I rather doubt it,"
wrote an anonymous official or critic in an 1881 government report
on provincial museums. He did not believe that inspectors could be
effective unless their mission was clearly defined and their working
conditions conducive—he did not say how—to the purposes Hous-
saye had spelled out. Presumably this reporter shared the hesitations
of François Peraldi, the curator of the Ajaccio museum, who in 1880
had written, "Even admitting that these inspectors do their duty
conscientiously, they will only be able to record trouble, when there
is any to report."[105] In their different ways these views present two
possible models of conduct for the inspectors: Houssaye's involved
activist versus Peraldi's passive spectator. In the course of their
duties inspectors had recourse to both these models as well as to
others that fell somewhere between the extremes. Some inspec-
tors, detached or mildly supportive, served as the conduits of local
wishes. Others became reluctant pragmatists, defending what they
saw as locally justified deviations from regulations. The interplay
of these various roles, and the administration's reactions to them,
reveal the ways in which the discourses and processes of the inspec-
torate shaped and ultimately constrained its impact on provincial art
museums.

Of all the men working for the Inspection des Musées after 1887
(other than Roger Marx, the chief inspector, who did not carry out
inspections on a regular basis), Lucien Charvet probably best fit
Houssaye's activist model. He must have been a bustling, formi-
dable figure during his visits to provincial museums, doubtless
striking terror in the hearts of those whose institutions in some
way displeased him, probably overwhelming others with the sheer
sweep of his approval. In an 1887 inspection of the Saint-Etienne
museum, for example, Charvet briskly oversaw the reinstallation of
the print and medal collection, provided suggestions on how the
museum could gain more space for new acquisitions, and satisfied
himself that a chemistry laboratory associated with the local girls'
school would forthwith be removed from the building housing the

museum. He then recommended to Paris that the museum be sent works of sculpture, in his opinion the most useful supplement to an otherwise strong collection, and also that the state pressure the city to increase the curator's salary.[106] It is hardly surprising that a man of such energy and enthusiasm should also have articulated, so consistently and so forcefully, the uncompromising standard of a museum as an institution facilitating "general instruction," and not just "a site for the assemblage of objects."[107]

Enthusiasm and warmth, however, which marked the relations between the inspector Beylard and the curator of the Dijon museum in the early 1900s, could hardly be expected outside the select ranks of the truly praiseworthy museums.[108] In dealing with museums below this exalted level although still, on the whole, acceptable, inspectors went no further than transmitting requests for envois and on occasion making some requests of their own. This practice extended not only to prominent museums but also to smaller, more obscure ones where an inspector's recommendation could make a difference. In 1895, for example, the inspector Fournereau wrote that because the museum in Troyes combined a distinguished collection, an energetic and learned curatorial staff, and little room, it deserved envois but could only receive "small works of real value."[109] In 1890, Pillet commented on the high quality of the Reims museum's collection of Barbizon masters, stating that the city was hoping to receive from the state "a handsome work, of great choice." Suggesting that such an envoi could be supplied following one of the periodic reshuffles of the Luxembourg collections, he concluded, "The inspector insists that this wish be taken into the strongest possible consideration."[110]

In so strongly urging the merits of Reims's case, however, Pillet was demonstrating, if not actual apathy, at least a certain insouciance with regard to the regulations he was supposed to be enforcing. At the time of his report, the city had elaborate plans for a new museum building but no construction schedule, and the existing building was plainly inadequate and overcrowded. These were signs that should have triggered caution on the part of an inspector rather than encouragement. In 1907, nearly two decades after Pillet's prediction that the city would soon construct a new museum, the Commission des Musées de Province included Reims in a list of the seventeen worst offenders among provincial museums and called its museum building "unworthy of such an important city and such a rich col-

lection."[111] Nor was this the only occasion on which Pillet acted as an apologist for local peculiarities; he had also done so in 1887 in urging envois to the badly overcrowded museum in Nancy.[112]

Perhaps the most striking demonstration of Pillet's willingness to tolerate contraventions of even the Fine Arts Administration's most basic principles involved Verdun in the late 1880s, when the city government refused to exert authority over the private association that ran the museum, although its collections included both envois and works belonging to the city. Despite the administration's concern over the lack of fire and security precautions, Pillet lavished praise on the (irregularly appointed) curator, predicted that a new museum would be constructed in five or six years' time, and even recommended a subsidy to aid in the publication of a catalogue.[113] In this case Pillet's forbearance served no one very well: in 1894 a fire in the city hall destroyed a number of paintings and caused serious damage to several others, including nine envois.[114]

The difference between Pillet's permissive attitude and one of complete apathy probably lay in his temperament. Pillet was essentially an optimist; one could hardly imagine him writing as bleakly as did Charvet of the museum in Carcassonne in 1895: "Since it would be almost impossible to alter the situation, because of the degree of kinship between the curator and the mayor, and since many similar questions in Carcassonne are left to the vagaries of the imagination, the inspector is of the opinion that there is no step the Fine Arts Administration could usefully attempt at the moment, and that it is therefore advisable to wait for a happier conjuncture of circumstances."[115] In their defense, both Pillet and Charvet might have said they were only being realistic, recognizing the limits both of what municipalities could do and of what the state could compel.

Pragmatism, moreover, was entirely consistent with the administration's stated policies. In elaborating its new standards for provincial museums in 1883–1884, the administration sent out a number of reassuring letters, telling the prefect of the Charente-Inférieure, for example, that the administration could bend its criteria as a function of the "modesty of the collections or of cities' budgetary resources."[116] Even the central requirement, based on the law of frimaire year 3, that all museums be "set aside for no other purpose and isolated on all sides," could not be strictly enforced: as the circular on the establishment of the inspectorate put it, "even the richest cities could not conform" to it. The government, the circular

stated, expected only that museums observe the "spirit" of the law of frimaire.[117]

Justification could also be found, in the administration's practices if not in its rhetoric, for the attitude of complete apathy that pessimists had predicted would paralyze the inspectorate. The problem involved not so much will but means: neither the inspectorate nor the administration it represented had at their disposal much more than the power of persuasion. In the case of a stubborn or unresponsive municipality like Verdun, this amounted to virtually no power at all. The state had at its disposal only one material means of manifesting its displeasure with recalcitrant cities, the threat to withhold, or in the most extreme circumstances to reclaim, its envois. On rare occasions, for example following Charvet's report on Carcassonne in 1895, the administration did suspend a promised envoi until a museum could demonstrate substantial improvement. But the enormous expense and bureaucratic complexity a wholesale withdrawal of envois would have entailed, to say nothing of the perennial lack of storage space in Paris, made the threat of withdrawal essentially an idle one.[118]

In general, moreover, for reasons in part alluded to in Chapter 1, the envoi system did not function well as a sanction. Indeed, to the limited extent that provincial museums figured at all in its conception of the envoi system, the state thought only in terms of those that satisfied its minimum standards. As the director of fine arts wrote in that remarkably frank letter to the prefect of the Charente-Inférieure: "The grants of works of art by the state to provincial museums should only be considered as encouragements to the enthusiasm [zèle] of towns and departments, who ought to make sacrifices to expand their collections and safeguard them against risks of fire and deterioration."[119]

But many cities that had rarely shown much enthusiasm or made many sacrifices for their museums received envois anyway. If a city had not received many envois before incurring the wrath of an inspector, it could claim, like the curator in Verdun, that the state had done too little for the city to expect compliance.[120] Inspectors encountered all too many cities that expected substantial "encouragement" before they undertook any sacrifices, which in effect reversed the state's conception of the envoi system.[121] And if a city had benefited liberally from the state's generosity, while at the same time developing its own collections to the point of overcrowding,

the prospect of not receiving any more envois could hardly have troubled it a great deal.[122] The administration thus found itself in a kind of stalemate resulting from the fundamental incompatibility between its theoretical goals for provincial museums and the ultimate basis of its intervention in their affairs, the envoi system. Caught in the vise of this contradiction, the inspectors, whatever their attitudes and exertions, could do little to extricate the administration from the paradoxes of its own practices.

By the turn of the century, a general realization seems to have been spreading among art critics and members of Parliament that the Inspection had not brought about any significant, overall improvement in the conditions of provincial art museums. Dujardin-Beaumetz, the future undersecretary of state for fine arts, showed a clear awareness of the nature of the problem. He observed in his 1899 report on the fine arts budget, "Whatever the moral authority of the inspectors of provincial museums, their influence remains proportional to the expenditures [*sacrifices*] undertaken by the state." Similarly, the reporter of the 1903 budget said of the state's allocation of only twenty thousand francs in direct grants to provincial museums, "Limited by such a minimal appropriation, the intervention of the state or its representative[s] cannot be as efficacious as one might desire."[123]

This particular perception of the inspectorate, moreover, coincided with a growing chorus of criticism of provincial museums themselves, as deputies launched extravagant charges against those responsible for museums at both the local and the national levels. In 1900, in terms redolent of traditionalist laments over decadence and cultural decline, the Christian Socialist deputy from the Nord, the Abbé Lemire, decried what he called the "museum mania": "Too many museums are not only unnecessary, they are harmful, harmful to the works of art which are uprooted [*déracinées*]. It has been written that the men of our era are rootless; the same complaints and the same criticisms could be made in regard to the works of art that are uprooted!" Lemire then launched into a nostalgic paean to the genius of the traditional regions and peoples of France and urged the government to support manifestations of regional culture.[124] A whole pejorative vocabulary for provincial museums grew up among journalists and art critics, most of it variations on a theme: "prisons of art," "dungeons," "dilapidated necropolises," "charnel-house," or, more unusually, "the aspect of a bazaar or a wretched antique

shop." [125] Descriptions in Parliament tended to associate museums with the lower orders of animals, chiefly rodents. "Part of the country's artistic heritage," wrote Charles Couyba in 1901, "is scorched in summer, frozen in winter, and visited only by mice and rats." The deputy Louis Buyat conjured up the vision of a "stuffed squirrel next to a painting" to illustrate the random quality of many museum installations: "They go very well together! But what could the rare visitors possibly get out of their pairing?" [126]

Beyond making standard calls for more state intervention and increased local action, most critics of provincial museums did not offer any solutions; they were primarily seeking to score easy points off the government. Those few who did propose measures to remedy the situation did not, conceptually at least, break much new ground. Both the conservative deputy Fernand Engerand, in a 1901 article in the popular *Revue hebdomadaire,* and the radical Couyba, in his budget report of the same year, believed that reform could only originate in legislation setting out the precise rights and responsibilities of provincial museums, particularly in regard to envois. Members of various governments had, of course, been considering such a statute ever since the proposals of Bardoux in 1878 and Turquet in 1881. [127] Another idea in vogue in the early years of the century involved granting provincial museums the *personnalité civile,* a legal status variously translated as fictional or artificial personality, which entitles public institutions to raise and capitalize funds independently of local authorities. [128] This idea also went back to the early years of the Third Republic and the long struggle to establish some kind of cultural endowment, or *caisse,* with the proceeds from the sale of the crown jewels. [129] Some concerned observers were reduced to vague "calls to public opinion" to demonstrate interest in the reform of provincial museums. [130]

By the time he joined the government as undersecretary of state for fine arts in 1905, Dujardin-Beaumetz seems to have found prevailing public opinion about museums propitious for reform. Yet the new minister probably realized that the diverse critiques and proposals hardly constituted a sufficient consensus for parliamentary action. In July 1905 he adopted a proposal by Engerand to establish an extraparliamentary commission on the problems and the potential reform of provincial museums. The commission's membership of seventy-nine consisted of eleven senators; eighteen deputies, including Engerand, Couyba, and Berger; Roger Marx and twenty-

five other high-ranking curators, government officials, and members of government advisory committees; and eighteen artists and critics.[131] Dujardin-Beaumetz himself served as chairman, and the *rapporteur* was Henry Lapauze, the curator of the Petit Palais and a self-made expert on museological questions. The inspectors, as secretaries, had the right to speak but not to vote. No representatives of local interests, other than the deputies, were invited to serve.

The establishment of the commission received a highly favorable response in both the daily and the artistic press, as had Engerand's original proposal; journalists voiced hopes that the commission at long last signaled the state's readiness to take the lead in reforming provincial museums.[132] The undersecretary hoped that in addition to drafting the long-awaited statute for provincial museums, the body would survey local concerns and needs relating to museums and would boost efforts to centralize information about their collections.[133] In its first full meeting, on 12 July 1905, the commission agreed to constitute itself into two subcommissions, one to work on proposals for legislation and the other to consider "artistic matters," that is, the actual conditions of provincial museums that needed reform.[134]

The legislative subcommission first turned its attention to the *personnalité civile*. From the Fine Arts Administration's and, apparently, the commission's point of view, the chief advantages of civil status lay in the authority it gave museums to raise funds, establish endowments, and accept gifts and bequests without authorization from city councils and prefects.[135] Simply applying for such status, however, would require a museum to assemble considerable documentation—catalogues, building plans, precise administrative regulations—and to establish an administrative board and financial authority for the newly independent body. The commissioners hoped that these processes would themselves stimulate reform, yet they tried to keep them sufficiently loose in order not to discourage cities from applying: Marx stressed that "the requirements of the state must not prevent municipalities from applying for civil status for their museums."[136] Nonetheless, an inspector reported in 1908 that though curators and officials in larger towns understood the theoretical benefits of the *personnalité civile,* they saw little practical advantage in the 1906 decree that formalized the procedures for obtaining it. Smaller towns, he wrote, remained essentially in the dark about the whole idea and were thus suspicious of it.[137] A year after the decree's

promulgation, and despite Dujardin-Beaumetz's efforts to encourage applications, only three museums, none of them major, had gone to the trouble of applying for civil status.[138]

The legislative subcommission devoted the remainder of its work to a proposed decree regulating the operating conditions *(conditions de fonctionnement)* of provincial museums. The arts subcommission, on the basis of a comprehensive inspection it had commissioned immediately after its creation, formulated what it forthrightly called a wish list *(liste des voeux).*[139] Despite their different procedures, however, members of both subcommissions shared essentially similar concerns. They generally agreed with Marx on the centrality of reforms in two areas: first, dramatically increasing state funding and second, raising the caliber of curators, through both expanded training and more rigorous selection procedures.[140] A consensus seems also to have existed on a less pressing matter, state assistance in developing regional museums devoted to local cultural traditions.[141] Certain members of the commission, moreover, showed no concern at the prospect that some small museums, unable to satisfy the new regulations, might simply disappear. As Couyba put it, following a tradition that included Engerand's 1901 article and at least one official report, "Better no museum than a bad one. Under these conditions, if cities do not wish to maintain their museums, they will abolish them."[142]

The conjunction of the two main lines of argument that marked the commission's plenary sessions explains the blandness of the measures that eventually emerged from them. On the one hand, commission members from outside the government, principally deputies like Couyba, Berger, and Engerand, showed considerable suspicion of measures that in essence would only formalize or tighten existing administrative procedures; on the other, government bureaucrats resisted proposals for more exacting requirements or increased state intervention. No one disputed the state's assertion of its proprietary rights over envois. A provision of the decree on operating conditions, for example, described the circumstances in which the state could reclaim envois: insufficient care, lack of security, nonexhibition, or unauthorized removal from the museum. This clause occasioned little debate. Anything that seemed to give the state new authority, however, aroused controversy. Thus the commission significantly watered down another provision in an earlier draft that formalized the government's authority to reclaim

its envois for up to eighteen months. The final text reduced the maximum loan period to a year, required that the minister consult with local officials, and specified that the loan be "in the public interest."[143]

Paradoxically, however, commissioners associated with the state bureaucracy generally resisted proposals from deputies or private members that would have either increased state intervention or imposed more stringent requirements on municipalities. Indeed, the officials claimed, stricter regulations inevitably meant increased intervention, which both their training and the nature of the fine arts bureaucracy disposed them to avoid. Marx, for example, opposed Engerand's suggestions that the state require cities to insure their envois during shipping and that it establish a uniform catalogue model.[144] Backed by Bigard-Fabre, a durable division head in the Fine Arts Administration, Marx even objected to a *voeu* "inviting" cities to undertake "the renovations seen as *indispensable*" for the safety and preservation of museum collections; he called it "purely platonic" because of budgetary limitations. At his insistence, the subcommission added the phrase "to the extent that available credits permit" to this clause; Lapauze, disgustedly, said of the addition, "that's what can be called being all talk."[145] Dujardin-Beaumetz himself quashed two *voeux* put forward by commissioners from outside the government. He pronounced a proposed national lottery to benefit provincial museums impractical and counterproductive, because it might discourage local initiative, and rejected the idea of a consultative commission on envois, which he felt would compromise his authority without lessening his responsibility.[146]

Only in one area of disagreement, the important issue of curatorial appointments, did the division between government officials and outsiders break down. These discussions too, however, led to a watering down of the original proposal.[147] Reflecting a continuing dissatisfaction with the competence of local curators, the legislative subcommission had approved a requirement that candidates for curatorships in museums containing more than twenty envois pass a state qualifying examination. Although the subcommission had dropped an accompanying provision that candidates for this examination be graduates of the state's "grandes écoles scientifiques," the proposal gave rise to a wide range of objections even as it stood.[148] Commissioners doubted whether highly qualified candidates could be attracted to small-town museums with minimal salaries and little

to do, and they feared that local scholars or collectors, people ideally suited to provincial curatorships, might not be able to pass a curatorial examination and would in any case be reluctant to attempt one.[149] Edouard Aynard, for his part, expressed grave doubt about the establishment of "mandarinism in art"; and the commissioners could not agree on examinations specific to particular posts or on informal "conversations" (i.e., interviews) rather than written tests.[150] Ultimately the commission agreed to a much vaguer wording, proposed by Charles Bayet, the director of higher education: "The curators and assistant curators will be chosen from among those candidates who have demonstrated their fitness for these positions to a commission named by the minister."[151]

Even thus diluted, the requirement that curators submit their qualifications to the state for approval represented the most significant innovation in the decree that eventually emerged from the commission's work. Finally published, after further bureaucratic delay and revision, in the *Journal officiel* of 10 October 1910, the decree for the most part simply restated in formal terms the standards and policies the administration had already been articulating for more than a generation. As such it was reasserting a system of supervision and guidance that most cities had found neither terribly constraining nor particularly helpful. Even the new provision on curatorial appointments essentially only answered the long-standing question of whether the administration had to approve prefectoral appointments or merely be notified about them.[152] The government did henceforth examine the qualifications of candidates the prefects selected, but the available evidence suggests that for the most part these pro forma reviews had little real impact on the types of people appointed.[153]

To a relatively modest extent, the 1910 decree contained threats of sanctions for museums that did not comply with certain of its provisions. The sanctions were the familiar ones of reclaiming envois, and their hollowness must have been clear from the beginning. Marx had admitted in the course of the commission's deliberations that, on the strength of existing appropriations, the government simply did not have the funds to reclaim its envois from even one important museum.[154]

Yet for all the commission's advocacy, it could not compel an increase in the funds available to the state either to sanction or to assist provincial museums. Again and again commissioners pointed out that the commission could not accomplish its goals without the

fivefold increase in funding (from twenty thousand to one hundred thousand francs annually to be dispensed by the Fine Arts Administration to provincial museums) it was recommending.[155] But the discussion of this proposal in the full commission presaged its fate: Dujardin-Beaumetz and several deputies promised to support an increase, but for various reasons said they could not themselves propose one in the current fiscal year.[156] A year later, in the 1908 debate on the fine arts budget, Engerand criticized the undersecretary for not having carried through on the funding increase and suggested he ought to have made cuts in other budget items if there were no other way. In 1909 Engerand, as a member of the budget committee, strenuously pressed for the eighty-thousand-franc increase, which he argued should be taken from the acquisitions budget. Buyat, the reporter this year as in 1907, admitted the justice of his case but said simply, "The condition of the budget did not allow this improvement."[157]

In the final analysis, the least exalted of the state's representatives, the inspectors, probably had the greatest influence and the greatest practical impact on museums. Inspectors' influence, of course, derived from their visibility, their familiarity with local conditions, and the personal relationships they built up with local officials. The inspectors' impact, such as it was, depended almost entirely on highly individual choices, lesser of two evils or second-best solutions that had a practical chance of appealing to cities even though they fell short of official standards. Inspectors had to rely on their own resources, occasionally with the helpful backing of their chief, because the state they served had so little of its own to provide other than general standards or precepts, whether of security, installation, or interpretation, that the showcase Paris museums did not meet themselves. Without funds, sanctions, or a credible model, the state could offer, besides those precepts, only its envois, the grandiose but ultimately hollow symbol of its munificence, of its interest in the provinces, and of the true nature of its power.

If envois had clearly played a significant part in the development of provincial museums, by the turn of the century they had equally clearly outlived their usefulness. Yet so powerful was the envoi system in the logic of its own self-preservation that the state refused to sacrifice it, even given the alternative of applying the same funds directly to expenditures on provincial museums. That decision lays bare the limits of the state's interest in provincial museums; it shows,

too, the narrowness of its exercise of centralized power in this domain. To some extent, however, that narrowness may itself represent a deliberate, if perhaps not completely conscious, choice.

Ultimately the state, and particularly those responsible for developing its cultural policies, may simply have sensed that the situation of provincial art museums corresponded to an order and a hierarchy already quite familiar to them. Regional and local rivalries caused the proliferation of institutions to an extent far exceeding their potential usefulness. Initial enthusiasms often faded; parochialism for the most part triumphed over expertise. The best-funded, best-run, most useful museums could generally be found precisely where Paris would have expected to find them, in other large cities. Inspectors' approval of the enterprise of these larger urban museums thus flowed naturally from the cultural attitudes they shared with those responsible for them. But if the discourse that defined and classified museums can be seen as a joint product of the state and of local elites, the institutions that emerged in the second half of the nineteenth century were distinctly, and wholly, a local achievement.

THE MUSEUM
AND THE CITY

To this liberal conception of municipal duty is also due the successful development of the provincial museums of France. The decree of Napoleon authorising the distribution of upwards of a thousand pictures among the great towns of the departments would not have achieved the object with which it was made unless the different municipalities had been prepared to second the initiative of the state. In some instances the nucleus of a public collection of works of art already existed, and nowhere was there any uncertainty as to the expediency of corporate action. The museum passed at once into the category of public institutions. Its recognised connection with the city was established once and for all, and has never seemed open to argument or dispute. And this explains in a great degree not merely the success of these institutions, but their number. In a city of any pretensions the museum comes as a matter of course with other municipal developments. It is created without difficulty, for the simple reason that its establishment has long been counted among the recognised aims of local enterprise, and because the principles which determine its organisation and control form an integral part of the machinery of municipal government. The influence which this settled conception of public duty has exercised in advancing the cause of artistic culture can scarcely be exaggerated.

—J. Comyns Carr,
Art in Provincial France, 1883

CONTRAST THE ENTHUSIASM of the epigraph with the comments of the radical deputy Alfred Massé in a fine arts budget report twenty years later: "Unfortunately, in our country, where most municipalities do nothing when the initiative does not come from above, nothing is being done to preserve from the risk of loss the artistic treasures accumulated in rooms that are the prey, in winter of humidity and frost, in summer of heat, and at all times of mice and rats."[1] The enthusiastic British empiricist calls on French precedent to spur his compatriots to action; the cynical Paris politician cites the lethargy of the provinces in order to justify the state's own penury. Neither discourse was in any way innovative at the end of the nineteenth century.

Yet under close examination Comyns Carr and Massé do not entirely contradict each other. Indeed they might almost be said to converge, in the area of overlap between the latter's "most municipalities" and the former's "cit[ies] of any pretensions." As Massé well knew, only a relatively small number of cities had the economic and intellectual resources to include a museum among their pretensions, yet many more at least wished to keep up the appearance of doing so. In concentrating on cities whose resources matched their ambitions, in contrast, Comyns Carr was able to locate a vital connection between the idea of "artistic culture" that the most important museums embodied and the particular setting in which they emerged.

In the first few decades of the nineteenth century, large and small cities, and for that matter the state, hardly differed in their attitudes and their action regarding art museums. Without a clear idea of what museums might be or do beyond their role as adjuncts to the local art school, municipalities gave little thought to museum development. That a museum might have a vital role to play in the life of the city, both symbolizing and legitimating the aspirations of its leaders, hardly occurred to municipal officials during the Restoration and the July Monarchy. In this period, many such officials still belonged to an elite with its roots in the ancien régime aristocracy, confident of both its competence and its right to rule; they had little need to represent their legitimacy in terms of public cultural dis-

play.[2] Nevertheless, this somewhat inchoate epoch in the history of the art museum did play a part in the institution's long-term insertion in the city.

From the beginning cities had to confront a situation in which the state literally left them with the goods, often large and unwieldy ones at that, as well as with a complex of attitudes and expectations about their display. Whatever the character and preferences of the elites who governed provincial cities, they confronted in these objects the ineluctable transfer to the public sphere of the activities of collecting and display. As the consequences of this shift gradually became apparent, cities had to define, and then to refine, the processes through which they could suitably act as patrons of the arts. The proliferation in the 1830s and 1840s of travelers' accounts critical of museums suggested that, in certain well-informed and influential circles, a city's reputation might even become bound up with that of its museum. In the ensuing years of upheaval for urban society, a new kind of municipal elite, the bourgeoisie, could not allow itself to ignore such connections.

Some of the forces that affected the museum at mid-century, such as bureaucratization and the growth of bourgeois associations, exerted pressure on all public institutions run by the city; others, notably the wave of tourism spawned by railroads, were of particular consequence for museums. In reacting to these changes, cities naturally fell back on the model of the state: they made their first direct investment in museums as institutions in the form of purchases of works of art. Like the state, cities claimed to be perpetuating a distinguished tradition of cultural patronage, as heirs to such ancien régime elites as the *échevins* of Rouen, the *jurandes* of Bordeaux, and the Etats de Bourgogne. Yet municipal officials had a closer link to leading private collectors than did their counterparts in the national fine arts apparatus; indeed officials and *amateurs* came from the same ruling elites. Cities also had, relative to the state and to Paris, fewer resources, in terms of both monumental spaces and the production of discourse, with which to elevate or to disguise the fundamentally commercial nature of their patronage. Thus sooner or later they faced the need to construct new buildings for their museums. However strong the external pressures, this need had its roots in the distinct cultural purposes that cities had entrusted to art and to the museum.

Perhaps because their mode of representation calls for our active participation, even complicity, we seem to have less difficulty entering into the intentions of architects and builders than into those of painters and sculptors. The new French museums of the late nineteenth century, in any case, do not hide either their seriousness of purpose or the importance their builders ascribed to them. Yet the signification of new museum buildings involves more than the discourse of monumentality and aesthetic distinction with which contemporary rhetoric surrounded them. The stakes involved in the construction of these buildings were enormous, far surpassing the often considerable financial investment they entailed. Since for many urban elites the museum served not only to represent their aspirations but actually to achieve them, museums played an important role in urban renovation on two levels. They were, first, often the linchpin in the reconstruction and gentrification of the urban center. And second, in their peculiar combination of form and function museums also imbued these efforts with the nobility of purpose needed to legitimate them.

New buildings constructed new identities for museums and in the process heightened the sense of responsibility of those in charge of them. Both purchasing practices and administrative structures, particularly the status and functions of curators, acquired in this light a conventionality and a narrow focus on the museum's needs that resonated with the permanence and solidity of an established institution. In this way both acquisitions and administrative codes registered the museum's claim to embody and represent an autonomous sphere of high art. At the same time, museums also made concrete efforts to symbolize and protect this autonomy in the space occupied by visitors. Though less tangible than the architectural and decorative elements that physically constituted this space, written regulations contributed just as significantly to framing the experience of the visit, largely because they worked in tandem with the norms of social practice.

The forms of behavior that museums encouraged in their visitors coincided with the attitudes of the bourgeois elites who built them, flattering their sense of the museum as a sanctuary in which they could admire the fruits of their own labor and good taste. At the same time that museum regulations found an echo in the habits of an elite public, however, they also acted as a barrier to its expansion.

Museum officials steadfastly denied any intention to discourage visits by members of the working class, still less to exclude them. Yet the debate over admission fees in the early years of the twentieth century reveals just how tightly interwoven were the issues of security, financial integrity, and the nature, composition, and social construction of the museum public.

What had become fixed by 1914 was a set of practices, attitudes, and assumptions that governed the relationship between the museum and the city, the particular context in which the identity and role of the museum were inscribed. From the point of view of an institution, stability comes at the price of a heightened awareness of limits, in particular of limits to the sense of what is possible. The potential for innovation does not disappear, but the institution and its personnel often circumscribe it in a familiar, well-defined set of actions and reactions. Both those the museums welcomed and those it discouraged have lived the consequences of this trade-off of relatively unfettered possibility for institutional stability. All the more reason that the original terms of the exchange should be carefully distinguished from the reified image of the museum it has left us.

Museums in Formation,
1791–1850

Origins

Provincial art museums shared with the Louvre a common cultural genesis, but their practical origins and proximate antecedents differed markedly from those of the national museum. Provincial museums also differed in their ideological rooting, as the uncertainty and flux of the first phase of their institutional existence testifies. They, unlike the Louvre, lacked at their founding what Mary Douglas has called "the harnessed moral energies" of the communities that formed their social frame.[1] By the mid-eighteenth century, the idea of assembling works of art in a collection accessible to the public, with the particular purpose of instructing young artists, had gained currency both in Paris and in the provinces. Although the Revolution served to catalyze these ideas in both places, it did so in distinctly different ways.

Well before the Revolution, the Academy of Bordeaux considered a project for a museum, broadly conceived as an educational institution and a "common center and rallying point for the belles-lettres, sciences, and arts." In 1787 the Estates of Burgundy, the province's autonomous elected assembly, voted to establish in a new wing of their palace in Dijon a "Musée pour les progrès de l'art et l'utilité des élèves" (roughly, a museum for the progress of art and the education of students). Created by the director of the Dijon art school, François Devosge, this rudimentary museum contained mainly plaster casts of antique sculptures, plus a few scenes of the history of Burgundy commissioned from former students of the school, notably Bénigne Gagnereaux and Pierre-Paul Prud'hon, whom the Estates had awarded prizes to study in Rome.[2]

In Paris, a similar conception led to the public exhibition of works from the royal collection in the Palais du Luxembourg from 1750

until 1785, when the Luxembourg became the residence of Louis XVI's brother, the Comte de Provence. At this time the Surintendant des Arts, the Comte d'Angiviller, was considering various projects for installing this collection in the Louvre, long viewed as the ideal site for an art museum. But differences of opinion on various matters, principally the construction of skylights in the Grande Galerie and the expense involved, kept this project from realization. Thus it was left to the National Assembly to establish, in May 1791, the principle that the Louvre become a national museum. In July 1793 the Convention voted to open the Louvre to the public for the first time, and this took place in November of the same year.[3]

The circumstances of the Louvre's founding form a historical paradigm almost too perfect to be convincing: the ancien régime floundering in projects born of Enlightenment ideas, the Revolution acting swiftly to bring them about. In this case, however, the paradigm holds more than a grain of truth. For the Louvre's creation resulted from the new urgency of presenting to the public what had become the nation's property through the Revolution. Whatever its validity with regard to the Louvre, however, and despite its appealing clarity, the paradigm cannot be applied so simply to the provinces. The difference was not the absence of credible institutional precedents, although Dijon's example in founding a rudimentary museum before the Revolution was indeed a fairly isolated one. Rather the prior existence of a collection at the national level held within itself the logic of institutionalization, and the revolutionary catalyst to that process was essentially ideological. Jacques-Louis David epitomized this dynamic, urging in a speech about the Louvre in January 1794: "To place everything under the revivifying eye of the people, to illuminate every object in the light of public attention, with that share of glory that it can rightfully claim, to establish in the museum, at last, an order worthy of the objects it houses, let us neglect nothing, citizen colleagues, and let us not forget that the culture of art is one more weapon we can use to awe our enemies."[4]

In the provinces, however, museums as institutions emerged from the very processes that formed their collections: the protection, assemblage, and sorting of the works of art that the Revolution had brought into the public domain. These processes did not in themselves carry the same ideological significance attached to the Louvre; indeed Edouard Pommier has argued that many local officials saw it as a duty to preserve the distinct patrimonies of individual towns

and to resist the central government's efforts to redistribute them.[5] In a pattern repeated in major cities throughout France, many of the artists charged with bringing together and sorting through this patrimony invested in them an almost missionary zeal, claiming for their towns a share of the Revolution's artistic booty. In many cases, that fervor carried over into a determination to transform the newly assembled collections into durable local institutions, but such projects lacked both the practical and the ideological resources that gave them such force in the capital.

Although the manner in which public collections were formed varied from city to city, certain common patterns and particularly certain common triggers to action can be detected. The nationalization of church property (November 1789), the suppression of religious orders (February 1790 and August 1792), and the confiscation of the property of émigrés (November 1791) reflected both the ideological motivations of early leaders of the Revolution and the serious financial problems they were trying to resolve. But these measures also had the consequence of placing on the state the burden of protecting a cultural patrimony gravely threatened by vandalism. Ill-prepared to handle this responsibility, successive revolutionary regimes nonetheless did not shy away from it. From the beginning they excluded works of archeological, artistic, or scientific interest from the sales they conducted of confiscated property. In some areas, for example Rouen, local officials, responding to the periodic "Instructions" on the preservation of books and works of art sent out by the national Commission on Monuments and its successor, the Temporary Commission on the Arts, initiated the process of inventorying and sorting confiscated objects as early as the summer of 1791.[6]

In most cases, however, the decisive stimulus to action came from a decree of 8 pluviôse year 2 (27 January 1794), which required district administrators to send copies of inventories of confiscated art and scientific objects to officials of the department and to the Committee of Public Instruction.[7] In consequence of this and succeeding decrees, either local administrators on their own initiative or agents of the government sent from Paris appointed commissions to draw up the required inventories and attend to basic work of preservation.[8] Beyond these tasks, many of the most dedicated commissioners also took charge of the *dépôts* or depositories of confiscated property local officials had established, generally in secularized reli-

gious houses. However cramped and ill-suited to the exhibition of works of art, these depositories, by their very existence, nonetheless struck many of the revolutionary commissioners as potential public museums.

In Rouen, two artists, A. C. G. Lemonnier and Charles-Louis Le Carpentier, had since the summer of 1791 been surveying and cataloguing works of art in religious establishments not only in the city but throughout the department of the Seine-Inférieure. In May 1792, the departmental administration ordered the two commissioners to organize an exhibition of the most distinguished of the works they had assembled. The exhibition, divided between the Convent of the Jacobins, which had served as the original depository, and the Church of Saint-Ouen, lasted only a few months, because of a lack of funds and the general administrative chaos. In February 1793 the department approved a project for a "vast" departmental library and museum complex in the Hôtel de Saint-Ouen, adjacent to the church. This project too came to nothing when the decree of 8 pluviôse year 2 required that works of art be returned to the districts from which the commissioners had assembled them. The collections originating in Rouen remained, however, and at the end of year 7 (September 1799) they were moved to the former Jesuit church, where a temporary museum under Le Carpentier's direction awaited a more suitable installation.[9]

The 1793 project for a departmental museum had called for a public installation suitable to "guide public taste and elevate the spirit of artists" ("élever le génie des artistes"). Elsewhere as well, early plans for museums had strongly educational overtones. In Dijon, where the original museum had functioned as a branch of the art school, the school's director, Devosge, was put in charge of the revolutionary inventories. In nivôse year 3 (December 1794) the city administrators named Devosge to head a "Temporary Commission on the Arts" (not to be confused with its Paris counterpart), with the task of gathering all the confiscated objects from various depositories and placing them in the building it judged most suitable for a museum. Not surprisingly, the commission chose the prerevolutionary museum. In the summer of 1799, with the collections newly installed there, the departmental administration, judging that the museum contained "a considerable quantity of art objects [otherwise] lost to the instruction of the public," opened it to the public for the first time.[10]

In July 1794, a representative of the Convention appointed a com-

mission to sort through Bordeaux's patrimony and also ordered it to establish a "Lycée des sciences et arts," where the assembled objects could serve to instruct the public. Unfortunately two of the members of the commission, appointed chiefly for their political connections, did not approach their duties in an entirely altruistic spirit. One was dismissed for selling the works in his depository for his own benefit; the second fled Bordeaux at the Thermidorean reaction, as did the agent who appointed them. Thus the project for a public gallery came to nothing. But the third member of the commission, an artist named Pierre Lacour, did take his duties seriously. Having founded a Free School of Drawing in 1793, Lacour in 1795 obtained a post as professor of drawing at the newly established Ecole Centrale (which had no connection to the abortive Lycée project) and kept a watchful eye over the collections, for which he already had higher aspirations.[11]

The commission appointed to oversee and inventory confiscated objects in Marseilles attempted to establish more direct connections between its work and public instruction, but it encountered obstacles even more serious than those found elsewhere. In nivôse year 3 (January 1795), two months after the commission's appointment, one of its seven members sought to remove objects from the existing depository, the former Convent of the Bernardines, and to place them under his sole control. The commission managed to fight off this maneuver but could not obtain ministerial confirmation of the new, more elevated title of Conservatoire des Arts the department conferred on it in frimaire year 4 (November 1795); nonetheless, less than two months later, it received the department's authorization to take over the entire Convent of the Bernardines.[12]

A lack of funds and personnel slowed the commissioners' progress in presenting and restoring the works of art, natural history, and archeology in their collections, but in the summer of 1797 they invited the public to attend courses in what they were already calling the museum. Joachim Guenin, the artist member of the commission, offered the first course, in drawing. In ventôse year 7 (March 1799), in a notice headed "Musée National—Cours Publics et Gratuits," the self-styled "administrators of the Museum" announced a full program of courses in grammar, arithmetic, literature, and drawing, open to all citizens over the age of thirteen. Refulgent speeches at the ceremony inaugurating the museum proclaimed the vital importance of culture and education in the life of the republic.[13]

But the museum still lacked the resources for a proper installation

of its collections. In requesting assistance from the prefect, the "administrators" pointed out not only that works of art were suffering from being "piled up and covered with dust" but also that "the completion of a gallery . . . will be just as useful to the students as beneficial to artists to whom it will provide models."[14] The prefect, Charles Delacroix, father of the painter, eventually proved supportive: in frimaire year 10 (December 1801) he put forward a proposal for a museum-library complex including a painting gallery, a botanical garden, and a continued academic program. But the government had different ideas: in vendémiaire year 11 (October 1802) it turned the Bernardines over to the lycée it was moving to Marseilles from the former departmental seat in Aix. Notwithstanding the official view that the transfer of this "école centrale" from Aix to Marseilles would benefit the museum, the change in fact completely derailed the museum project.[15] A year after the lycée's incursion, Guenin, though continuing to insist on the educational value of the museum's collections, could only plead for "premises suitable to house the above-named objects provisionally, [and] to preserve, classify and restore them, while waiting until more favorable circumstances permit [their] definitive installation."[16]

Like their institutional status, the extent of the collections preserved from revolutionary vandalism varied widely from city to city, largely as a function of the length of the hiatus between the original threat to cultural property and the initial local action to protect it. Nearly two years elapsed between the first sale of *biens nationaux* ("national property," land and buildings confiscated from the church and émigrés and then resold at public auction) in Marseilles (December 1790) and the earliest effective preservation decrees; in Bordeaux Lacour was able to preserve only eight paintings and one sculpture for the original museum. Some sixty years later, Lacour's son and successor as curator explained: "The paintings from convents or churches had for the most part been piled up in the Church of Sainte Eulalie, where they had suffered greatly from the lack of care and even from the brutality of certain of the revolutionary magistrates. Some paintings had been destroyed, others had disappeared or were not suitable for a museum."[17]

As may be divined from Lacour's rather elliptical comment about suitability, various factors contrived to diminish the size of museums' original collections, even in cities that had worked more promptly and effectively to preserve works of art. During the Direc-

tory, officials routinely handed paintings over to churches or to returning émigrés. In Dijon, works judged unworthy of public display, chiefly enormous copies of religious paintings of little aesthetic interest, were sold at public auction. The sale still left Dijon with a collection of some 240 paintings; a similar triage in Marseilles, though it apparently did not result in a sale, left between 80 and 100 paintings.[18]

Although relatively little information has survived on the original pools of revolutionary confiscations, an article from the mid-nineteenth century lists most of the works in Le Carpentier's inventory of confiscated objects in Rouen. Of the 220 works cited, virtually all from churches and religious houses, only 40 can be definitely identified in the 1911 catalogue of the Rouen museum (the most authoritative to date), with a further 18 possible matches. Most of the remainder probably went back to churches and other ecclesiastical buildings, though the 1911 catalogue includes perhaps another two dozen works most likely of revolutionary provenance. Overwhelmingly religious in subject matter, both the Rouen and Dijon collections included works by a number of distinguished seventeenth- and eighteenth-century painters, among them Sébastien Bourdon, Philippe de Champaigne, Jean-Baptiste Jouvenet, Pierre Mignard, Jean Restout, Hubert Robert, and Carle Vanloo.[19]

The Revolution, in sum, created in major provincial towns a widespread, if largely unformed, interest in founding institutions that would use the arts to further public instruction.[20] At the same time it had also, to varying extents, furnished the rudiments of the collections on which these institutions would be based. The decree of 14 fructidor year 9 establishing the envoi system therefore did not represent any conceptual breakthrough. Indeed its theoretical purpose largely coincided with those already adduced in the provinces, as Chaptal's report made clear: "This decision, rooted in a sense of justice, can only be strengthened by the knowledge that it is consistent with the true interests of art. For the sight of the beautiful develops talent and inspires artists far better than mere lessons." Chaptal also argued that works of art might be better appreciated if placed in appropriate regional context, for example in a particular artist's birthplace. He even suggested that the possession of such collections might eventually be essential for provincial cities desirous of attracting visitors.[21] Nor did the impact of the fructidor decree derive from its stipulation that cities construct suitable facilities

before taking possession of their envois, since in practice, as we saw in Chapter 1, the government did not enforce it. Indeed, the Interior Ministry could have chosen no better means of achieving its purpose than by disregarding its own requirement: in most cases the actual arrival of the government's envois, beginning early in 1803, served to stimulate, rather than to confirm, the establishment of museums as local institutions.[22]

For Dijon, accommodating the works it received from Paris simply meant finding space to augment the four small, and already full, galleries of the existing museum. Two large galleries were pressed into service, first the Galerie de Bellegarde at the northern end of the Palais des Etats de Bourgogne, and then, in 1806, a large second-floor room in its southern wing, along what is now rue Rameau.[23] Matters elsewhere were more complicated. In Marseilles, Delacroix's successor as prefect, Antoine Thibaudeau, on 8 brumaire year 12 (31 October 1803) appointed a commission to find a suitable site for the museum in a "government building not already serving the public in some way." They could do no better than the chapel of the Convent of the Bernardines, the building once destined in its entirety for the museum. The chapel was at the time serving as a concert and dance hall, but Thibaudeau, seeing no alternative, declared with memorable brusqueness, "Unfortunately we must give Terpsichore her walking papers, but the useful arts should have preference." The decision once taken, the authorities could move quickly to carry out the necessary alterations, dividing the chapel into two wings and adding an exterior stairway for public access. The new museum, which opened to the public on 22 fructidor year 12 (9 September 1804), displayed its original collection from local sources as well as its first shipment of envois; like Dijon, it was still awaiting its second.[24]

The process of installing collections took even longer in Rouen and Bordeaux. On 25 floréal year 12 (14 May 1804) the Rouen city council voted to locate the city museum and library on the third floor of the newly occupied city hall, formerly the Hôtel de Saint-Ouen (this was the same building proposed in 1793, prior to its occupancy by the city government). The council also appropriated more than thirty thousand francs (in the following year's budget) for construction work, conservation of paintings, and installation of the books and works of art. The prefect approved both the estimates and the contract for the necessary work the following year, and a

curator, a long unemployed artist named Jean-Baptiste Descamps, was appointed in 1806. Only in March 1808, however, could the mayor report that the museum was about to open, and neither the museum nor the library officially did so until July 1809.[25]

Bordeaux's first envois arrived in April 1803 and went on view a year later in the eighteenth-century building that had housed the prerevolutionary academy. This exhibition in no way constituted a permanent installation, however; the academy building was crammed with the rudiments of the city library, and the librarian complained in 1805 that the municipality would not provide the necessary money and staff to install the pictures in a "suitable gallery" as specified in the fructidor decree. At length the need to find new space for the municipal art school, whose own building was required for the law courts, forced the city to take action. In August 1809 the city council approved plans to convert the former academy building into a combination library, drawing school, natural history museum, and art gallery. An appropriation of 25,850 francs, a little more than a quarter of it for the museum, covered the construction work, and Bordeaux's museum finally opened to the public in late 1810.[26]

In most though not in all cases, the formal opening of a museum as a public institution also ended a period of flux concerning its name. The choice lay between the modern *musée* and the more classical *muséum,* both derived, through the Latin *museum,* from the Greek *museion,* meaning a temple of the muses. Mid-eighteenth-century usage sanctioned two meanings for both *muséum* and *musée:* a place devoted to the study of the ?rts, sciences, and literature, derived from the Ptolemaic museum of Alexandria, and the modern meaning of a public collection of objects of artistic, scientific, or historical interest. Prior to the Revolution the French form of the word seems most frequently to have applied to informal artistic and literary societies like the "Musée" of Bordeaux, a kind of cross between an academy and a more informal discussion group or *cercle.*[27] In the early days of the Revolution public collections usually received the latinate title *Muséum,* like the Muséum Français, the first name of the Louvre, and the Muséum in Toulouse, although the Musée des Monuments Français, opened in 1795 in Paris, was an exception. The Muséum Français became the Musée Central in 1797, but the two terms remained interchangeable—the 1801 fructidor decree referred to the "Muséum" du Louvre—until the Louvre received the name Musée Napoléon in July 1803.[28]

The new name for the Paris museum may, in the course of everyday correspondence, have duly influenced provincial usage. In Marseilles, the first catalogue of the collection installed in the chapel of the Bernardines appeared under the title *Catalogue des tableaux du Muséum de Marseille* in the year 12 (1804). But various reports on the establishment of the museum had already used the term *musée,* and that usage quickly became the norm.[29] In Bordeaux, where *muséum* had only a brief, early currency, the mayor, the Comte de Lynch, in 1810 gave the title "musée" to the whole group of institutions established in the former academy building and at the same time specifically refused to allow a private association to use the title.[30] Meanwhile, the alternate form, *Muséum,* was taking on its habitual association with natural history museums, which endures to this day.[31]

By whatever name they had come to be known, museums at the end of the Napoleonic era continued to function in the two senses of the term current in the eighteenth century: as an assemblage of objects and as a place for study. But though a home, however primitive, and a name provided the essential framework in which museums could develop as institutions, they were very far from conferring on museums any definite institutional character or stability. In the absence of the revolutionary fervor that had endowed objects with a public mission, the prevailing sense of the museum's purpose tended to return to the narrower task of instructing artists. In the succeeding generation, some within the artistic community continued to harbor grander notions, but many obstacles lay in their path. The transcendence of the art object is not a self-evident concept; only an influential constituency, for whom it serves particular ideological needs, has the means to construct an institution to embody it. If the *musées* of the Restoration and July Monarchy served only utilitarian purposes, it was not only because they lacked the means to do more: they had yet to receive a broader set of purposes or, more simply, an ideology to serve.

Schools, Galleries, Museums

Provincial museums in the generation after Waterloo existed in a kind of limbo, the victims of several kinds of uncertainty. The persistence of ostensibly "provisional" installations dating from the Napoleonic era reflected the museum's ambiguous status, both a public gallery and an arm of the local art school. In the absence of

clearly delineated responsibilities, funding remained subject to conflicting interpretations of responsibility by the state, departments, and cities, and thus tended to be both sporadic and chronically inadequate. Overall, most provincial museums were peculiar hybrids: local collections in an externally constituted but poorly defined institutional frame. Some curators and local officials struggled mightily to give museums a proper identity and a distinct set of purposes, but on their own such efforts could have only limited results.

In Bordeaux in the early Restoration, a dispute about the museum's name reflected continued uncertainty about its installation and, more broadly, its role in the city. As early as March 1811, the new curator of the museum, the former revolutionary commissioner Pierre Lacour, complained to the mayor that books from the library were taking up space designated for the museum and preventing him from unrolling and hanging paintings. Although he secured the removal of the offending books, Lacour had already made clear that he considered the space allotted the museum and art school inadequate.[32] A number of large envois from the Restoration government, moreover, placed further pressures on the museum's installation. In November 1817 the mayor, the Vicomte de Gourgue, authorized the younger Pierre Lacour, who had become curator on his father's death in 1814, to look into other space for the museum. Then, in early 1818, Lacour provoked public protest when he kept the museum closed until a large painting by Jacob Jordaens, one of the original envois for which the museum had no room, could be removed from the stairway to the cathedral.[33]

Apparently stung, the prefect, Philippe de Tournon-Simiane, offered the city recently vacated space in the Palais de Rohan, an eighteenth-century residence still used on occasion by visiting members of the royal family. Lacour responded enthusiastically and drew up plans for the installation of the museum and art school. The arrival of four more envois in the spring of 1819 filled the existing gallery to capacity, and the city council formally petitioned the prefect to cede the city the north wing of the Palais de Rohan. Construction work delayed the opening of the new museum until March 1821.[34] But when Lacour issued a notice on the public hours of the "Musée des tableaux appartenant à la ville" (Museum of paintings belonging to the city) in its new location, he received a note from a city official reminding him that the title "Musée" belonged to the

whole "group of our scientific and artistic establishments," not to any one part of it.[35]

Not every provincial museum had to endure the upheaval that marked the first decade of the Bordeaux museum's existence, but all suffered in their early years from an enduring administrative instability, functional disarray, and physical precariousness. First, lines of authority were far from clear. Until 1833 the government appointed not only mayors but also city councillors, and therefore prefects, mayors, and city councils did not differ markedly in political orientation.[36] But the lack of a clearly defined authority over museums could lead to administrative confusion and occasionally to fiscal paralysis.

Although the government had formally transferred authority over the Rouen museum from the department of the Seine-Inférieure to the city prior to the new museum's installation, in 1808 the curator addressed a complaint about the nonpayment of his salary not to the city but to the prefect. On that occasion the prefect merely instructed the mayor to fix a salary and to inform him of the figure arrived at, but the curator, Descamps, had not misread the situation.[37] In early 1813, the city having appropriated no money, Descamps was in desperate straits and the museum was in danger of closing; the minister responded to the prefect's strenuous urgings with the 7,500 francs owed him, plus 2,500 for the concierge. The government then set up a special commission to look into the costs attendant on the construction and opening of the Rouen museum and library; in September 1815 the commission authorized a state grant of 100,000 francs in payment of these expenses.[38] Yet the state's generosity to the Rouen museum reflected less any commitment to provincial museums than the influence of one of the city's principal creditors. He was none other than Lemonnier, one of the original revolutionary commissioners in Rouen, now claiming more than 55,000 francs in restoration fees. Lemonnier had by 1815 become administrator of the Gobelins tapestry works, and was thus in a powerful position to press his claims.[39]

Elsewhere such administrative confusion had to do not with fiscal crisis but with standard if ill-defined procedures that gave the government the opportunity to interfere with local appointments virtually at will. Prior to the law on municipal government of 1837, local governments had no legal or jurisdictional autonomy; local officials functioned essentially as subordinates in a hierarchical chain

of authority running through the prefect to the minister of the interior. Bordeaux and Marseilles, however, seem to have experienced little interference. In Marseilles the city received formal control over the museum and art school in 1805, and the mayor appointed Augustin Aubert as director of both institutions in 1810, apparently with only pro forma approval from the prefect. The Bordeaux appointments of both the elder Lacour in 1810 and his son in 1814 similarly devolved from mayoral authority.[40] In Dijon, however, the minister of the interior actually reversed a curatorial appointment made by the prefect in 1806, and another minister, Adolphe Thiers, affirmed his right to name curators as late as 1835.[41] In 1818, nevertheless, the government firmly declined to define a broad role for itself in the day-to-day affairs of the Dijon museum. Responding to a "wish" the minister had expressed that the city consistently devote a portion of its budget to the upkeep of the museum and its collections, the mayor inquired whether the city could really regard the museum as a municipal institution. The minister cited in reply an 1803 decree that rendered cities responsible for state-funded lycée libraries, which he said applied to related collections. "In consequence," the letter declared, "I regard the Museum of Dijon as city property, and the city should [therefore] take the necessary measures to preserve the collections of which it consists."[42]

A second obstacle to museums' independent development lay in their close ties to municipal art schools. These ties arose naturally from the primarily pedagogical purpose assigned to museums during the Revolution, which remained paramount for both national and local officials of the next generation.[43] In 1811 the elder Lacour, criticizing what he considered the poor quality of the original envois to Bordeaux, urged the mayor to request a further allotment from the government "to fill up the gallery." He observed that history and genre scenes would "stimulate young artists . . . and would serve as objects of comparison."[44] The notion of "filling up the gallery," as the museum's first historian, Henri de la Ville de Mirmont, observed, essentially ruled out any chance that the museum's collection might develop independently of the art school; like most Bordelais at the time, Lacour saw the museum as, in Mirmont's words, "no more than a kind of annex to the art school, a museum supposed 'to contribute to the competition [*émulation*] of the pupils and to their encouragement.' "[45] A decade later, Lacour's son, recommending that the city purchase a collection of old paintings

offered to it, cited as potential benefits the development of public taste and an increase in the city's attractiveness to visitors, two themes that would later take on considerable importance. But his argument for the purchase centered on the usefulness of the arts to commerce and trade, a relationship promoted by education, particularly "in free drawing schools in these provinces."[46]

Like the Lacours in Bordeaux, Aubert in Marseilles served both as curator of the museum and as director of the art school; in 1824 he described the school as "linked by its very purpose to the museum."[47] The director of the Dijon art school, Devosge, had insisted on a curator separate from the art school faculty, an arrangement that lasted there until the beginning of the Second Empire. But the first few curators, former students of Devosge, were clearly subordinate to him, and the attitudes of the first really independent curator, Charles-Balthazar Févret de Saint-Mémin, a scholar and former émigré named in 1818, did not differ markedly from those of his counterparts in other cities. Despite his many qualifications and his interest in improving the museum's installation, a note in his hand in 1819 referred to "the greatest benefit that can result from a museum's existence, the opportunity [for artists] to study their art, either in copying the great masters, or in immersing themselves, through a reflective observation, in the principles and the beauties of painting."[48] Dijon's mayor expressed his attitude even more clearly in 1831: "The museum belonging to the city of Dijon was designed for the instruction of students of the [municipal] art school."[49] Nor did only officials hold this view: a potential donor to the Marseilles museum in 1819 hoped that the city would accept his paintings "for the use they will offer young painters, who will find [through them] a greater variety of models."[50]

On the most general level, connections between museums and municipal art schools relegated museums to a subordinate position, for a number of reasons. Both officials and the general public had some familiarity with schools' purposes and operations, and both academic schedules and students' needs placed more urgent demands on curator/directors than did vast but still largely inchoate collections. In addition, however, these ties had the effect of augmenting or exacerbating several other practical problems museums had to face, in particular problems of space and of physical plant.

In Marseilles, such difficulties stemmed mostly from the students of the *collège* with which the museum shared its building: in 1837

the curator complained about vulgar graffiti in the stairway and about a stone-throwing incident that broke several windows and nearly injured a copyist. Students may also have been responsible for the regular accumulation of garbage outside the museum entrance.[51] Students of the art school itself caused friction in Bordeaux: in 1841, finding the museum closed to them, a group of students denied to the mayor that they had caused any damage to works of art in the course of their studies. This dispute, like a similar one in Marseilles in 1847–1848, probably had to do simply with the lack of adequate space for copying. When the younger Lacour in 1842 submitted a report to city officials on the need to build a new gallery, he cited the severely cramped space as one of the principal reasons.[52] Lack of space had prompted Aubert in 1838 to draft a new regulation banning the displacement of pictures to accommodate copyists. He observed that while the Louvre had galleries available for copying, the Marseilles museum "has no room for this purpose, nor even for the restoration of paintings." The regulation did nothing to resolve the problem; in 1848 several artists berated a guard who had admonished them to move farther away from the paintings they were copying. They were, in consequence, banned from further work in the museum.[53]

Beyond their limited space, early museum buildings suffered from physical deficiencies, many of them familiar to readers of the inspection reports of a half century later, that further hindered their development. The falling plaster in the museum in Bordeaux hinted at graver structural deficiencies, the Marseilles museum's faulty drainage occasionally led to flooding, and in the Dijon museum, relatively well housed, a defective chimney periodically filled the sculpture gallery with thick black smoke.[54] Such problems might have disturbed curators less if municipalities' neglect of them had not fallen into a broader pattern of disregard. Lack of interest in the art museum either as a physical or as an institutional entity manifested itself in various ways and contributed probably more than any other single factor to undermining museums' stability.

In Marseilles, the city's disregard took the form of a continual succession of public meetings, chiefly of scientific and other learned societies, that made the museum, as an annoyed Aubert wrote in 1843, "the ordinary site for all these meetings." Academic and electoral meetings were particularly disruptive because they generally took place on Sundays, one of two days in the week that museums

were open to the public.[55] Nearly two decades earlier—in the letter characterizing the art school as "linked by its very purpose to the museum," and exempting it from his strictures—Aubert had charged that one such occasion, the prize ceremony of the *collège,* had caused serious damage to several works of art. The mayor had responded dismissively that the problem resulted from the museum's occupation of space that the *collège* had a right to consider its own, and that only an eventual move of the museum could resolve the situation.[56]

Bordeaux's disregard for its museum took a different, and as with the museum's origins, a more disruptive form. After the Revolution of 1830 the Palais de Rohan had lost its status as a royal residence, and in 1835 it became the Bordeaux city hall. Wishing, however, to install first the Cour d'Assises, then the new Faculties of Arts and Sciences in the wing of the building occupied by the museum, the city in 1839 moved the museum collections into the unused formal reception rooms of the palace. Lacour, of course, had had no love for the dank and crumbling rooms he was abandoning, but he evidently did not regard the new ones as much of an improvement; he described them in the 1855 catalogue as "dark and inconvenient."[57] Worse, though the Palais was no longer a royal residence, it still served as the official guest house for visiting royalty, whose quarters happened to coincide with the museum's. This situation became notorious, provoking scathing comments in journal articles on the museum:

> When some king's son or some great personage comes to Bordeaux with his suite, the city, for lack of better lodging, has him camp out in the museum. Two weeks before his arrival, paintings and sculptures leave, the upholsterers come in and patch together a temporary boudoir. The naive traveler who comes to see the gallery during an illustrious guest's stay in Bordeaux is pitilessly stopped on the threshold—and that's only a minor inconvenience. For in a museum as in a library, it is stability that creates order. Well, then! Wasn't it necessary the other day to remove a Rubens or a Veronese so that a noble traveler could hang his sword and his hat on the wall? Paintings do not adapt well to this eternal traveling.[58]

In the 1840s the Bordeaux city council did begin to consider several possible sites for a permanent museum to replace this "temporary" facility, but various changes in municipal leadership and the greater priority given to other expenditures kept all such projects at the talking stage.[59]

Curators did not suffer these indignities in silence. In 1836 Aubert wrote the mayor of Marseilles about the damage that "thirty-two years . . . without any kind of care" had caused the collections, and urged a special appropriation for conservation work. Three months later, frustrated by the lack of response, Aubert went further:

> The current state of the museum is extremely painful to me; it has discouraged me deeply, even passionately, about the state of the fine arts. I am not in a position to be useful to [the museum], to bring it out of this obscurity, this indifference, I might even say this contempt, which an inconceivable fate has brought to this institution, relegated to a tiny corner of the spacious and beautiful edifice once entirely devoted to it. For since then its eternally provisional status has constantly prevented every improvement, whether in construction or in the acquisition of objects, that its various needs required.[60]

Févret de Saint-Mémin had occasion in 1840 to complain to the mayor of Dijon about the disruptions and loss of space the impending transfer of the city hall would cause the museum. He noted that the commission planning the move was evidently ignoring promises made to him two years before. Stiffly requesting at least the courtesy of official information, Févret pointed out that he could not carry out his duties without consultation.[61]

Lacour, in his periodic proposals for a more permanent facility for the Bordeaux museum, struck a similar note, subsuming his indignation into a resigned rehearsal of truths that should have been self-evident but all too obviously were not. In 1832 he wrote of the Palais de Rohan, for which renovation plans were still incomplete, "If it had [a definite function], using some of its rooms for the preservation of artistic monuments would only add to its noble purpose and to its utility." By 1842 his tone had taken on a more admonitory quality: "It is a matter of preserving [things of] real value, the kind of value for which nothing can indemnify a city, and which no *sacrifice* on its part can restore to it once it has lost them."[62]

That curators' protests went largely unheard points to another aspect, both cause and effect, of museums' instability: curators' lack of either real authority or the moral suasion that devolves from competence and a defined professional role. Curators had little autonomy in their work, functioning rather as lesser municipal officials, with virtually every decision, major or minor, subject to reversal by the mayor. The mayor of Marseilles emphasized to Aubert just how little power he had when, in 1818, he rebuked

the curator for trying to remove a copyist whose materials were obstructing the gallery: "I must observe in addition that you could not believe that you had the authority to ask M. Garnerin to leave the museum, where he had established himself with my permission, as long as I had not made known to you that I had revoked it." Sixteen years later another mayor treated Aubert more courteously but still overruled him and ordered a Rubens moved to accommodate another copyist.[63]

The curator's job came with no set routine, let alone a clearly defined sphere of responsibility. After Dassy replaced Aubert as curator in 1845, under the authority of Emile Loubon, the new director of the art school, he twice had to request a distinct budget account for the museum, as well as uniforms for the guards and barriers for crowd control.[64] Moreover, city officials routinely saddled curators with projects unrelated to the functioning of their museums, in particular the restoration of works of art in churches. In Rouen and in Marseilles, however, curators often solicited such commissions because they received additional payment for them.[65]

Although they chafed at the undignified treatment they had to endure, curators often proved, or at least felt themselves, incapable of performing duties essential to their institutions. In particular, many curators found daunting the task of appraising works of art presented for possible purchase. "Artists are not very skillful at this kind of thing," the younger Lacour complained in 1822; "carried away by their enthusiasm, they evaluate certain works much more highly than the market, and often place many others much lower."[66] Lacour nonetheless did his best to assess the distinguished collection of paintings the Marquis de Lacaze was trying to sell Bordeaux. Aubert, in contrast, on at least two occasions declined to pass judgment on the monetary value of works offered to the city. Calling himself "insufficiently versed in the market prices of paintings," and without the means to follow Paris sales, Aubert recommended that the city appoint a special appraiser.[67]

These statements reflect two prevalent attitudes, parallel but contradictory, about curators and their functions. Most cities, on the one hand, clearly preferred that an artist of some merit, and preferably with local ties, head their museums. As the prefect of the Seine-Inférieure wrote to Joseph-Désiré Court, the eventual winner in the fierce competition for the Rouen curatorship in 1853, "Your artistic reputation, and your Rouen origins, seem to me two counts that

place your candidacy in the first rank."[68] The link between museums and art schools naturally led to the choice of artists to head both of them. But even when, as in Rouen, the curator did not also head the municipal art school, cities conceived of curatorships, if not exactly as sinecures, at least as rewards for artists who had proved their worth but whose output might still not provide a dependable financial base.[69]

On the other hand, undoubtedly as a consequence of the very characteristics sought in curators, the perception that artists lacked the aptitude to evaluate works of art critically seems to have been commonplace. One critic who sensed Rouen's preference for an artist expressed doubts about the competence of such a person to serve as curator and suggested the additional appointment, without salary, of a local *amateur* (in the French sense, a collector or simply a connoisseur) he considered suitable. Commenting on a solicitation for the position of *expert* or appraiser in Marseilles, an anonymous city official in no way disparaged the value of such a position, which obviously made sense only if the curator himself could not perform such duties. He simply observed that the city intended to devote its expenditures to public works rather than to acquisitions of works of art and thus would have no use for an appraiser in the foreseeable future.[70] This sense of the museum's connection to the marketplace would eventually lead to elaborate mechanisms designed to protect its aura of transcendent value and downplay its commercial worth, but for the moment acquisitions played too small a role to matter.

The clearest result of these peculiarly self-defeating standards for curatorial appointments came in the area of catalogues, the shortcomings of which were notorious and indeed often self-confessed. The first museum catalogues had been little more than pamphlets, unadorned checklists of the paintings on view. In the 1840s and 1850s curators began to compile more ambitious accounts, which included dimensions, descriptions of subjects, and biographical sketches of artists.[71] But curators rarely based their efforts on a serious, exacting study of the works in their care. In the preface to the 1855 catalogue of the Bordeaux museum, Lacour and his young collaborator, Jules Delpit, dismissed the classification of works according to national schools with the comment, "these so-called scholarly categories seem to us more attractive in theory than in practice." Lacour and Delpit insisted on rendering all foreign artists' names into some approximate French equivalent, and alphabet-

ized Van Dyck and Vanloo under the letter V on the principle that "it would seem to us difficult to accept that the names of sons of millers or of blacksmiths were preceded by an aristocratic particule."[72]

It would, of course, be unreasonable to hold a catalogue from the middle of the nineteenth century to today's scholarly standards, but only the oddest of standards could justify an admission that "a few of the individual entries formally contradict some of the attributions of our catalogue." In fact, though Lacour and Delpit claimed to have based their explanatory texts on "the documents that appeared to us the most authentic," their attributions hewed not to any standard but to a general philosophy:

> In the arts, as in the other spheres of human intelligence, there are only a few hundred powerful identities whose names are known and to whom all the work done in their manner is instinctively attributed, unless there is proof to the contrary. Thus, there are thousands of generations of artists whose numerous original works, and whose even more numerous copies or imitations, are invariably attributed to better known artists. The usurpation of titles of nobility was never as frequent as that of artistic attributions. This usage is so widespread that it is not only permissible but necessary, and one might even say indispensable. How many galleries and museums would survive a serious and rigorous examination of their attributions?[73]

Attributions of this kind eventually became embarrassments for cities trying to prove themselves the worthy embodiments of the Western cultural tradition, and at the time they served as targets for the condescension of Paris-based critics. Louis Clément de Ris, a minor official at the Louvre, collected a series of articles for *L'artiste* and other journals into a two-volume work with the misleadingly general title of *Les musées de province*. The book does, indeed, contain capsule histories and descriptions of the major provincial museums, but it consists largely of a point-by-point debunking of museum attributions. Some of these Clément de Ris treats almost as a joke: "The Rouen museum claims to possess four works of Raphael. We have always professed a profound respect for these charming pretensions of collectors, which harm no one and convey so much pleasure to these delicious originals. Never, before the sincere expression of these illusions, have we allowed ourselves the least smile of doubt, the slightest glance of incredulity. Why can we not do as much here?" Rapidly returning to business, however, the critic went on to state that three of the paintings were clearly not by

Raphael, and that "a few seconds' inspection" sufficed to demonstrate the error.[74]

Arsène Houssaye, writing on the Bordeaux museum in the *Moniteur universel,* had some kind words for Lacour's labors, but not for his and Delpit's catalogue. He criticized the catalogue for not classifying works by national schools and for "giving official status to erroneous names," and concluded that it "contributes to presenting this fine gallery as a succession of private *cabinets* [print or curio cupboards or study rooms] rather than as a museum." On the question of attributions, Houssaye foreswore as useless any attempt to correct them systematically and contented himself with a bit of raillery: "The Rembrandts of provincial museums are shown above all to provoke the hilarity of anyone who knows an authentic work of that magician, who seems [in his authentic work] to have created kingdoms of shadow and light. One might almost say that the need to possess some false Rembrandts is inherent in the existence of a museum."[75] Clément de Ris disparaged the Dijon catalogue on similar grounds, saying that it "was not put together with the care a collection of this quality merits. The classification was done too hastily, and attributions were not considered sufficiently critically." Marseilles's most recent catalogue he found full of "weaknesses, omissions, and errors"; he also faulted the Caen museum catalogue for devoting too much space to discussions of paintings' subject matter and not enough to "artistic" (i.e., formal) questions.[76] At several points Clément de Ris urged provincial curators to follow the example of their colleague in Lille and base their catalogues on the "excellent" recent catalogues of the Louvre paintings produced by Frédéric Villot. As matters stood, he made clear his belief that curators bore the responsibility for the deficiencies of existing catalogues.[77]

With all the problems from which provincial museums suffered in their early days, what kinds of experiences did they offer to visitors? Ordinary city dwellers, in the first place, may have found access to museums rather difficult. In keeping with their largely pedagogical orientation, most museums were open on weekdays (including Saturdays) only to students and artists wishing to study or copy works of art. The public could gain entrance only on Sundays, and sometimes also on holidays, for as few as two or as many as six hours. One day a week, generally Monday, most museums were entirely closed for cleaning; at all other times foreigners could

gain admission on presentation of their passports.[78] Such were the rules; they did not always correspond to actual practice. The fictional "tourist" whose experiences Stendhal recounted in his *Mémoires d'un touriste* claimed to have visited the Dijon museum at 5:30 in the morning, admitted by an unusually obliging concierge. In contrast, an irate citizen of Bordeaux named Cuvillier complained to the mayor in 1846 that he had been refused admission to the museum on Ascension Day, a holiday when it should have been open. He said further that he had found the museum closed "eight times out of ten in the past two years, although I have only requested admission on the days reserved for the public."[79]

Once inside, visitors probably found an atmosphere far removed from the "order and silence indispensable in a place devoted to study" that one museum's regulations called for. Though the critic Paul Mantz spoke of visitors to the Bordeaux museum as "rare," he may well, as a distinguished out-of-town traveler, have gained admission at a time the museum was usually closed to the public.[80] Normally, to judge from curatorial reports at various times, museums expected substantial influxes of people during their Sunday public hours. The arrival of a new envoi or envois, particularly those in the early Restoration of overtly dynastic significance, proved a particularly powerful attraction not only in staunchly legitimist Bordeaux but in Marseilles as well.[81] But people seemed to pour in on normal Sundays too, which created crowd-control problems of occasionally alarming proportions.

Lacour observed in 1818 that the police officers sent to act as guards on Sundays could do little to prevent visitors from bringing in packages and walking sticks. Worse, the lone guard on Thursdays had trouble keeping people from touching the paintings, "because the common people believe they haven't seen well if they haven't touched. The worst offenders find it extraordinary that they are even reprimanded, and often threaten the concierge who does so." Dassy reported in 1846 that the lack of special uniforms for guards had "occasioned some unpleasantness when the guard has tried to prevent people from touching the paintings."[82] To combat these problems, museums instituted mandatory checkrooms for walking sticks and umbrellas, and many installed hefty iron barriers to keep visitors away from the works of art. As a sign of just how disorderly conditions could be, the Dijon museum's regulations for 1847 found it necessary to ban dogs from the museum, "even those on a leash."[83]

Even without the distraction of milling crowds, visitors might have found prolonged contemplation of a particular work difficult, or at least a strain on their eyes. Observers almost uniformly criticized the lighting in provincial museums. Stendhal, for example, described the Marseilles museum, in its churchlike gloom, as "venerable in its obscurity." He went on to explain, "It is in the form of a capital T, of which only the branches are dimly lit, so that, at the point where the two lines join, there is complete darkness."[84] A traveler named Dubosc de Pesquidoux described similar conditions in the Marseilles museum in even more explicit terms: "Ask the city government of Marseilles why it leaves the rooms of its museum in almost complete darkness. Only one gallery is lit; in the others one discerns only a confused mass of gilded frames, from which certain bright colors stand out, that's all. One needs the patience of an angel and the eyes of a lynx to make out the paintings displayed. It is, I think, urgent to remedy this singular inconvenience, and to give these abandoned paintings a little more air and light."[85] Mantz called the lighting in Bordeaux "dubious," adding that "the paintings are scarcely lit by a thin streak of light barely admitted by the large trees in the garden."[86] Nor did most museums present the collections in any but the most rudimentary chronological order or national classification; generally they did not have the space to do so, and the crowded, virtually floor-to-ceiling hanging of pictures did not lend itself to precise classification.[87]

Nonetheless, even in their primitive state, provincial museums could still offer the occasional transforming experience. In Dijon, that revelatory moment most often took place in the Salle des Gardes, the room, opened in 1827, housing the treasures from the funerary chapel of the Dukes of Burgundy at the Chartreuse de Champmol. Stendhal, in the guise of his fictional tourist, recalled how he came upon the most remarkable of these treasures, Klaus Sluter's mourning figures on the tombs of Philip the Bold and John the Fearless: "In this museum, in the midst of many mediocrities, I encountered seventy small figures in marble, no more than a foot high; they are monks of different religious orders. The expressions of fear of hell, of resignation and of scorn for the things of this earth are really remarkable . . . Such a statue would certainly have astonished Pericles."[88]

Elsewhere, works with similar special ties to local traditions seem to have attracted the most admiration among visitors, if only because their merits were so unexpected. "The really interesting

thing in provincial museums are the portraits," Stendhal wrote of Marseilles, where he also admired the artist Michel Serre's scenes of the 1732 plague in Marseilles.[89] Dubosc de Pesquidoux too found the Serre impressive, and he admired as well the works of Marseilles's most celebrated native artist, Pierre Puget. In Rouen he praised the collection of works by the seventeenth-century masters Jouvenet and Restout, and in Dijon the works of the most prominent members of the Dijon school, Devosge, Prud'hon, and Gagnereaux. In addition, most of the important provincial museums could boast of at least a handful of undoubted masterpieces by well-known artists to which locals could point with pride. Even the most jaded critics remarked on these with respect; those most frequently mentioned in travelers' accounts included a Veronese in Rouen, a Perugino and a Rubens in Marseilles, and another Perugino in Bordeaux.[90]

These so-called jewels, the works that attract a large proportion of museum visitors to this day, were beginning to take on that special luster that emanates from a secure position in an established canon. The curators who argued for increased funding, and who sensed the importance of standards of attribution linked both to the market and to existing scholarship, were clearly trying to tap that resonance. Stendhal's reaction to the Sluter figures is, on that score, doubly revealing. First, the Salle des Gardes in Dijon represented one of the first attempts to structure the experience of works of art museographically. Though a resolutely decontextualized presentation would eventually triumph over Févret de Saint-Mémin's historicism, the importance of this installation lay in the conscious use of museum spaces as signifiers to endow objects with meaning. The promise of such a strategy emerges in Stendhal's reference to Pericles, the kind of evocation of the classical tradition that would become the museum's overriding objective. Issues of attribution, scholarship, and classification ultimately came down to questions of value, and only the most skillful museographical strategies could imbue works of art with an aura that subsumed the marketplace in the hazy glow of cultural tradition. Precedents for such strategies can be detected as early as the 1820s, but their true emergence dates from a new era in urban culture.

Museums in Transition, 1850–1870

Bureaucrats, Curators, Tourists

Barely a quarter century after Stendhal's memorable account and only a few years after Dubosc de Pesquidoux's, the city of Marseilles was engaged in building an ornate and expansive palace to house its artistic treasures. It was neither the first nor the last city to do so: Amiens had blazed the trail in the late fifties, and a legion of other cities would shortly begin their own museum construction projects. Buildings erected consciously and specifically as museums mark a crucial stage in the development of the institution. Yet in an important sense, and notwithstanding the elaborate ceremonies with which most cities "inaugurated" them, they represent a culmination as well as a beginning. The palaces of art that became a familiar part of the urban landscape in late nineteenth-century France offered a new configuration for the cultural meanings with which museums had already come to be associated. New buildings, in other words, gave form to the museum's institutional identity, but the emergence of that identity, embodying a distinctly nineteenth-century construction of artistic value, had its own independent trajectory, one that architects and builders essentially joined mid-course.

The new buildings, indeed, impressed on museums the stamp of cities whose development had already indelibly colored the identity of the institution. The commitment to build a museum, in most cities at least, crowned a gradual process of adaptation to broader forces of sociocultural, and specifically urban, change. Whatever their age, French cities in the nineteenth century were undergoing a metamorphosis that was not only dynamic but formative—formative of new urban identities, of new ruling elites, and of new institutions bound up with them. In the course of this transforma-

tion, broad in both origin and scope, a few forces had a direct and early impact on institutions, principally in the domains of public administration, professionalization, and transportation. All, moreover, registered in important ways the habits, practices, and assumptions of the provincial bourgeoisie.

To begin with public administration, bureaucratization at the local level naturally grew out of structural changes initiated by the state. The July Monarchy, in addition to instituting the election of city council members and the appointment (by prefects or, for larger towns, by the interior minister) of mayors from within their ranks, gave local governments independent legal status for the first time. The law on local government of 6 July 1837 invested mayors with two kinds of power: authority over public welfare and safety, the so-called *police municipale,* which they exercised independently as agents of the state, and executive authority to carry out the decisions of the city councils. The councils' competence included such matters as the municipal budget and various city services, including museums. But the law limited each city's independent authority to the administration of communal property in the strictest sense; council decisions on other matters still required prefectoral approval, and on questions of religion, education, and public assistance city councils had only an advisory role.[1]

The Second Empire's legislation on local government, in keeping with that regime's authoritarian character, represented something of a regression from the law of 1837. Although city councils, like the rubber-stamp Parliament, the Corps Législatif, were now elected by universal suffrage, the state no longer had to choose mayors from among their members. The regime, indeed, generally preferred to appoint officials who had no independent power base. In addition, a law of 25 March 1852 stipulated that prefects, not mayors, appoint museum curators and a variety of other officials. In its own way, however, this legislation helped bolster the trend toward more orderly and responsible local administration. The law permitted local governments to appoint all officials or functionaries it did not specifically name (this had previously been a matter of some ambiguity), and it allowed mayors to delegate authority to their *adjoints,* or assistant mayors (also appointed by the state), in specific areas of responsibility. The Empire also left unaltered the spheres and gradations of authority that the July Monarchy had entrusted to city councils.[2]

The policy consequences of this consolidation of local govern-
ment, like those of any bureaucratic shift, are more apparent than
purely administrative developments, although the latter can often be
glimpsed through the former.[3] In 1856 the mayor of Marseilles,
Jean-François Honnorat, informed the curator, Dassy, that he had
erred in thinking the approval of *adjoints* sufficient in matters of
installation. In imperious tones reminiscent of some of his predeces-
sors, the mayor called the misunderstanding "a regrettable disregard
of propriety and of duty," and made clear that "in the future no
work of art will be admitted to the museum without my prior
approval."[4] But the beginning of specialized spheres of authority,
together with the introduction of regulations that spelled out cura-
tors' duties more clearly, made the administrative liaison between
museums and city officials more routine and thus less arbitrary.[5]
From the late 1850s in Bordeaux, and the mid-1860s in Marseilles,
curators came increasingly to deal with the *adjoint* in charge of edu-
cation and cultural affairs. Usually individuals with some affinity
for, and often an *amateur*'s familiarity with, the arts, these officials
generally took the lead in city council discussions of artistic matters.
As museums attracted increasing public attention, both *adjoints* and
ostensibly apolitical civil servants could shelter curators from the
buffeting winds of political criticism, as will be seen in the case of
Bordeaux's Oscar Gué in the 1860s, and allow them to get on with
their jobs.[6]

Such criticism came mainly from *amateurs,* who considered cura-
tors, still mainly artists, inherently unfit to run museums. The men
who took over in the 1840s and 1850s from the first, long-serving
generation of curators owed their appointments to exactly the same
criteria as their predecessors: their distinction as artists. A four-page
memorandum on Jules Ziégler, who succeeded Févret de Saint-
Mémin as curator in Dijon in 1854, detailed his artistic achievements
at great length; his sole accomplishment outside painting apparently
consisted of a report on "glass painting in Germany." Ziégler was
the first of a series of minor Romantic painters whose "essential
preoccupation" as curators, in the contemptuous words of one of
their more eminent successors, "was to have one of their works pur-
chased and sent to the museum as an envoi."[7] The state, moreover,
in the persons of Nieuwerkerke, head of the imperial art bureau-
cracy, and his nominal ministerial superior, specifically advocated
the combination of the posts of curator and director of the art school

in both Dijon and Rouen. They made these recommendations on the grounds of administrative convenience: in Dijon, which boasted one of the two municipal art schools outside Paris supported by the state, the minister said the addition of the curator's salary would make the directorship of the art school worthier of its incumbent, whose own salary as director the state was unwilling to increase. But the state's urgings also bore the hallmarks of the old relegation of museums to an essentially inferior status; the minister noted that "the two agencies . . . present a certain affinity, because they are both connected to the fine arts and to artistic instruction."[8]

Beyond these general observations, however, the minister also found it necessary to observe that the director of Dijon's art school, Louis Boulanger, had "proven his capacity" to run the museum. Boulanger only became curator in 1862 on the death of another artist, Jean-Auguste Devillebichot, who had served as curator under Boulanger's orders and those of his predecessor as art school director, Alexis Pérignon, since 1856. The city had resorted to this system of twin appointments after dismissing Ziégler, whose frequent absences in Paris, high-handedness, and political intriguing in Dijon it soon found intolerable.[9] Pérignon also spent much of his time in Paris and essentially left Devillebichot a free hand. A former professor in the art school, Devillebichot expressed delight with his appointment to a more tranquil post and showed a distinct flair for museum work. He kept the first day-to-day record of the museum's activities, including restorations, the arrival and installation of envois, and purchases of supplies ranging from new furniture to the register in which he was writing. Devillebichot also began a comprehensive reworking of the museum's catalogue, revising Févret de Saint-Mémin's attributions on the basis of new evidence he had found in both printed and archival records. His description of the process in a letter to Pérignon is one any scholar would find familiar: "I spend the whole day working on our reprinting, but, as I was saying to you, a thousand small impediments come up that can certainly be surmounted, but prevent me from moving as fast as I would like." Pérignon praised the catalogue resulting from these labors for its "considerable and exacting research" and "many improvements."[10]

Devillebichot might not have found his position so enjoyable in Bordeaux, where Oscar Gué, the offspring of a well-known family of Bordeaux artists, succeeded Lacour as curator and director of the

art school in 1859. Gué's so-called qualifications, though the standard entrée to the positions he was assuming, may have condemned him simply by association with Lacour, a member of the same establishment. Lacour's infirmity (he was over eighty at the time of his death) had brought about Jules Delpit's collaboration on the embarrassing catalogue of 1855, which had quickly become the object of general ridicule, particularly among members of Bordeaux's new and very active artistic society. Even worse, when in 1862 Gué, acting under instructions from the *adjoint,* brought out a revised version of the 1855 catalogue, Lacour's estate and Delpit sued the city for what they called the unauthorized use of "their" property. In response, the city council ordered all copies of the new catalogue destroyed, and the following year Gué compiled a brief checklist of the museum's collections, without any commentary or description, which served as the museum's only catalogue for nearly twenty years.[11]

Although the Delpit suit's lack of civic spirit can scarcely be defended, Gué unfortunately bore some responsibility for the debacle. As Adolphe Charroppin, a particularly vocal member of the artistic society, pointed out in 1864, the new curator had blundered in not consulting or even informing Delpit about his plans to revise the catalogue. But Charroppin went further, saying that Gué's catalogue "was as bad as all those that preceded it, as bad as those that the artist-curators of the museum put their names to in the past or could concoct in the future. That has always been and always will be the case, because no artist, even the worthiest of that name, has ever been capable of drawing up a catalogue of any value—witness M. Lacour in the past, witness M. Gué in the present." Charroppin recommended that the city assign the task of drawing up a new catalogue to the Bordeaux-born Paris critic, Paul Mantz.[12]

In his first years as curator, Gué might almost have joined in this assessment of his competence. Chastened by the 1862 incident and unsure of his own abilities, he accepted, at the time he submitted the 1863 checklist to the mayor, the idea of bringing in an outside "appraiser of paintings capable of drawing up *your* catalogue and of providing you with serious attributions to replace those set down by tradition but now contested."[13] But Gué's confidence increased as he grew more experienced. Reports in 1864 displayed both scholarship—he consulted books and prints in the Bibliothèque Impériale to doubt the authenticity of two supposed Poussins that the city was

considering buying—and command of the technical vocabulary of restoration (or, as it would now be called, conservation), even though he himself did not carry out such work. That responsibility belonged to the museum's permanent concierge-restorer, a rather shady character who dabbled in picture dealing, some of it to the museum, and whose ethics evidently made Gué uncomfortable.[14] In 1868, in sharp contrast to the earlier hesitations of Lacour and Aubert, Gué provided a shrewd evaluation of the authenticity and market value of two eighteenth-century paintings offered to the museum. He observed that one work, whose attribution to Watteau he considered dubious, "is under a kind of fog, which is not what one might call the patina of age but rather the glaze of the restorer." The owner was asking four thousand francs, down from the original figure of eight thousand; Gué thought eight hundred more reasonable.[15]

By the end of the Second Empire, local governments had acquired enough of an independent identity to be the target of political criticism, and with their leaders still appointed from Paris, they naturally attracted the hostility of the increasingly vocal opposition to the imperial regime. Museums, as highly visible and visibly imperfect institutions run by the city, became an issue in this political debate. But the same process of administrative change that had made museums a locus of controversy had also endowed many curators with an aura of professional competence and authority that made them relatively impervious to attack. By 1868 Gué felt secure enough in his position to contest the continuing efforts to hire Mantz to do the new catalogue, and he enlisted his friends in the city administration on his behalf. He also had sufficient equanimity to shrug off two 1868 press attacks on the city for failing to build a new museum, one of which he attributed to Charroppin. Realizing that he could hardly be held personally responsible for the museum's long-standing deficiencies, Gué described the articles as "goadings aimed at the administration and the city council."[16]

Museums during the Second Empire were also responding to the expansion of travel and tourism, though the latter term, borrowed from the English, did not come into general use until somewhat later. Travel had been increasing in France since early in the century, as a consequence of improvements in the country's long-distance road system, but it remained slow and limited into the July Monarchy. The decisive impetus to widespread travel for pleasure came

from the advent of railroads. Emile Péreire, the developer of the rail line between Paris and Saint-Germain-en-Laye, which in 1837 became the first to offer regular passenger service, deliberately chose a popular excursion route as a way of exposing the public to train travel; the service's popularity surpassed even his most optimistic hopes.[17]

Despite this initial success, disagreements over the role of the state versus that of private investors in railroad construction, and over the routing of the national network, slowed development. Construction had hardly begun to take off in the mid-1840s, moreover, when the economic crisis of 1847 and the Revolution of 1848 brought it virtually to a halt. The railroad industry thus needed the generous incentives it received from the government of Louis-Napoléon Bonaparte, and the rail network expanded dramatically in the 1850s. Rouen had been one of the first two cities to acquire a direct rail connection to Paris, the Paris-Rouen line opening a day after the Paris-Orléans line in May 1843. Dijon-Paris service began in 1851, Bordeaux-Paris in 1852. The Marseilles-Avignon route, involving very advanced engineering and what is still the longest tunnel within France, opened in 1848; service to Paris began with the completion of the Lyons-Avignon link in 1855.[18]

Trains brought in their wake several developments of particular significance to tourism, including organized group excursions and guidebooks. Thomas Cook conducted his first group tour of France in 1863, though he had previously offered cheap fares from England to Paris for the Exposition Universelle in 1855 and had organized workingmens' exchange visits to Paris in 1861 and 1862. Most Cook's tours to Italy and Switzerland in subsequent years included stops in France.[19] Guidebooks, like tourism, predated the railway age: most authorities consider Hans Ottokar Reichard's *Guide des voyageurs en Europe* (1793) the first general tourist guide. Prior to the 1840s, however, guidebooks tended, with few exceptions, to be historical and anecdotal rather than practical, with titles like *Voyage pittoresque en Côte d'Or* (1835). The coming of trains provided an immediate stimulus to the publication of new guidebooks: in 1844, only a year after the opening of the Normandy line (which did not reach Le Havre until 1847), the Rouen firm Le Brument brought out a *Guide du voyageur en Normandie* and advertised the availability of other guides, including one to Rouen and the Murray *Hand Book for France*.[20]

The increase in the volume of travel for pleasure also brought to guidebooks a more systematic organization and a profusion of practical detail about the new mechanics of travel, such as station hotels. Indeed, the modern guidebook in France had its roots in the tremendous potential of the rail passenger market, a market the publisher Louis Hachette was the first to tap. Inspired by the example of W. H. Smith, whose station bookstalls he had seen during a visit to London for the Great Exhibition of 1851, Hachette in 1852 signed contracts that gave him exclusive privileges to sell books in most French railway stations, and by 1855 his contracts covered the entire French railway network. [21]

The prospectus for Hachette's "Bibliothèque des Chemins de Fer" listed seven different series, including history, French and foreign literature, and childrens' books. To fulfill his commitment in the category of travel books, Hachette acquired the travel lists of two other publishers, including five guides to the museums of Europe by Louis Viardot (the volume on France covered only Paris, principally the Louvre) and the guidebooks of Adolphe Joanne, whose first work had appeared in 1841. Under Joanne's direction the Hachette travel series expanded rapidly: in 1861 Joanne began to bring out his *Itinéraire général de la France* in six sections (eight volumes) corresponding to the six consolidated railway lines of the time. [22] His list also included, in addition to numerous guides for foreign countries, both more specialized books and the less detailed, more portable Guides-Diamant, for travelers on shorter trips. The various Joanne series had a reputation for erudition and utility equal to that of the Baedecker and Murray guides available to German and British tourists; the Joanne descendants appear today as the Guide Bleu series, a title they acquired after the death of Joanne's son Paul in 1912. [23]

Students of tourism in nineteenth-century France have conceptualized it in two different but not necessarily contradictory ways, both relevant to museums. Some have traced tourism to the Romantic love of nature and desire to recapture the national past, which also manifested itself in Alexandre Lenoir's Musée des Monuments Français, a Paris museum of sculpture that existed from 1795 to 1816, and in the writings of Victor Hugo, Charles Nodier, and others. The state gave institutional status to the task of preserving its patrimony when it created, during the July Monarchy, the Historic Monuments Service. The reports of the first inspector of monuments, Prosper Mérimée, further fueled interest in both pres-

ervation and travel.[24] Art museums, with their goal of preserving the relics of past cultures and their early interest in local and regional artistic traditions, held an obvious attraction for tourists of such historicist inclinations. Stendhal's *Mémoires d'un touriste* testifies to the importance of such tourists, as do the guidebooks devoted entirely to museums, the articles on provincial museums in art journals aimed chiefly at an elite Paris audience, and the "very precise" descriptions of museums in Joanne's guidebooks.[25]

Most scholars, however, view the expansion of resort towns, both mineral and seaside, as the central touristic phenomenon of the Second Empire. Still dominant socially if not politically or economically, the aristocracy set the tone for leisure activities at midcentury, and it flocked to such resorts, an ever-increasing bourgeois contingent in its wake. This kind of tourism too seems to have brought more visitors—who may also, of course, have shared a certain Romantic interest in the past—to provincial museums, especially those in cities strategically situated on railroad lines to the new seaside developments. The Atlantic resort town of Arcachon, for example, which owed its reputation to the patronage of Haussmann and other celebrities, did not become a separate commune until the completion of the railroad line from Bordeaux, forty miles away, in 1857. Trouville and Deauville, which competed with Biarritz for the distinction of being the Second Empire's most fashionable resort, similarly brought many travelers through Rouen.[26] Thus in the 1860s the mayor of Bordeaux several times ordered Gué to keep the museum open on Mondays to accommodate tourists passing through the city on excursion trains. Marseilles, meanwhile, was an increasingly important gateway to North Africa and, after the completion of the Suez Canal in 1867, to the Orient. In 1858 the mayor of Marseilles instructed the curator to expand the museum's summer hours, citing (unspecified) popular demand.[27]

Museums responded to their growing pool of visitors in other ways as well. Several cities tried to bring catalogues up to the standards of their well-educated, and now perhaps well-traveled, visitors: in 1864 Charroppin urged the mayor of Bordeaux "to rescue at last our compromised reputation, by providing our museum with a catalogue worthy of the position that we occupy, or rather that we ought to occupy, in the world of art."[28] In Dijon too, the curator and director recognized that for the museum to maintain its reputation as one of the best in the provinces, "it is necessary not only to

preserve [what exists] but to improve [it]." In 1857 the city completed a new wing at the eastern end of the Palais des Etats de Bourgogne; though it now consists entirely of exhibition space, and houses the museum's main entrance, at the time the wing contained mainly municipal offices. Nevertheless, the small amount of additional space the museum received in the new wing gave Devillebichot the opportunity to make certain changes in installation, aimed primarily at separating old masters from more recent works. The rehanging, completed in 1858, divided the older paintings by school and placed works by living local artists in a special gallery. Devillebichot also did his best to improve viewing conditions. He gave the museum's masterpieces pride of place in an airy, skylit gallery and turned a small, low-ceilinged ground-floor room over to the display of prints and drawings, which for reasons of preservation demand less illumination.[29]

For the museum's visitors, Devillebichot offered comfort not only for the mind, in the form of the new catalogue, but also for the body. He ordered four benches in "embossed red velvet" in 1857 and "two upholstered chairs" in 1860 for the museum. He also installed twelve spittoons, distributed throughout the galleries. Students or copyists might have welcomed the spittoons, but they would surely not have had much use for the upholstered furniture; in any case Devillebichot, who had had occasion to complain about students' unruliness, did not intend the furniture for their backsides. His purchases signal, rather, the beginning of a subtle but steady shift in museums' perceptions of their public. That shift can also be detected in a casual reference by the director of the Marseilles art school, Philippe Jeanron (who had served briefly as director of the Louvre during the Second Republic), to "l'intérêt de la curiosité et de l'étude" that the new museum building, then under construction, would serve.[30] Not only study but also *curiosité*, which might best be translated as "attraction," meant that museums, in the eyes of their curators, were coming to serve a public broader than those directly involved in artistic production or instruction. Though the purposes of education may have remained central to museums, those who administered them increasingly saw education in the general and highly malleable terms of enlightenment rather than in the specific sense of training.

Of course the public of which curators were becoming aware in the 1850s and 1860s did not consist only of tourists. Museums were

also responding to a tremendous new local interest in art, both a consequence of and a continuing impetus to the dramatic expansion of exhibitions and the art market at mid-century. In 1860 Paul Lacroix, a curator at the Arsenal Library and a member of a government advisory board on historic monuments, brought out a volume of over three hundred pages with the title *Annuaire des artistes et des amateurs.* The *Annuaire* contained information on government officials with responsibilities in the cultural sphere, critical essays on developments in the arts in the past year, obituaries, and descriptions of schools and museums throughout the country. In tribute to the burgeoning art public, Lacroix also included capsule descriptions of important private collections both in Paris and in the provinces and an extensive bibliography of the year's writings on the arts. Of the twenty-two periodicals listed in that bibliography, fifteen had been founded within the past decade, eight in the past two years alone. The journals ranged from the scholarly *(Revue archéologique)* to the professional *(Revue générale de l'architecture et des travaux publics),* critical *(L'art au XIXe siècle),* and commercial *(Moniteur des arts,* which covered exhibitions and sales); a number were clearly aimed at *amateurs* rather than at artists. Many proved ephemeral (the *Annuaire* itself only lasted three years), but distinguished futures lay ahead of some of the newcomers, including the now venerable *Gazette des beaux-arts.*[31]

In his introduction to the first issue of the *Gazette* in 1859, its founding editor, the former (and future) director of fine arts Charles Blanc, observed that the magazine "would not have been possible fifteen years ago; it would not have had 800 subscribers: today . . . it could easily have 10,000." Not entirely happily, Blanc attributed this new interest in art to the general increase in wealth and the consequent expansion of the art market; yet despite his disapproval, only three years after its founding the *Gazette* itself inaugurated a weekly supplement, the *Chronique des arts et de la curiosité,* at first devoted mainly to art sales. But Blanc also cited the recently instituted universal expositions, travel, and the maturation of art criticism among the factors creating the new demand for information about the arts. And he took note of a veritable flood of scholarly and critical work on the arts coming from the provinces. Declaring that "the time has come to bring everyone into this fortunate revolution in the arts," Blanc dedicated the *Gazette* to the task of enlightening *amateurs* and keeping them informed about developments

throughout the world of art.[32] The *Gazette,* of course, not only por-
trayed this world as centered in Paris but helped to reinforce its cen-
tripetal order. Yet Blanc's words, as well as the organization of the
Gazette and of the *Chronique,* reflect a shrewd understanding of a
broader phenomenon. Blanc well knew that provincial cities and
their institutions were coming to play a vital role in the functioning
of the national art market. Although for the art press the stage
remained in Paris, the provinces represented an important part of
the audience to which they were playing, and which they could not
afford to ignore.

Friends of the Arts: Collections, Exhibitions, Purchasers

Like many areas of bourgeois leisure in the nineteenth century,
interest in the arts acquired an institutional form of some distinc-
tiveness, one that would have profound consequences for the devel-
opment of the art museum. Beginning in the 1820s and 1830s,
private citizens in a number of cities began founding associations
dedicated to the "progress" or "propagation" of the arts. Generally
taking the name Société des Amis des Arts, these associations typi-
cally used members' dues, which ranged from ten to fifty francs per
year, to organize annual or biennial exhibitions similar to those of
the Paris Salon. At each exhibition, the society used most of its
funds to purchase a certain number of the works displayed, which it
then distributed among its members by means of a lottery. Private
collectors, of course, were free to make purchases as well.[33] In this
enterprise provincial societies were following the example of the
Paris Société des Amis des Arts, which had a brief existence during
the Revolution and a longer but not very successful one from the
Restoration to around 1850. The critic Léon Lagrange observed in
his 1861 study of the societies, originally a series of articles in the
Gazette des beaux-arts, that "the existence of such societies in Paris
will always be difficult to the extent that they have to contend with
the rivalry of the state on their terrain." Thus, Lagrange declared,
"the real theater of the Sociétés des Amis des Arts is the provinces."[34]
 That is not to say that art lovers in provincial towns had an easy
task in forming such organizations. Lagrange apparently found no
trace of the society that had been formed in Bordeaux around 1820,
although it held several exhibitions, attracted a certain amount of
press attention, and even induced the city to purchase some of the

works it put on view in 1830 before disappearing shortly there-after.[35] With the exception of Lyons and Nantes, where societies mounted exhibitions continuously from the mid-1830s on, the crit-ical mass necessary for the survival of private artistic associations seems not to have existed before the late 1840s. Only at that time did societies founded much earlier, like those in Strasbourg, Mar-seilles, Rouen, and Bordeaux begin, if not in all cases to flourish, at least to have a continual existence. The 1850s also saw the birth of similar associations in lesser provincial centers such as Nîmes, Le Havre, and Saint-Etienne.[36] Art associations appealed to a wide range of urban elites, and their social composition varied from city to city: those in Bordeaux and Lyons, for example, came from old money, whereas in Saint-Etienne a new industrial elite may have been involved.

Most provincial art associations would probably have described their goals in words similar to those of the Bordeaux society's charter: "to promote the progress of the arts in Bordeaux, and to propagate artistic taste." The annual exhibition constituted, again according to the Bordeaux group, "the first and the principal means of achieving our goals."[37] It could "propagate a taste for the arts" by providing a public showcase for (in theory, at least) the best of contemporary art, and it could "promote the development of art" in the city by furnishing local artists with models in the form of other artists' works, with a context for the evaluation of their work, and with a regular forum for selling it. Museums entered into artistic societies' purposes in two ways, in offering societies space in which to mount their exhibitions and in providing a rationale for cities to make purchases from them.

Although the Bordeaux society, recognizing the grave physical problems of the city museum, never held its exhibitions there, asso-ciations elsewhere did use their cities' museums, a practice Lagrange condemned as "a scandalous act, a flagrant abuse." As Lagrange noted, the erection of temporary panels to install temporary exhi-bitions deprived artists and visitors of access to museum collections, and extreme crowding of the displaced permanent collections could damage them.[38] From 1848 on the Louvre no longer had to suffer the regular invasion of the Paris Salon, which had long since out-grown its original home in the museum's Salon Carré, but in Dijon the installation of the 1858 exhibition forced the closing of that museum. In Marseilles in 1856 the mayor considered the inconven-

ience so great that he at first refused to let the association again use the museum, where the exhibition had been taking place for four years. He relented, unwillingly, only after the society's president had failed to find any alternate space and on the condition that the society shorten the exhibition's duration from two months to six weeks.[39]

Even more important than housing exhibitions, museums represented the goal to which exhibiting artists could aspire. From early on, the associations' influential officers urged municipalities to purchase for museums one or two of the most distinguished works shown at local salons; the alternative of association gifts to museums, although it occurred in Marseilles in the early 1850s, was never widespread, and Lagrange emphasized that cities should take on the responsibility for acquisitions themselves.[40] Since most societies took no commission on these or other purchases, they had no financial stake in the sale of exhibited works.[41] Rather, regular municipal purchases from exhibitions could considerably enhance a particular society's reputation and help ensure the success of its salons. The Dijon curator Pérignon, recommending such a purchase in 1858, wrote: "[The city] will thereby show the artists invited to contribute to the *éclat* of our exhibition that the call made to them had the real and serious intent of [encouraging them to] take advantage of the incentives so necessary to their work."[42]

What Pérignon meant, of course, in this convoluted passage, was money. Both private buyers and the societies themselves tended to purchase small, inexpensive works, ranging in price from ten or fifteen francs for a Barye bronze to a few hundred for an accomplished if unremarkable still life. Private buyers, after all, were for the most part only seeking objects to decorate their homes: serious collectors tapped the Paris market rather than provincial salons as their primary point of purchase.[43] Societies, meanwhile, were trying, with purchase funds ranging from ten to twenty thousand francs, to assemble a respectable pool of works for their membership lottery. Municipalities, in contrast, bought only a few works, but they spent so much more on each one that they had the luxury of choosing from a pool of far more highly regarded art. At the Bordeaux society's 1853 exhibition, for example, the city purchased Léon Cogniet's *Tintoretto Painting His Dead Daughter* (Figure 1) for the spectacular sum of 20,000 francs; at the same exhibition the average price paid by private purchasers was 270 francs (total 17,280 francs for 64 works), by the society 308 francs (total 16,670 francs for 54 works).[44]

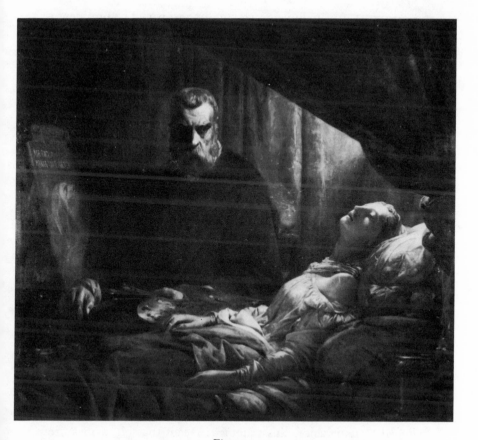

Figure 1
Léon Cogniet, *Tintoretto Painting His Dead Daughter.*
Bordeaux, Musée des Beaux-Arts.

Why, though, did municipal involvement matter so much to soci-
eties, if their own purchases and those of private viewers were pro-
viding the "incentives" *(encouragements)* to which Pérignon had
referred? The answer has to do with another of Pérignon's terms,
éclat. Like a gun, an exhibition with *éclat* (in one of its original mean-
ings, a burst or clap) invariably had *retentissements,* or reverbera-
tions. Bordeaux's acquisition of the Cogniet, according both to the
society and to Lagrange, had "an immense *retentissement*" in the art
world.[45] The prospect of such a purchase could attract to provincial
salons important artists whose work—often paintings they had not
managed to sell at the Paris Salon—fetched far more than the soci-

eties, or most private buyers, were willing to pay. The president of the Marseilles society wrote in an 1865 request for a municipal purchase: "This measure of encouragement would result in the submission of more important works, signed by more celebrated names."[46]

The established artists who sold works at provincial exhibitions between 1850 and 1870 included members of the Académie des Beaux-Arts like Cogniet and Delacroix, up-and-coming Prix de Rome winners like William Bouguereau, Paul Baudry, and Henri Regnault, and even prominent outsiders (who nevertheless had something of a clientele) like Courbet or Millet. None of them would have had much to gain from the meager *encouragements* small purchasers had to offer, but representation in the collection of a major provincial museum had the potential of adding to their reputations and providing at least a minor boost to their careers. They also had little to lose in sending works to the provinces, since societies generally paid for the transport of works to and from their exhibitions.[47] For the organizers, in turn, the presence of works by well-known artists could completely transform their exhibitions' character. The Bordeaux society's annual report described this potential in typically refulgent terms: "Cities can do much to increase the importance of exhibitions, in requesting from them works of an elevated style for their museums, thus encouraging the most serious artists to submit their works. That is why we have always attached so much value to this noble practice of the city of Bordeaux, and why we have maintained such a lively gratitude for its enlightened munificence."[48] Reduced to its essence, this statement meant that big names drew crowds—and only the prospect of purchases for museums could draw big names.

Municipalities did not, however, invariably garner praise from art associations; indeed, cities' acquisitions for museums often gave rise to complaints. The Bordeaux society, with its many contacts in the municipal administration, rarely had occasion to complain, and even when it did, it spoke only in muted tones. "Private acquisitions were less numerous than usual," the society's annual report stated in 1859; "this low level results, first, from the fact that the city only made one small purchase for its museum."[49] Officials of the Marseilles artistic society, in contrast, frequently protested the city's attitude toward its exhibitions. The city had been making purchases at the annual exhibitions since 1857, and in 1861 began appropriating ten thousand francs annually for the acquisition of works of art. The

society believed that the city should spend the entire sum on works from its exhibitions, in order, as it made plain, to attract to them "more important works and . . . more reputable names." When, in 1864, the city made its purchases outside the exhibition, the society's president, Alexandre Clapier—the same Clapier who, as a deputy in the 1870s, outmaneuvered Charles Blanc over the Musée des Copies—was outraged. Accusing the city of straying from the appropriation's original purpose, he expressed the hope that this "derogation" would not be repeated. But the works the city purchased in 1864— a Lebrun, a painting possibly by Puget, and three paintings and two sculptures by local artists—typified its choices and its practices throughout the decade.[50] The city was not only trying to get the most for its money; it was also attempting to fill the needs it perceived in the museum's collections.

Art associations, both in Marseilles and elsewhere, were in fact confronting the last great change of this period, the emergence of municipal purchasing practices, a phenomenon to which they contributed only as one factor among many. The term "practices," rather than "policies," is appropriate, for what developed in city halls in the 1840s and 1850s involved a kind of standard process based more on a few commonly understood principles than on any articulated doctrine. Combined with the definite purpose of acquiring works of art for museums, however, this process constituted a policy of sorts, particularly in contrast to the modes of acquisition prevalent in the first half of the century. In the early days of provincial museums, cities had made few purchases, and made them only haphazardly. Indeed at the beginning of the century municipal purchases showed almost as little regard for museums as the state displayed in the envois it sent.

Cities did not lack opportunities to acquire art: indeed, the earliest image of the museum in the public mind seems to have been of a place where one could unload the odd work of art in exchange for some badly needed cash. Such proposals began quite early: in 1813, for example, a Parisian offered to sell Bordeaux an eighteenth-century drawing depicting the city and its port, but the municipality politely turned him down.[51] Would-be sellers more often cited their personal circumstances than the particular merits of the object in question. In 1825 an aging artist named Robineau implored the city of Marseilles to buy one of the paintings he had sent for temporary display in the museum. He explained that "the closer I come to my

end, the more I fear leaving this work to a scheming and ungrateful nephew." A young artist seeking the same favor of the city of Bordeaux in 1848 made prominent mention of his sick wife and four young children, and assured his correspondent that his "heart would bleed" to see the squalid conditions in which they were living.[52] Robineau's ploy of sending the proposed object on approval, as it were, was also common: the owner of a massive Puget sculpture sent it to Marseilles in 1837 and, like the Marquis de Lacaze in Bordeaux, allowed it to languish for seven years before asking for a decision.[53]

Those pleading illness or poverty, moreover, probably knew what they were doing. Museum and municipal officials in this earlier period had little interest in adding to their collections—recall the elder Lacour's idea of "filling up the gallery" with a few more paintings—and refused most of the proposals they received. Their rare decisions to make a purchase rested not on artistic considerations but, for the most part, on the strength of the seller's claim to municipal charity. In 1838 the Marseilles city council agreed to acquire six paintings, at a thousand francs apiece, from the estate of a late municipal employee, on the grounds that "there are feelings of justice that one does not discuss, because they have the power to move generous souls." In 1846, however, the mayor rejected a proffered painting with a solid attribution to Philippe de Champaigne, although its owner, who had just acquired the work through a bequest, needed the funds to support his recently orphaned sister-in-law; apparently he had no claim on the city.[54] Occasionally an object's particular local interest constituted a secondary consideration: arguing for the purchase of a Bordeaux scene by his father, the younger Lacour in 1842 put forward the view that "only the works of artists born or established in that city can claim for it the esteem and even the glory that the human spirit acquires through the arts"; still, he was also acting on behalf of his recently widowed sister.[55]

The most striking instance of municipal indifference to even the most advantageous of acquisitions involved the collection of paintings that the Marquis de Lacaze offered Bordeaux in 1821. Consisting of nearly 280 old masters, including works of Titian, Palma Vecchio, Salvator Rosa, Van Dyck, Rubens, Teniers, and Tiepolo, the collection went on public view in the museum in 1822. Despite Lacour's assertion that the museum's collection badly needed augmenting and his observation that Lacaze's asking price of eighty

thousand francs represented an extraordinary bargain, given the high quality of the collection, the city council rejected the mayor's proposal to effect the purchase in ten annual installments. Five years later, the minister of the royal household informed the city that Charles X was willing to pay forty thousand francs, half the purchase price, as a token of gratitude to a devoted royalist, Lacaze, and a staunchly legitimist city; the council only agreed to the purchase in May 1830, after Lacaze had lowered his price to sixty thousand francs. Bordeaux's museum thus acquired the gems of its Italian, Dutch, and Flemish collections for twenty thousand francs, or about seventy-five francs apiece. Had the city's parsimony lasted a few months longer, the museum might have lost the collection altogether; Charles X lost his throne in the July Revolution of that year.[56]

By the 1840s, however, attitudes toward acquisitions were beginning to change. Despite the crowded conditions with which they had to contend, curators urged municipal officials to augment museum collections with specific kinds of works. Aubert found admirable an Italian painting offered to Marseilles in 1845, but he said that the museum really needed "genre scenes of modest dimensions, what are generally called cabinet pictures," of which it had none and which he required for instructional purposes.[57] No longer content to await whatever treasures chance brought across their thresholds, officials also began actively pursuing works of special local interest. In 1846 the Bordeaux city council actually considered commissioning a painting from one of its most celebrated native artists, Jacques Brascassat, of whom it possessed only an early work; it instead obtained from the government the promise of an envoi.[58] Some years later Devillebichot advised Pérignon and the mayor of Dijon, both then in Paris, of a forthcoming Paris sale that would include several pieces of Burgundian sculpture of interest to the museum. They apparently attended the sale but could not match the winning bid.[59]

Meanwhile, cities were attempting to exert more control over the conditions under which they considered unsolicited offers. In 1850 Lacour strongly resisted an artist's request to display a painting in the museum for a month, because he feared it would tarnish the museum with the hint of commerce. In 1864, following a similar logic, Marseilles included in the museum's regulations a ban on the exhibition of pictures the city did not already own. In the late 1850s

Marseilles instituted a special commission of the city council to review possible purchases. Its chairman, the fine arts *adjoint* Rougemont, made it clear that the commission wanted to consider only works brought before it at a specified time of year, generally coinciding with the art association's exhibition.[60]

These administrative developments coincided with the emergence of a broad consensus on the components of what might be called the "museum picture," the kind of painting that should by rights be hanging in a museum. Curators, municipal officials, and members of the public most frequently alluded to elements of value, size, and either authenticity, for a painting from the eighteenth century or earlier, or quality, for modern as well as older pictures. Most of these terms do not lend themselves to precise definition, but they meant something quite concrete to those who used them. On the matter of authenticity, for example, Emile Loubon, who as director of the Marseilles art school regularly passed judgment on works offered to the city, described one such painting as apparently from the early Florentine school, but "very far from satisfying the conditions of authenticity necessary to figure suitably in the museum of a large city." Those "conditions" generally meant the conviction of a knowledgeable authority that a work's style corresponded to that of the attributed artist. Though not very rigid by today's standards in that it demanded neither a signature nor even a solid provenance, this criterion sufficed to dispose of most of the works presented for cities' consideration.[61]

The nineteenth-century notion of artistic quality, as reflected in the state's term "oeuvre de mérite," had an absolute as well as a relative character. Certainly critics and curators saw some paintings as better than others, but at the simplest level quality or merit signified a work that satisfied certain basic standards of execution and transmitted generally accepted notions of beauty. Even in these terms, quality is an elusive concept, but museum officials again seemed to know it when they saw it, or particularly when they did not. In 1861 Devillebichot quickly rejected two portraits submitted for his consideration, calling them "too weak to be admitted to the museum." Curators were realistic about what museums could hope to obtain for their modest acquisitions budgets and occasionally even defended the historical interest of "mediocre" works, but the notion of quality provided them with a clear set of limits. "Our museum can certainly acquire works that are not of the first

rank," Gué wrote in 1867, "but it should not saddle itself with works repainted by anyone at all."[62] The actual characteristics that imparted a level of quality worthy of a museum, of course, depended very much on subjective responses to particular works. Consideration of this question must therefore await a more detailed discussion of certain specific purchases.

The elements of value and size shared, particularly in the public conception of the museum picture, contours both imprecise and yet, through a kind of process of elimination, immediately discernible, rather like an elephant glimpsed through a haze. Anything too big for the average "bourgeois salon," or too expensive for most private collectors to buy, clearly belonged in a museum. "Only a museum could make this acquisition," wrote a cleric in Orange who claimed to have a number of old masters to sell to Marseilles. The wealthiest and most dedicated private collectors, of course, would have been much more willing than a municipal government, with all its fiscal constraints, to risk substantial sums on a work of uncertain authenticity. A genuine Rubens, Rembrandt, or Raphael, moreover, to name three of the past artists most respected at the time, would have cost more than most cities spent on purchases in a decade.[63] But in the area of contemporary art, as the different price levels of municipal and private purchases suggest, the prices artists *asked* for works they sent to provincial salons clearly reflected the destinations they had in mind. The vast majority of works both exhibited and purchased commanded prices below five hundred francs. Thus artists who priced their works above a thousand francs, and sometimes in the thousands of francs, were aiming either for an official purchase or for none at all. Established artists like Millet might send a work such as *Woman Feeding Her Child (La bouillie)* (Figure 2) to a succession of provincial exhibitions (again, with transport paid, they had little to lose), gambling that one city would eventually take the bait.[64]

Contemporary discussions of size provide somewhat more precise information than do those concerning quality or price, although even the largest pictures provincial cities selected for their museums paled in comparison to the colossal works they were receiving from the state. Knowing how little space they had, curators may well have shuddered at one man's description of a painting: "because of its proportions . . . destined to grace a museum rather than an apartment." This owner, a hairdresser in Gray, felt that the size of the

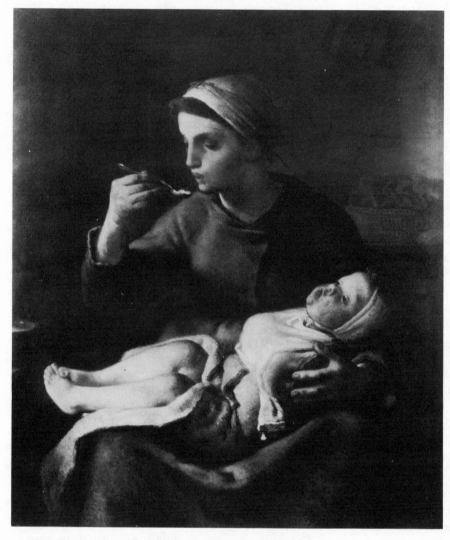

Figure 2
Jean-François Millet, *Woman Feeding Her Child (La bouillie)*.
Marseilles, Musée des Beaux-Arts.

Antigna he had somehow acquired, approximately seven feet by six, made it suitable only for a museum; he sent the identical letter to at least two different museums.[65] But such views did not come exclusively from private citizens encumbered with the proverbial white elephant: curators shared them as well, perhaps out of an instinct they might have disavowed in more clear-sighted moments. In 1863 Gué recommended, and the city agreed to, the purchase of two paintings by the distinguished Bordelais artist Jean Alaux, known as Alaux le Romain, one a rare original canvas and the second a copy after the battle painter Horace Vernet. Referring to this second work, reputedly so good a copy that Vernet had offered to sign it, Gué wrote that "the dimensions of this canvas are worthy of a museum." The painting in question measures eleven and a half by seven and a quarter feet; but at eight and a half by six and three quarters, the original Alaux could hardly have been called unworthy.[66]

But how did this conception of a work of sufficient size, accomplishment, and originality, in both senses of the word, translate into practice? How did cities arrive at particular choices? In particular, did municipal purchasing policies reflect a hidden agenda, some unspoken criteria of appropriateness? At the most basic level, cities had to choose between *peinture ancienne* and *peinture moderne,* between past art and the art of their own day. Discerning patterns in this domain, however, does not involve finding a hidden agenda as much as it involves distinguishing actual purchases from statements of policy, rhetoric to which practice only rarely or imperfectly corresponded.

In Bordeaux, a city council commission recommended in 1865 that the city, as a matter of policy, not acquire works of past art. The commission observed that the city could not be sure of the authenticity of the older works proposed for its acquisition, except for certain undoubted masterpieces it could never afford anyway. The museum would thus have to content itself with acquiring such works only through gifts, bequests, or the "complete disinterest of their owners," that is, their willingness to sell below market rates. In 1859, for example, Bordeaux had received a bequest from the estate of a former mayor, Lodi-Martin Duffour-Dubergier; his collection included a number of solid if unspectacular works from the Italian, Flemish, and Spanish schools.[67] Yet of fifty purchases Bordeaux made in the period between 1850 and 1870, eighteen, or

Table 7. Purchases in Marseilles and Bordeaux, 1850–1870

	Marseilles	Bordeaux
	Number/Percent	Number/Percent
Works		
Older works	8/16.7	18/36
Exhibition purchases	16/33.3	27/54
Other contemporary	24/50	5/10
Total	48/100	50/100
Value (francs)		
Older works	19,500/17.0	35,160/27.1
Exhibition purchases	45,500/39.8	90,600/69.8
Other contemporary	49,425/43.2	3,950/3.0
(Total contemporary)	(94,925/83.0)	(94,550/72.9)
Total	114,425/100	129,710/100
Subject matter (contemporary works)		
History	10/27.8	8/32
Landscape	10/27.8	7/28
Genre	14/38.9	10/40
Portraits	2/5.5	0
Total	36/100	25/100

Source: Archives Municipales de Bordeaux and Archives Municipales de Marseille, city council debates and purchase records.
Note: Number of works and value exclude drawings, but include sculpture. Subject matter excludes sculpture. The fifteen paintings acquired from the Robert Brown collection in 1860 count as one purchase. Not all percentages sum to 100 because of rounding.

over a third, were of noncontemporary works, representing over a quarter of the city's purchase funds (see Table 7).[68]

Marseilles had no such stated policy, although its refusal to consider works officials could not examine, which was an attempt to discourage unsolicited offers, affected older works much more than contemporary ones. Nonetheless, the city had several times to defend itself against the criticism that it was purchasing too *many* old masters and not offering enough support to contemporary artists. Marseilles actually devoted a much smaller proportion of its purchases to old masters than did Bordeaux: a sixth versus a third in numbers and 17 percent of its funds versus 27 in Bordeaux. Bordeaux's purchasing policies, however, remained comparatively

immune to criticism, other than sniping in the press at its acquisition in 1860 of fifteen paintings formerly in the collection of Robert Brown. In that instance, moreover, the press was objecting not to the purchase of past art as such but to what it considered the undiscriminating nature of that particular acquisition.[69]

These differing responses concerned appearances, or what today would be called public relations, rather than substantive issues. In 1867 Marseilles's *adjoint* in charge of the fine arts, Rougemont, responded to his critics by pointing out that in the past three years the city had bought fourteen contemporary works and only five older ones. The critics probably dismissed this reply as disingenuous, since, as Rougemont well knew, they were objecting not so much to time as to place.[70] Bordeaux made over half of its purchases, and nearly 90 percent of its purchases of contemporary art, at the local salon; only a third of Marseilles's acquisitions, however, or 40 percent in the contemporary field, favored the expositions of the Société Artistique des Bouches-du-Rhône (see Table 7). Moreover, Marseilles insisted on making all its annual purchases together, in the highly publicized forum of a city council commission, followed by a debate and vote of the entire city council. These procedures invariably caused delays and led to considerable disgruntlement among the exhibiting artists whose works the city was ostensibly considering.[71]

Bordeaux, in contrast, until 1863 actually left the choice of works from the exhibition to the association's own administrative committee (the city council could have rejected this choice, but it never did more than question it). More important, the city for the most part handled purchases of past art separately from those of contemporary works, trying to make them quietly and as much as possible out of available funds in the museum budget, so as to avoid a city council vote.[72] Though the works it obtained in this way were small and generally minor, they often had quite respectable signatures: Pierre-Narcisse Guérin, the younger David Teniers, Jan Steen. Marseilles, for all its publicity, hardly did much better. In the late 1860s it acquired two fine portraits by Anne-Louis Girodet de Trioson and Antoine-Jean Gros, which Rougemont justifiably described as "important and masterful" representatives of the "transitional era ushered in by David," as well as a *Martyrdom of Saint Sebastian* by the sixteenth-century Brescian painter Moretto.[73]

A second obvious question about municipal purchases involves

Figure 3
William-Adolphe Bouguereau, *The Return of Tobias*.
Dijon, Musée des Beaux-Arts.

subject matter. Discussions of the kinds of works appropriate for museums rarely referred to paintings' subjects; those that did employed a fairly conservative frame of reference that at first glance has the look of academicism. Pérignon, the director of the Dijon museum, in 1858 successfully recommended the purchase of Bouguereau's *Return of Tobias* (Figure 3) over various (unspecified) "genre subjects, which are doubtless more charming, but which appeal [only] to the crowd. It is up to public officials," he maintained, "to seek out history painting, in the strictest sense, and to support it." Gué four years later described the subject of another Bouguereau, *The Day of the Dead*, eventually purchased by the city, as "not really right for a salon but in every way suitable for a museum."[74] In calling the painting "academic in the positive sense of the word," however, Gué implied that the word had negative connotations as well, and that academic training neither granted works exclusive claim to official purchase nor even made them automatically suitable for a museum.

Although the Bordeaux Bouguereau was a genre scene, most works that fit both Pérignon's criterion of not appealing to "the masses" and Gué's of not suiting a bourgeois salon would have been history paintings. Yet a tally of the contemporary works purchased by both Bordeaux and Marseilles reveals a similar distribution of subject matter, one that in no way privileged history painting in the grand manner (see Table 7). Genre scenes, not historical painting in the broadest sense, predominated; history indeed had only a marginal edge over landscape in Bordeaux, and none at all in Marseilles.[75] Landscape and genre had an overwhelming majority (66.7 percent in Marseilles, 72 percent in Bordeaux), one they would retain even if the categories were shuffled to contrast "contemporary" subject matter with historical or "historicizing" paintings like the two Colin paintings of scenes from the *Commedia dell'arte* Bordeaux purchased in 1864.[76]

As these figures suggest, subject matter in itself did not play a decisive part in determining cities' choices of works of art. On the one hand, a Bordeaux official could praise Antony Serres's *The Sentence of Joan of Arc*, which the city purchased in 1868, for its historical accuracy, and predict that "this great history painting" would become a veritable history lesson for the public, inspiring "faith in God and love of the *Patrie*."[77] Apparently following the logic of this argument, a member of the same city council expressed doubts

Figure 4
Jean-Pierre Alexandre Antigna, *Mirror of the Woods*.
Bordeaux, Musée des Beaux-Arts.

about Alexandre Antigna's *Mirror of the Woods* (Figure 4), which depicts a nymphlike girl about to immerse herself in a forest stream. Arguing that the museum already contained too many "nudités," he suggested that the city ought to purchase more paintings recalling heroic deeds of the past and thus capable of "elevating the spirit." The council as a whole, however, accepting the commission's view that a "striking grace" redeemed the picture and conveyed the "purity of spirit" of its "delicious" central figure, ratified the purchase.[78]

Adjoints responsible for the arts and other officials also specifically urged the merits of acquiring works of all genres and tendencies. When Bordeaux purchased a landscape by Daubigny at the exhibition of 1863, the council commission observed that it would form a happy contrast with a Corot acquired five years previously. The Daubigny, moreover, meant that the museum would be able to display examples of the two leading landscape schools of the day. In Marseilles, Rougemont said of the 1867 purchase of a drinking scene by a recently deceased, minor Marseilles artist, "It is appropriate that the museum possess works of all types."[79] Cities even acquired the works of the much derided masters of realism, though they did hesitate. Guibert, the Bordeaux city councillor who reported on the possible purchase of Millet's *La bouillie* (Figure 2) in 1865, epitomized this hesitancy in his series of contrasting questions:

> This school [realism] is not represented in the museum. Would it be prudent to admit it? This genre, which really constitutes a whole system, will be copied by our young people. Will it not warp their taste, carrying away their imagination and leading it astray? . . . Nonetheless, should a museum of Bordeaux's rank not contain [works of] all schools? If the realist school presents some dangers, its brush is powerful, its color burns with genius and inspiration. Its goal is to move; the truth, without adornment, is its religion. This school produces and is capable of producing masterpieces that can win over its opponents, even its antagonists.[80]

Despite this mixed review, the council commission did recommend purchase of the work; the full council, however, turned it down by a vote of fourteen to ten. A dispute over the price with Millet's dealer, Petit, might have had something to do with this decision; the city had a number of times shown itself capable of haggling over sums as small as the five hundred francs in question, 10 percent of the asking price. The course of the debate, however, suggests that

even at a more acceptable price the painting would not have won a majority of the council: in Bordeaux in 1865 Millet still provoked as much suspicion as admiration.[81]

When Marseilles actually did purchase *La bouillie* in 1869, Rougemont tried to downplay Millet's association with realism by contrasting him with Courbet: "He does not systematically seek out ugliness in the manner of Courbet, who goes so far as to slander nature, but he does not flee it when he comes in contact with it." But the *adjoint* had to preface his remarks by conceding that Millet had "pitched his tent in the realist camp," and he spoke in admiring terms of the artist's sincerity and commitment to conveying the natural truth he observed.[82] Moreover, the city had four years before actually purchased a work by none other than Gustave Courbet, though one of his hunting scenes, *Stag in a Stream,* rather than a peasant subject. At the time of that purchase Rougemont devoted most of his presentation to the complexities of the painting's ownership that had made it available to the city (it was never shown at a Marseilles salon), thus placing his emphasis on the unique opportunity this purchase represented. For the work itself he used the term of simple acceptability, "oeuvre de mérite."[83]

What, then, had happened to the notion of the museum picture? It still survived, in its penumbra of convenient vagueness, even if *La bouillie* stretched it to its limits. The descriptions of works presented for the approval of city councils stressed elements that, though they could be found in a wide variety of pictures, still did not, according to common belief, characterize a large number of them. These qualities included an immediately evident level of artistic attainment, or "art" in the sense of skill, an "elevated" sensibility, an individual style or tone, and not least, public approval. Rougemont, for his part, often emphasized technical accomplishment. He referred to "light . . . distributed with the greatest skill [art]" and "architecture ably reproduced," both in a *View of Seville* by Achille Zo. He used much the same terms to describe the "intelligent palette" of Amable Crapelet's *View of Theban Ruins,* the "careful and finished execution" of Benjamin Ulmann's *L'Ora del Pianto,* a genre scene set in Italy, and Louis Viger's historical scene *The Empress Josephine before the Coronation,* which he praised for its "scrupulous accuracy."[84]

Rougemont's encomium to a young Marseillais artist, François Reynaud, makes clear his most fundamental beliefs. The artist's *The*

End of the Day (Abruzzi), Rougemont said, demonstrated his understanding of "this truth, that a fully and precisely correct execution was the first condition for the viability of a work of art."[85] The Bordeaux artistic society similarly found in Constant Troyon's *Cows Ploughing* "skillful drawing, an admirable model, a simple, strict composition, [and] a perfectly achieved execution." The reporter on the second Bouguereau Bordeaux purchased (in 1864), *Une bacchante*, lauded its "qualities of good, solid painting," including "a correct drawing [technique]."[86]

But in both cities officials were looking for something more than technique. They admired, for example, the "striking grace" of Antigna's young girl, the simplicity, "elevation," nobility, and serenity of Curzon's *Vesuvius Seen from the Ruins of Pompeii*, and the "deep feeling and penetrating grace" of Corot's *Bath of Diana*.[87] Rougemont similarly found "nobility" and "style" in Millet, "talent as elevated as it is conscientious" in Ulmann, "an elevated style and an arresting effect" in Antoine Viot's *Sunset*, and "nobility and grandeur" in Joseph Beaume's *Episode from the Retreat from Russia*, which had also "required assiduous labor."[88]

To a large extent, these terms have more to do with responses to works of art than with the actual conditions of their production or the modes of their representation. In a sense, any painting could thus become a "museum picture" by virtue of this external application of the appropriate signifying discourse. Perhaps for this reason, city officials made energetic efforts to show that their choices derived from a public consensus and not simply from their own aesthetic preferences. In 1855, the mayor of Bordeaux went so far as to declare that if art lovers found in the exhibition "that ensemble of beauty that constitutes a remarkable work," the city had no choice but to buy it.[89]

Deference to public opinion had in fact provided the rationale for Bordeaux's practice of letting the art association choose works for municipal purchase. But even after the council took over the decision making in 1863, the society's officers, many of them former city officials, retained considerable influence. In particular, they often served as intermediaries between the city and artists, who were invariably asked to lower their prices in exchange for the honor of a museum purchase.[90] In Marseilles, Rougemont referred to the enormous public interest in the young Henri Regnault's *Judith and*

Holofernes, shown at the exhibition of 1869. "It was," the *adjoint* declared, "a duty, an imperative obligation for your commission to examine with the utmost seriousness a work so warmly recommended to its attention," and the city did purchase it. Of course the public did not restrict its acclaim to any one kind of work: according to Rougemont's presentations at the time of purchase, *amateurs* admired Charles Landelle's history painting, *The Women of Jerusalem Exiled in Babylon,* in 1863 as well as Ulmann's Italian genre scene in 1868.[91]

Cities could not, of course—to bring this discussion full circle— invariably please their art-loving citizens. In 1870 the Bordeaux city council, citing fiscal constraints stemming from heavy public health costs, declined to purchase Auguste Bonheur's *Souvenir des Pyrénées,* a favorite at that year's Bordeaux salon.[92] But officials and *amateurs* increasingly seemed to share the same goal: to keep their museums "in the first rank," or at least on a par with those of other important cities. Gué noted in 1862 that whereas Bordeaux made all its acquisitions ad hoc, other cities devoted regular budget items to the acquisition of works of art. But he added that, with its own record of purchases, Bordeaux could walk "entirely in step" with them.[93] The growing importance of museums to cities' self-image can be seen also in Marseilles's concern for posterity. Strongly urging the merits of Regnault's *Judith,* Rougemont commented that fiscal constraints generally precluded the city from purchasing major works by established artists such as Meissonnier, Gérôme, Hébert, and Fromentin. He argued, however, that the city could preserve the museum's reputation by snatching up the works of promising young artists for whom the critics were predicting a great future. Regnault was an obvious example, and Rougemont quoted at length from Théophile Gautier's enthusiastic review of the artist's early work.[94]

In 1870 Marseilles could well afford the luxury of a few moments' reflection on its museum's more remote future. The city had ten years earlier made the move from acquisitions to the logical but momentous next step of constructing a new museum building. Work had begun in 1862, and the new museum opened in 1869. Other cities, of course, had been considering this step as well. Like Marseilles, though more slowly, they were coming to understand that the acquisitions policies they had developed not only responded to changes in the city and the art world but also contributed to the

process through which museums were acquiring an independent identity clearly linked to that of the city. At the end of the Second Empire, many cities were thus on the point of realizing that the continuing acquisition of works of art, far from providing an acceptable substitute for a new museum, had made its construction indispensable.

· · · CHAPTER 5 · · ·

Museums in Construction,
1860–1890

Urban Transformation and Museum Construction

For many provincial cities in the 1860s and 1870s art museums posed something of a dilemma. For the better part of two decades municipalities had been spending consistently, if not lavishly, on museum collections, and hoping at least in part to add to their own prestige and reputation as enlightened patrons of the arts. Yet anyone who visited these institutions found them in conditions more akin to those of a warehouse, at best, or a prison, at worst. Indeed, each new, much vaunted acquisition had the potential to make a museum's existing inadequacies even more glaring by forcing a more familiar work into storage.[1] Ultimately, then, an institution needed a "monument," in the sense of a large and identifiable civic structure that would not only house it but give it a symbolic presence. As the Marseilles city councillor Marius Roux said of that city's proposed new museum in 1862: "Artistic genius must impress on public buildings that contribute to a city's éclat a character clearly indicating the importance of the monument and of its purpose."[2]

On one level, of course, the planning and construction of museum buildings provided the ultimate solution to certain basic institutional problems, particularly those of space and safety. But as Roux makes clear, monuments were also symbols, and as such they emerged from ideas about the city and its purpose that were firmly rooted in a particular sociopolitical context. The timing of provincial museum construction, moreover, concentrated between 1860 and 1890, depended more on a certain fixing of the conceptual framework than on a sudden apprehension of urgent need. In their practices as in their forms, new museums registered the need for

cultural legitimation of a political elite in whose conception of the modern city they were firmly inscribed. Their monumental form represented an attempt to appropriate the prestige of high culture on behalf of those who built them; at the same time it asserted, in a way that acquisitions alone could not, the continuity of a cultural tradition whose moral value superseded the materiality of the objects that signified it.

On the practical level, it will be recalled, by mid-century most cities had long been aware of the physical deficiencies—and, in some cases, of the rank inadequacy—of the buildings that housed their museums. In all likelihood the accounts of Stendhal, Dubosc de Pesquidoux, and others did not escape municipal officials' notice; in any case, their own curators' complaints, usually more detailed, went back even further. In 1854 the Rouen city council even allocated the considerable sum of seventeen thousand francs to the repair of crumbling floors and ceilings in its museum, then occupying a portion of the city hall. But, though one council member described the condition of the museum as "shocking" and stressed the importance of Rouen's being "counted among those provincial cities interested in the arts," the city did not consider the possibility of a more permanent solution.[3] In 1868 two Bordeaux newspapers decried the heat and humidity in the temporary museum building and cited specific works suffering from these conditions; one declared that it "despaired of ever seeing" a new museum. This was the attack the curator, Gué, dismissed as a politically inspired "goading" aimed at the administration, which on this occasion managed to weather the storm. Gué did not, however, deny the reports' basis in fact.[4]

Of course the museum construction projects cities ultimately adopted did mention both the inadequacies and the dangers of existing facilities. Roux, the *rapporteur* on the Marseilles project in 1862, cited the old museum's lack of space and light and described its exterior appearance as "wretched, deficient, and in bad taste." Reports in Rouen in the mid-1870s not only called conditions there "as unsuitable from the point of view of lighting as from that of space" but also cited conflagrations in the Bordeaux museum and in public buildings elsewhere as evidence of the serious risk of fire. But municipal officials and city council members could hardly pretend that these were new problems that had suddenly come to their attention. Roux, indeed, referred to "an inadequacy that is more notorious than ever."[5] The city councillor who submitted the proposal

on a new Bordeaux museum in 1874 preferred to pass over the museum's less than illustrious past, saying: "This is the kind of sadness and sorrow that the soul internalizes, and which it would ill befit our dignity, and above all the dignity of the city whose interests have been confided to us, to publicize and to bring to the attention of strangers."[6] Bordeaux had good reason not to dwell on the past, since its undertaking to build a new museum came only after a second fire had damaged the museum's collections and disrupted its installation.

While evincing some discomfiture in discussing practical problems, these same proposals built on a common thematic framework to convey their more fundamental purpose. Virtually all the proposals evoke the notion of worthiness, specifically the idea that an inadequately housed museum was unworthy of a great city. The 1862 deliberation in Marseilles stressed the need to construct "a museum in harmony with the ever-increasing importance of our city." The mayor of Rouen, Etienne Nétien, described the state of the museum in 1874 as "a situation unworthy of the Norman capital." That same year in Bordeaux, the city councillor Paul Deloysnes told his colleagues that they had the reponsibility to "provide our city with a monument worthy of it, worthy of our rich collections, and adequate for the present and future needs it is intended to serve."[7] The phrase "monument digne," and the closely related "musée vraiment digne," crop up again in press reports on ground-breaking or opening ceremonies in Rouen in 1877 and in Bordeaux in 1881.[8]

Although less concrete than solutions to the problems of gloom, leaks, or fire hazards would have been, the notion of worthiness obviously possessed a resonance, an all-encompassing quality, and finally an attraction the specifics lacked. But why? What was it about large provincial cities in the 1860s and 1870s that cast the pall of unworthiness on institutional conditions that, routinely deplored, had on their own failed to provoke any significant reform? What made civic leaders feel they had to go beyond merely increasing the size of museum collections—an act more often imputed to the vague purpose of supporting the arts in general than to the needs of art museums in particular—to the far more decisive and expensive step of building?

In the previous chapter we considered a number of forces of change that contributed to the emergence of art museums as distinc-

tive institutions: bureaucratization, tourism, and the development of the art public and art associations. But these developments, though linked to the larger process of urbanization, were largely external to it. The key to the cast of mind that led municipal leaders to erect "worthy monuments" to house their art museums lies in the more distinctly urban dynamics of social and political change, including the expansion of commerce and trade, industrialization, migration and social segregation, and the reworking of the urban landscape. Complex and varied, the processes of urban change cannot be reduced to a single cause: they did not, for example, operate on a purely economic current. Bordeaux, Rouen, and Marseilles, for example, all constructed new museums in this period, but the three cities differed widely in the nature and the pace of their economic development in the nineteenth century.[9]

Marseilles during the Second Empire could be characterized as a boom town. Its principally commercial economy, based in a thriving port, was in full expansion; its industrial base, consolidating in traditional areas like soap, tanning, and milling, was also developing in such new fields as chemicals, oil-pressing, and machine construction. The city's population was growing far more rapidly than that of most other French cities: the rate of increase for the period 1821–1872, 186 percent, exceeded even that of Paris, 179 percent, for the same period. The development of both its port facilities and its commercial structure, moreover, received substantial infusions of outside capital.[10]

Rouen, in contrast, one of the first cities in France to experience large-scale industrialization, was at mid-century reeling from a crisis in its leading industry, textiles. Even before the deep economic downturn of 1847–1851, the primitive, dispersed production methods of the Rouen textile industry hindered its ability to compete with its rivals in the Nord, Alsace, and Britain. The Second Republic slump, followed by the free-trade policies of the Second Empire, hurt it even further. Though the city's population crept above 100,000 around 1850, it dipped in the mid-1850s and remained virtually stagnant for twenty years, a period of generally rapid growth elsewhere in France.[11]

Bordeaux remained fairly prosperous throughout the Second Empire, and a substantial influx of immigrants sustained a steady increase in its population. But its trade remained under the leadership of a conservative commercial elite, suspicious of innovation.

Committed to sailing vessels and small, family firms, Bordeaux merchants were neither expanding nor adapting to changing markets and commercial practices. Bordeaux's economy was, in fact, on the brink of a stagnation so profound that one of its historians has dubbed the entire century and a quarter from 1815 to 1939 "the time of immobility." [12]

Yet beginning in the 1840s and continuing throughout the Second Empire all these cities, like most large cities in France, were engaged in *urbanisme*. Though at its simplest the word translates as "town planning," in the nineteenth century it involved nothing less than the wholesale transformation of the urban fabric. Although the transformations varied in pace and in extent from city to city, they shared a common purpose, that of *assainissement,* or sanitary reform. According to prevailing theories, such reform could be achieved largely through an improvement in a city's *circulation,* meaning not only traffic but the whole infrastructure supporting communication and transportation services. [13] The massiveness of such an enterprise in a city of any importance inevitably meant that it unfolded over a course of decades rather than years. Over such a long trajectory, *urbanisme* often took on consequences and implications that its originators could have anticipated, if at all, only in the sketchiest of outlines.

Marseilles's urbanizing efforts began in the 1830s with the construction of an ambitious canal, completed in 1851, to ensure the city a reliable supply of fresh water from the Durance River in the neighboring Vaucluse department. Also in the 1830s, speculative developers began laying out broad new boulevards (the Prado to the south, the Longchamp to the east of the city center), with the primary aim of providing the commercial bourgeoisie with more spacious housing and a more agreeable environment than existed in the overbuilt, decaying city center. In the 1840s the city undertook a large-scale expansion of the commercial port, which continued in stages throughout the Second Empire. During the Second Empire the *percement,* literally the "driving through," of new streets shifted to the old city in order to connect the new port to the city center, to renovate the crumbling housing stock, and "assainir," that is, to level, areas of the old city considered unhealthy. The scale of these transformations rivaled those of Paris and Lyons, and like them benefited from generous state subsidies. The Second Empire also saw the construction of a number of new "monuments," including,

symbolically, both a cathedral (not completed until 1882) and a commercial exchange (bourse), as well as a new prefecture, library and art school, and courthouse.[14]

In Rouen, successive plans for the *assainissement* (which in this case meant clearance) of the slum of Martainville, the city's most urgent problem, foundered on the dubious prospects for a return on the necessary private investment. In 1859 Mayor Charles Verdrel unveiled a more successful plan to connect the new railroad station, the river, and the city hall, which form a rough topographical triangle, with two new intersecting boulevards. The Verdrel plan succeeded in largely transforming the center of the city by 1870. In the process it destroyed a thousand homes and displaced 6,800 people, mainly workers, whom the exigencies of public hygiene forced into equally grim but more remote quarters to the east or across the Seine in Sotteville. The project, which also involved 61,000 square meters of road work, cost fifteen million francs, a third obtained from state grants and the rest from loans.[15]

Urban renovation presented different problems in Bordeaux, dispersed over a much more extensive, flatter terrain than the more compact, hill-enclosed sites of Rouen and Marseilles. Plans for a more effective disposition of residential and commercial districts involved the special complications of annexing neighboring communes and the construction of a delimiting *ceinture,* or circular bouevard, running around the city. After a decade of squabbling between the city, the government, and neighboring communities, a scaled-down annexation of communes chiefly on the already extensively developed left (west) bank of the Garonne took effect in 1865. The first stage of the *ceinture* followed two years later. Meanwhile, the municipality was also engaged in the clearing of "unhealthy quarters" in the old city, most notably in the area around the cathedral. The new streets included the familiar broad boulevard, named the cours Alsace-Lorraine two years after its completion in 1871, which connected the cathedral and the city hall to the Garonne.[16]

Historians have traditionally connected these transformations with Haussmannisation, the rebuilding of Paris under Napoleon III, and in many ways they reflect both the direct influence of Baron Haussmann, who served in Bordeaux as prefect of the Gironde from 1851–1853 before going to Paris, and aesthetic and social concerns that paralleled his.[17] In provincial cities, however, many of these plans had their own impetus at the local level and predated the

Second Empire. Some of the actual construction also began before 1850. Notwithstanding the importance of state subsidies, *urbanisme* was largely the work of a new political elite, the bourgeoisie, whose replacement of land-owning notables at the head of local affairs it signaled. Having come into their own during the July Monarchy, commercial and, to a lesser extent, industrial elites used the expansionist climate of the Second Empire to impress their stamp on urban life.[18] The clearest example of this dynamic can be found in Marseilles, where an aggressive, innovative mercantile class used its political as well as its economic clout to initiate the extension of the port, key to all the city's subsequent transformations. Jean-Pierre Chaline has also demonstrated the importance of the commercial interests of Rouen's bourgeois leadership—normally fragmented, but united on questions of overwhelming local importance—in shaping that city's transformation.[19]

Virtually from the moment of its emergence, the bourgeois political elite evinced a keen awareness that it constituted an easy target for what would become familiar, even stereotypical charges of narrowness, of philistinism, of interest only in economic advantage.[20] Seeing themselves not only as administrators but in a certain sense as the embodiment of a broadly conceived civic interest, mayors and city councillors were highly sensitive to witticisms that, for example, dubbed Marseilles "a great countinghouse, admirably situated," or commented pointedly on the city's lack of civic and religious monuments.[21] City fathers did not shy away from casting cities in their own image, but they were determined to make that image an expansive and, in a term popular at the time, an "elevated" one. They wanted their descendants to be able to point to their fathers' work with pride; they wanted to surpass or at least to equal the achievements of comparable French cities; they even sought to rival the past. For this reason merely purchasing works of art was not enough; indeed for a commercial elite it might almost be worse than nothing. Marius Chaumelin, editor of a cultural journal founded by the major Marseilles art association in 1857, observed: "The great commercial city of the south, the maritime center of the Mediterranean, has finally understood that, in order to deserve the fine title of 'façade of France' awarded her by a poet, she must ask of the arts an adornment worthy of her ever-increasing greatness."[22]

The cultural models of municipal elites naturally included the

cities of prerevolutionary France, renowned for their cultural richness and diversity as well as for their greater autonomy from centralized power. But they also cited more universal examples, the city-states of the ancient world and of the Italian Renaissance. The achievements of these civic societies lay, according to a common interpretation, in their ability to "unite, in such fortunate concord, the commercial instinct with a love of the arts."[23] By their own lights, the bourgeois of provincial France could do no less. Though Chaumelin and others called for private initiative to give visible, and especially architectural, form to the elite's taste and civic pride, such appeals were clearly intended to complement and in some cases to stimulate the official projects of municipal governments.

Marseilles gave these ambitions their loftiest and most grandiose expression. Both contemporary observers and historians have customarily associated the transformation of Marseilles with the Second Empire's dictatorial prefect-administrator of the Bouches-du-Rhône, a crony of Napoleon III named Charlemagne-Emile de Maupas. But plans for the new museum predated de Maupas's arrival in Marseilles, and they received their essential administrative formulation under the leadership of two mayors, François Honnorat and Jules Onfroy, who resigned to protest prefectoral interference. The museum project came to fruition under two more docile mayors, Balthazar Rouvière and Théodore Bernex, but for all intents and purposes they were simply following a course laid down by their predecessors.[24]

The art museum in fact represented the last of three elements to be incorporated in a "monument" celebrating the first and among the most important of Marseilles's public works projects, the Durance canal. As an early example of the municipal will to self-improvement and a spectacular triumph of modern technology applied to sanitary problems, the canal represented a particularly fitting object for municipal commemoration. In 1839, a year after construction began, the city council decided in principle to construct a water tower at the Plateau de Longchamp, site of one of six subterranean filtration basins and the symbolic point of the canal water's entrance into Marseilles. But even before the canal's completion in 1851 and then throughout the decade, the city added various elements to the project in order to make it symbolic not only of the water supply but of the city's wider achievements. The new art museum the city had long been contemplating was a natural candi-

date.[25] Such a linkage did not appeal to everyone: in the debate preceding the city council's adoption of the definitive project in April 1862, Rougemont, the *adjoint* for fine arts, accused the city of sacrificing the interests of the city's art public to the idle uses of commemoration. The Plateau de Longchamp, he maintained, was simply too far from the center of the city; to send works of art there, in undignified juxtaposition to what he called "stuffed animals" (a planned natural history museum) amounted to banishing them. The mayor, Rouvière, and the *rapporteur,* Roux, responding that Longchamp had already attracted a large number of Sunday strollers who would provide the art museum with a ready-made public, dismissed these objections.[26]

The administration's manner of presenting the project, moreover, demonstrates the crucial place of the arts in the image the city wished to present of itself. In Roux's words, only a solidly constructed, well-proportioned, "hygienic," and elegant "monumental ensemble" could be in keeping with the city's growing importance. Such a building would have the space to display the "veritable riches" of Marseilles's collections, which the old museum's inadequacies had left largely unappreciated.[27] In this way Roux conflated two distinct though connected conceptions of worthiness: a museum worthy of its collections and a museum worthy of the city. He thus managed to imply that the modern city was simply restoring a tradition of cultural greatness, symbolized by its collections, to a position of rightful prominence, embodied in the new museum. In so doing, of course, he was also at least implicitly endorsing a belief that Marseilles could not claim civic greatness until its culture occupied a symbolic position as prominent as that of its commerce.

The involved history of the design of the Palais de Longchamp, as the city called its "monumental ensemble," need only be summarized here. It began in 1859 when the mayor, Honnorat, asked the young Alsatian sculptor Auguste Bartholdi, fresh from winning a sculpture design competition in Bordeaux, to submit a design for a water tower and natural history museum. Bartholdi on his own initiative included an art museum in his preliminary design; the city council, though basically approving, could not agree on this added element and submitted the whole project to an ad hoc committee of three noted architects, Henri Labrouste, Victor Baltard, and Léon Vaudoyer. The committee judged the design meritorious but

unworkable, in part because of the uncertainty over how many museums it would incorporate, and recommended a number of revisions. But political upheaval at the Hôtel de Ville, which saw three mayors in three years, postponed the project, and when Onfroy took it up again in the fall of 1861, he asked for a submission from Henri Espérandieu.

Espérandieu, a young protégé of Vaudoyer, had come to Marseilles as site architect for the new cathedral being constructed to Vaudoyer's design and himself designed the now more celebrated basilica of Notre-Dame de la Garde, overlooking the old port from atop a rugged hill. Espérandieu's project for Longchamp included, at the mayor's request, a water tower, two museum wings, and a semicircular colonnade connecting them. This design the city council approved in April 1862.[28] Although Espérandieu, who died at only forty-five in 1874, was long listed as Longchamp's sole architect, Bartholdi believed he should receive credit for the original conception of the building, and he argued for it through lawsuits and press campaigns spanning more than three decades. Notwithstanding his eventual fame as the creator of the Statue of Liberty, the issue seems to have meant a great deal to Bartholdi; by the eve of World War I the standard texts on the Palais de Longchamp were giving him some very generalized credit for his contribution to its design.[29]

Whatever its inception, the project proved expensive, and the curving central colonnade (Figure 5), the key element in defense of Espérandieu's originality, set the tone for an elaborate ornamentation that greatly increased its cost. The total cost of the building, 2.8 million francs, though only a drop in the overflowing bucket of Marseilles's public-works expenditures, exceeded Espérandieu's original estimate by over 25 percent; it was a considerable sum even for two museums. The city received no direct assistance from the state in constructing the Palais de Longchamp, though it did benefit from the Second Empire's lenient policy on municipal borrowing.[30] When concerns about construction costs began to mount, the city council signaled its priorities by choosing, from among the options Espérandieu had presented, to reduce the size of the two buildings by about a quarter. This diminution, in theory, would allow for an augmentation in the ornamentation budget without increasing the project's total cost. Council members professed outrage when they learned in 1864 that Espérandieu had unilaterally ordered the size of

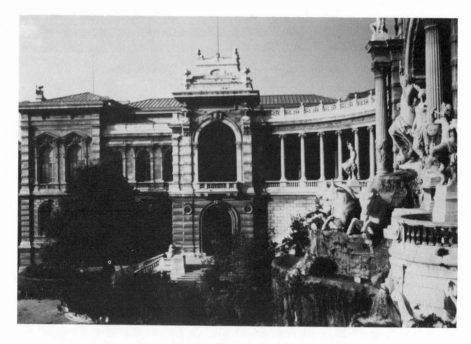

Figure 5
Palais de Longchamp, Marseilles:
Musée des Beaux-Arts from the central arcade.

the two museums increased virtually to the scale of the original design, ostensibly on the grounds that the smaller buildings would not suffice to house the museums' collections. They nonetheless voted the additional funds his action made necessary.[31]

This pattern of protest followed by acquiescence was to be repeated several times before the completion of the Palais in 1869. A number of opponents of the imperial regime were elected to the city council in 1865, and they sharply criticized slapdash cost planning that had neglected such elements as landscaping, floors in museum service areas, paint, and furniture. They did not hesitate to accuse the appointed mayor, Bernex, of dissembling, of arbitrariness, and of disregarding the council's will. (They may also have suspected him of feathering his nest, since before starting construction the city had had to purchase a house belonging to him on the Plateau de Longchamp.) But, differing little from the mayor in their sense of the museum's importance to the civic image, the republican mem-

bers of the council did not press their criticisms too far. One of the leaders of the opposition faction, Alexandre Labadié, in 1866 played a key role in persuading the council to appropriate the additional funds necessary to complete the building. He seemed to express the general sentiment when he praised the "beau monument" under construction and suggested that it would be beneath the city's dignity to economize on anything necessary to complete it in a worthy fashion.[32]

When the Palais de Longchamp opened to the public in August 1869, its two museums only partially installed, Marseilles greeted it with virtually unanimous enthusiasm. Even opposition newspapers that had criticized buildings completed earlier, notably the bourse, the courthouse, and the prefecture, joined in the chorus of praise. The republican *Petit marseillais* wrote in mock astonishment, "Who would have said that Marseilles would ever have a *monument?* Certainly not us. We have one, though, there's nothing else to say, we have one." Suspicious as always of the administration, the *Petit marseillais* addressed its plaudits to Espérandieu and to the artists responsible for the building's decoration, crediting them with producing "a monument of which Marseilles is already justly proud." The right-wing *Gazette du Midi,* on the other hand, used the occasion to propound the connection between Marseilles and the Italian Renaissance; the loyalist *Courrier de Marseille* evoked ancient Greece.[33]

Bernex, in his speech at the official opening of the museum (which because of illness he left to an *adjoint* to deliver), took up this theme with aplomb, paying tribute not only to Montricher, the engineer in charge of the canal construction, but also to his own father, one of the city's first private developers, responsible for laying out the Prado district. Bernex noted the symbolism of the Palais de Longchamp's location: it was not only at the point where the water from the Durance entered the city but also at the end of one of the city's new "leafy promenades." All this the mayor had every reason to believe that the citizens of Marseilles would remember in visiting the Palais; as one pamphleteer triumphantly proclaimed, "it is thus that great cities are rich, and it is thus that rich cities are great!" The inauguration of the Palais coincided with Napoleon III's official birthday, and Bernex, dutifully if not very percipiently (the Franco-Prussian War was only a year away), predicted that it would also recall the glories of the imperial regime and its contribution to the transformation of Marseilles.[34]

The Rouen city fathers planned their new museum more pru-
dently than had their counterparts in Marseilles; in the straight-
ened financial circumstances of the 1870s they had little choice. In
their own way, nonetheless, with stereotypical Norman shrewd-
ness, the Rouennais showed an equally strong determination to
build a "worthy monument." Rouen had two essential needs, an
art museum and a library. Both collections had been housed since
the Revolution in cramped quarters in the city hall. Preliminary
reports on the new museum-library complex spoke feelingly of the
city administration's own need for more office space; they also em-
phasized the serious risks of fire arising from an antiquated heat-
ing system and gas lighting. The city architect, Louis Sauvageot,
proposed to erect a massive structure near the intersection of the
two Haussmannian boulevards, the rue Jeanne d'Arc and the rue
Thiers, which would remedy these deficiencies in a suitably "monu-
mental" fashion. Construction of the entire complex, however,
would cost three million francs, require a substantial loan, and
involve the expropriation of privately owned property through the
time-consuming process of *utilité publique,* a strictly regulated form
of eminent domain. For the city administration, therefore, an attrac-
tive aspect of the Sauvageot. plan lay in the option of phased con-
struction it presented. The first stage could make use of land the city
already owned and of resources available to it without additional
borrowing. This would answer the more urgent need, that of a new
art museum.[35]

When a new city council took up the matter in April 1876, a
number of members objected to the prospect of accepting Sauva-
geot's design without an architectural competition; some even
accused the administration of violating the republican principle of
impartial selection according to merit. The mayor, Nétien, and the
rapporteur, Barthelemy, argued that architectural competitions often
produced impractical designs and reminded the council of Sauva-
geot's prestigious training (he had studied in Paris with the well-
known architect Eugène Viollet-le-Duc), considerable experience,
and record of never having gone over budget. To provide further
assurance of the project's merit, the administration accepted the sug-
gestion of a council commission that it ask the fine arts director,
the Marquis de Chennevières, to appoint an ad hoc committee of
experts to review the plans. Chennevières complied with pleasure.
His committee, working with dispatch, approved Sauvageot's pro-

posals without reservation and only suggested minor changes in the interior disposition of the library.[36]

Ground breaking for the first wing of the museum took place in August 1876, and the laying of the cornerstone followed in May 1877. The city financed this first phase of construction, estimated at 496,000 francs, with funds transferred from an aborted project for an artillery school and from the sale of property the city had inherited, plus a small additional appropriation.[37] In February, however, with work scarcely begun on the site, the administration presented the *completion* of the museum-library project as a matter of urgency; it seems to have had the city's image very much on its mind. It therefore included a sum of 2.06 million francs for the project in a loan package of 15 million francs that the council then approved and submitted to the prefect. Because of the elements of this phase that required approval from Paris, namely the loan and the declaration of *utilité publique,* as well as the required public hearings on the expropriation of property, the second part of the construction did not begin until early 1880.[38] By this time the first phase, the museum wing on the rue Thiers, was nearing completion.

Since the completed wing constituted only about a quarter of the projected surface area of the entire building, the opening ceremonies in February 1880 could be neither as definitive nor as triumphant as those in Marseilles. Taking his cue from municipal officials, Alfred Darcel, the Rouen-born head of the Gobelins tapestry works who had taken the place of the ill curator in installing the new museum, struck a somewhat apologetic note in the *Journal de Rouen.* He wrote that a temporary modern staircase constructed to permit access to the second floor "deliberately" lacked a "monumental character," because a grand stairway was planned for the part of the building still to come.[39] The mayor, Alexandre Barrabé, stressed in his speech at the opening that the city intended the museum to provide its art treasures "a safe and honorable refuge . . . without seeking to create a rival to the older monuments of which our city is justly proud."[40] But the museum's, and the city's, more exalted pretensions did not go unnoticed.

Rouen's two established newspapers, the conservative *Nouvelliste* and the moderate republican *Journal de Rouen,* which used Darcel as its main critic, devoted extensive coverage to the new museum over several issues, including highly detailed descriptions of the newly installed collections. The radical *Petit rouennais,* normally critical of

the municipal administration and its close ally, the *Journal,* was more restrained in its enthusiasm, but it still joined in calling the new building a "worthy museum."[41] One of the *Petit rouennais'* readers, however, acknowledged the building's "monumental" character in a considerably more sour fashion: "In an attempt, no doubt, to transmit his name to posterity, Monsieur le Maire, with the assistance of his most illustrious Sauvageot, has decided to leave monuments as a souvenir of his time at city hall." The museum, the reader complained, "resembles a barracks more than a palace," a reasonably apt judgment but an unfair one, since the rue Thiers wing was only intended to provide a subsidiary façade in the total design. The *Journal,* in responding to this criticism, characteristically defended the mayor rather than the building.[42]

The museum the city of Bordeaux opened in 1881 had a considerably more checkered past than those of Rouen and Marseilles. Through an oddly fitting historical irony, it fell to perhaps the most unpopular of Bordeaux's mayors in the nineteenth century, the Vicomte de Pelleport-Burète, to preside over the laying of the cornerstone for the new museum in May 1875. The Moral Order government of the Duc de Broglie had installed Pelleport-Burète as mayor in 1874 to replace an elected republican, an act that poisoned an already fractious political climate. At the ceremony the mayor, somewhat tactlessly under the circumstances, likened previous efforts to construct a museum to the Homeric story of Penelope and said that few felt any enthusiasm for the site and design ultimately chosen.[43] The right-wing *Courrier de la Gironde,* describing the cornerstone laying as funereal, sarcastically expressed surprise that the military band present did not play a requiem. The project itself the paper damned with faint praise, calling it honorable but lacking in "taste and artistic sentiment." The republican *Gironde* had little to say about the museum, actually a project of the suspended republican administration, and reserved its jibes for Pelleport-Burète's sententious rhetoric: "Modesty and simplicity were equally conspicuous in his speech—by their absence."[44]

Whatever his defects as an orator, Pelleport-Burète was only reflecting the general opinion when he ascribed the failure of previous efforts to construct a new museum to overambitiousness. As Adrien Sourget, the *adjoint* for the fine arts, observed in his report on the project the city council finally adopted in 1874, "[In the 1860s] it seemed to us that we had only to imagine the grandest, the

most beautiful of projects for its realization to follow as a matter of course." The city had been considering possible sites for a new museum, in various combinations with a library or art school, since the mid-1850s. In 1863, following a fire in the city hall that displaced the museum's collections but did not seriously damage them, the city council allocated a million francs out of a requested loan of seventeen million francs to the construction of a new museum.[45] The most elaborate proposal came, twice, from the ebullient Henry Brochon, mayor from 1863 to 1867, and it shows how much the goals and aspirations of the Bordeaux city council had in common with those of its counterparts in other large cities.

Brochon had the city architect draw up plans for a two-wing museum–library complex on the Esplanade des Quinconces, the largest such open esplanade in Europe. The future mayor Emile Fourcand, in his report on Brochon's proposal, glowingly expounded on the symbolic significance of this location, adjacent to the Garonne and to Bordeaux's commercial port:

> Bordeaux, whose natural vocation is commerce, will provide this brilliant testimony to its respect for higher things, its artistic and reflective spirit, in uniting, with equal liberality, the speculations that enrich with those that enchant and embellish life. In just a few more years, factories, refineries, those great industrial enterprises that our economy and our navigation so lack will, I hope, rise on the right [i.e., east] bank of the river that carries our ships and the coveted products of our soil to far distant shores . . . Opposite, on the left bank, the Museum and the Library will appear, silent and contemplative. In just a few more years the public will conjoin as objects of its admiration both that magnificent monument, the Bourse, palace of commerce—built [in the eighteenth century] through the sacrifices of its worthy representatives—and these two monuments, splendid palaces where arts and letters will at last have received an imposing hospitality.[46]

But the proposal had too much against it, including a projected cost of 2.4 million francs, far above the amount allocated in the 1864 loan, and the reluctance of some council members to countenance construction on the Esplanade. Some councillors may also have felt that this area of the city, known as the Chartrons and dominated by wine merchants and those involved in export, ought not be favored in the cultural sphere at the expense of the old city center to the south. Despite Brochon's lament that the city was forsaking the

opportunity to erect two "worthy monuments," the council twice, in 1864 and 1866, rejected his proposal.[47]

In the last years of the Second Empire, buffeted by reports in the local press that paintings were deteriorating in the museum's green-houselike temporary quarters and by similar criticism in the *Gazette des beaux-arts,* the city council considered a number of other possible sites, all in the old city. In 1869 the council went so far as to approve pending technical review a site in the Place Pey-Berland, adjacent to the cathedral, but the war and political upheaval of 1870 intervened.[48] After another, far more damaging fire in December 1870, the city confronted the problem again. All the old possibilities remained on the table.[49] In addition to the Esplanade, these included three sites in the old city: the former municipal barracks on the rue Vital-Carles, the gardens of the city hall where the temporary museum had stood from 1863 to 1869, and the Place Pey-Berland. Although the city council commission appointed to study the question in 1874 was inclined to be practical, it had its limits. As Deloysnes, the *rapporteur,* put it, the city was seeking to construct a "worthy monument" in the best possible financial conditions. Thus the commission dismissed the idea of renovating the barracks, not only because of cost but because the building's location, at the bottom of a hill, did not offer a sufficiently "monumental" perspective. Meanwhile, a new street alignment around the cathedral made the Place Pey-Berland site inopportune.[50]

Thus the city came back to the park to the west of the city hall, the Palais de Rohan. The council had twice rejected this site, in 1862 and 1872, on the grounds that construction there would block the view of the Palais, after the Grand Théâtre the most notable eighteenth-century structure in Bordeaux. The 1874 proposal tried to respond to previous objections in two interconnected ways. First, like their counterparts in Rouen, the city fathers concluded that the art museum had sufficient importance to stand on its own, without close, immediate proximity to the library or the art school. This allowed the city architect, Charles Burguet, to equalize the dimensions of the two wings proposed for the northern and southern sides of the garden (in the 1872 design the library wing had had two stories and the museum only one, an asymmetry the commission had found lacking in grace).[51] The new design envisioned an open colonnade connecting the two galleries at the far end of the garden, if the columns could be arranged in a way that would not mask the view of the Palais de Rohan. This did not prove possible, however,

so the two wings remained separate. The project had one further, and probably crucial, advantage: its estimated cost of 905,000 francs kept it within the limits of the 1863 loan.[52]

A note of resigned realism attended the final approval of the museum project in 1874 and, as we have seen, the beginning of construction. Deloysnes set the tone with the familiar French maxim that "the best is sometimes the enemy of the good"; he appealed to his colleagues to abandon "the illusions of another era" and to sacrifice their personal preferences for the good of the museum and its collections. In his speech a year later, Pelleport-Burète confessed that he too "would have wished to be able to construct one of those imposing monuments that, in testifying to the enlightened taste of a wealthy city, transmit to posterity the names of those officials fortunate enough to have been the instruments of a great municipal conception." The mayor devoted most of his speech at the cornerstone laying to reassuring critics that the new museum would not alter the public's "habitual walks" in the gardens. He had less to say about the plan's merits and expressed confidence only that the completed building would "disarm" its critics.[53]

When the museum opened in October 1881, after a construction period nearly twice as long as anticipated (severe winter weather and unexpectedly hard soil caused the delays), the *Courrier* virtually trumpeted its early opposition to the project. With inexorable severity it noted, first, that the city had not kept Pelleport-Burète's promise to preserve two splendid plane trees between the two museum wings. The buildings (see Figure 7, below) the newspaper described as "cold, regular, and monotonous, with their rectilinear architecture and the frigid bareness of their walls." The *Courrier's* critic conceded, ungraciously, that the galleries were sufficiently wide and well installed, but he disparaged the ceiling height (he thought it too low) and concluded that the museum only made Bordeaux more ugly. That this critique rested more on the *Courrier's* royalist politics than on specifically museographical concerns can be seen in its extended and savage attack on the placement of a large statue of Louis XVI in a gallery too small for it.[54]

In contrast, with Pelleport-Burète out of the way (Fourcand had reclaimed the mayoralty in 1876; another republican, Albert Brandenburg, succeeded him in 1878), the *Gironde* had no reason to attack the administration and thus gave the museum its general approval. Though also expressing some reservations about the installation of the sculpture, the *Gironde* found the museum "very

suitably adapted" to its purposes of instruction and enjoyment. With its "spacious dimensions," tasteful decoration, conscientious installation, and useful new catalogue, the museum constituted a "revelation for the city's art lovers." Bordeaux need no longer be ashamed, the paper concluded, for its museum was now "capable of sustaining comparison with the most beautiful in the provinces."[55]

In their new buildings, museums could finally lay claim to the prestige of high culture not only in what they contained but in how they contained it. Indeed, the status and the modalities of the *contenant*, the frame, had become their essence. The image of the museum ceased to be an abstract entity, separate and distinct from its physical surroundings: it had become both visible and palpable. This is, to a large extent, the image of the museum we still carry with us, even if we have lost touch with its original construction. Yet the construction of an image involves more than the construction of a building. Not all monuments are monumental: in the case of nineteenth-century museums, it took the very particular art of building decoration to make them so.

The Art of the Monumental

Despite the very different histories of their design and their contrasting architectural programs, the museums of Marseilles, Rouen, and Bordeaux shared in a process of signification that bespoke a particular conception of the modern, "Haussmannized" city. This process involved every aspect of the space museums occupied and defined: their sites, their structure and design as buildings, the transformation of their surroundings, and their own internal and external decoration. The very sites chosen, first of all, had considerable symbolic significance. Officials in both Bordeaux and Rouen stressed that a museum should be at the center of the city, in order to bring art "within reach of the greatest number." Those in Marseilles, on the other hand, minimized this consideration and argued that the Plateau de Longchamp, while admittedly to the east of the city center, was already a popular promenade spot and that the museum would only attract more visitors.[56] But a museum's actual location, to judge from the comments of both officials and other observers, mattered less than the role it could play in defining the character of surrounding neighborhoods.

Louis Brès, one of several journalists who published pamphlets

about the newly opened Palais de Longchamp. began with an unflattering description of the site prior to construction: "The plateau itself, with its terrain of yellow ochre, full of pebbles and ravines, its disreputable little outdoor cafés, its paralytic mulberry trees, its arid plots enlivened only by the odd *boules* player or distinguished by a few rags drying in the sun, its blue sky streaked with kites, breathed that enervating melancholy of the South, a thousand times more to be feared than the foggy spleen of the North." Bernex touched briefly on this "disreputable" past in his speech at the opening of the Palais in 1869, saying, "It is pleasant, it seems to me, to find today, in place of those vulgar buildings, this graceful edifice."[57] In Bordeaux and Rouen, construction of the museum involved the demolition of old and, for the most part, rather decrepit buildings; Pelleport-Burète called those in Bordeaux "small houses and workshops serving industries of less than secondary interest." Once museums had raised the tone of a neighborhood, moreover, city officials would not brook any recidivism. In 1872 a municipal official "invited" the curator of the Marseilles museum, Paul Bouillon-Landais, to express his opinion as to whether, "in the interest of his institution, there [were] not grounds" for opposing the opening of a soap factory in the vicinity of the museum.[58]

Behind all these discussions of neighborhood transformations there lurks the element of class. Inside the Palais de Longchamp on its official opening day, Bernex's representative began his speech by observing to the assembled group of high officials, prelates, and *notables,* "seeing around me the elite of our city crowded into these precincts, still too narrow to contain all those I should have liked to admit . . ." Was the *adjoint* thus acknowledging, through a kind of uneasy formal denial, the city's deliberate exclusion of the crowd outside, who lent the occasion the air of a "popular festival" but who were not admitted to the museum itself until the following day?[59] The critic Etienne Parrocel bluntly expressed the city's hopes for the area: "[The Palais] will bring to a district until now rather neglected a source of inspiration for the neighboring property owners, who will not fail to harmonize their houses with the improvements that the city's munificence has effected." Those *propriétaires* were already likely to come from the middle class, a step above the area's former working-class inhabitants. The Longchamp district, still in an early stage of development in the late 1860s, became even more fashionable and more bourgeois in the following decades.[60]

Though older and more central than the Longchamp district, the areas surrounding the new Bordeaux and Rouen museums were also undergoing a social transformation in the mid-nineteenth century, and city fathers were obviously eager to speed the process along. Pelleport-Burète clearly intended his reference to "secondary industries" as a kind of prodding to what he called "the inhabitants of this district of rich private residences [hôtels]," who, he felt sure, would support the museum project out of civic pride. The hidden message contradicted the spoken one: while talking of "the loyal disinterest" displayed by Bordeaux elites in the past, the mayor was actually promising concrete social benefits. Pelleport-Burète was sending an unmistakable signal that the new museum would, in displacing members of the lower classes, hasten the process of social segregation. For upper-class residents, those who feared for their "habitual walks" in the city hall gardens, the museum thus meant increased property values; officials hoped they would contribute to this process by renovating their own properties according to the city's architectural norms.[61]

In Rouen the rue Thiers, on which the new museum was rising in the late 1870s, was one of two major Haussmannian boulevards the administration had driven through the heart of the medieval city a decade earlier. Only a new park, a square block in size and appropriately named for the renovating mayor, Verdrel, early in the Third Republic, separated the museum from the intersection of the rue Thiers and its north-south counterpart, the rue Jeanne d'Arc. This new grand axis served to unclog traffic in the center of the city and to connect the train station, the Seine, the city hall, and the new (bourgeois) residential quarter in the western part of Rouen. But it also had the effect of uprooting working-class families, notably those whose property the city expropriated for the second phase of the museum project. For these residents, mostly small shopkeepers, artisans, and widows, the move east to the still festering slums of Martainville probably altered their status abruptly, and not for the better.[62] The rue Thiers and the rue Jeanne d'Arc together with the museum, the principal new monument the avenues set off, thus both facilitated and represented the bourgeois elite's appropriation of the city center as its own territory. By the early 1880s houses on the rue Thiers had some of the highest property values in the city.[63]

If we change our focus from the neighborhood to the narrower space surrounding the institution, we find that the three new

museums either adjoined, enclosed, or lay in the midst of public gardens or parks. This common choice of site had its own signification, which worked on two levels. On the one hand, officials in both Marseilles and Rouen expressed the view that the park, as a popular spot for family outings, would attract to the museum, as Rouen mayor Nétien put it, a large "clientele." No one in Rouen seems to have suggested that this "clientele" would be socially very diverse, but Brès, one of the Marseilles pamphleteers, pointedly declared:

> The common people will thus have an easy and fruitful use for their Sunday afternoons. The worker will be able to come with his family and relax in these pleasant *allées,* breathe in the cool shade, watch over his children's games, all in the kind of place [*dans l'un de ces milieux*] until now reserved for the wealthy classes. He will at the same time, no doubt, become accustomed to taking an interest in science, whose specimens will be spread out before him in a splendor designed to reveal them to him, and will gradually became initiated into the knowledge of the serene beauties of pure art, and he will come to love them, even he![64]

This lyrical vision contrasts strikingly, on the other hand, with the more matter-of-fact tone of the 1862 report on the museum project, which saw the gardens as a "respite" from the "severe fatigue" visitors could be expected to experience from visiting the museum. It was only to counter Rougemont's charges of remoteness that proponents made the claim that the gardens would entice visitors. The Bordeaux city councillor Deloysnes echoed this practical view twelve years later in observing that the city hall gardens would permit visitors "happily to rest their eyes, tired from the long contemplation of artistic masterpieces, on the beauties of nature."[65] These two views of museum gardens are not, of course, incompatible, but they do make clear an assumption that art museums had a preexisting clientele, one with marked similarities to the class responsible for building them. If those lower on the social scale could learn to take an interest in the arts, they would do so only gradually, through a kind of sugar-coated transition from the more familiar pleasures of the outdoors.[66] The bourgeoisie, in contrast, already took art sufficiently seriously to need a respite from the fatiguing experience of viewing it conscientiously.

In any case, bourgeois seeking tranquillity in museum parks

were likely to have better luck than workers looking for playing grounds. The French, unlike the British, design their public parks as ordered spaces, in the words of Françoise Choay, "not claiming to be natural, but assuming the values of artifice." Brès's picture of the relaxed worker happily watching his children play would carry more conviction if the Longchamp gardens, leading up from the Palais arcade to an observatory and zoo, did not consist of carefully laid out, geometrically intersecting paths, flower beds, and shrubbery. Indeed, members of the city council expressed concern that the landscaping of the Palais grounds be in keeping with the dignity of the building and were willing to spend money to that end.[67] And boys playing games nearby were treated in reports after the museum's completion essentially as a security problem. Alluding to rocks aimed at museum windows, officials ordered stepped-up policing to keep such youths out.[68]

In the midst of these gardens, the museums themselves, like many large public buildings of the period, sheathed modern construction methods, particularly steel skeletons, in the cladding of "style." Style meant the accoutrements of classical or some other period architecture, in some cases (the medieval restorations of Viollet-le-Duc) applied with historicist rigor, in others (Charles Garnier's Paris Opéra) combined in unexpected though not always unappealing ways.[69] Both the new and the old aspects of museum design represented something of importance to city fathers. The use of the latest technology attested to a city's forward-looking, progressive spirit, by virtue of its having availed itself of the crucial element of "expertise." Members of the Rouen city council proudly chronicled the journeys of their architect, Sauvageot, to investigate museum lighting; they boasted that he had devised a system of reflectors based on tested scientific principles. Given the rarity of sunlight in Rouen, the museum prior to the installation of electric lighting around 1900 must have been extremely dim; early visitors, however, without this standard of comparison, pronounced the lighting adequate.[70]

All three museums relied on skylights to illuminate the large painting galleries, on the principle—advocated by state inspectors as well—that light diffused from above was more consistent, less distracting, and less damaging to works of art than direct window light. In Rouen and Marseilles, however, the architects encircled these central galleries with window-lit smaller rooms, or *cabinets,*

intended to display smaller paintings. They may well have been following the example of Leo von Klenze's Alte Pinakothek in Munich (1826–1836), which pioneered this arrangement of galleries. Sauvageot included the Pinakothek in his survey of lighting systems, and any architect who had taken part in official competitions as he had would surely have been aware of it, since it was the first and until mid-century the only building on the Continent designed specifically as a public painting gallery.[71]

Yet however mindful they were of functional considerations, cities attached extraordinary importance to style, which encompassed ornamental and decorative programs as well as buildings' overall shape and formal character. As we have seen, the Marseilles city council quadrupled the initial budget item for exterior ornamentation, from 125,000 to 500,000 francs, and continued to support the higher level of expenditure even after the economies of scale intended to make up for it had been abandoned. In supporting a staggering supplementary appropriation of 800,000 francs in 1866, the councillor Martin maintained: "The City of Marseilles has begun this project, and it is incumbent on its dignity to complete it, and, in completing it, to insist that everything, in the details as in the whole, befits the character of grandeur that it has wished to create. The day this monument is conveyed to the public, Gentlemen, the day the doors of our Museums shall open, the visitor going through the rooms, the gardens, the walks, must be able to say: This is truly the work of a great city! It is a creation that honors Marseilles!"[72] The completed Palais de Longchamp (Figure 5) evoked for some observers the architecture of ancient Greece, though more in its site on a promontory than in any formal attributes, and for others the Italian Renaissance. Since eclecticism, and Espérandieu's work in particular, aims to employ various historical elements within a unique stylistic and structural unity, neither of these observations could be conclusively refuted. Still, a third group of viewers who found in the building the inspiration of the French Renaissance were probably closest to the mark.[73]

But specific stylistic precedents mattered less than the symbolic power of style itself, a power that in its resonance approached the very essence of the civic purpose. There could hardly be a clearer example of Barthes's notion of myth making, in which bourgeois elites appropriate whole an existing signifying process (e.g., columns as signifiers for the ancient world) to stand for their own cul

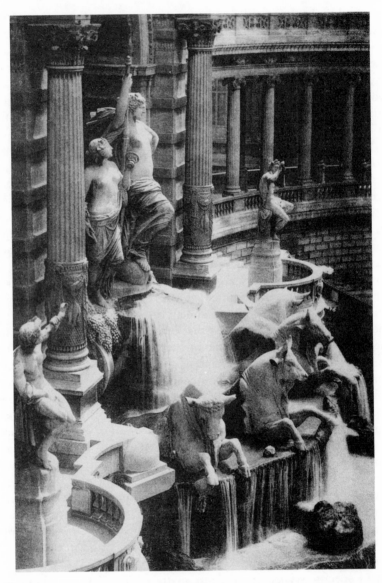

Figure 6
Jules Cavelier, *La Durance*. Marseilles, Musée des Beaux-Arts.
From a postcard, ca. 1914.

tural prowess.[74] The *Courrier* described the Palais as an "architectural marvel." It praised its proportions, its elegance, and its decoration and expressed the view that in devoting "the most exquisite of its monuments" to the arts, Marseilles had erected "a veritable symbol: it proves that we have preserved among us a taste for the arts, in the midst of a commercial populace, and that the cares of business in no way exclude that contemplation of works of art that provides a respite from the ordinary cares, the serious labors of life and refreshes the spirit by elevating it to its purest and most fertile sources . . . [Today Marseilles] has her architectural splendors that make her more worthy of her high destinies. She is no longer a city given over exclusively to commerce." Similarly, the *Gazette*'s comparison of Marseilles to Italian Renaissance cities, cited earlier, led into an extensive, detailed, and rapturous description of the Palais and all its ornamentation.[75]

Four sculptures by Antoine Barye, the most celebrated animal sculptor of the nineteenth century, stood flanking the gateways in the fence, itself described in one newspaper account as "richly worked." One critic found these animals, two lions and two tigers in various stages of consuming some less fortunate creatures, "palpitating with life"; another declared that they had "a certain distant kinship with the creations of the Greek chisel."[76] The sculptural decorations also included two seated tritons blowing into conch shells; three friezes, the one on the art museum depicting Minerva surrounded by various "geniuses of the arts"; four medallions, two above the art museum entrance depicting Puget and Poussin, two on the natural history museum of Aristotle and Cuvier; and a horn of plenty crowning the water tower, from which, appropriately enough, the visitor had a panoramic view of the city (the slope of the hill behind the Palais is such that it is possible to see over the top of the tower). Less prominent portions of the façade were graced with secondary ornaments: signs of the Zodiac, lamps of learning, garlands, the municipal coat of arms, and human heads with the "attributes" of appropriate virtues and skills.

The whole scheme centered on a huge sculpture by Jules Cavelier (Figure 6) to which one newspaper gave the descriptive if cumbersome title of "The Durance, between Vine and Wine, on a Chariot Drawn by Bulls of the Camargue." Placed just below the water tower and at the top of an exuberant but carefully channeled waterfall issuing from it, this group presented an almost painfully literal

representation of the feat the city intended the monument to cele-
brate.[77] Most accounts of the opening of the Palais noted that the
waterfall displaced 600 liters of water per second, and commented
almost wonderingly on its abundance: "The water shot up, bub-
bling forth from the feet of the Durance sculpture, and streamed
down in a magnificent cascade into a pool, while two gigantic foun-
tains gushed forth at either end of the vast lower basin, and other
fountains and shells discharged more water in exuberant leaps."[78]
Such comments signal more than a recognition of the obvious, that
the whole elaborate, not to say ostentatious display of the Palais de
Longchamp served above all to celebrate the city's achievement in
securing a dependable water supply. As the key to its broader devel-
opment, nothing could better represent Marseilles's new, confident
self-image, and in Provence, nothing could be more extravagant
than the profusion of water itself.[79]

Less sumptuous, in keeping with their different design histories,
the architecture of the Bordeaux and Rouen museums had no less
symbolic a purport. In Bordeaux, both officials and critics made a
virtue of the museum's budget-conscious plainness. La Gironde, for
example, called its decoration "simultaneously artistic and severe
without being overbearing." Burguet, the city architect, chose a
"severely" classicizing style (Figure 7), in order, it need hardly be
said, to harmonize with the neighboring Palais de Rohan. Indeed,
the priority attached to not obstructing that eighteenth-century
façade had an importance so overwhelming that it effectively consti-
tutes the central motif of the museum wings: the wings themselves,
considered in isolation, cannot be said to convey or represent any
architectural ideal. More than idle fetishism, the powerful attraction
of the Palais de Rohan reflects a strong tendency among Bordelais
even today to regard the eighteenth century as the city's, and indeed
the nation's, golden age. Pelleport-Burète expressed this perspective
concisely: "In a style whose sobriety will not exclude a certain ele-
gance, the ensemble of these galleries will recall that era when France
extended a friendly hand to America, abolished forced labor, and
happily saluted its sovereign as the restorer of public freedoms."[80]
For Bordeaux, greatness meant the eighteenth century, and its nine-
teenth-century museum consciously represented both parts of that
equation.

In Rouen, as already noted, officials explicitly stated that they did
not intend the museum building to compete with the city's existing

Figure 7
Musée des Beaux-Arts, Bordeaux: North wing.

medieval monuments. Although this reasoning reveals a certain defensiveness, it also bespeaks a kind of condescension, more confident than the mood in Bordeaux, toward those more vigorous and more vulgar cities who were attempting to make up in ostentation what their cultural traditions lacked in longevity. Content simply to evoke the "aspect sage et monumental" of the new museum (Figure 8, showing the entrance on the Square Verdrel as completed in 1887), the mayor and others called the roll of the "great Norman masters: Poussin, Jouvenet, Géricault," as a reminder that the city was expending most of its effort, and its resources, on the preservation of its considerable patrimony.[81] Thus the very restraint of Sauvageot's design symbolized the distinctive character of Rouen's purpose, with a forceful monumentalism more reminiscent of Marseilles than of Bordeaux.

Museums did, however, have decorative elements in common, and prominent among these were provisions for commemorating the great men of the past. Plans in Bordeaux called for twenty-nine

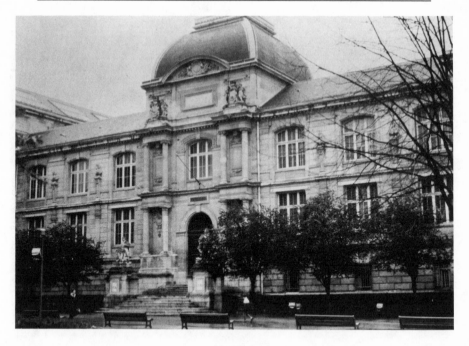

Figure 8
Musée des Beaux-Arts, Rouen: Main entrance.

busts, not all of personages from the world of art, but the city com-
missioned only four: the younger Pierre Lacour; Doucet, the first
benefactor of the museum and art school; Lodi-Martin Duffour-
Dubergier, a former mayor and important benefactor; and Charles
Fieffé, at one time cultural *adjoint,* and a founder of the Société des
Amis des Arts. In addition, two full-length allegorical sculptures,
Painting and *Sculpture,* occupied niches in the narrow street façade
of each wing, overlooking the cours d'Albret. The installation of
these sculptures formed an apt coda to the whole convoluted serio-
comedy of the museum's construction and installation: one was too
tall for its niche and had to have its pedestal lopped off in order to
fit in. The two figures prompted virtually unanimous derision from
the critics, who suggested, not entirely in jest, that two *pissoirs* the
city had placed in front of them had greater artistic interest.[82]
 Rouen also commissioned sculptural groups representing Painting
and Sculpture, and the results aroused less controversy—not so
much because Bartholdi had created them but because they were

placed above the main entrance cornice, too high up to attract much notice. These works formed part of a decorative scheme almost as elaborate as Marseilles's, including twelve busts of artists (on three sides) and writers (on the library façade). Among the latter, a bust of Flaubert originally occupied a position of honor in a corner niche, but it had to be brought inside after two decades of wet weather, as well as some stone throwing, had seriously damaged it. In an irony Flaubert would have appreciated, the bust now languishes in a service area of the museum, out of public view; there is also a curious full-length portrait of the novelist in the library stairwell and a bust of his friend Louis Bouilhet in a corner niche of the library façade.

The arrangement of the busts followed a general hierarchy of importance, with Géricault, Court, Sacquespée, and Pesne, the engraver of Poussin, on the rue Thiers side, Letellier, Restout, Deshayes and Lemire on the façade of the corresponding, northern side of the building, and the "most eminent" of the pre-nineteenth century artists on the main entrance façade. There busts of Jouvenet and Lemonnier flanked the life-sized seated statues of Poussin and the sculptor Michel Auguier on either side of the entrance stairway.[83] The commissions for these sculptures also followed a rather rigid hierarchy, with the choicest orders going to well-known artists, like Bartholdi, from outside the city. This practice caused considerable discontent among native sculptors, who found themselves left with standardized ancillary decorations (inside the museum as well as outside) like garlands, consoles, and laurel wreaths, of which Rouen too had a full complement. Marseilles experienced similar grumblings.[84]

Since even an elite public could hardly be expected to recognize the physiognomic features of anyone less celebrated than Poussin, the Rouen design provided for the inscription of artists' names on the wall above their busts. In Marseilles, as in many other museums and libraries, inscriptions of names alone, without actual sculptural representations, served as a kind of suggestive catalogue of what lay inside.[85] Whereas Rouen chose to honor exclusively artists with at least some claim to Norman roots, Marseilles, invoking the universal in a manner more suggestive than accurate, included among its inscriptions such names as Raphael, Michelangelo, Velasquez, and Rubens, among whom only the last actually had a painting in the museum's collections. For the names of local artists the city reserved the grand stairway inside the museum.

Figure 9
Musée des Beaux-Arts, Marseilles: North side of the main stairway.

In Marseilles and Rouen, as in most museums, a grand stairway (Figure 9, showing the upstairs landing) served as an appropriately imposing introduction to what some were already calling a "temple" or a "sanctuary" of art.[86] Though Bordeaux, with single-story galleries and only shallow two-story pavilions on the street front, lacked a monumental stairway, its architect tried to convey an equivalent sense of solemnity. He made the entrances as imposing as possible, using suitable decoration including four "mascarons," or female grotesques, an ornamental form characteristic of the eighteenth century. The lobbies or vestibules, with their marble floors, ceiling heights (twenty-six feet) worthy of a stairhall, and sixteen Corinthian columns, gave the requisite air of grandeur to the experience of entrance.[87]

Cities did not, of course, intend their ornamental programs to stop at architecture and sculpture: painting, the most prized medium in their collections, needed a suitably monumental representation in these important introductory spaces. Asked for his opinion on the

further decoration of the Bordeaux vestibules, Emile Vallet, who had succeeded Gué as curator in 1877, assumed automatically that one of the leading mural painters of the day, Pierre Puvis de Chavannes (1824–1898) or Paul Baudry (1828–1886), would receive the commission. Choosing two subjects he deemed suitable, *The French Republic Protectress of the Arts* and *The City of Bordeaux,* Vallet proceeded to give a startlingly vivid description of the murals he imagined these artists would execute:

> The two figures are young women conceived with a truly elevated artistic feeling, beautiful and interesting in themselves and in their pose, and also in the character and charm of the drawing and the palette. The artist has used discreetly those attributes that [in other hands] might make them look like mere patriotic devices: the note of allegory does not go beyond the bounds of necessary indication. The Republic, in the dominant position, greets various figures representing the different arts. The city of Bordeaux sits calmly, her eyes turned toward the Ocean; in the background the city itself can be made out, as well as the river full of ships. Such subjects, I know, often lead to absurdities in the hands of people devoid of talent, but a better artist could find in them the stuff of greatness.[88]

Probably for financial reasons, Bordeaux never commissioned any such decorative murals, but Vallet's vision shows a remarkable similarity to the decorative aesthetic at work in Marseilles and Rouen. His imaginary *Republic Protectress,* through an uncanny, almost synesthetic descriptive effect, sounds quite like a Puvis de Chavannes, as can be judged from the works that the artist created for the Marseilles and Rouen museums (Figures 10–12). The two paintings for Marseilles, *Marseilles, Greek Colony* and *Marseilles, Gateway to the Orient,* represented only Puvis's second major commission; the first had been the initial stage of the decorative program for the Musée de Picardie in Amiens.[89] The murals caused something of a stir in Marseilles, as they had at the Salon of 1869, for some critics viewed their conscious figural simplifications, distortions of perspective, and lack of the conventional glossy finish as signs of naiveté or inexperience. In the main, however, the critics responded favorably. Brès compared the paintings, in a general way, to works of the Italian Renaissance and found them suitable to the "general decorative effect" of the stairway. Parrocel, revealingly, proposed that the works should be evaluated not as oil paintings (though they are, mounted to the walls; Puvis never executed a

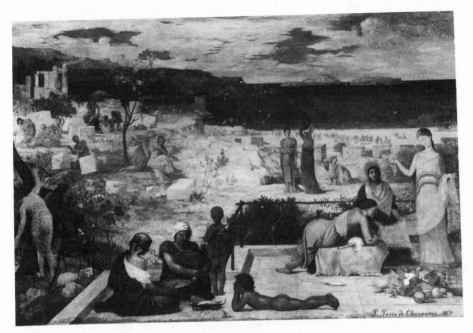

Figure 10
Pierre Puvis de Chavannes, *Marseilles, Greek Colony.*
Marseilles, Musée des Beaux-Arts.

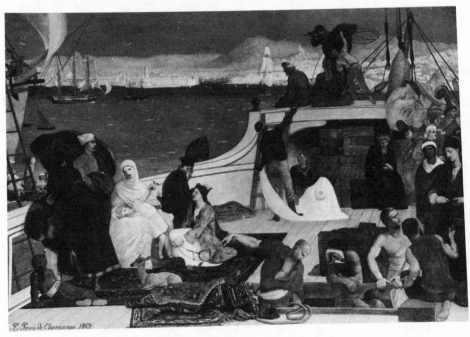

Figure 11
Pierre Puvis de Chavannes, *Marseilles, Gateway to the Orient.*
Marseilles, Musée des Beaux-Arts.

true fresco) but as decorative elements like frescoes, tapestries, or mosaics. He adjudged them so charming in their distinctiveness and in their overall effect as to excuse a few minor faults of technique.[90]

By 1888, when the Rouen city council was considering the decoration of the newly completed grand stairway of the museum, Puvis's position as the preeminent decorator of civic monuments of the day could not be doubted.[91] The Fine Arts Administration, which was offering eighteen thousand francs toward the cost of forty-three thousand francs for the murals in the museum and library, suggested entrusting them to Puvis, and Ernest Fauquet, the council's acknowledged expert on artistic matters, welcomed the proposition with enthusiasm. Calling Puvis "one of the greatest masters of the nineteenth century," Fauquet observed, one can imagine in what hushed tones, that "the thoughts of those who gaze on his admirable work easily rise to the heights of their poetry and their austerity." The departmental Conseil Général, meanwhile, rhapsodized over the "incontestable elevation [and] elysian symbolism" of his work.[92]

The large central panel in the Rouen museum, *Inter Artes et Naturam* (Figure 12), represented something of a departure in Puvis's late work, in that for the first time in a decorative commission it showed people in recognizably modern dress. Despite this innovation, however, the Rouen work shares one crucial aspect with the Marseilles paintings. In both cases, the extraordinary stillness of the figures, one of the hallmarks of Puvis's work, lends an inviolable dignity and solemnity to the scenes.[93] One would normally associate such solemnity with traditional allegories like those Vallet outlined, for example the centerpieces of the programs Puvis executed for the Lyons museum *(The Sacred Grove, Beloved of the Arts and of the Muses)* and the Boston Public Library *(The Inspiring Muses Acclaim Genius, Messenger of Light)*. This almost supernatural dignity seems fitting, too, in Puvis's sacralized historical commissions, including the scenes from the life of Sainte Geneviève in the Pantheon in Paris. Yet the Puvis commissions in Marseilles and Rouen have a specificity the others lack; above all, they are not traditional allegories.

The paintings in Marseilles represent actual, if obviously idealized, events in the history of Marseilles as a center of commerce: the founding of a Phoenician trading colony and the growth of the modern port. Puvis placed *Inter Artes et Naturam* too in a recognizable setting, on the heights of Bonsecours to the east of

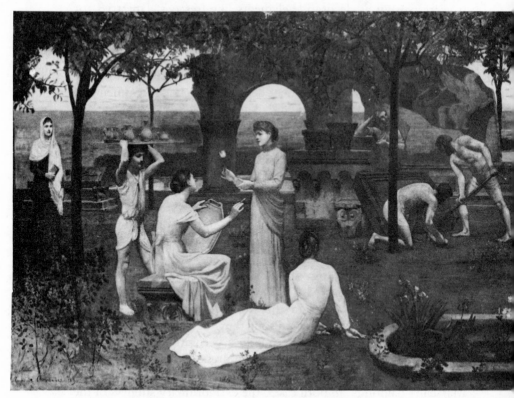

Figure 12
Pierre Puvis de Chavannes, *Inter Artes et Naturam.*
Rouen, Musée des Beaux-Arts.

Rouen, with the modern city visible in the background. The fig-
ures in this work are using the riches of the local landscape,
including the hidden treasures of its archeological tradition, as the
basis for modern artistic production. With two rear panels, *Pottery*
and *Ceramics,* commenting more explicitly on Rouen's traditional
ceramics industry, the entire sequence, like that of Marseilles, if
somewhat more obliquely, glorifies an economic activity strongly
associated with the city's development and prosperity.[94]

His preeminence notwithstanding, Puvis de Chavannes had rivals:
Toulouse, using a host of artists, managed to decorate an entire
"Salle des Illustres" in its city hall, the Capitole, without him. Thus
his appeal to municipal patrons must be understood not solely as a

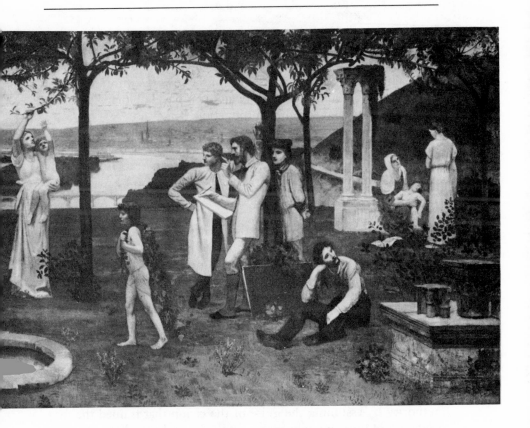

matter of prestige;[95] that appeal lay also in the inherent dignity of his work, that "elevated" quality to which Fauquet referred, in Puvis's ability to place references to traditional art within a distinctively personal idiom, and in his mastery of a total decorative sense based on a unique feeling for monumental spaces.[96] These qualities created in Puvis's work an ethereal sense, bordering on the mysterious, that made it the epitome of a symbolic system that said more by implication than by confrontation.

Unlike, for example, the powerful *Knight on Horseback (Guidoriccio da fogliano)* in the Palazzo Pubblico in Siena, unlike Leonardo's *Battle of Anghiari* (now obscured) in the Signoria in Florence, the interior ornamentation of provincial art museums is largely devoid of references to political power or authority. Yet the builders of these museums laid no less of a claim to the cultural hegemony that power confers on those who exercise it. They did so in the paintings of

Puvis, in Cavelier's sculpture of the Durance, and in countless rhetorical flourishes, by presenting art as the natural outgrowth of the economic and social activities on which political power rested in the nineteenth-century city. Some of these works, moreover, like *Inter Artes et Naturam,* consciously and completely blurred the lines between artistic and economic production.

In a sense, Puvis's work not only represents but virtually enacts the way in which art and the appropriation of cultural tradition exalt the domain of commerce. Like most artists of the time, Puvis worked on canvas, the transportability of which can be regarded as essential to the functioning of the modern art market and indeed to the very treatment of art as a commodity. Yet the purposes of museum builders in the nineteenth century required, if not a denial of the material and objective character of art, at least, in contradistinction to that materiality, an overwhelming emphasis on its moral quality as cultural signifier. Not the least of Puvis's appeal to this constituency, then, lay in his talent for creating works on canvas that, when attached (the technical term in French is *marouflé*) to the walls of monumental spaces, acquired the timeless appearance of the mural. A critic for the Marseilles journal *Tribune artistique et littéraire du Midi* wrote in 1869, "No one knows better how to place his technique at the service of the spirit."[97]

The aura of tradition also reinforced the museum's claim to authority by assuming the guise of the canon that framed the presentation of museum collections, a cultural tradition that only elites could fully understand. Even seemingly superfluous decorative elements served to invoke this canon: the "attributes" attached to groups of childrens' heads in the Marseilles stairwell, the two "fine Atlanti," as Parrocel called them, on the doorway leading into the Grand Salon, and the "well-designed" cornice elements the critic Jules Adeline remarked on in Rouen.[98] Most visitors today, of course, would hardly notice the Atlanti or the cornice ornaments, let alone pass judgment on their fabrication. For, though this decoration is not a deliberately mystifying art—the uninitiated can at least take in its basic signification—it is an encoded one. People today, like those visitors in the nineteenth century uninstructed in the texts of high culture, can respond to the realism of Barye's animals without knowing of the seminal importance of his artistry or can admire the effect of the busts and inscriptions without recognizing more than a few of the names. But only the initiate can enter

fully into the internal meanings these emblems both frame and represent.[99]

In the nineteenth century, the proper experience of high art involved serious effort, not casual relaxation, which explains the careful provision of comfortable seating and of the respite of parks and gardens. And since even the best classical education could contain a few gaps, the explanatory texts spend a great deal of time providing the necessary keys, to ensure the "inclusion" of anyone who read the right newpapers or who knew enough to purchase a descriptive pamphlet or catalogue.[100] But these aids themselves formed part of the encoded system and offered little assistance to those educated outside of it. Radical and popular newspapers did not have the space to reprint official speeches or to provide lengthy descriptions of museums, nor did they have the clientele to make the effort worthwhile. As for descriptive catalogues, at a franc or more they cost more than most working-class visitors would have been able to afford. Laden with the emblems of bourgeois cultural pre-eminence, art museums constructed from the Second Empire to the Belle Epoque did not actually exclude others, but they hardly made them feel very welcome. More fortunate than Moses, those excluded from the dominant cultural system could enter the promised land they beheld from outside, but they could not fully partake of its pleasures.[101]

The Museum and the Institution
of Culture, 1870–1914

The Consolidation of the Institution

"The high triumph of institutional thinking," Mary Douglas has written, "is to make the institutions completely invisible." In Bordeaux, where curators had once had to contend with fires, floods, and continual disruption, Emile Vallet had nothing more serious to complain about in 1890 than the uselessness of submitting quarterly reports to his superiors in city hall. Museums, he explained a few years later, "are and ought to be essentially conservative institutions: . . . the course of their existence is peaceful and uniform."[1] That state of tranquillity, the placidity of an administrative routine so familiar to Vallet as to seem self-evident, also set the tone of the institution for decades to come, aptly embodying the qualities of a particular cultural model that valued order and harmony above all things. This model assumed that its application to the museum resulted from an inevitable historical progression and, as Douglas suggests, called for the effacement of institutional structures in witness to the sweep of its domination. In this domain as in others, however, the triumph of the institution represented a construction, the work of years of patient and often disputed effort. The crucial arenas of this effort had a direct bearing on the functioning of the museum: patterns of administration, modes of acquisition, and the evolving relationship between curators, their political masters, and their various constituencies.

The values of the bourgeois elite had clearly informed the design programs of new art museums, and the key to those programs lay in the way they made the connections between art and commerce the basis for an implicit claim to cultural legitimacy. Officially, in the only visible layer of meaning, architects and decorative artists

elevated art to a place apart from daily life, one requiring a "sanctuary" or a "temple" to house it. Museums thus functioned as the institutional counterpart to the critical discourse of the "autonomy of art," which, as Raymonde Moulin has observed, served as a "compensatory ideology" to insulate artistic production from the taint of the marketplace.[2] As crucial to the self-legitimating elites as to artists, this strategy of separation played a crucial role in delimiting the connections between elites and their institutions. City councillors, for example, tried to avoid discussing art in the normal, everyday context of politics, confirming Barthes's observation that "myth is depoliticized speech." When some controversy arose in a public session over an artistic matter, it caused an almost palpable collective embarrassment: "Certainly," one councillor in Bordeaux declared, "it is very disagreeable to have to discuss the merits of a work of art in a public meeting."[3] In a self-conscious effort to remove art from the realm of politics, city councils created consultative commissions to advise them on artistic matters. Officials in Marseilles spoke of the "support of competent men and of connoisseurs [*amateurs*]," those in Bordeaux of "lumières" and "specialized knowledge": the comforting bromide of "expertise" always provided an antidote to any suggestion of politics.[4]

Composed chiefly of the best-known local artists, art school professors, and prominent *amateurs* or art lovers, usually including the presidents of local artistic societies as well as former *adjoints* for the fine arts, committees often began as advisors on the installation of new museum buildings.[5] The responsibilities of committees varied from city to city—their advice could be sought on matters ranging from requirements on checking coats and other objects to catalogues to renovations—but they spent the bulk of their time on acquisitions, whether purchases or proposed private gifts. Ostensibly, a committee served to protect the city council, which had the ultimate power of decision, from inappropriate personal or political influence. In 1888, for example, the Dijon committee rejected the proposed purchase of works from an artist's estate and thus insisted on the autonomy of acquisitions from the realm of charity and personal influence. By the turn of the century, in keeping with this trend, even the Bordeaux committee, originally an arm of the Société des Amis des Arts, had acquired considerable independence; it turned down most of the works the art association proposed for the city's purchase at its 1904 exhibition.[6]

Members of advisory committees could also serve to attract donors to a museum: indeed, mere appointment to a committee could provide a sufficient stimulus to a collector's munificence. An elderly Dijon *amateur* appointed to the committee in 1894 promised to give at least one work to the museum and to use his influence to bring about several other acquisitions. In Rouen, members of the committee, particularly that redoubtable gray eminence Alfred Darcel, served as intermediaries between the city and collectors it wished to encourage, evaluating their collections, advising them on which works to offer and on timing, coaxing them to ever greater acts of generosity. In this respect too advisory committees were performing, in only a marginally more official capacity, functions previously carried out by the Paris representatives of artistic societies, like the Bordeaux-born Orientalist painter Adrien Dauzats.[7]

Relations between curators and advisory boards varied as much as the boards' functions. The curator in Marseilles, Bouillon-Landais, felt hamstrung by his committee, which, moreover, he accused of being too susceptible to outside influence. Bouillon-Landais's frustrations derived in part from the persistence of an unusually cumbersome purchasing system in Marseilles: an initial fund authorization by the city council, followed by committee consideration of possible purchases, followed in turn by a city council vote on the actual purchase. In part too, Bouillon-Landais had spent the first few years of his tenure (1865–1894) struggling against the curator's subordination to the director of the art school. Ultimately successful, he regarded the museum's institutional integrity as a function of his curatorial independence and guarded them both zealously.[8]

Other curators, increasingly likely to come from backgrounds other than painting, had a more sophisticated understanding of the workings of the art world and thus dealt easily with the complexities of advisory committee procedures. Bouillon-Landais's two successors, Paul Guigou and Philippe Auquier, both of whom died after relatively brief tenures, were art critics and writers. Vallet's successor in Bordeaux, Jean Cabrit, more *notable* than artist, showed a flair for bring the museum into the whirl of the city's *mondanités,* or social occasions, gaining the good will of both city administrators and distinguished visitors by giving them tours of the museum.[9] In Dijon, after the uninspiring twenty-year curatorship of a rather crotchety artist named Emile Gleize, Albert Joliet, a dynamic,

wealthy, well-connected *amateur* from an old Dijon family took over in 1892. Joliet's "reign," to use the term of one of his successors, Pierre Quarré, lasted thirty-seven years; in that time, with the unofficial and later the official assistance of his brother, a former prefect, he completely transformed the Dijon museum. Through a combination of social skill, bureaucratic adeptness, and pure stubbornness, Joliet, whose refusal of a salary seems to have consolidated his authority, succeeded in cajoling and shaming the city into renovating the dilapidated rooms of the museum and into dramatically increasing the space allotted to it. Not coincidentally, with Joliet as chairman (most curators served as secretary) the museum commission in Dijon became merely another instrument of curatorial dominance.[10]

In another manifestation of the museum's new and distinct institutional identity, council members and critics came to downplay, and eventually to eliminate, the link between museum acquisitions and purchases at local salons. Instead of spending a fixed sum, typically ten thousand francs, at each exhibition, many felt that cities should each year add such an amount to a permanent acquisitions fund, from which it could make substantial purchases as the occasion warranted.[11] In Rouen, exceptionally, the city itself organized and financed the biennial salons, a task it was finding increasingly burdensome, and therefore it could deal with the issue of support for exhibitions in a simple and direct way. On the proposal of Ernest Fauquet, a member of the city council and president of the less elitist of the city's two art associations, the council voted in 1887 to hold an exhibition only every three years and to apply the funds thus saved from salon purchases to general acquisitions. Over twenty years this transfer would more than double the general acquisitions fund from forty thousand to one hundred thousand francs.[12]

Supporters of Fauquet's project presented it straightforwardly as a way of bestowing the city's favors on the museum, the rightful beneficiary, rather than on artists of dubious merit. Declaring bluntly that the exhibition was attracting neither outstanding works nor large numbers of visitors, the councillor Hippolyte Héduit contrasted it with the museum, for him a place where "a taste for the beautiful is formed, as well as the critical faculties." Fauquet also observed that the museum was attracting more visitors and the salon fewer, a trend he said the city council should encourage.[13] "Noblesse oblige," declared the *rapporteur,* Lefort, in a telling characterization

of the responsibilities of a bourgeois administration, as he invoked once more the incantatory concept of worthiness: "The doors of such a rich collection should not be open to creations unworthy to take their place with those already there. If you wish the Museum to preserve the rank it occupies, if you wish to fill in some most unfortunate gaps, which astonish the visitor dazzled by its other riches, if you wish it to continue to offer artists inspiring models, do not transform your temple into an asylum. Do not purchase for your collection canvases you will have to conceal in some dark corner or hide in the attic."[14]

Although in 1893 the council, with Fauquet no longer on the scene, reversed itself and made salons biennial once again, after exhibitions on schedule in 1895 and 1897 there was a gap of six years until the next one, after which they took place at three-year intervals until the war.[15] The forces favoring support for "the arts" in general, with an emphasis on official exhibitions rather than on the museum, were fighting a losing battle. In the years between the two decisions Rouen had made several purchases in Paris for the museum, and it had no interest in reverting to an exclusive reliance on the local salon for its acquisitions. That exhibition, increasingly lampooned in the press as a pastiche of the two conservative Paris salons, the Société des Artistes Français and the Société Nationale, was, like them, facing increased competition from dealers and from smaller private exhibitions. The praise the shows of the Rouen-based Société des Artistes Normands and Société de Peinture Moderne received in the press thus sounded the death knell of the old official exhibition. After temporarily shunting responsibility for its salon to the Société des Amis des Arts in 1899, Rouen let the exhibition wither on the eve of World War I and did not attempt to revive it thereafter.[16]

Advocates of traditional purchasing practices also won a pyrrhic victory in Bordeaux at the turn of the century; there as in Rouen, it was in the nature of a last hurrah. Henri de la Ville de Mirmont, *adjoint* for the fine arts, formulated the issue of exhibition purchases versus an acquisitions fund in terms of the fundamental character of the museum. Purchases at the local salon, Mirmont declared, would preserve the museum's local character: "Let us know how to be provincial, and let us have in our province paintings that represent the school of Bordeaux, from its origins to the present day." Disparaging the more celebrated, more expensive works that would be the target of a purchase fund, and by implication the workings of the

art market itself, Mirmont claimed such works were "valuable only because they are fashionable, because some rich bourgeois has wanted to hang [them] in his collection."[17]

Mirmont's chief opponent, the financial *adjoint* Georges Périé, ridiculed his colleague's argument: "M. de la Ville de Mirmont's thesis runs as follows: we live in the provinces, and, poor little provincials, we must keep the fruits of our vineyard in our midst, and forbid ourselves the paintings of other schools. If the same argument were applied to beverages, since Bordeaux produces wine, we would be forbidden from drinking anything else!" Périé, stoutly defending bourgeois taste, said that the museum had reason to be grateful for the generosity of the city's elite: "You see, then, that sometimes lawyers and financiers, and yes, even vulgar clubmen have merit; indeed, they often have taste and an aesthetic sense."[18] In light of the overcrowding that already afflicted the museum less than twenty years after the completion of the new building, Périé urged the city to "acquire [only] works truly worthy of inclusion in a great provincial museum," by which he meant those having attained "the double prestige of age and of genius." Périé lost the battle on this occasion, not on principle but because some of his colleagues suspected that as financial *adjoint* his real interest was in economy rather than in the museum, but as in Rouen, his side was clearly winning the war. A briefer discussion of the issue in 1901 demonstrated that traditional exhibition purchases were losing support; meanwhile, the city had already begun to make purchases at smaller, more eclectic exhibitions. Though the salons of the Société des Amis des Arts lasted until 1939, a generation longer than the Rouen exhibitions, the more diversified purchasing policy remained in force.[19]

Périé's indignant "poor little provincials" forms a striking counterpoint to the debate in Paris in the same period about the "quality" of envois, in which more than one deputy suggested that provincial museums were getting what they deserved. The search for new acquisition outlets represented in part an avenue of escape for museums from categories not of their own choosing, whether of "provincial" or even of "museum" art. As they had in the Second Empire, cities continued to purchase history, genre, and landscape paintings, but the emphasis was shifting, coming to evoke notions of representativeness rather than the considerably eroded idea of the "museum picture." The discourse of museum purchases gradually

deemphasized the qualities of "elevation" that had formed the crucial link between different kinds of pictures and instead devoted far more attention to technical accomplishment and the capturing of "effect." As a practical matter this conceptual change resulted, by the 1890s, in a highly receptive attitude toward impressionist or impressionist-derived canvases. More generally, it exemplifies Douglas' description of the ways "institutions do the classifying": "First the people are tempted out of their niches by new possibilities of exercising or evading control. Then they make new kinds of institutions, and the institutions make new labels, and the label makes new kinds of people."[20]

In Bordeaux in the 1870s, officials still presented history painting in the "grand style" as something close to an ideal. In 1875 the *adjoint* Sourget declared that the young Bordelais artist Daniel Casey deserved encouragement for his *Crucifixion,* which appeared to mark a transition from the "light and somewhat effeminate subjects" he had favored hitherto. That same year the city also purchased Evariste Luminais's *Gallic Scouts,* in which the advisory committee had found "all the characteristics of a museum picture."[21] Darcel, who in addition to everything else served as art critic of the *Journal de Rouen,* praised the city's purchase of Jules-Charles Aviat's *Assassination of Marat,* one of four scenes of the event exhibited at the Rouen salon of 1880, saying that "the very style of the principal figure and the sober execution together give this work *an* elevated character." Even landscapes had to demonstrate something of the same qualities. Vallet found "an elevated sentiment" in Louis Auguin's *Summer Day on the Grande Côte (Gulf of Gascony),* purchased in 1885; two years later, Auguin recommended his friend Alexandre Rapin's *Evening in La Hague* as "an excellent landscape, true in effect and elevated in sentiment."[22]

But standards were changing, though more rapidly among critics than among municipal purchasers. The press in the 1880s greeted traditional historical scenes and the more classicizing genre pictures, particularly nudes, with boredom, sometimes shading into distaste. In 1882 the *Courrier de la Gironde* ridiculed Bordeaux's choice of Jules Delaunay's *Ophelia* as "pretentious . . . trivial and vulgar" and "a bad joke."[23] By the turn of the century, the traditionally praised attributes of history paintings no longer attracted much notice or support even in official circles. If critics liked a history painting, they usually had something to praise other than its "elevation." Of the

two paintings Rouen purchased in 1897, the *Journal de Rouen* found in Alphonse Dawant's *Saint Bonaventure Refusing the Cardinal's Purple* "a successful composition . . . lacking neither severe emotion nor a picturesque interest." The *Petit rouennais* called Alphonse Laurent-Desrousseaux's *Suspects,* a scene of the Revolution, "very modern in its technique and its disposition."[24] Neither, obviously, had much to do with "grande peinture."

But when a work that positively flaunted its connections to traditional history painting, Carolus Duran's *Danaë* (Figure 13), came before the Bordeaux city council in 1902, it caused a storm of controversy. In part the dispute had to do with the state's offer of six thousand francs, half the purchase price, only if the city applied it to this work; this some city councillors and most of the press considered overt interference in municipal affairs. In addition, critics noted

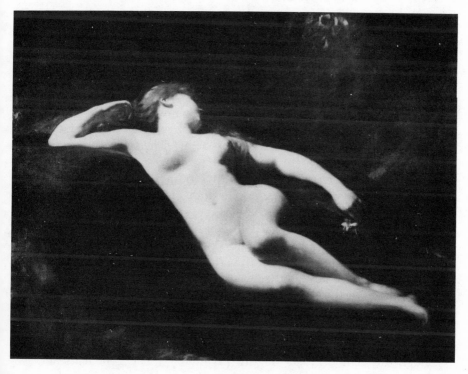

Figure 13
Carolus Duran, *Danaë.* Bordeaux, Musée des Beaux-Arts.

that the painting was not at all typical of the artist's work, which consisted largely of society portraits. A generation before, of course, municipal officials would not have considered such portraits worthy of purchase, but now they were seeking paintings representative of an artist's best work; in 1889 Bordeaux had even purchased a *Self-Portrait* by Alfred Roll that seemed to meet that criterion. The council eventually ratified the administration's deal with the Fine Arts Administration, but its lack of enthusiasm for *Danaë,* the archetypal museum picture, was palpable. By 1900 the kind of painting produced expressly for official purchase, large in scale and almost inevitably retrograde in conception, rarely represented anyone's best work, in part because the flourishing private art market offered the artist much greater flexibility in format and technique. In the double-edged words of one newspaper's account of *Danaë,* "Mythology has had its day, and reality has long since pushed dreams into the background."[25]

At the same time, cities were devoting most of their attention and purchase funds to genre scenes and landscapes far more concerned with the ephemeral than with the eternal. Vallet, in 1890, did not much care for Etienne Tournès' *Young Woman Undressing* (Figure 14), which, in an ironic turnabout of anti-academic criticism, he felt too exclusively represented the "system" or "group of *pleinairistes* [a common term for the impressionists], whose art consists almost entirely of an exact, literal reproduction of the effects of persons and objects in their particular atmosphere." The press, however, responding more favorably, called the painting a "canvas of great character" and declared that in it "M. Tournès proclaims himself indisputably a stylist and a technician of the first order."[26]

As for landscape, few in the 1890s were still searching for "elevation." In Bordeaux, critics and officials alike praised Alfred Smith's *Quais of Bordeaux, Evening* (Figure 15), purchased in 1892, for its felicitous rendering of the atmosphere of a busy Bordeaux street at twilight.[27] Rouen, around the turn of the century, made virtually all its purchases of landscapes from artists associated, either personally or in terms of technique, with the impressionists. Following the typical pattern, the press had been extolling Charles Fréchon, leader of the "Rouen school" of impressionists, for years before the city bought his *Spring Leaves* (Figure 16) in 1907. The *Petit rouennais* unreservedly adopted the appropriate critical and technical vocabulary to describe in the painting "an intense effect . . . the sincerity of

Figure 14
Etienne Tournès, *Young Woman Undressing*.
Bordeaux, Musée des Beaux-Arts.

Figure 15
Alfred Smith, *Quais of Bordeaux, Evening.*
Bordeaux, Musée des Beaux-Arts.

his vision . . . the impeccable logic of his decomposition of tones."
The *Journal de Rouen* found "some very pretty spots" in Luigi Loir's
Flood Tide of the Seine, Paris (Figure 17), which the city bought
in 1903: "The yellow streak of a bus, the comings and goings of
passers-by, just suggested with the tip of the brush." But Georges
Dubosc, who had taken over as the newspaper's art critic on Darcel's
death in 1893, lavished praise on two Monets in the exhibition, one
of them from the Rouen cathedral series, and wondered whether
works of the "real" impressionist masters would ever enter the
museum.[28] They did soon enough, but not in the way the critic
likely had in mind.

Although purchases of contemporary paintings often occasioned
disputes of a political or an aesthetic kind, supporters of exhibition
purchases and proponents of acquisition funds could agree in one
area: acknowledged masterpieces by native sons or (very rarely,

notably Rosa Bonheur in Bordeaux) daughters. The search for such objects, indeed, exemplified a gradual process through which individual museums were defining their own characters; in the area of past art, de la Ville de Mirmont's urging that cities collect the work of local artists provoked little dissent. Only at the turn of the century did Marseilles begin to articulate officially its policy of collecting works by the seventeenth-century artist Pierre Puget, but collectors with works attributed to Puget had long known of the city's interest in him.[29] Dijon also sought works by a celebrated sculptor, François Rude (1784–1855), a native of the city who was best known for his sculpture of *The Marseillaise* on the Arc de Triomphe in Paris. His hometown had not neglected the sculptor during his lifetime: it commissioned a major work, *Hebe and the Eagle of Jupiter,* from him in 1846. Under Gleize and Joliet, however,

Figure 16
Charles Fréchon, *Spring Leaves*. Rouen, Musée des Beaux Arts.

Figure 17
Luigi Loir, *Flood Tide of the Seine, Paris*. Rouen, Musée des Beaux-Arts.

the museum devoted considerable effort to acquiring drawings, models, and plaster casts of Rude works, in order to reconstruct the artist's career as fully as possible. The city's pride in the achievement of the school of Devosge, the founder of the museum and Rude's teacher, led it to purchase in 1882 a painting by another of Devosge's students, Pierre-Paul Prud'hon. An official report on this work, *Portrait of Georges Anthony* (Figure 18), acquired relatively cheaply from one of the subject's descendants, said that it would be "highly regrettable" if the museum lost the work to another purchaser.[30]

Bordeaux had no signal native artist in its past, though it did regularly purchase drawings depicting parts of the pre-Haussmannian city by a skilled local draftsman, Léo Drouyn.[31] Eugène Delacroix's brief childhood residence in Bordeaux, however, conferred on him something like honorary native-son status. Delacroix's personal affection for the city enabled it to acquire his *Greece on the Ruins of Missolonghi* for a mere 2,500 francs at the first local salon in 1851, and the most regretted damage in the 1870 fire was the loss of his 1853 envoi *The Lion Hunt,* of which the remaining fragment was hung "as a precious memorial to the work of the master." In 1886, accordingly, the city spent forty thousand francs to acquire at auction an interesting if decidedly preliminary competition sketch by Delacroix, *Boissy d'Anglas at the Convention.* An exultant letter from Vallet, whom the city had sent to Paris to bid on the painting, records an intense Bordelais satisfaction at keeping the painting out of the hands of the Louvre.[32]

Rouen, already well endowed in the paintings of the seventeenth-century Norman masters, actively collected the works of a more recent native son, Théodore Géricault. Though the city's acquisitions of Géricault went back to the 1860s, they received a special impetus in 1901 when the curator, Gaston Le Breton, a distinguished *amateur* in the Joliet mold, decided to devote a separate gallery to Géricault's works. Because Géricault produced only a small number of major canvases during his brief life (1791–1824), the city often had to settle for drawings or small oil sketches. But in 1908 it was able to acquire an important small oil painting, *Officer of the Imperial Guards Charging.*[33]

The pursuit of particular artists or kinds of works (Dijon, for example, sought medieval decorative art to complement its extraordinary collection of Burgundian sculpture) did not depend wholly on purchases; museums actively solicited donations in these areas as

Figure 18
Pierre-Paul Prud'hon, *Portrait of Georges Anthony*.
Dijon, Musée des Beaux-Arts.

well. Vallet, with his usual gift for articulating universal truths without much regard for their practical applications, observed that "to give to a museum is to give at the same time to everyone and to no one," because museums "have an impersonal character of general utility, which places them above certain considerations [of private collectors]." He left it to his successor, Cabrit, to worry about points of detail, for example whether the obvious lack of space in the Bordeaux museum might deter potential donors from offering works to the city.[34]

Admittedly, Vallet's characterization applied rather neatly to the particular gift he was evaluating, a group of medals from Baron Alphonse de Rothschild (1827–1905), the former head of the Paris branch of the family bank, a member of the Institut, and a well-known collector. Since the late 1880s de Rothschild had been engaged in a massive campaign of philanthropy, apparently modeled on the patronage of the state itself, to provincial museums. Offers of works of art came from Paul Leroi, editor of the bimonthly *L'art,* rather than from the donor; like the state, Rothschild had special forms printed up for his gifts, which specified that museums could not sell the works and had to keep them on permanent view. Like the state's generosity and on the whole no more daring, the Rothschild gifts consisted largely of recent works from the Paris salons, paintings as well as prints, drawings, and medals. But whereas the state placed its emphasis on supporting artistic production, de Rothschild's philanthropy was principally concerned with institutions, which demonstrated, as Leroi put it, his "true interest in the development of provincial museums."[35] As might be expected, the baron and his agents had a much better sense of the market than did the state: he gave a Boudin, *Low Tide at Etaples,* to Bordeaux in 1890, and in 1891 he provided Dijon with the first Rodin, *Head of a Weeping Woman,* to enter that museum's fine sculpture collection.

If the Rothschild gifts are any indication, by the late nineteenth century the major provincial museums had acquired an important place in the consciousness of even nationally prominent collectors. Support from local collectors, on the other hand, revealed the extent to which museums had carved out for themselves distinctive *local* identities. Far from having an "impersonal character," concerned only with the "general utility" of the museum, most gifts grew out of a deep attachment to a particular city or region and from a desire to honor some person or persons, often the donor himself, associ-

ated with it. In 1893, for example, Vallet reported that a collection of paintings Albert Brandenburg had left to the museum would constitute "a material recollection that, alongside his well-known works of charity, will bring alive the respected memory of a former mayor of Bordeaux."[36]

At Vallet's instigation, Bordeaux devoted a separate room to the Brandenburg collection. Cities made such provisions for reasons of self-interest: named galleries appealed to the commemorative intent never far from the minds of even the most sophisticated collectors. Two Lyons collectors, Anthelme and Edma Trimolet, having had a falling-out with their own city administration, left their extensive and important collection of old paintings and decorative arts to Dijon in 1878. The bequest came with two principal conditions: that the collection receive a separate integral installation, or "Musée spécial," and that Dijon commission, at its own expense, busts of the donors. At the prospect of its greatest windfall since the days of Devosge, the city readily complied. It accorded the same favor to another major collection of paintings that came to the museum in 1905, naming a room after "Henri and Sophie Grangier, as a testimony to our gratitude and to perpetuate the memory of our generous donors."[37]

Rouen had an invaluable asset in Alfred Darcel, from 1885 curator of the Musée de Cluny in Paris and easily the most prominent member of the museum advisory committee. The city credited him with encouraging Victor Loutrel, a Rouen printmaker and collector, to give his choice collection of over 350 paintings and drawings to the museum. Darcel arranged this transfer in two installments, in 1886 and 1891; he was also involved in other gifts. Recognizing the irreplaceable quality of Darcel's influence, after his death in 1893 Rouen could only attempt to provide an official, institutional incentive to giving. In 1894 the city council voted to establish memorial tablets in the hall at the top of the main museum stairway. Like Bordeaux and Dijon, Rouen also created special installations for the most important donations it received, notably a collection of 227 drawings presented by the daughter of the Romantic painter Ary Scheffer in 1897; it could not, however, attract the city's most important private art collector, Auguste Dutuit, who disliked the town and so left his collection to Paris.[38]

In 1909 the Rouen museum did all it could to oblige the donor of a collection of fifty-three paintings. The city provided three rooms

for this collection and permitted the donor, François Depeaux, to arrange the works himself. Since the Depeaux collection still constitutes the most important group of impressionist paintings in provincial France, the city had good reason to make such allowances. In one sense, Depeaux's purpose in donating his collection to the city differed little from that of other collectors: "to contribute to the artistic reputation of our dear and ancient city." But he also knew that the city's acceptance of the paintings constituted a kind of consecration. He said at the opening of the Depeaux galleries: "I am happy to think that my native city will be one of the first in the provinces, if not the first, to open wide the doors of its museum to an art that, so denigrated in its early days, and for some years thereafter, has now acquired, through the truth of its technique and the ardent conviction of its apostles, Claude Monet, Sisley, Renoir, Degas, Cézanne, Pissarro, Guillaumin, Lebourg, and all the young artists who have succeeded them, its place among the most beautiful that human genius has produced."[39]

Coming at a time when impressionism was first achieving wide popularity, the ceremonial opening of the Depeaux collection served as a celebration of everything the art museum had come to stand for. The mayor, Auguste Leblond, lavished praise on the donor and the gift, but used them also as exemplars of a familiar theme:

> The city owes it to herself, she owes it to the visitors who, each day in greater numbers, come to admire her artistic treasures, to show that, knowing how to be an active and industrious city, she also knows how to make manifest her intellectual and artistic spirit. For thirty years now, our city administrators have understood that here more than anywhere else they had to attend to the fine arts, that this was a sacred duty they could not derogate; they have satisfied it in the greatest measure. It is to this concern that we owe the idea of constructing the building in which we are assembled today.

Fortunately, Leblond added, some "generous donors" had recognized that the city's own resources alone could not maintain the museum at its traditional level of excellence.[40] As an industrialist, shipowner, social reformer, and philanthropist, Depeaux was a long-standing member of the Rouen elite, and his generosity thus had a special significance. In his willingness to overlook his compatriots' initial indifference to the impressionists, Depeaux offered a welcome and reassuring signal of the art museum's continued power

to evoke the civic values that had underlain its construction and consolidation.

In a sense, moreover, the evolution of municipal acquisition policies played an important part in consolidating the claims to authority that cities made through their museums. Cities did not, of course, greet all gifts with the enthusiasm that Rouen showered on Depeaux. Indeed, using the opinions of advisory committees as a "contrôle de goût," in the words of one Rouen city councillor, they even refused some outright.[41] With a similar goal, some curators were suggesting a "purification" *(épuration)* of their collections even before constricted space made such a measure inevitable.[42] The authority of choice that museums exercised in the last quarter of the nineteenth century had a significance that their original acquisitions practices lacked: it bespoke a serene and absolute self-confidence fully consonant with the spirit of the new museum buildings.

In the initial period of acquisitions, city governments had been content to choose from among works that proclaimed their own suitability for the museum's spaces. Municipal purchases in the Second Empire, like those of the state throughout the century, represented an endorsement of technical accomplishment, not a judgment of artistic quality. The language of "elevation" and "sensibility" that framed these purchases served a kind of ritual function, consecrating the city's choices as something more significant than mere objects. But this distinction clearly resided in the act of choice rather than in the object chosen. Sensibility can only be recognized; it cannot be imposed in a technical sense by the artist's fiat.

The turn, toward the end of the century, to a notion of representativeness thus paralleled, though in a less exclusive fashion, the state's embrace of critical discourse. In the provinces, however, this shift had if anything even greater significance. For while the state was merely giving its purchases an authority that many of its critics had long accused it of exercising, cities were now claiming, through the mediation of their curators, expert advisors, and private collectors, an authority to which they had never previously pretended. In part, as they became more involved in the intricacies of private collecting and of the market, cities needed a more compelling vocabulary of disinterest in which to couch their activities. But beyond this necessity, decried by the Mirmonts, embraced by the Périés, lay a genuinely new spirit.

After a half century of patronage, urban elites felt entitled to

define for themselves the qualities that made a work suitable for their museums. Whether elegant or merely sumptuous, the museums they had constructed testified to their taste and their judgment and thus provided the basis for a further authority of choice and categorization. Elites used this authority to choose art that, in standing for the qualities of an entire career or even an entire epoch, solidified their reputation, and their authority, as connoisseurs. Over the long term, authority derived from culture conferred authority over culture. Artistic production, however, was only one of the domains over which museums could exert that authority. On its own, indeed, as subsequent developments confirmed, authority of choice provided the basis for a more sweeping institutional exercise of the power to define and to exclude.

Space and Order: The Museum in the Bourgeois Image

Resplendently housed in a freshly constructed palace, its collections invested with newly articulated notions of quality, the museum of the late nineteenth century constituted itself in the image of a class elite, which it then invoked as its public. Beginning with the rhetoric of museum administrators, this invocation operated on a number of levels: the arrangement of collections, the framing of regulations, the ordering of the visit. Often solidly founded in the pragmatic needs of the institution, these practices nevertheless also worked as signifiers, shaping the institutional character and identity in ways that not only invoked one public but largely excluded another.[43]

In their early days, it will be recalled, museums were linked in prevailing opinion to art schools. The instruction of artists had not completely disappeared a half century later, but it occupied a place clearly distinct from museums' primary functions. Writing while the Palais de Longchamp was still under construction, Bouillon-Landais called the museum "an instrument of civilization intended to shape and to purify the public's taste through the presentation of masterpieces, to awaken slumbering [artistic] vocations or those as yet unsuspected, and to complement the instruction offered by the art school, whose students can be admitted to study in the Museum."[44] Not only the ordering of the sentence but also the tone, which moves gradually from the lyrical and inviting—"instrument de civilisation," "oeuvres magistrales"—to the bureaucratically pre-

cise—"qui peuvent être admis"—relegates instruction to a subordinate position. Although Bouillon-Landais had long been struggling against the authority of the art school, Darcel, called in at the last minute to supervise the installation of the new Rouen museum in 1880, had no such animus. Darcel nonetheless expressed a very similar attitude toward art students. He wrote of an academic sketch by Géricault, installed "in a corner" of an out-of-the-way gallery on the second floor, "Students of our school will certainly know how to find it when they wish to study it."[45]

As "instruments of civilization," museums had a constituency that went beyond artists alone; the "public," an implicit presence in the construction phase, took center stage. "What is a museum?" a member of the Rouen city council asked in 1877, and he provided this answer: "A collection offered to the public as a model of taste." Reporting on visitors' satisfaction with the Bordeaux museum in 1891, Vallet declared that "our fine collection . . . contributes in large measure to diffusing a taste for the arts in our city." Twenty years later, a Bordeaux city councillor described the museum's purpose, in related but slightly different terms, as "the artistic education of the public."[46] As a "representation of the *significant* totality" of the empirically identifiable audience, the public, in Thomas Crow's terms, "appears . . . via the claims made to represent it."[47] How did museums, through their various practices, make such claims?

The idea of the museum as a "model of taste" clearly informed the installation of collections in new museum buildings, which provided the first opportunity most curators had to lay out paintings according to a set of coherent principles. Although arrangement by national school constituted a kind of theoretical ideal, it gave way in practice to the more intangible dictates of taste and pictorial harmony. An ad hoc advisory committee set up to consider the installation of the Palais de Longchamp in 1869 decided that a division by schools would cause too many "difficulties with regard to the disposition of the galleries . . . and to later arrangements following possible new acquisitions of paintings"; it recommended considering only paintings' dimensions and their "importance." Vallet, reporting in 1878 on his plans for the installation of the future Bordeaux museum, observed that "a classification by national schools is the most rational and the most scientific, but the rigorous imposition of such an order would entail ignoring the space available" and was thus impractical.[48] Darcel, expressing himself more posi-

tively on classification by national schools, said that he had adopted it as "a means of proceeding methodically." But he had to admit that "a logical order did not preside over all the installations." Considerations of space, for example, forced some Italian pictures into a gallery largely devoted to French paintings of the seventeenth century.[49]

A simple imperative caused this disfiguration of the most "rational, scientific," and "methodical" order. In Vallet's words, "the need to cover the walls almost entirely can lead to the juxtaposition of paintings from different schools or of different types."[50] Art museums in the nineteenth century inherited from noble and princely collections of the Baroque an aesthetic that dictated the virtual blanketing of exhibition surfaces with pictures. Samuel F. B. Morse's 1833 painting of the *Gallery of the Louvre* (Terra Museum, Chicago), for example, to cite a celebrated image of the nineteenth-century museum, recalls Giovanni-Paolo Pannini's pictures of Italian princely galleries in the eighteenth century, and the same aesthetic prevailed in the nineteenth-century museum (see Figure 19, below, showing the Grand Salon in Rouen). Throughout his lengthy guided tour of the Rouen museum, published in the *Journal de Rouen*, Darcel treated empty spaces or "vides" as anomalies, and felt bound to explain the circumstances that had prevented him from filling them in.[51]

Curators did not intend merely to cover surfaces, however. Contemplating a rearrangement of paintings in Dijon in 1903, Joliet wrote of the importance of neighborly relations ("rapports de voisinage") between pictures. For Vallet the very essence of the museum lay in these juxtapositions. He hoped they would be "piquant," in order to make the museum "not a necropolis, a collection of dead objects that must be arranged methodically, but rather a kind of cosmopolitan gathering, a sort of congress, where many peoples and generations are represented."[52] Darcel aimed more for harmony than for piquancy, but the idea of a pleasing totality remained the same. His installation, intricate in detail but simple in conception, aimed at achieving an "equilibrium of surfaces, forms, and colors" with enough internal contrast to avoid monotony: "We wished to make paintings of the same dimensions, more or less, and of the same shape—coupling those higher than they are wide, and vice versa—into pendants, so long as they were both either light or dark. In addition, we have tried to hang next to each other only paintings with different color schemes, choosing subjects, moreover, in such

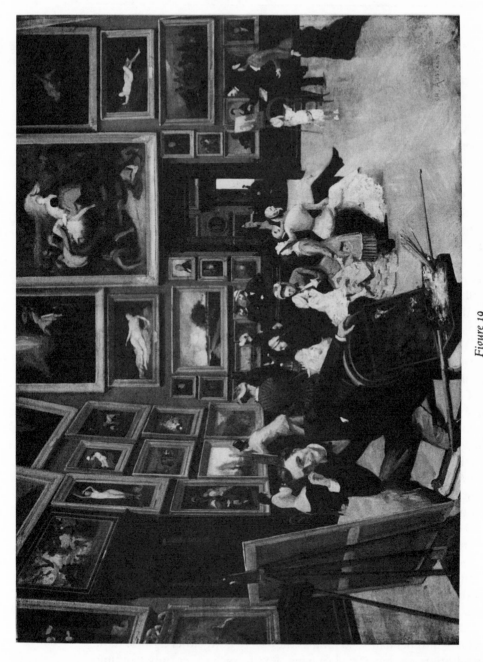

Figure 19
Charles Angrand, *The Rouen Museum in 1880*. Private collection.

a way as to contrast them absolutely, placing landscapes and still lifes in between historical and anecdotal pictures and portraits, so as to avoid any monotony of color, of subject matter, or of scale."[53] Vallet believed that this kind of ensemble would, by virtue of its assemblage, call attention to "the particular life of art" rather than to the "diversity of origins" of individual works.[54] The goal was a kind of aestheticized totality, analogous to a world of external reality but distinguished from it by the recognizable agency of a structuring taste.

In Bordeaux and Marseilles, the preparation of such installations involved the construction of elaborate mock-ups, bits of cardboard representing paintings stuck onto small wooden bulletin boards that stood for walls. Darcel, more pressed for time, supervised trial runs—laborious, but faster than making models—with the actual paintings on the floors of the new Rouen museum. As though aware that such trial runs had something of the air of a game, both Bouillon-Landais and Darcel stressed the considerable effort and concentration they entailed.[55] Models facilitated the arrangement of pictures in an approximate order of importance, with the most notable examples of a particular period or school occupying the center of each panel. Curators hung the better works "de première ligne," that is, close to eye level on the *cimaise* or dado, and shunted the inferior works to a less visible position higher up on the wall. The central works served to order the entire installation, or as Darcel said, "to make conspicuous the system we have adopted." Placing the paintings in a way that "forced" the viewer to look at the better ones, in Vallet's view, simply presented "the entire collection in the most favorable light, the one most apt to display it to advantage."[56]

In Rouen, the rooms themselves duplicated this principle on a larger scale. The three central galleries, each two full stories in height and lit from above, housed works from the most prestigious schools: Italian, seventeenth-century French, and, in the Grand Salon (see Figure 19), contemporary French paintings. Other works from these schools, together with the museum's distinguished collection of Dutch and Flemish pictures, occupied the outer tier of galleries on the first floor, with secondary works by both older and contemporary French painters relegated to more remote rooms on the second floor. Darcel explained that the "immense size of certain canvases of the modern French school obliged us to devote the central

Grand Salon to this school, which in any case was only just."[57] He meant that the contemporary school boasted several of the museum's acknowledged masterpieces, and these very large works dominated three of the panels: Delacroix's *Justice of Trajan,* Louis Boulanger's *Agony of Mazeppa,* and Joseph-Désiré Court's *Boissy d'Anglas at the Convention: 1 Prairial Year 3.* Joseph Palizzi's *Milking of Calves in Normandy,* an envoi that complemented these works in size, though not in merit or historical resonance, took up the center of the wall above the entrance door, presumably the last work most visitors would see.

A number of other historical scenes, most of suitably grisly subjects—a *Martyrdom of Saint Agnes,* a *Saint Sebastian,* a *Massacre of the Abencerages*—flanked these central works, with the exception of the extraordinarily large Court, which at nearly sixteen by twenty-six and a half feet had the entire top of one panel to itself. Below these paintings hung smaller works, mostly genre scenes and landscapes, with small still lifes in between serving an essentially decorative purpose. Close to eye level the visitor found small works by the best-known contemporary artists, including an Ingres portrait, some Géricault studies, a Troyon animal painting, and landscapes by Corot, Daubigny, and Ziem.[58]

Four free-standing elements at the corners of the Italian gallery to the west of the Grand Salon transformed that room into an octagon, and the same technique was used in its counterpart to the east. Darcel used these corner panels as the "basis for the installation," placing on them four "superb works of which the museum should be proud, and which occupy a place of honor,"[59] including two Veroneses and a Guercino from the original Napoleonic distribution. Less important or less well authenticated works hung over the doorways, and on the lower panels works were grouped by subject matter rather than by individual Italian schools. Darcel confessed that one panel consisted of a "perhaps rather monotonous assemblage of dead Christs"; another presented a number of scenes of the Madonna and Child. Adeline observed in the *Nouvelliste* that the "carving up" of the exhibition surfaces in the octagonal galleries created special problems of installation, particularly for larger works, but he nonetheless found the Italian gallery "one of the most attractive in the museum."[60]

In none of the new buildings had curators completed labeling the works of art by the time of the public opening, a further sign of

their basic lack of concern with instructing, as opposed to pleasing, the public. A year after the opening of the Palais de Longchamp, visitors, in order to understand the two series of numbers, one black, one red, attached to picture frames, had to refer to catalogues; three years later, in 1873, Bouillon-Landais was still working on descriptive labels, and in 1876 he requested funds for labels for fifty-five paintings that still lacked them. In 1882, a year after the opening of the Bordeaux museum, Vallet promised that the placement of labels would be completed "forthwith [*prochainement*]."[61]

The Dijon museum completely lacked descriptive labels prior to Joliet's arrival in 1892; the paintings carried indications only of artists' names and dates. In 1885 a member of the city council proposed adding a brief description of each painting's subject, so that the labels would contain "all the information necessary to inform the visitor, without his having to consult the catalogue." Gleize reacted negatively to the proposal and said that it would entail considerable expense and many practical difficulties: the placement of labels for works hung high up on the wall, for example, or the description of "complicated" subjects. He also declared that labeling would amount to the "suppression" of the catalogue he had written, because then no one would buy it. Moreover, he asked querulously, might not labels on paintings eventually lead to the labeling of drawings and of objets d'art, which "would lose all their charm if they were interspersed with too brief, illegible little notes?"[62]

Joliet had his work cut out for him. Although he did not share his predecessor's aversion to labels, he wrote in his annual report on the museum for 1899 that since he had at his disposal "only a very small sum each year" for labeling, he could proceed only gradually.[63] And even for Joliet labeling counted for much less than the renovation of old rooms or the appropriation of new ones to display recently acquired works, which themselves usually had to wait several years for labels. Adeline's comments on the lack of labels in the Rouen museum thus can be taken to exemplify a generalized assumption about the museum public: "There should be, at the entrance to each room, or in front of every panel, a placard indicating the artist and subject for every painting, or, better, each painting should have an individual label. We would then have a kind of abridged catalogue—not enough for real art lovers, it's true, but enough to disseminate some 'glimmerings of truth' among the mass of the public, who are only interested in a work when they know the subject or

when a famous name halts them en route and forces their admiration."[64] Labels, in other words, represented a kind of service to the visually illiterate; they did not do much for real connoisseurs, who, though aware of the need for them, could not be expected to regard them as a high priority. As a kind of official recognition of the social division of the museum's public, they emphasized rather than dispelled its less educated members' inferior status.[65]

Meticulously arranged, carefully structured installations established the museum visit as an ordered experience of the realm of Art, clearly elevated above the level of the everyday. But the ordering of the visit involved certain other elements as well, prominent among them the concept of "bonne tenue," meaning a standard of decent appearance and decorum that can apply both to people and to buildings. The concern for "bonne tenue" manifested itself at the most mundane level—for example, in curators' preoccupation with cleanliness, especially as reflected in, and signified by, highly polished floors. In 1872 a Marseilles official fretted that "the public is not always satisfied with the state of cleanliness of the museum," even though Bouillon-Landais had two years earlier worked out a detailed schedule and budget for cleaning the building. This plan anticipated a twice-weekly sweeping and polishing, with monthly applications of linseed oil and semiannual waxings; Vallet in Bordeaux, however, considered that daily cleanings and weekly waxings would be necessary to maintain "sufficient cleanliness."[66] The question arose again in Marseilles in the 1890s, after a newly elected socialist administration, with priorities revealingly different from those of its predecessors, cut funding for the museum. The new curator, Guigou, in 1894 called the reduced funding levels "totally inadequate" to maintain the museum "in a proper state of cleanliness." He warned that parquet floors deteriorated without regular waxing, and he described the dusty stairways as "unworthy of a city like Marseilles."[67]

In Dijon, Joliet used much the same argument to prod the city into funding badly needed renovations in the older sections of the museum. He called one gallery, known as the Salle des Chinoiseries from its original decoration, "in its dilapidated state a blemish on and a distraction from the ensemble of our fine museum, giving it a deplorable appearance and . . . leaving visitors with an unfavorable impression." This argument, of course, had the advantage of being reusable. After the completion of renovations in the Salle des Chinoi-

series and the nearby gallery containing the Devosge collection, Joliet wrote of the room in between, which housed some works by Rude, "the *Hebe* gallery . . . stands out as a blemish in the museum."[68] Although the curator did not always get his way, over a fifteen-year period his repetition of this theme did succeed in dramatically transforming the museum. The Dijon museum expanded not through new construction but by spreading gradually through an existing building, and Joliet's invocation of standards of appearance provided a kind of attenuated discourse of worthiness. In 1895, for example, he noted that a state inspector had found the Devosge and Chinoiserie galleries "unworthy of a museum like ours."[69] The curator obviously shared this view and did his utmost to emphasize it to others.

Comparable standards of appearance and behavior applied to the visitor as well; in this way museums summoned a public that conformed to the notion of worthiness they themselves embodied. The regulations for the Dijon museum did not allow unaccompanied children, dogs, or "any person whose *tenue* is not decent." Rouen's regulations similarly prohibited dogs and children and also barred persons with large parcels or baskets that might cause "an encumbrance or congestion" in the museum. It also excluded people of unsuitable *tenue* and "anyone in a state of inebriation."[70] Bordeaux's regulations stated that "order and silence should be observed in the galleries," and Marseilles made the same point even more stringently: "Any person, painter, *amateur,* or ordinary visitor, who causes any disturbance or trouble in the museum, and who ignores such warnings as might be given him, can be deprived of the privilege of working therein or even excluded altogether for a given period of time."[71] Dijon mandated similar penalties for those "disturbing the order and silence that should be observed in the museum"; Rouen forbade any "demonstrations in front of the works of art, either with the hands or with some object that might damage them." Banned also, of course, were smoking, eating, touching works of art, and, in Bordeaux, "any labor unrelated to the arts."[72]

Regulations of this kind served a variety of purposes. To begin with, they constructed in outline an ideal type of museum visit, which curators and other officials wanted to be as orderly, as tidy, and as elevated as the (ideal) museum itself. They had on their side others with direct influence over visitors, including Paul Joanne, the son of Adolphe and editor of the family guidebook series from 1881

to 1911. In a correspondence extending over at least seven years, Joanne asked Joliet to list the masterpieces in the museum that merited boldface highlighting, to comment on staff writers' descriptions of the galleries, and to provide information on recent changes in the installation. At one point he apologized for requesting "all this minutia," but added that "it is very important for a visitor to a museum to get his bearings, so that he can find the objects discussed."[73]

But the "codification" of the visit, in Dominique Poulot's well-chosen term, also set up a model for the visitor or at least made a distinction between those whose visits corresponded to the Joanne / Joliet paradigm and those who had other ideas.[74] That epitome of the *amateur,* the Rouen city councillor Fauquet, discussed the ordered and purposive museum visit in terms that clearly disparaged the possibility of any other kind. "Those who attach some importance to artistic matters," he declared, " . . . think that frequenting these collections provides the public with something more elevated and more beneficial than the satisfaction of idle curiosity or a pleasant diversion."[75] This distinction had such currency that those with an unimpeachable claim to membership in the category of serious visitors could use it to their own advantage.

In a neatly insidious turnabout, for example, some critics charged that curators' actions, and thus by implication their intentions, placed them in the camp of the *less* serious visitors, tourists and others without any appreciation of the higher significance of art. Protesting to the mayor of Dijon about Joliet's uncooperativeness regarding a photography permit, a student writing a thesis for the Ecole du Louvre noted acidly, "Museums are not intended solely for Sunday strollers, and it would be wise of them to assist as far as possible the work of those who view works of art as more than simple images."[76] Though unjust in imputing to Joliet something like philistinism, this gibe had the intended effect: the student promptly received the authorization he had been seeking. It may also have had an unintended effect, for just over a year later, Joliet circulated to the Louvre and the major provincial museums a questionnaire inquiring about their policies on taking photographs.[77]

As Douglas and other anthropologists have made clear, nothing points more intriguingly to the existence of a code of behavior, especially one unwritten other than in the broad outlines of regulations, than an incident perceived as contravening it.[78] Like most

border patrols, those policing the frontiers of *bonne tenue* displayed a heightened sensitivity to the essential characteristics of the domain they were charged to protect. Since the limits of the permissible were vague and inconstant, moreover, museums' guardians often fell back on their instinctive sense of visitors' social and professional backgrounds. Such knowledge provided the best, and indeed often the only, means of evaluating both the risks of potential transgressions and the seriousness of those committed.

One area of controversy involved suggestions of human sexuality, both in works of art and in the conduct of visitors. Obviously, and as Peter Gay has discussed, museums contained large numbers of images of nudes of both sexes, though the female clearly predominated.[79] The most visible manifestations of official prudery, like the paper underdrawers on statuary in the tiny museum of Vaucouleurs (Meuse), offer almost irresistible opportunities for the amused condescension of historians, but the evidence suggests that such practices were rare.[80] It is true that Roger Marx's reaction to a report of "vine leaves" on sculptures in Nancy—he referred to "certain prejudices more persistent in the provinces than anywhere else" and noted that the state had never interfered in such cases—suggests that this one was not unique, though he cited no others.[81] But the views of state inspectors on these matters coincided exactly with those of Vallet, Darcel, Joliet, and most artistically minded city councillors. They make clear that no one with pretensions to aesthetic sophistication would have dreamed of such a crude form of censorship. Politicians and administrators without any such "expertise," moreover, usually had far too much respect for their more cultured colleagues to attempt anything of the kind against their will.

Nonetheless, some inconclusive evidence does suggest that nudity in art was causing somewhat more unease in the last twenty years of the nineteenth century than it had during the Second Empire. Subtle in its contours, this unease manifested itself not in any vulgarly obvious way but in a certain descriptive reticence. Whereas a city councillor in Bordeaux in 1865 had not hesitated to call the female nude in Antigna's *Mirror of the Woods* (Figure 4) "delicious" (though he had also dutifully cited her "purity of spirit"), curators and critics in the later period seemed determined to avoid any expression of physical pleasure. In 1882, describing a picture the city did not purchase, Vallet, while acknowledging that it contained "nothing shocking or tasteless," nonetheless "admitted" that "the attraction

that this almost entirely nude body of a young girl might exert, rather than seducing me, makes me mistrustful." The curator suspected that this "attraction" was meant to compensate for various minor faults of technique and for the painting's lack of originality.[82]

Vallet may, of course, have been dissembling his true feelings, but chances are he was being perfectly frank. Even when curators liked paintings of nude women, they took pains to justify their reactions in technical terms. In 1879 Gleize described Jean-Paul Laurens' *Alone,* which Dijon ultimately did purchase, as "a seated nude woman viewed from the back." He went on to praise the "successful delineation" of the picture and the "vigor" with which the figure "stands out from the background." That figure, he observed, had a "considerable effect"—he did not say of what kind—and, he concluded, "this is an attractive and a highly estimable work."[83] Critics in Rouen discussed Emmanuel Benner's *Bathers* (Figure 20) in

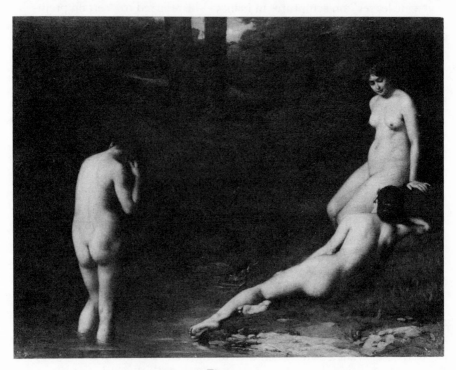

Figure 20
Emmanuel Benner, *Bathers.* Rouen, Musée des Beaux-Arts.

similar fashion. The *Nouvelliste de Rouen* wrote, "There are many excellences in the modeling and drawing of these bathers' bodies, whose pearly flesh stands out against the harmonious background of greenery." Darcel, in the *Journal de Rouen,* described the standing woman somewhat ambiguously as "an excellent morsel" and continued, "on that score, we should add that the painting is far from lacking in charm, with its three ivory brown women set off by a dull green background enlivened by a bit of water in which it is reflected."[84]

If these comments have a slightly disturbing quality, it probably derives from the impression they create of middle-aged men exchanging knowing winks: this is what John Berger, both in general and with specific reference to representations of the female body, has called the language of mystification.[85] Although "men of taste" were perfectly prepared to enjoy paintings of the female nude, they could countenance such pleasure only by circumscribing it, by aestheticizing it and denying it any basis in prurient interest. This carefully controlled complex of reactions, in turn, helps explain curators' sensitivity to anything that even hinted at a more overt response. Some forms of behavior, of course, were beyond the pale by almost any standards. In 1876 a guard in the Marseilles museum discovered a visitor crayoning on "what is called, in artistic terms, the Mont de Venus," as Bouillon-Landais delicately said, of a statue of Daphne. When the culprit, caught in the act, denied the charge and identified himself as a city councillor in Digne, prefecture of the Basses-Alpes, the curator let him go, though not without reporting the incident to the mayor. Two years later, also in the sculpture galleries, a guard surprised a man "making indecent gestures." In this instance an officer conducted the man to the local police station, with "two ladies called as witnesses."[86] Unfortunately the record does not list the charges on which he was booked.

But even before these incidents, Bouillon-Landais had become considerably vexed at the behavior of groups of "young boys from 12 to 15," who, he found, "do not always have a *tenue convenable.*" Proposing that the mayor curtail the number of study cards, he noted that "the principal pastime of these young men consists of lengthy chats, and if now and then they do take up their studies, it is always in front of some nude or other." The curator excluded from his strictures "the young ladies, who are always chaperoned," but evidently this safeguard no longer obtained fifteen years later.[87] In 1890 Bouillon-Landais received a letter from an irate visitor,

224 · THE MUSEUM AND THE CITY

signed only "Un amateur," which managed, in the accepted fashion, to be both suggestive and circumspect:

> I do not understand how people as indecent as those who are admitted to study in the Museum can be tolerated there. Certainly there are very suitable people and I'm not complaining about them, for I am among those who love pictures and encourage as much as possible [*sic*].
>
> But if you permit these goings-on it will no longer be a place of study, it will be a B . . . [*bordelle?*] Those who visit the museum are so annoyed by this that I am venturing to write you and to ask you to have the situation investigated, between 3 and 5 P.M.

A note on the bottom of the page in Bouillon-Landais's hand indicates that the curator took this suggestion, obtained the necessary authorization from an *adjoint,* and showed at least two young women to the door.[88]

However distracting to curators and visitors, flirtations and giggling hardly threatened more than museums' decorum, and that in not very great measure. Vandalism, rooted far more impenetrably in the depths of the human psyche, constituted a much greater threat to the code of behavior the museum embodied. It also provided compelling evidence that museums' association with the structures of social and political power made them and their collections vulnerable to the same hostility and physical violence these structures normally attracted. In 1881 Fauquet brought to the attention of the Rouen city council "an odious act of vandalism, which one would like to believe the work of a lunatic." The assailant had damaged a number of paintings in the museum, most in the Grand Salon, with the "point of a knife or a needle." The mayor of Bordeaux reported a similar incident to the Fine Arts Administration in 1897: "a miscreant or a lunatic" had vandalized five paintings with a sharply pointed instrument. Though none was an envoi, the mayor sought the state's guidance on the repair of the most seriously damaged works.[89]

In the ensuing decade, press reports drew a picture of an epidemic of both vandalism and theft. The latter, in theory a more straightforward phenomenon, nonetheless presented a number of shadowy but disturbing links to vandalism. To a certain extent, the wave of robberies in 1907–1908, many targeting rural churches, derived from uncertainty over the status of religious art and other church

property after the 1905 law on the separation of church and state. But the *Chronique des arts et de la curiosité* also cited three slashings of paintings in the Louvre in three months in 1907 and burglars' "evisceration" of antique furniture in a museum in Louviers. In October of that year, the *Chronique* commented that the trial of a gang of art thieves in the southwest "has revealed to the most skeptical and the most optimistic that the pillage of our museums and country churches has become an organized industry, and unfortunately an all too flourishing one."[90]

In response to these attacks, officials and journalists at first could propose only better security measures for both buildings (bars, burglar alarms) and works of art (glass panels, railings to keep visitors at a distance), including the hiring of additional guards.[91] But, as do many situations that provoke feelings both of outrage and of helplessness, vandalism also raised in the minds of its victims (in the most general sense) the idea of retaliation. Those in positions of authority, as well as members of the public, were wary of anyone perceived as a threat, regardless of whether any evidence seriously implicated the individual in the crime or crimes. It is an indication of the direction that concepts of the museum public had taken by the turn of the century that this particular climate of anxiety spawned a heightened suspicion of artists.

Museums already strictly regulated the conditions of artists' work. They required them to apply for study cards, to provide an oilcloth "of at least a square meter" in size for their workspace, and in Dijon, to remove easels and painting materials prior to the crowded Sunday open days.[92] But in the wake of the 1897 incident in Bordeaux, the city tightened procedures for the issuance of study cards and now required copyists (including those already authorized under the old procedures) to undergo a police check. The curator, Vallet, had no choice but to submit to this regime, but in his last quarterly report prior to his death in 1899, he strongly defended the artists:

> In all the time I have been familiar with the museum, none of the artists working in our galleries has ever committed an act of this nature. They are fine fellows incapable of dishonoring themselves through an act as indecent as it is stupid . . . Copyists have too much respect and admiration for the works of art they are reproducing to think of damaging them; they are more likely to defend them against ignorant or heedless visitors. I have myself seen some warning people

who might have damaged various pictures with their fingers or lor-
gnettes. Far from distrusting them I tend to think of copyists as
guards who cost the city nothing.[93]

But the time was not a propitious one for artists in museums, which
already regarded them as at best untidy and an inconvenience, more
often a nuisance detrimental to institutional serenity.[94] The increased
anxiety almost inevitably made them an object of suspicion as well.

Only one sort of regulation prompted controversy prolonged
and heated enough to bring about change, and this involved the deli-
cate though hardly earth-shattering matter of checking. Most provin-
cial art museums required, at a minimum, that visitors check wet
umbrellas and walking sticks; some stipulated that they be checked
whatever their condition. In a few museums members of the public
had to pay the concierge a fixed gratuity of five or ten centimes for
this "service"; most left tipping to the visitor's discretion.[95] Enforce-
ment of these rules generated impassioned and vituperative argu-
ments that seemed bafflingly disproportionate to the banal incidents
that provoked them. The usually combative Bouillon-Landais appar-
ently decided early that this was one battle he did not wish to join.
When officials in Bordeaux, following a common practice of inter-
city consultations, asked their counterparts in Marseilles for advice
on checking and other regulations, Bouillon-Landais responded that
the museum had no checking requirement, because experience had
demonstrated that "it was nothing but a vexatious tax on the public.
I have even seen," he added, "fathers walk away from our galleries
to avoid paying ten centimes apiece."[96]

The Bordeaux city council voted on these grounds not to impose
any fee on checking and to make it mandatory only in wet weather.
But even this requirement could provoke controversy, as the *Petite
Gironde* had occasion to recount in detail and with evident relish.
One autumn afternoon in 1888, a journalist entered the north wing
of the Bordeaux museum with a dry umbrella, which he kept with
him during his visit. Crossing the garden to the other wing, he
noticed that it had rained while he was inside, though rain was no
longer falling. When he entered the south wing, nonetheless, the
guard asked him, "politely but not without a certain stiffness," to
check his umbrella. Let the visitor take up the tale:

> "But at the other door [he protested] I was allowed to go through.
> I was told checking was optional."

"It is optional when it's not raining."

"But it isn't raining: my umbrella is dry."

"O.K. [*D'accord*], it isn't raining, but it has been. If your umbrella is dry, that's its problem [*il est dans son tort*]. I only know the rules."

"Excuse me, but I see fifty-odd people whom you have allowed to enter with their umbrellas. Why won't you let me do the same?"

"Those people had come in before the rain, while you are entering after it."

"But my umbrella is no wetter than theirs, because I was under shelter while it was raining—in the museum itself, on the other side of the garden!"

"That doesn't matter. The rules say"

This somewhat surreal encounter ended only when the police officer on duty approached and, failing to persuade the visitor to check the offending umbrella, allowed him to proceed, but only after taking down his name and address.[97]

In Rouen, just after the 1881 incident of vandalism, the city council took up the matter of checking in a session ostensibly devoted to security. In a brief but tart exchange, members of the council disagreed not only on the merits of mandatory checking, which one member called "a petty nuisance and an unnecessary hindrance," but on whether the advisory commission had previously issued an opinion on the matter. To one member who proposed that checking be required as long as it remained "entirely free," Fauquet observed that this policy had been in effect for two years but was not enforced. The mayor expressed his support for a proposal to enforce mandatory checking, and after further study the council adopted it.[98] The following year the *Petit rouennais*, always happy to twit the city administration, printed a letter from a visitor protesting the regulation. The writer observed that the Louvre did not have such a requirement, and he complained that the regulation subjected the public to unnecessary delays. The newspaper endorsed its correspondent's views, and a few months later weighed in with an editorial calling the regulation "freakish" ("fantaisiste").[99] In 1887 a visitor named Brunel made a similar protest to the Fine Arts Administration, on the mistaken assumption that "since museums are the property of the state, they should be subject to a single set of regulations; there is no reason to forbid in Rouen what is permitted in Paris." Though Brunel called the requirements "an abuse of power and an excess of zeal that are difficult to understand," the reply

informed him that the administration had no authority whatever in this domain.[100]

All this fuss about what appears to be a relatively innocuous regulation has the air of an intriguing but esoteric ritual; as such it invites closer examination. If one takes another look at some of the arguments, a familiar picture of the museum public begins to emerge. The journalist in Bordeaux observed "fifty-odd" people carrying what he called "these engines of preservation." Even allowing for the likelihood of cloudy skies before the afternoon's rain, this plethora of umbrellas suggests a considerable prudence on the part of the museum's visitors. The *Petit rouennais*'s correspondent claimed to have seen people in the Louvre carrying "soaking wet umbrellas that were soiling the floor." From this scene he deducted that "since guards are there to maintain the cleanliness of the galleries, I see no reason why the public should have to wait first when checking the object, and then again in another place on leaving."[101] As for Monsieur Brunel, though he listed no profession in his letter to the minister of fine arts, he did give a solidly bourgeois address.[102]

One begins to suspect that the carrying of umbrellas and walking sticks had some special significance for members of the bourgeoisie and the middle class. Such weighted meaning explains why visitors objected so intensely to giving up their "engines of preservation," particularly in the context of such a socially codified activity as visiting an art museum. Both contemporary and more recent writers on fashion have observed that by the middle of the nineteenth century at the latest the carrying of umbrellas, once confined to an elite, had spread to all classes, and that the shape and condition of an umbrella could provide clues about the social status of the person carrying it.[103] That avenue of investigation, alas, holds little promise without any physical descriptions of the umbrellas visitors were so loath to check, but we can look a little more closely into the practice of carrying umbrellas.

The wedding party in Zola's *L'assommoir*, to take one obvious (if fictional) working-class example, carried and checked umbrellas on their visit to the Louvre, but then they would not even have thought of going to a museum if it had not been raining.[104] The controversy over checking requirements involved chiefly bourgeois, people who visited museums in fine as well as in wet weather, and who had visited enough of them to be able, in their protests, to comment on practices in a number of different museums. Sketches for the

post-1870 period in Louis Uzanne's history of Paris fashion, which appeared in English in 1897, almost invariably depict women dressed to go out holding either an umbrella or a parasol ("ombrelle"), an accessory to which checking requirements also applied. That might explain why the women the Bordeaux journalist observed were all carrying umbrellas. As for the men, this comment by Pierre Larousse in his *Grand dictionnaire universel du XIXe siècle* provides a clue: "The *umbrella* is the symbol of the quiet and peaceful life. It is the implement of the steady and careful man, of the bourgeois, of M. Prudhomme. When one wants to depict the stereotype of calm, of mediocrity, and of *bonhomie,* it suffices to show a man carrying under his arm a very solid, very solemn umbrella, a slim brolly [*riflard*] in good condition." [105]

As an alternative to the hypothesis that umbrellas constituted a form of status identification, one might postulate that individuals like the Bordeaux journalist and Brunel were simply protesting, in time-honored fashion, the whims of an overweening bureaucracy. Certainly that element had its place, but in the classic pattern outlined by Michel Crozier and others, protest against French bureaucracy has a chiefly cathartic character and produces no concessions whatever. [106] In this instance, however, arguably owing to the class status and consequent influence of the protesters, protest did lead to change. In Bordeaux, at Vallet's suggestion, the city responded to the *Petite Gironde* article by making checking optional at all times, even in inclement weather. Rouen, after another quick discussion in the city council, took the same step in 1890. [107]

The Dijon city council, however, had by 1890 gotten no further than discussing the possible elimination of the five-centime fee imposed on checking. It had rejected the proposal because the proceeds from this fee paid for cleaning the museum: the assumption that museum staff could clean up after visitors, though to some extent shared at an official level, had ramifications that complicated the issue in unexpected ways. Thus when the council considered the imposition of admission fees in 1899, a subcommittee of the museum commission noted the prospective disappearance of gratuities as one of its likely benefits. [108] In the context of the debate over admission fees, perhaps the most contentious and significant issue provincial museums faced at the turn of the century, checking at last became secondary. Its appearance in the Dijon discussion, however, illustrates how proponents of paid admission portrayed

fees as the ultimate means of resolving problems inherent in the administration of the museum as well as in the ordering of the visit. Obviously, too, the debate over paid admission and the measures ultimately resulting from it were closely bound up with both the discursive and the actual constitution of the museum public.

Admission and Exclusion

The first two fee systems in French museums began in Rouen in 1898 and in Dijon in 1904.[109] In both cities, either the contemplation or the implementation of these measures produced a substantial battery of data on the number of visitors to municipal museums; although each set contains gaps, together they suggest general patterns. Rouen and Dijon did not collect fees on Thursdays (then a school holiday), on Sundays, or on public holidays, days that typically attracted the largest numbers of visitors. Rouen began recording attendance figures only after the imposition of admission fees, and it recorded actual numbers only for the days visitors had to pay. But its rough estimates for free days show that the difference between them and paid admission days amounted to an order of magnitude (see Table 8): on Sundays and holidays the Rouen museum attracted an average number of visitors from ten to twenty times greater than on weekdays, for example 327 versus 14 in 1897. The imposition of entry fees may have had something to do with this disparity, but it could at most only have reinforced the public's already substantial preference for visiting museums on Sundays.

The data for Dijon do not include even estimates for Thursday and Sunday admissions, but they do include attendance before and after the start of the fee system. From 1901 to 1903, the number of weekday visits to the museum rose an average of 5.5 percent per year. In the first year of paid admission, attendance dropped by 12 percent, and in the second, 1905, it fell an additional 17 percent.[110] Put another way, in 1900, when Rouen had fees and Dijon did not, Dijon received almost three times the number of weekday visitors that Rouen had; in 1905, when both charged admission, Dijon attracted a little less than twice as many and in 1906 just over twice as many. Though not negligible, this falling-off in weekday attendance after the imposition of fees does not even approach the huge contrast observed in Rouen between weekday and Sunday admission.

Table 8. Attendance in Rouen and Dijon, 1898–1906

Year	Rouen Sunday avg. (est.)	Rouen Weekday daily avg.	Rouen Weekday total	Dijon Weekday total
1898	327	14.0	3,591	—
1899	234	12.8	3,267	—
1900	420	11.2	2,848	8,257
1901	—	—	—	8,456
1902	—	—	—	9,199
1903	—	—	—	9,893
1904	—	—	—	8,667[a]
1905	327	14.3	3,646	7,176
1906	257	13.1	3,392	7,114

Source: For Rouen, annual reports (on the previous year) in Ville de Rouen, Conseil Municipal, *Procès-verbaux des séances.* For Dijon, figures for 1900–1903 from Musée des Beaux-Arts de Dijon, Archives XII, an undated sheet in Joliet's hand headed "Entrées au Musée pendant la semaine"; figures for 1904–1906 from ibid., Archives V, annual reports.

a. Estimated figure based on 6,139 paid admissions from 16 April through 31 December; calculation explained in note 110.

Anecdotal information from throughout the period and from all over France provides additional evidence of this preference for Sunday visits. Bouillon-Landais referred in 1875 to "the crowd that congests our galleries" every Sunday; twenty years later, his successor reported that the museum "is constantly visited by a large public, and by a veritable crowd on Thursday and Sunday afternoons." In Bordeaux, Cabrit wrote in 1903 of "the visitors who throng into the galleries, especially Sundays and Thursdays." Joliet, in the wake of thefts in other museums, in 1902 proposed an augmentation in the number of guards on Sundays and holidays, "because of the crush of visitors on those days."[111] Elsewhere, many museums surveyed in the course of the 1895 state inspection reported substantial differences in attendance between weekdays and Sundays: between 500 and 1,000 on Sundays and 120 on weekdays in Grenoble, 150 to 220 on Sundays versus only a handful during the week in Perpignan, several hundred versus forty to fifty in Toulon.[112]

Within the confines of these visiting patterns, which they intended neither to disrupt nor to exploit, admission fees aimed most fundamentally at providing museums with at least one dependable source of financing.[113] The proceeds from the fees could not, of course, completely replace municipal appropriations, but they could offer some shelter from the whims of politicians and their changeable priorities. Beyond this fairly obvious goal, officials in Dijon also presented their proposal simply as a means of ending the administrative fiction that the museum was open to the public only on Thursdays and Sundays, a system that had visitors on other days tip the concierge to gain admission. Fees would not only eliminate this haphazard arrangement, so that visitors would always know what to expect, but also provide a means for officials to consolidate their control over the institution. Gratuities, for checking as well as for admission on "nonpublic" days, had gone into the pocket of the concierge, who used this fund at his discretion to pay for cleaning and maintenance. Joliet chafed at this practice and anticipated its termination with satisfaction: "With the maintenance of the museum no longer dependent on the good will of the concierge, the authorities would be free to have the galleries put in order whenever and however they find necessary."[114]

The Rouennais, whose museum had been open every day since the completion of the new wing in 1880, could not make the Dijon claim that they were simply "regularizing" an existing situation. But proponents of fees made a related argument, saying that the charges would affect mainly out-of-town visitors and tourists, who were in their view the only visitors the museum normally attracted on weekdays. Residents of the city, who generally came on Sundays, would continue to enter free of charge. The administration's original proposal had left Sunday as the only free day, but as a concession both to opponents of the measure and to the logic of their own argument, officials agreed to exempt Thursdays as well.[115]

In Dijon, in contrast, the same premise resulted not in more exemptions but in a proposal for even higher fees. Whereas the administration and the museum commission had initially suggested a fee of fifty centimes (as opposed to a franc in Rouen), the city councillor Durnet found this figure too low, for an eminently logical reason: "Since it is a matter of milking foreigners, people who never bother to bargain, for a certain sum of money, I don't see why we should hesitate to ask them for a franc. In thus doubling the pro-

posed figure, you won't get one fewer foreigner, and you'll have 10,000 francs instead of 5,000." To the objection that Rouen had suffered a considerable drop in attendance with its one-franc fee, Durnet replied loftily, "The Rouen museum is not comparable to that of Dijon." The city council agreed to the higher charge, which prompted a vigorous protest from Joliet, who feared that it would "prevent many Dijonnais and even foreigners from visiting the museum as often as they would like." Wishing to mollify the curator, Durnet then proposed, and the council accepted, a compromise: fees were set at a franc for individuals and fifty centimes apiece for members of "groups" of two or more.[116] These still represented considerable sums for workers, at a time when one could purchase a popular tabloid for a few centimes and a meal in a working-class restaurant for a franc or less.

No matter how cities presented them, as emblems of a certain sociocultural outlook admission fees attracted intense scrutiny and in some cases outright opposition. Though proponents of the fees made many references to foreign museums that had long charged admission, principally in Italy and Germany, such comparisons carried little weight. The Dijon museum commission observed in its report on the question, "The system of admission fees common in the large majority of European museums has always been repugnant to the French, who want museums nourished at the expense of the state or the city to be open liberally to everyone."[117] The minister of public instruction and fine arts took exactly this position when informed early in 1898 of Rouen's decision to charge admission. Justifying the state's intervention on the basis of its envois, the minister, in a letter drafted by the fine arts director, Henry Roujon, declared that "in entrusting these works to the city of Rouen, the state implicitly intended that they be freely exhibited to the public, without restrictions or reservations, either at [the time of transmittal] or in the future." The minister went on to note that Parliament had recently "indirectly endorsed this interpretation by voting against fees in the national museums [i.e., the Louvre, the Luxembourg, the Musée de Cluny, and Versailles]." On his colleague's recommendation, the minister of the interior refused to ratify the Rouen decision.[118]

Though the state thus technically rendered the Rouen fee system null and void, the city used a bureaucratic loophole to continue it: the government had approved the municipal budget, which included

proceeds from the fees among anticipated revenues. In ratifying the municipality's decision to defy the state, the city council, in tones of righteous indignation, affirmed its commitment to a measure it characterized as "in the highest municipal interest." One member of the council commented sarcastically that, on the basis of the state's "pretension," the city might logically ask it to contribute to the museum's operating expenses. Though the government threatened later in the year to use one of its most drastic powers, rejection of the entire city budget, to force Rouen's compliance, it never did so.[119] Joliet, when the mayor of Dijon first consulted him on the fee question in 1899, warned that in view of the state's opposition to admission charges the city might not have the authority to impose them. But by the time Dijon actually began charging admission in 1904, the climate had changed dramatically: Joliet reported in June of that year that the Fine Arts Administration would not oppose fees as long as "the proceeds serve to augment [the museum's] resources."[120]

Even the state's eventual acquiescence, however, could not eliminate the taint of elitism. A letter published in the *Journal de Rouen* in 1897 put forward the practical objection that tourists would simply bypass the museum in favor of the city's (free) medieval sites, and that the fees would thus not bring in the anticipated revenue. But the writer also attributed to city officials an exclusionary intent: "It is possible," he wrote, "that abuses have been committed by people who come in only to warm themselves or who talk politics in the galleries, but that can be handled through internal regulations and policing."[121] The official argument, that fees would affect only wealthy tourists, in theory placed the motives behind them above suspicion, but city councillors nonetheless displayed considerable sensitivity to the charge of elitism. In the session in which the Rouen city council voted to defy the state, the *rapporteur*, Petit, noted somewhat defensively that the system "leaves free the two days when visits are most frequent, above all among the less fortunate classes, who are the object of the administration's particular solicitude."[122] Yet such declarations had a somewhat forced quality, especially in comparison to spontaneous expressions of concern, both in Rouen and in Dijon, that admission fees might discourage city residents who habitually took their out-of-town guests through the museum.[123]

The *Chronique des arts et de la curiosité,* a reliable source for the

opinion of the well-informed art public, initially endorsed admission fees in only moderate, even cautious terms. Affirming in 1907 that "there can of course be no question, in a democratic country, of removing from the greatest number the right to enter museums freely," the journal suggested that "one or two days per week" of paid admissions would not infringe on this principle. But a few months later, in the near hysteria of its response to the wave of vandalism that coincided with the separation of church and state, the *Chronique* shed some of its democratic rhetoric. A brief news report bluntly treated Lyons's decision to charge admission as one of a number of security measures "following the damage done by miscreants" to paintings in the museum. The other measures included the mounting of glass panels over the smallest and most accessible paintings, construction of a steel bar to keep visitors at a distance from the walls, and, dare it be said, mandatory checking of "umbrellas, sticks, and parasols."[124]

Meanwhile, curators in a number of other provincial museums were writing to Joliet for financial data to use as ammunition in their own campaigns for admission fees. In the course of such correspondence, normally businesslike, a curator might occasionally express the kind of sentiment kept carefully out of the public discussion. The curator of the Grenoble museum, Bernard, wrote to Joliet in 1904: "My proposal was rejected almost without discussion, despite the favorable opinion of the advisory committee. The inevitable formula 'it's undemocratic' was the main argument used against me—a completely erroneous argument, because the working population would be able to benefit on Thursdays and Sundays from works of art acquired with resources provided exclusively by the fortunate classes."[125]

It would, of course, be misleading to impute such an acute sense of class distinction to every supporter of admission fees. Without actually attempting to exclude particular classes from the museum, however, curators and officials knew full well that admission fees would at best only perpetuate the existing composition of the museum public rather than in any way expand it. To this extent at least, fee systems also promised to preserve a code of behavior clearly associated with the "fortunate" classes. Those in charge of museums could hardly have felt much concern if fees caused workers to visit museums even less often than they had before.

The debate over admission fees, as a focal point for the assem-

blage of information and the expression of opinion, offers a suggestive picture of the museum public and its habits at the turn of the century. On the question of visiting patterns, the evidence provides a way of assessing the relative importance of two "types" of museum visit proposed by Poulot, one a rare and exceptional event, a "fête intime," the other a serious, tranquil, quasi-professional exploration.[126] Certainly museums attracted unusually large numbers of visitors, most of them undoubtedly the merely curious, on holidays and in conjunction with other special events. The Bordeaux museum, for example, reported two thousand visitors on the day of a fair in 1903. Museums were also receiving increasing numbers of visits from groups who could only have regarded them as special occasions. Groups of schoolchildren appeared often in Bordeaux and Dijon after 1900, and Marseilles welcomed somewhat more exotic visitors: a delegation of Algerian teachers in 1889, sailors from the visiting Russian fleet in 1893.[127] But crowds on Sundays could not have been consistently so much more numerous than those during the week without a large number of repeat visitors. If these were scholars or artists, why would they have come on the days most popular with the public at large? In view of their frequent evocation by municipal officials, many were probably local bourgeois, whether they were showing off the city's treasures to guests from out of town or merely engaging in a pleasant Sunday pastime.

The development of visiting patterns in the late nineteenth century does not, however, lend itself to an optimistic view of "democratization" or of an expanding public. One can reasonably posit the presence in museums of the "new middle class," for example clerks, mid-level managers, and secretaries, many of them bent on self-improvement.[128] In the context of the city as a whole, however, the inclusion of this new social stratum, with all its aspirations to upward mobility and its aping of elite mores, could not be considered a radical diversification. It is likely, too, that different professional groups and even different classes commingled on Thursdays and Sundays, and the proliferating school groups had the potential at least of exposing working-class children to one of the bastions of high culture. Curators like Joliet in Dijon and Cabrit in Bordeaux encouraged such visits and also showed other signs of recognizing the needs of a potential audience broader than the museum's traditional public. In his first report as curator Cabrit wrote that "a clear, simple, and precise catalogue, practical in its popularization, is

indispensable"; such a catalogue, he felt, should be priced at a level "within reach of everyone." The following year he reported on his efforts to improve and complete the labeling system so that "the public can learn the principal facts relating to a work without fatigue, without effort, and without the aid of the catalogue."[129]

Praiseworthy in themselves, Cabrit's efforts were far from unique. But they did not represent his fundamental preoccupation. Before expounding on what schoolchildren could learn in museums, the curator had recounted a visit by the celebrated artist and academician William Bouguereau and had recorded his every comment in the hushed tones of devoted discipleship. Cabrit's reports in succeeding years, and to a certain extent Joliet's as well, often contained this peculiar mixture of rank social and cultural snobbery and sincerely popularizing attitudes, frequently accompanied by appropriate action. Neither curators nor their municipal superiors would have seen any contradiction in this juxtaposition, for they never questioned the essential worth of the culture that museums embodied.

A model of hierarchy, of order, of respect for art as something separate from the exigencies of daily life, as long as it laid claim to this special status in certain accepted and moderate ways, the art museum thus stood in a virtually metonymical relationship to the system of values of the bourgeois elite as a whole. Far from questioning these values, those in charge of museums clearly recognized, although rarely in explicit terms, the museum's connection to these values, not merely as symbol but as bulwark. Museums could do much within the confines of this cultural model, and at the turn of the century they were beginning to do more, but they could not transcend it. For this reason they provoked for the most part indifference, but occasionally, as we have seen, outright hostility from those who found the value system itself at best elusive, at worst indecipherable, irrelevant, and exclusionary.

Like the mythology of Carolus Duran's *Danaë,* the dominant culture of late nineteenth-century elites has had its day. Though its limitations, in retrospect, seem painfully apparent, much can also be said in its favor. Art museums at the turn of the century showed signs of increasing conscientiousness in preservation, of care in scholarship, of imaginativeness in presentation: newspapers commented approvingly on the spaciousness of the Depeaux installation, where each work had room to breathe.[130] Cabrit and Joliet owed their positions as much to their wealth and social prominence

as to their expertise, but their approach to running museums suggested the possibility of a museum profession capable of restoring to the museum something of its original educative purpose. Their tireless pursuit of donors confirmed the passage of art into the public domain and provided an incentive for keeping at least some of it in the communities that had produced it. The era of consolidation gave museums force and weight in the city, and this was by no means a modest achievement.

But if we tend today to overlook the effort and the dedication that underlay and shaped the museum as institution in the late nineteenth century, it is not simply because we take them for granted. Culture as institution, in the form of the art museum, is subject to a particular set of constraints, signified above all by an air of stultification, a pervasive solemnity that leads as readily to boredom as to insight.[131] Jean-Paul Sartre was giving voice to a commonplace when he recorded his impressions of a provincial museum in the 1930s:

> A guard was sleeping by a window. A pale light was falling from the skylights and hit the paintings in streaks. Nothing was alive in this great rectangular room except a cat that took fright at my entrance and ran away . . .
> A gentleman and a lady had come in. They were dressed all in black and tried to make themselves very small. Struck, they stopped on the threshold, and the gentleman mechanically bared his head.[132]

The museum in the bourgeois image was, after all, an "instrument of civilization," with all that those words imply in terms of power, ideology, and domination. It remains possible, of course, as both Sartre's boredom and his irony suggest, to derive pleasure from the institution without wholly assimilating its values, but such a strategy cannot alone vitiate museums' power, the signal realization of their creators. That power manifests and perpetuates itself through the sense of permanence and inevitability that is at once the most familiar institutional achievement of bourgeois elites and, to the extent it masks their power, the most dangerous. Recognizing museums as constructed institutions also restores to them the dimensions of finiteness, of concreteness, of fallibility. Nothing was inevitable about the history of the art museum except that, like most human institutions, it would in the long run embody the imperfections as well as the highest aspirations of its creators.

Conclusion

Like culture itself, museums are part of a complex and variable formation of social structures, political groupings, and beliefs and values with which individuals construe lived experience. As institutions of culture, museums embody the structures and relationships that give them and culture shape. Their development, as this book has argued, thus illuminates both particular histories, here that of modern France, and more general problems in the social construction of culture. Since the interplay of institutions with their social frame is quintessentially dynamic, a summary of museums' relationships, whether in terms of French history or of contemporary culture, demands that they be brought up to date. The following observations, then, both reflective and speculative, aim to review the relationships and dynamics that developed in the course of the history presented here and, in examining their transmutations in the period since 1914, to outline their conjunctures with the history that museums continue to make.

That the French state left to local elites the possibility and in some senses the necessity of forming art museums in their own image reflects not a consistent single outlook but the coincident aims and consequences of several phases of its cultural policy in the nineteenth century. In the beginning, monarchical regimes signaled their investment in and their authority over the culture of the whole nation primarily by sending objects to the periphery. Their investment in institutions they confined to the capital, traditionally the site of the most visible and ostentatious manifestations of power. Later, under the impulsion of both the theoretical and the practical concerns of republican ideology, arts administrators felt the need to take part in shaping the character of institutions outside the center. They employed various means, chiefly personal representatives, to

inject those concerns into the discourse and practices of provincial museums. The state in this period ultimately did not play as active a part as it proclaimed for itself, not only because it did not bother to synchronize the discourse it produced with the current phase of the museum's development but also because the authorities to whom inspectors reported could measure success only in terms of the achievement of policy objectives, not in terms of the instruments used to achieve them. For the state, provincial museums were always a means: its rhetoric never acknowledged that for many cities they had come to constitute an end in themselves.

Yet though by the end of the nineteenth century the major provincial museums had long since ceased to be primarily devoted to the training of artists, in other respects they corresponded reasonably well to the ideals of republican cultural policy. State inspectors recognized and endorsed the desire of municipalities to celebrate their own cultural heritage with special installations devoted to local artists and to local artistic production, both past and contemporary. Indeed, in its centripetal vision of the turn of the century, more focused if less ambitious than in Napoleon's day, the state Fine Arts Administration would probably have preferred provincial institutions to be even more localized in their presentation than they already were. But the state could hardly demur from practices of acquisition and display that, like its own investment in contemporary art, had come to construe themselves as an act of critical judgment in order to cement the relationship between cultural and political authority that the museum embodied.

Despite this effective consensus with the state on the nature and significance of their collections, the local elites who built museums and made up their privileged constituency had too much respect for cultural hierarchy to equate their institutions with those of the state. If the museum stood for authority, the Louvre and the Luxembourg, whatever their deficiencies, represented the apex of that authority. In addition to their local peculiarities, provincial museums were far more heterogeneous than those in Paris, in terms of both chronology and generally accepted notions of quality. Not only could local bourgeois invoke the Louvre when opposing their own museums' regulations; more than a few must have shared the reaction of the hero of Huysmans' *L'oblat,* who on a visit to the Dijon museum is so struck by Alphonse Legros' *Ex-Voto* that he wonders why it is not in Paris.[1] But however hierarchical their

notions of quality, those acquainted with both the national and the important municipal museums at the turn of the century could not ignore how much they had in common. On the level of collections, museums in major provincial cities included virtually all of the artists housed in the Luxembourg, the supreme accolade the state could bestow on the work of living artists. They also began moving at about the same time to embrace artists who worked in modes of production and distribution (dealers and small exhibitions rather than the Salon) that had previously been denied official recognition.

Though all museums around the turn of the century suffered from overcrowding, the major provincial institutions, with a few exceptions, had little to apologize for in the matter of lighting, installation, and conditions of display, particularly in comparison to the notorious inadequacies of the Louvre and Luxembourg. National arts officials prided themselves on their expertise in cataloguing and labeling objects for the edification of their visitors. Yet they shared with curators and connoisseurs in the provinces an aesthetic of display that valued a trained eye with no need of catalogues or labels. Efforts by local officials to enforce an orderly, tranquil, almost sacralized visit of the museum also met with a responsive chord in Paris. The state was even prepared to repudiate firmly stated democratic principles, such as that of free admission, when the preservation or consolidation of institutional authority seemed to demand it; in instituting fees, indeed, provincial museums were anticipating measures that the national museums later adopted.

Precisely this set of common standards, which allowed the state in good conscience to leave responsibility for museums to local elites, in the long run made such a relationship untenable. New standards of quality and notions of representing an oeuvre or period had the effect of virtually pricing provincial museums out of the market for art not only of the distant but also of the recent past. By the turn of the century associations devoted to local history, archeology, and preservation were largely replacing art associations as the focal point of elite interest in local culture. These groups often entered into productive relationships with municipal art museums, occasionally even donating objects—generally drawings, graphic art, or decorative art of local fabrication—to museum collections. Most cities, however, were still unwilling to situate their museums in a discursive space confined to local traditions and the local patrimony. The expansion of tourism that came with the auto-

mobile may have had something to do with this reluctance: a museum of local interest may receive one or two Michelin stars, at best "worth a detour," but only those with works from the art historical canon can boast the third star indicating they are "worth the trip." Generally accepted standards of scholarship, installation, and interpretation, meanwhile, demanded more expert, more professional curators and considerably expanded levels of funding. State approval of all candidates for provincial curatorships, the compromise solution of the 1910 decree, fell far short of meeting the first need, but curators began developing professional standards and a professional esprit de corps on their own. Shortly after World War I, reacting among other things to continued municipal parsimony, curators formed their first professional association.[2]

The forces that exerted pressure on the museum and its image in the twentieth century recall those that were at work in its formative period. In the nineteenth century the nature and pace of urban development impelled urban leaders to give the museum a new form and status; in the twentieth the consequences of war served as the catalyst to a dramatically expanded state role in the affairs of provincial museums. The physical consequences of World War I, while devastating, touched chiefly northern and eastern France, but the pervasive financial instability of the interwar years was a general phenomenon. In every region and at every level of government inflation and the massive cost of reconstruction and rehabilitation placed stark constraints on public spending. Curators' recollections of this period display the frustration of people without the means to effect even the most basic of improvements. As a natural consequence of the new claims and purposes they invested in museum collections, for example, connoisseurs and officials found the old aesthetic of floor-to-ceiling display increasingly unsatisfactory. Yet they found themselves entirely without the means to change it.[3]

The far more widespread physical destruction of World War II, including that wrought by Allied bombing as well as by the occupying authorities, had much to do with the energetically reformist atmosphere of the period following the Liberation. In July 1945 the (provisional) government finally produced an ordinance broadening the basis of the state's commitment to provincial museums.[4] This decree established, first, a category of *musées classés*, the thirty-five or so most prominent provincial museums. The state requires that candidates for the directorships of these museums (and in some cases their deputies) have passed the examination that grants entrance to

the national curatorial corps; it also pays a portion (since 1984 all) of their salaries.[5] Because preparation for this examination normally includes courses offered by the Ecole du Louvre, the state has essentially assumed responsibility for the training of curators, something the museum reform commission proposed as early as 1908.

But the partnership that has developed between the state and the various levels of local government goes beyond curatorial appointments. The state participates in major municipal purchases, in conservation, and in the construction and renovation projects in which many cities, a century after the original boom of museum construction, have recently been engaging. Municipal museums receive not only funding, information, and regulation but also, through a descendant of the Inspection des Musées, technical advice on a continuing basis. The Réunion des Musées Nationaux, one wing of the national museum administration, supports the publication of major scholarly projects from the provinces, such as the 1987 catalogue raisonné of the Italian paintings in the Bordeaux museum. Loans for major exhibitions move in both directions, from Paris to the provinces as well as the reverse.

This partnership does not, of course, enjoy either perfect harmony or perfect equilibrium. The interests of the national museum establishment sometimes conflict with those of provincial museums, and curators with loyalties to both often find themselves caught in the middle. In the early 1950s, for example, the state decided to reassemble the Campana collection for presentation in a single museum, an effort that culminated with the opening of the Musée du Petit Palais in Avignon in 1976. The state offered museums compensation for their Campana pieces, but it did not have enough Italian primitives to fill in all the gaps its requests would leave in provincial collections. The resulting negotiations were often arduous, with the local curator in the position of advising both the city on what it could reasonably ask for and the Louvre on what it could get away with offering.[6] As members of the 1906 museum reform commission feared, moreover, many curators, as skilled professionals with both administrative and intellectual links to Paris, are reluctant to take up positions in the provinces. They know that municipal support for museums remains as subject as ever to political variation, and though the range and quantity of funding from the state and other levels of government has increased, so has the political and bureaucratic complexity involved in obtaining it.

Notwithstanding such problems, the recent cultural policy of the

state reflects a far broader and more generous conception of France's patrimony and of the state's own responsibility to the cultural life of the nation than has obtained in the past.[7] In the standard view, the prospects for genuine decentralization in France seem mixed at best, given the continued preponderance of the capital in the national culture and the homogenizing effect of modern mass communications. In a sense, however, the notion of "decentralization" as a policy imposed outward from Paris is itself an illusion, the vision of a bureaucracy and a political class conscious of their historical role as avatars of the centralized state. *Décentralisation* has long figured as a desideratum in French political discourse; on the state's part it has meant either its opposite, as under the two Napoleons, or not much at all, as in the Third Republic. Even local elites, while citing *décentralisation* either as an objective or as an alibi, have not always taken it seriously in political terms; they have simply made it a reality in other domains. A vital urban culture in provincial France is, for that reason, not something that needs to be created: such a culture is, rather, a tradition that supporters of decentralization now have an opportunity to tap.

The new collaboration of the state and local governments has invoked as its purpose such principles as wider access, broader inclusion, democratization. Yet it is far from certain that the social and ideological construction of the museum has, even in this light, substantially shifted ground. Museum exhibitions, for example, have in recent years become more ambitious, more concerned with the exposition of historical and on occasion even ideological problems, and certainly more popular. Yet these developments, though to some degree complicating the treatment of the objects exhibited, in the case of past art almost never confront fundamental problems involving the status of the object and do not compromise the authority that museums claim and exercise on behalf of their organizers.[8] Similarly, the proliferating sociological surveys that reveal the elite composition of the museum public and comment on the absence of the working class from the institutions of high culture often seem to be doing little more than assembling statistics for their own sake.[9]

Recent developments in the United States, however, demonstrate, if not the intractability, at least the extreme complexity of the problem of the museum and its public; it is hardly as though Americans have found some easy solutions that the French have somehow

missed. The work of Neil Harris, Paul DiMaggio, and others has linked the development of American museums in the late nineteenth century to the familiar need for legitimation of bourgeois elites. As in France, that purpose has remained central; Vera Zolberg observes that "public education has been claimed as a basic function of American art museums since their founding . . . Nevertheless, until recently very few have systematically pursued this aim if it meant sacrificing others."[10] Recently, indeed, some American museums have pioneered strategies that treat museums as centers of neatly packaged entertainment, pushing education further into the background. Not only has the notorious commercialism of the special exhibition become rampant, but it has spread to permanent collections as well. Museums invest these installations with dubious claims, frame them with spurious innovations, most egregiously the reproduction of donors' homes, and inundate them with the trappings of spectacle, of which the latest is the "celebrity" acoustiguide. On its own, simply increasing public traffic in the museum resolves nothing but (if the museum is lucky) the balance sheet; the arrival of the crowds is more likely to prompt the construction of a new restaurant than any serious questioning, let alone subversion, of the museum's traditional claims or associations.

Many of the most striking characteristics of recent museological practice in the United States can be traced, at least indirectly, to the American museum's overwhelming reliance on private funding, in which corporate philanthropy has of late assumed an important role.[11] French museums, particularly in the provinces, in some respects suffer from the relative absence or at least poverty of this tradition: at the most basic level, they are far less generously endowed and less amply staffed than their American counterparts. The museum in France has always resolutely insisted on its public character, which, because of prevailing assumptions about the state and its responsibility to the national patrimony, has automatically meant public funding. One may deplore the weakness of the tradition of private philanthropy in France (though, given the appropriate incentives, it can emerge; witness the Musée Picasso in Paris), yet clearly an insistently public status has its benefits as well. For, in sorting out its future course of action, the French museum at least does not have to regard as inevitable its thralldom to the particular interests of any one constituency. Throughout its history, the museum in France has represented the conjuncture of ideas about

culture in the public sphere and of concepts of the city. Its character depends on those of its component parts and of the authorities over them, which means that its capacity for change, though not infinite, is considerable and constant.

Those who built the museum in the nineteenth century encountered many obstacles; they overcame them through a combination of confidence in themselves and commitment to their community that, however hegemonic the purposes they were serving, can legitimately claim our admiration. The project of changing the museum today, either in France or anywhere else, begins in a more interrogative mode and with different assumptions. Yet even on its own terms, the museum of the future could surely benefit from the same kind of commitment, albeit, given the temper of the postmodern age, necessarily in smaller measure. The museum, after all, is only the institution of culture, and its power to shape perceptions and channel memory depends on the space conceded to it by a given society. An understanding of museums' history may thus be regarded as the first step to conceiving an alternative relationship between the institution and its social frame. Historical knowledge need not be, as it too often is, simply a source of authority for the institution, but can also serve to empower those outside it: not the least of history's uses is its potential to remind us that, like culture itself, change is always within the realm of possibility.

Abbreviations

Bibliography

Notes

Index

Abbreviations

ACD/D	*Annales de la Chambre des députés. Documents parlementaires*
ACD/DP	*Annales de la Chambre des députés. Débats parlementaires*
ADBdR	Archives Départementales des Bouches-du-Rhône
ADCdO	Archives Départementales de la Côte-d'Or
ADSM	Archives Départementales de la Seine-Maritime
AMB	Archives Municipales de Bordeaux
AMD	Archives Municipales de Dijon
AMD DNC	Dossier non coté
AMD CC	Correspondance des conservateurs
AMD CD	Correspondance diverse
AMM	Archives Municipales de Marseille
AMR	Archives Municipales de Rouen
AN	Archives Nationales
ASCD/D	*Annales du Sénat et de la Chambre des députés. Documents parlementaires*
BMR	Bibliothèque Municipale de Rouen
CAC	*Chronique des arts et de la curiosité*
CM Extrait	Extrait des Registres des Délibérations du Conseil Municipal
CMB	Ville de Bordeaux. Conseil Municipal. *Procès-verbaux des séances*
CMP	Commission chargée d'étudier toutes les questions relatives à l'organisation des musées de province et à la conservation de leurs richesses artistiques. *Rapport* (1908)
CMP/SCA	Sous-Commission Artistique

CMP/SCL	Sous-Commission de Législation
CMP/SP	Séance Plénière
CMR	Ville de Rouen. Conseil Municipal. *Procès-verbaux des séances*
GBA	*Gazette des beaux-arts*
JO	*Journal officiel*
JO CD	Chambre des Députés (Debates)
JO CD/A	Chambre des Députés/Annexes (Documents)
MD	Musée des Beaux-Arts de Dijon (Archives)
MM	Musée des Beaux-Arts de Marseille (Archives)
MM NS/C	Notes de Service—Correspondance
Min. *CD*	Ministère de l'Instruction Publique et des Beaux-Arts. *Compte définitif des dépenses*
RBM	Rouen, *Bulletin municipal*
SAB *CR*	Société des Amis des Arts de Bordeaux. *Compte-rendu de la Commission administrative*

Bibliography

Archival Records

Paris

ARCHIVES NATIONALES (AN)

Series on envois

F^{21} 2196–2201	1800–1860
F^{21} 436–439	1851–1860
F^{21} 440–452	1861–1870
F^{21} 453–475	1871–1880
F^{21} 2202–2228	1881–1890
F^{21} 2229–2260	1891–1900
F^{21} 2264–2284	1901–1910

Cahiers on provincial museums (records of envois)

F^{21} 4500	A–L
F^{21} 4909	M–R
F^{21} 4910	S–Z

Series on inspections

F^{21} 4505	1879–1880
F^{21} 4506–4511	1881–1890
F^{21} 4511–4514	1891–1900
F^{21} 4514–4517	1901–1910

Administrative and miscellaneous

F^{21} 485–486	Musée des Copies; miscellaneous requests
F^{21} 492–495	Papers of Charles Blanc
F^{21} 558, 3982, 4711	Organization of the Direction des Beaux-Arts
F^{21} 562	Organization of the Inspection; miscellaneous

Budgets, 1858–1920

AD^{XVIIIF} The Inventory for this series lists individual registers by ministry or, in the case of the Fine Arts Administration, division, and year.

Bordeaux

ARCHIVES MUNICIPALES (AMB)

Musée de Peinture et de Sculpture

1431 R 1–2	Règlements
1432 R 1	Fire, December 1870
1434 R 1–15	Correspondence, Year 10–1914
1435 R 1–2	Quarterly reports, 1881–1930
1436 R 1–27	Gifts and bequests, 1883–1934
1438 R 1–5	Acquisitions, 1867–1902
1440 R 1–2	Moves (buildings), 1861–1881
8303 M 4–11	Projects for new museum building, 1858–1874
8303 M 12–26	Construction of new museum, 1875–1881

ARCHIVES DÉPARTEMENTALES DE LA GIRONDE

150 T 4	Société des Amis des Arts
165 T 1	Musées, Expositions, 1801–1894
165 T 1 ^{bis}	Musées, Expositions, 1896–1918
165 T 2	Musées, Expositions, 1908–1911

Dijon

MUSÉE DES BEAUX-ARTS (MD)

III	Works of art, gifts, catalogues, 1820–1867
IV	Curatorial files, 1854–1874
V	Annual reports, correspondence, 1892–1920
VI	Museum commission, 1892–1927
VII–VIII	Gifts and acquisitions, 1892–1928
IX	Miscellaneous correspondence, 1892–1927
XI	Proposed acquisitions, 1892–1927
XII	Admission fees, 1899–1908
XIII–XIV	Photography (policy, authorizations), 1892–1913
XVI–XVII	Maintenance and supplies, 1892–1927
XVIII	Administration, security, renovations

ARCHIVES MUNICIPALES (AMD)

Much of the relevant material is uncatalogued. References in the notes give the general museum call number, 4 R I, and the following abbreviations corresponding to the informal arrangement of documents at the time of consultation.

DNC Dossier non coté
CC Correspondance des conservateurs
CD Correspondance diverse

Designations CC and CD are followed either by a pair of delimiting dates (e.g., 1893–1897) or, for correspondence prior to Joliet, the name of a curator. The main divisions are CC: 1817–1856 (Févret de Saint-Mémin), 1851–1878 (dossiers by curator); CC and CD: 1880–1890, 1891–1892, 1893–1897; CD: 1898–1903, 1904–1910.

There is also a dossier on Envois, Acquisitions, and Gifts, 1822–1879. A certain amount of catalogued material exists as well:

4 R I 2 Trimolet collection inventory
4 R I 5–6 Devosge and Trimolet bequests, 1850–1864,
 1878–1897
4 R I 7 Miscellaneous inventories

ARCHIVES DÉPARTEMENTALES DE LA CÔTE D'OR (ADCDO)

33 T 2 Appointment of curators, Year 9–1938
33 T 3 Règlements, inspections, general reports
33 T 4a Acquisitions, gifts, bequests, Year 9–1879
33 T 4b Acquisitions, gifts, bequests, 1880–1934
33 T 9 Construction, maintenance, conservation, Year 12–
 1901

Marseilles

MUSÉE DES BEAUX-ARTS (MM)

Documents in the museum, though well arranged, are completely uncatalogued. A transfer of these materials to the Archives Municipales is planned but did not seem imminent at the time of consultation. The main series was abbreviated in the notes as:

NS/C Notes de Service—Correspondance

NS/C is divided chronologically into folders for the years: 1810–1849;

1850–1871; 1877–1880; 1881–1884; 1885–1888; 1889–1892; 1893–1894; 1895–1896. At this point it becomes "Bulletins de livraison–Facteurs–Notes de Service–Correspondance," with one folder per year from 1897 to 1913 (1909 is missing).

There are also folders on conservation, framing, etc., mostly 1895–1907; appointments of members of advisory committee, 1864–1913; minutes of advisory committee meetings, index to city council discussions on museum, 1830–1892; and loans to exhibitions and Expositions Universelles.

In addition, individual file boxes contain information on gifts and bequests, 1817–1940 (mostly after 1884); envois and acquisitions, 1817–1907; 1876 catalogue (manuscript and notes); and the 1908 catalogue (manuscript, notes, inventories).

ARCHIVES MUNICIPALES (AMM)

57 R 1	Revolutionary confiscations and museum formation, 1790–1813
57 R 2–6	Règlements, correspondence, and miscellaneous: administration, collections, etc.
2	1816–1845
3	1846–1859
4	1860–1869
5	1870–1900
6	1901–1914
101 M 1	Palais de Longchamp (design, construction, estimates, Bartholdi affair, to 1874)
101 M 2	Palais de Longchamp (final construction, repairs, maintenance, 1871–1910)

ARCHIVES DÉPARTEMENTALES DES BOUCHES-DU-RHÔNE (ADBDR)

4 T 5	Beaux-Arts Personnel (naming of curators, etc.)
4 T 50	Musée des Beaux-Arts (opening, personnel, acquisitions, correspondence, règlements, building)

Rouen

ARCHIVES MUNICIPALES (AMR)

The archives contain virtually no original documents from the pre–World War I period, owing to the 1926 fire; most of the material in the *liasse* 2 R 3,

Musée des Beaux-Arts, 1820–1954, is drawn from Ville de Rouen, Conseil Municipal, *Procès-verbaux des séances*, printed and bound from 1875 (cited as CMR) and *Bulletin municipal* (cited as RBM).

ARCHIVES DÉPARTEMENTALES DE LA SEINE MARITIME (ADSM)

4 T 219	Origins, règlements, personnel, curatorial nominations, conservation, Year 8–1898
4 T 220	Acquisitions, gifts, bequests, 1812–1925 (missing at time of consultation)
4 T 221	Conservation, loans, exhibitions
2 OP 1538/52	Museum building (repairs, construction, sculpture), 1865–1889
2 OP 1538/53	Museum building, 1897–1937

Serials: Periodicals and Government Documents

Paris

Annales de la Chambre des députés. Débats parlementaires
Annales de la Chambre des députés. Documents parlementaires
Annuaire des artistes et des amateurs
Bulletin de l'art ancien et moderne
Chronique des arts et de la curiosité
Gazette des beaux-arts
Journal officiel
Revue des deux mondes

Bordeaux

Courrier de la Gironde
La Gironde
La petite Gironde

Marseilles

Courrier de Marseille
Gazette du Midi
Nouvelliste de Marseille
Petit marseillais
Le sémaphore de Marseille
Tribune artistique et littéraire du Midi

Rouen

Dépêche de Rouen et de la Normandie
Journal de Rouen
Nouvelliste de Rouen
Petit rouennais

Catalogues (Listed Chronologically by City)

Bordeaux

Musée de Peinture. *Notice des tableaux et figures exposés au Musée de la ville de Bordeaux.* Bordeaux: N. Duviella, n.d. [1821?].
Lacour, Pierre, and Delpit, Jules. *Catalogue des tableaux, statues, etc. du Musée de Bordeaux.* Bordeaux: N. Duviella, 1855.
Vallet, Emile. *Catalogue des tableaux, sculptures, gravures, dessins exposés dans les galeries du Musée de Bordeaux.* Bordeaux: G. Gounouilhou, 1881.
Musée de Peinture. *Catalogue.* 1910.

Dijon

Musée Municipal. *Notice des objets d'arts exposés au Musée de Dijon, et catalogue général de tous ceux qui dépendent de cet établissement.* Dijon: Victor Lagier, 1834.
———— *Notice des objets exposés au Musée de Dijon, et catalogue général de tous ceux qui dépendent de cet établissement.* Dijon: Victor Lagier, 1842.
———— *Notice des objets d'art exposés au Musée de Dijon, et catalogue général de tous ceux qui dépendent de cet établissement, suivi d'un supplément.* Paris: Dumoulin, 1850.
———— *Catalogue historique et déscriptif du Musée de Dijon: Peintures, sculptures, dessins, antiquités.* Dijon: Lamarche, 1869.
———— *Catalogue historique et déscriptif du Musée de Dijon: Peintures, sculptures, dessins, antiquités, Collection Trimolet.* Dijon: Mersch, 1883.
Musée des Beaux-Arts. *Catalogue des sculptures.* Dijon, 1960.
———— *Catalogue des peintures françaises.* Dijon, 1968.
———— *Catalogue des pastels–gouaches–miniatures.* Dijon, 1972.

Marseilles

Musée. *Notice des tableaux et monuments antiques qui composent la collection du Musée de Marseille.* Marseilles: Basile, 1844.

Bouillon-Landais, E. *Catalogue des objets d'art composant la collection du Musée de Marseille, précédé d'un essai historique sur le Musée.* Marseilles: Marius Olive, 1876.

—— *Catalogue des objets d'art composant la collection du Musée de Marseille, précédé d'un essai historique sur le Musée.* Marseilles: Marius Olive, 1884.

Auquier, Philippe. *Catalogue des peintures, sculptures, pastels et dessins; illustré de 161 reproductions photographiques.* Marseilles: Barlatier, 1908.

Rouen

Musée. *Catalogue des objets d'art exposés au Musée de Rouen, augmenté de notices sur la vie et les ouvrages des principaux maîtres de chaque école, ainsi que sur les Personnages célèbres dont les Portraits figurent dans la Collection.* Rouen, 1837.

—— *Catalogue des objets d'art exposés au musée de Rouen, augmenté de notices sur la vie et les ouvrages des principaux maîtres de chaque école, ainsi que sur les Personnages célèbres dont les Portraits figurent dans la Collection.* Rouen, 1858.

Minet, Emile. *Musée de Rouen: Catalogue des ouvrages de peinture, dessin, sculpture et d'architecture.* Rouen: Girieud, 1911.

Popovitch, Olga. *Catalogue des peintures du Musée des beaux-arts de Rouen.* Rouen, n.d. [1967].

Books and Articles

Agulhon, Maurice, et al. *La ville de l'âge industriel: Le cycle haussmannien.* Histoire de la France Urbaine, 4. Paris: Seuil, 1983.

Angrand, Pierre. "L'Etat mécène: Période autoritaire du Second Empire (1851–1860)." *Gazette des beaux-arts,* 6th ser., 71 (1968): 303–348.

—— *Histoire des musées de province au XIXe siècle.* 4 vols. to date. Les Sables d'Olonne: Le Cercle d'Or, 1984–1986.

—— "Les musées de Bordeaux sous le Second Empire." *Gazette des beaux-arts,* 6th ser., 102 (1983): 139–142.

Bailleux de Marisy, A. *Transformation des grandes villes de France.* Paris: Hachette, 1867.

Baratier, Edouard, ed. *Histoire de Marseille.* Univers de la France et des Pays Francophones: Histoire des Villes. Toulouse: Privat, 1973.

Barnaud, Germaine, with Samoyault, Jean-Pierre. *Répertoire des musées et collections publiques de France.* Paris: Réunion des Musées Nationaux, 1982.

Barthes, Roland. *Mythologies.* Paris: Seuil, 1957.

Beaurepaire, Charles de. "Notes historiques sur le Musée de peinture de la ville de Rouen." *Précis analytique des travaux de l'Académie des sciences, belles-lettres et arts de Rouen* (1852–1853): 388–449.

Benoit, François. *L'art français sous la révolution et l'empire: Les doctrines, les idées, les goûts*. Paris: Société Française d'Édition d'Art, 1897.

Berger, John, et al. *Ways of Seeing*. New York: Viking, 1973.

Berthélemy, H. "Les institutions municipales de la France: Leur évolution au cours du XIXe siècle." *Verfassung und Verwaltungsorganisation der Städte*, 7: *England–Frankreich–Nordamerika. Schriften des Vereins für Social-politik* 123 (1908): 153–227.

Blanc, Charles. "Introduction." *Gazette des beaux-arts*, 1st ser., 1 (1859): 5–15.

Boime, Albert. *The Academy and French Painting in the Nineteenth Century*. London: Phaidon, 1971.

———— "Entrepreneurial Patronage in Nineteenth-Century France." In *Enterprise and Entrepreneurs in Nineteenth- and Twentieth-Century France*, pp. 137–207. Edited by Edward C. Carter III, Robert Forster, and Joseph N. Moody. Baltimore: Johns Hopkins University Press, 1976.

———— "The Second Empire's Official Realism." In *The European Realist Tradition*, pp. 31–123. Edited by Gabriel P. Weisberg. Bloomington: Indiana University Press, 1982.

Boudeville, Pierre. *Les nouveaux musées de Marseille*. Marseilles: Marius Olive, 1870.

Bouillon-Landais, [P.]. *Coup d'oeil sur le Musée de Marseille*. Marseilles: H. Seren, 1867.

Bourdieu, Pierre. *La distinction: Critique sociale du jugement*. Paris: Minuit, 1979.

Bourdieu, Pierre, and Darbel, Alain. *L'amour de l'art: Les musées d'art européens et leur public*. 2nd revised ed. Le Sens Commun. Paris: Minuit, 1969.

Bouvier, Jean. "Le système fiscal français du XIXe siècle: Etude critique d'un immobilisme." In *Deux siècles de fiscalité française, XIXe–XXe siècles: Histoire, économie, politique*, pp. 226–262. Edited by Jean Bouvier and Jacques Wolff. Le Savoir Historique, 5. Paris and the Hague: Ecole Pratique des Hautes Etudes, VIe Section and Mouton, 1973.

Boyer, Marc. *Le tourisme*. Paris: Seuil, 1972.

Brès, Louis. *Le Palais de Longchamp*. Marseilles: Barlatier, 1869.

Busquet, Raoul, and Guiral, Pierre. *Histoire de Marseille*. New ed. Paris: Robert Laffont, 1978.

Carr, Joseph Comyns. *Art in Provincial France: Letters Written during the Summer of 1882 to the Manchester Guardian*. London: Remington, 1883.

Chaline, Jean-Pierre. *Les bourgeois de Rouen: Une élite urbaine au XIXe siècle*. Paris: Presses de la Fondation Nationale des Sciences Politiques, 1982.

———— "Le milieu culturel rouennais au temps de Flaubert." In *Flaubert et Maupassant, écrivains normands*, pp. 17–25. Université de Rouen, Institut de Littérature Française, Centre d'Art, Esthétique, et Littérature. Paris: Presses Universitaires de France, 1981.

Chennevières, Philippe de. "Les musées de province." *Gazette des beaux-arts*, 1st ser., 18 (January–June 1865): 118–131.

———— *Souvenirs d'un directeur des beaux-arts.* 5 vols. Paris: *L'artiste*, 1883–1889.

Clément de Ris, L. *Les musées de province.* 2 vols. Paris: Jules Renouard, 1859, 1861.

Crow, Thomas E. *Painters and Public Life in Eighteenth-Century Paris.* New Haven: Yale University Press, 1985.

Crozier, Michel. *The Bureaucratic Phenomenon.* Translated by the author. Chicago: University of Chicago Press, 1964. Originally published as *Le phénomène bureaucratique*, Paris: Seuil, 1963.

Crubellier, Maurice. *Histoire culturelle de la France, XIXe–XXe siècle.* Collection U. Paris: Armand Colin, 1974.

Dauzet, Pierre. *Le siècle des chemins de fer en France (1821–1938).* Fontenay-les-Roses: Bellenand, 1948.

Desgraves, Louis, and Dupeux, Georges, eds. *Bordeaux au XIXe siècle.* Histoire de Bordeaux, 6. Bordeaux: Delmas/Fédération Historique du Sud-Ouest, 1969.

Douglas, Mary. *How Institutions Think.* Syracuse: Syracuse University Press, 1986.

Dubosc de Pesquidoux, Léonce de. *Voyage artistique en France. Etudes sur les musées d'Angers, de Nantes, de Bordeaux, de Dijon, de Lyon, de Montpellier, de Toulouse, de Lille, &c.* Paris: Michel Lévy Frères, 1857.

Duchet, René. *Le tourisme à travers les âges: Sa place dans la vie moderne.* Paris: Vigot Frères, 1949.

Duncan, Carol, and Wallach, Alan. "The Universal Survey Museum." *Art History* 3 (1980): 448–469.

Dupré, Paul, and Ollendorff, Gustave. *Traité de l'administration des beaux-arts. Historique–législation–jurisprudence.* 2 vols. Paris: Paul Dupont, 1885.

Engerand, Fernand. "Les musées de province." *Revue hebdomadaire*, 2nd ser., 5, no. 4 (16 March 1901): 357–376.

France. Commission chargée d'étudier toutes les questions relatives à l'organisation des musées de province et à la conservation de leurs richesses artistiques. *Rapport présenté au nom de la Commission, par Henry Lapauze, 25 Octobre 1907.* Paris: Plon-Nourrit, 1908.

French Painting 1774–1830: The Age of Revolution. Catalogue of an exhibition at the Grand Palais, Paris, the Detroit Institute of Arts, and the Metropolitan Museum of Art, New York, 1974–1975.

Gay, Peter. *The Bourgeois Experience: Victoria to Freud.* Vol. 1: *Education of the Senses.* New York: Oxford University Press, 1984.

Genet-Delacroix, Marie-Claude. "Esthétique officielle et art national sous la IIIe République." *Le mouvement social*, no. 131 (April–June 1985): 105–120.

—— "Vies d'artistes: Art académique, art officiel et art libre en France à la fin du XIXe siècle." *Revue d'histoire moderne et contemporaine* 33 (1986): 40–73.

Gerbod, Paul. "L'action culturelle de l'État au XIXe siècle (à travers les divers chapitres du budget générale)." *Revue historique* 270 (1983): 389–401.

Girard, Louis. "La politique des grands travaux à Marseille sous le Second Empire." In Chambre de Commerce de Marseille, *Marseille sous le Second Empire: Exposition, conférences, colloque organisé à l'occasion du centenaire du Palais de la Bourse, 10–26 novembre 1960.* Paris: Plon, 1961.

—— *La politique des travaux publics du Second Empire.* Paris: Colin, 1952.

Gordon, David M. *Merchants and Capitalists: Industrialization and Provincial Politics in Mid-Nineteenth-Century France* (University: University of Alabama Press, 1985).

Gould, Cecil. *Trophy of Conquest: The Musée Napoléon and the Creation of the Louvre.* London: Faber and Faber, 1965.

Gras, Pierre, ed. *Histoire de Dijon.* Univers de la France et des Pays Francophones: Histoire des Villes. Toulouse: Privat, 1981.

Guédy, Théodore. *Musées de France et collections particulières, comprenant: La formation des musées de France; l'histoire de chacun de ces musées; . . . appréciation sur les principales oeuvres; le nom des collectionneurs.* Paris: Chez l'auteur, [1888?].

Guey, Fernand. "Origine et destinée des musées de province." *Cahiers de la république des lettres, des sciences, et des arts,* no. 13 (1931): 318–332.

Guiral, Pierre, and Amargier, Paul. *Histoire de Marseille.* Paris: Mazarine, 1983.

Hanson, Anne Coffin. *Manet and the Modern Tradition.* New Haven: Yale University Press, 1977.

—— "Manet's Subject Matter and a Source of Popular Imagery." *Museum Studies* 3 (1969): 63–80.

Harris, Neil. "The Gilded Age Revisited: Boston and the Museum Movement." *American Quarterly* 14 (1962): 545–564.

Haskell, Francis, ed. *Saloni, gallerie, musei e loro Influenza sullo sviluppo dell'arte dei secoli XIX e XX, Atti del XXIV Congresso C.I.H.A., Bologna 1979.* Bologna: CLUEB, 1981.

Hautecoeur, Louis. *Les beaux-arts en France: Passé et avenir.* Paris: Picard, 1948.

—— *La fin de l'architecture classique 1848–1900.* Vol. 7 of *Histoire de l'architecture classique en France.* Paris: Picard, 1957.

Higounet, Charles, ed. *Histoire de Bordeaux.* Univers de la France et des Pays Francophones: Histoire des Villes. Toulouse: Privat, 1980.

Histoire des chemins de fer en France. Preface by Louis Armand. Paris: Presses Modernes, 1964.

Hoog, Michel. *L'art d'aujourd'hui et son public.* Collection "Vivre son temps." Paris: Editions Ouvrières, 1967.

Houssaye, Arsène. "Les musées de province: Le Musée de Bordeaux." *Moniteur universel* (1858): 343–344, 355–356, 362–363, 375, 379, 569.

Houssaye, Henry. "Les musées de province, leur origine et leur organisation." *Revue des deux mondes,* 3rd ser., 38 (1880): 546–565.

Lacambre, Geneviève. *Le Musée du Luxembourg en 1874: Peintures.* Catalogue of an exhibition at the Grand Palais, Paris, 1974.

Lafenestre, Georges. *Artistes et amateurs.* Les Idées, Les Faits, et Les Oeuvres. Paris: Société d'Edition Artistique, 1899.

Lagrange, Léon. "Des Sociétés des amis des arts en France: Leur origine, leur état actuel, leur avenir." *Gazette des beaux-arts,* 1st ser., 9 (1861): 291–301; 10 (1861): 102–117, 158–168, 227–242.

Larroumet, Gustave. *L'art et l'Etat en France.* Paris: Hachette, 1895.

Laurent, Jeanne. *Arts et pouvoirs en France de 1793 à 1981: Histoire d'une démission artistique.* Université de Saint-Etienne, Travaux 34. Saint-Etienne: Centre Interdisciplinaire d'Etudes et de Recherches sur l'Expression Contemporaine, 1982.

La Ville de Mirmont, Henri de. *Histoire du Musée de Bordeaux.* Vol. 1: *Les origines: Histoire du musée pendant le Consulat, l'Empire et la Restauration.* Bordeaux: Feret, 1899.

Legendre, Pierre. *Histoire de l'administration de 1750 à nos jours.* Collection "Thémis." Paris: Presses Universitaires de France, 1968.

Leroy-Beaulieu, Paul. *L'administration locale en France et en Angleterre.* Paris: Guillaumin, 1872.

Mainardi, Patricia. *Art and Politics of the Second Empire: The Universal Expositions of 1855 and 1867.* New Haven: Yale University Press, 1987.

Mantz, Paul. "Les Musées de Province: I. Le Musée de Bordeaux." *L'artiste,* 4th ser., 8 (1846–1847): 49–52.

Marrinan, Michael. *Painting Politics for Louis-Philippe: Art and Ideology in Orléanist France, 1830–1848.* New Haven: Yale University Press, 1988.

Masson, Paul, ed. *Les Bouches-du-Rhône: Encyclopédie départementale.* 15 vols. Marseilles: Archives Départementales des Bouches-du-Rhône, 1913–1933.

Mirmont. *See* La Ville de Mirmont, Henri de.

Mistler, Jean. *La librairie Hachette de 1826 à nos jours.* Paris: Hachette, 1964.

Mollat, Michel, ed. *Histoire de Rouen.* Univers de la France et des Pays Francophones: Histoire des Villes. Toulouse: Privat, 1979.

Moulin, Raymonde. "Les bourgeois amis des arts: Les expositions des beaux-arts en province, 1885–1887." *Revue française de sociologie* 17 (1976): 383–422.

——— "Champ artistique et société industrielle capitaliste." In *Science et conscience de la société: Mélanges en l'honneur de Raymond Aron,* 2 vols., 2:183–204. Paris: Calmann-Lévy, 1971.

Nochlin, Linda. *Realism.* Style and Civilization. Harmondsworth: Penguin, 1971.

Ory, Pascal. "Politiques culturelles avant la lettre: Trois lignes françaises, de la Révolution au Front populaire." In *Sociologie de l'art: Colloque international, Marseille, 13–14 juin 1985,* pp. 23–30. Paris: Documentation Française, 1986.

Parrocel, Etienne. *L'art dans le Midi: Célébrités marseillaises—Marseille et ses édifices—architectes et ingénieurs du XIXe siècle.* 4 vols. Marseilles: E. Chatagnier, 1884.

Pevsner, Nikolaus. *A History of Building Types.* Bollingen Series 35, A. W. Mellon Lectures in the Fine Arts, 19. Princeton: Princeton University Press, 1976.

Peyret, Henry. *Histoire des chemins de fer en France et dans le monde.* Paris: Société d'Editions Françaises et Internationales, 1949.

Pinçon, Jean. "La construction du musée de peinture et de sculpture de Bordeaux." *Revue historique de Bordeaux et du département de la Gironde,* n.s., 22 (1973): 89–102.

Pinkney, David H. *Decisive Years in France, 1840–1847.* Princeton: Princeton University Press, 1986.

Pommier, Edouard. "Naissance des musées de province." In *Les lieux de mémoire.* Vol. II: *La nation* (3 books), book 2, pp. 451–495. Edited by Pierre Nora. Paris: Gallimard, 1986.

Ponteil, Félix. *Les institutions de la France de 1814 à 1870.* Histoire des Institutions. Paris: Presses Universitaires de France, 1966.

Poulot, Dominique. "Les finalités des musées du XVIIe au XIXe siècle." In *Quels musées, pour quelles fins aujourd'hui?,* pp. 13–22. Séminaires de l'Ecole du Louvre. Paris: Documentation Française, 1983.

——— "L'invention de la bonne volonté culturelle: L'image du musée au XIXe siècle." *Le Mouvement social,* no. 131 (April–June 1985): 35–64.

——— "La visite au musée: Un loisir édifiant au XIXe siècle." *Gazette des beaux-arts,* 6th ser., 101 (1983): 187–196.

Proust, Antonin. *L'art sous la République.* Paris: Bibliothèque-Charpentier, 1892.

Puvis de Chavannes 1824–1898. Catalogue of an exhibition at the Grand Palais, Paris, and the National Gallery of Canada, Ottawa, 1976–1977.

Quarré, Pierre. "Le Musée de Dijon: Sa formation, son développement." *Mémoires de l'Académie des sciences, arts et belles-lettres de Dijon* (1947–1953): 144–172.

Une question de propriété artistique: La vérité sur le Palais Longchamp. Paris: Ducher, 1884.

Réau, L. *Histoire du vandalisme: Les monuments détruits de l'art français.* 2 vols. Paris: Hachette, 1954.

Ricaud, Th. *Le Musée de peinture et de sculpture de Bordeaux de 1830 à 1870.* Bordeaux: Bière, 1938.

Ronchaud, Louis de. "De l'encouragement des Beaux-Arts par l'Etat." *La nouvelle revue,* 7th year, 33 (March–April 1885): 130–161.

Rosen, Charles, and Zerner, Henri. *Romanticism and Realism: The Mythology of Nineteenth-Century Art.* New York: Viking, 1984.

Rosenthal, Léon. *Du romantisme au réalisme: Essai sur l'évolution de la peinture en France.* Paris: H. Laurens, 1914.

Roujon, Henry. *Artistes et amis des arts.* Paris: Hachette, 1912.

Rouland, Norbert. *Le conseil municipal marseillais et sa politique de la IIe à la IIIe République (1848–1875).* Aix-en-Provence: Edisud, 1974.

Roy, Alain. *Les envois de l'Etat au Musée de Dijon (1803–1815).* Ville de Dijon et Association des Publications près l'Université de Strasbourg. Paris: Ophrys, 1980.

Saunier, Charles. *Les conquêtes artistiques de la révolution et de l'empire.* Paris: Renouard/H. Laurens, 1902.

The Second Empire 1852–1870: Art in France under Napoléon III. Catalogue of an exhibition at the Philadelphia Museum of Art, the Detroit Institute of Arts, and the Grand Palais, Paris, 1978–1979.

Sewell, William H., Jr. *Structure and Mobility: The Men and Women of Marseille, 1820–1870.* Cambridge: Cambridge University Press, 1985.

Sherman, Daniel J. "Art Museums, Inspections, and the Limits to Cultural Policy in the Early Third Republic." *Historical Reflections/Réflexions Historiques* 15 (1988): 337–359.

———— "The Bourgeoisie, Cultural Appropriation, and the Art Museum in Nineteenth-Century France." *Radical History Review,* no. 38 (1987): 38–58.

Sigaux, Gilbert. *Histoire du tourisme.* Geneva: Editions Rencontre, 1965.

Stendhal. *Mémoires d'un touriste.* Edited by V. Del Litto. 3 vols. La Découverte. Paris: François Maspero, 1981. Originally published 1838.

Thomson, David. *Democracy in France.* 5th ed. London: Oxford University Press, 1969.

Vaisse, Pierre. "La troisième république et les peintres: Recherches sur les rapports des pouvoirs publics et de la peinture en France de 1870 à 1914." Thèse de Doctorat d'Etat, Université de Paris IV, 1980.

White, Harrison C., and Cynthia A. White. *Canvases and Careers: Institutional Change in the French Painting World.* New York: John Wiley and Sons, 1965.

Zeldin, Theodore. *France 1848–1945.* 2 vols. Oxford: Oxford University Press, Clarendon Press, 1973, 1977.

Zola, Emile. *Oeuvres complètes.* 15 vols. Edited by Henri Mitterand. Vol. 3: *L'assommoir.* Paris: Cercle du Livre Précieux, 1967.

Zolberg, Vera L. "Tensions of Mission in American Art Museums." In *Nonprofit Enterprise in the Arts: Studies in Mission and Constraint,* pp. 184–198. Edited by Paul J. DiMaggio. New York: Oxford University Press, 1986.

Notes

Introduction

1. Will Crutchfield, "Secret's Out: It's Now the Met Museum of Opera," *New York Times,* 18 June 1987.

2. Timothy Garton Ash, "In the Churchill Museum" (review of *Winston S. Churchill,* vol. 7: *Road to Victory, 1941–1945,* by Martin Gilbert), *New York Review of Books,* 7 May 1987, p. 22.

3. William Plomer, *Museum Pieces* (London: Jonathan Cape, 1952); Elizabeth Tallent, *Museum Pieces* (New York: Knopf, 1985), and Louise Erdrich's review of it, "Life in Shards and Fragments," in *New York Times Book Review,* 7 April 1985, p. 10; André Malraux, *Le musée imaginaire de la sculpture mondiale,* 3 vols. (Paris: Gallimard, 1952–1954); Champfleury, *Le musée sécret de la caricature* (Paris: Dentu, 1888); Walter Kendrick, *The Secret Museum: Pornography in Modern Culture* (New York: Viking, 1987); "'McMuseum' Opens," *Washington Post,* 23 May 1985 (on the McDonald's Museum in Des Plaines, Illinois).

4. "Museum," trans. Annette Michelson, *October,* no. 36 (Spring 1986): 25.

5. John Berger et al., *Ways of Seeing* (New York: Viking, 1973), p. 24.

6. On the contemporary American situation, see Stephen E. Weil, *Beauty and the Beasts: On Museums, Art, the Law, and the Market* (Washington, D.C.: Smithsonian Institution Press, 1983); Vera L. Zolberg, "Tensions of Mission in American Art Museums," in Paul J. DiMaggio, ed., *Nonprofit Enterprise in the Arts: Studies in Mission and Constraint* (New York: Oxford University Press, 1986), pp. 184–198; Mark Lilla, "The Great Museum Muddle," *New Republic,* 8 April 1985, pp. 25–30.

7. Typical of this approach are Calvin Tomkins, *Merchants and Masterpieces: The Story of the Metropolitan Museum of Art* (New York: Dutton, 1970); Walter Muir Whitehill, *Museum of Fine Arts, Boston: A Centennial History,* 2 vols. (Cambridge, Mass.: Harvard University Press, 1970); Nathaniel Burt, *Palaces for the People: A Social History of the American Art*

Museum (Boston: Little, Brown, 1977); and, for France, Claude Souviron, *Exposition "Anniversaires" 1800–1830–1900–1980*, catalogue of an exhibition at the Musée des Beaux-Arts, Nantes, 1980; Pierre Angrand, *Histoire des musées de province au XIXe siècle*, 4 vols. to date (Les Sables d'Olonne: Le Cercle d'Or, 1984–1986).

8. Carol Duncan and Alan Wallach, "The Universal Survey Museum," *Art History* 3 (1980): 448–469; see also the stimulating polemic by Kenneth Hudson, misleadingly entitled *A Social History of Museums: What the Visitors Thought* (London: Macmillan, 1975), and Walter Grasskamp, *Museumsgründer und Museumsstürmer: Zur Sozialgeschichte des Kunstmuseum* (Munich: C. H. Beck, 1981).

9. For further discussion of this point, see my "The Bourgeoisie, Cultural Appropriation, and the Art Museum in Nineteenth-Century France," *Radical History Review*, no. 38 (Spring 1987): 38–41.

10. Neil Harris, "The Gilded Age Revisited: Boston and the Museum Movement," *American Quarterly* 14 (1962): 545–564; and idem, "Museums, Merchandising, and Popular Taste," in Ian M. G. Quimby, ed., *Material Culture and the Study of American Life* (New York: Norton, 1978), pp. 140–173.

11. The closest we have come to this is a collection of papers on different countries presented in the same forum: Bernward Denecke and Rainer Kahsnitz, eds., *Dans Kunst- und kulturgeschichtliche Museum im 19. Jahrhundert: Vorträge des Symposions in Germanischen Nationalmuseum, Nürnberg* (Munich: Prestel, 1977).

12. One sign of this supranational status is the attention—in some cases homage might be a better term—paid to the Louvre in works primarily concerned with museums in other countries. See, for example, Burt, *Palaces*, pp. 23–26; Grasskamp, *Museumsgründer*, pp. 21, 24–35; Edward P. Alexander, *Museums in Motion: An Introduction to the History and Function of Art Museums* (Nashville: American Association for State and Local History, 1979), pp. 23–27.

13. The pioneering work is Adeline Daumard, *La bourgeoisie parisienne de 1815 à 1848* (Paris: S.E.V.P.E.N., 1963); more recent contributions include Jean-Guy Daigle, *La culture en partage: Grenoble et son élite au milieu du XIXe siècle* (Grenoble: Presses Universitaires de Grenoble, 1977); Jean-Pierre Chaline, *Les bourgeois de Rouen: Une élite urbaine au XIXe siècle* (Paris: Fondation Nationale des Sciences Politiques, 1982); Bonnie G. Smith, *Ladies of the Leisure Class: The Bourgeoises of Northern France in the Nineteenth Century* (Princeton: Princeton University Press, 1981); David M. Gordon, *Merchants and Capitalists: Industrialization and Provincial Politics in Mid-Nineteenth-Century France* (University: University of Alabama Press, 1985).

14. Notably Michael B. Miller, *The Bon Marché: Bourgeois Culture and the Department Store* (Princeton: Princeton University Press, 1981); Susanna

Barrows, *Distorting Mirrors: Visions of the Crowd in Nineteenth-Century France* (New Haven: Yale University Press, 1981); Mary Jo Nye, *Science in the Provinces: Scientific Communities and Provincial Leadership* (Berkeley: University of California Press, 1986).

15. I employ the terms "bourgeoisie" and "bourgeois elites" interchangeably in the book; the latter indicates my use of the former in the French sense, which corresponds more closely to the English "upper middle class" than to the common Anglo-American equation of "bourgeoisie" with "middle class." When I use the term "middle class," I mean a segment of the population, largely engaged in white-collar employment, that aped "bourgeois" manners and styles of living but without the financial security and status of the upper middle class. On the use of the term "bourgeois" to denote an elite constituting no more than about 15 percent of the population, see Chaline, *Bourgeois de Rouen,* pp. 21–48, 78–93; on definitions in general, see Peter Gay, *The Bourgeois Experience: Victoria to Freud,* vol. 1: *Education of the Senses* (New York: Oxford University Press, 1984), pp. 18–28, 54–56.

16. Roland Barthes, *Mythologies* (Paris: Seuil, 1957), pp. 194–233; on hegemony, a useful and suggestive analysis is T. J. Jackson Lears, "The Concept of Cultural Hegemony," *American Historical Review* 90 (1985): 567–593; on "cultural capital," Pierre Bourdieu, *La distinction: Critique social du jugement* (Paris: Minuit, 1979), pp. i–iii, 128–135, 331.

17. M. Clairefond, "Introduction," *L'art en province* 5 (1840): 6.

18. On the social and economic development of Bordeaux, Marseilles, and Rouen in the nineteenth century, see Chapter 5. On Dijon, see Pierre Gras, ed., *Histoire de Dijon,* Univers de la France et des Pays Francophones: Histoire des Villes (Toulouse: Privat, 1981).

19. In particular, from the perspective of this study, all four cities had, at various points in the century, art associations that provided a channel and a focus for the cultural interests of the bourgeoisie. All four were also among the fourteen original recipients of envois from the state under the Napoleonic regime, which makes possible a comparison over the entire century. Finally, though the archives in these cities vary in their richness and comprehensiveness, enough evidence has survived to permit comparison between at least two and usually three cities on all major points.

20. For France, notably, William H. Sewell, Jr., *Work and Revolution in France: The Language of Labor from the Old Regime to 1848* (Cambridge: Cambridge University Press, 1980); Lynn Hunt, *Politics, Culture, and Class in the French Revolution* (Berkeley: University of California Press, 1984); William M. Reddy, *The Rise of Market Culture: The Textile Trade and French Society, 1750–1900* (Cambridge: Cambridge University Press, 1984). On definitions of culture and methodological issues, see Robert Darnton, "Intellectual and Cultural History," in Michael Kammen, ed., *The Past before Us: Contem-*

porary Historical Writing in the United States (Ithaca: Cornell University Press, 1980), pp. 344–348.

21. See, on these matters, Roger Chartier, "Intellectual History or Sociocultural History? The French Trajectories," in Dominick LaCapra and Steven L. Kaplan, eds., *Modern European Intellectual History: Reappraisals and New Perspectives* (Ithaca: Cornell University Press, 1982), pp. 13–46, especially pp. 42–46.

22. Mary Douglas, *How Institutions Think* (Syracuse: Syracuse University Press, 1986), citations from pp. 46, 92, 100; cf. Michel Foucault, *Discipline and Punish: The Birth of the Prison,* trans. Alan Sheridan (New York: Pantheon, 1978), pp. 135–194, and idem, *Power/Knowledge: Selected Interviews and Other Writings, 1972–1977,* ed. Colin Gordon (New York: Pantheon, 1980), pp. 118–119, 146–165.

23. Douglas, *How Institutions Think,* pp. 69–70; Barthes, *Mythologies,* pp. 229–233, 239.

24. Cited in Gordon A. Craig, "The War of the German Historians," *New York Review of Books,* 15 January 1987, p. 19.

Introduction to Part I

1. The original French of the epigraph reads: "Tout cela [les musées nationaux] constitue un ensemble très riche et très incohérent, mal installé et mal classé, répondant de manière insuffisante à son double but d'agrément et d'enseignement. C'est une image fidèle de la France elle-même depuis cent ans, bouleversé par les révolutions, campant au milieu des ruines, créant un nouvel état social avec les ruines de l'ancien régime, poursuivant cette création avec une énergie et une persévérance admirables, mais périodiquement arrêtée et obligée aux expédients, entreprenant beaucoup, ne finissant guère et espérant toujours, pour unifier les résultats de ce travail confus, l'apaisement des esprits et l'union des volontés dans la patrie libre." All translations by the author unless otherwise indicated.

2. On the various phases of cultural policy in France, see the tentative typology proposed by Pascal Ory, "Politiques culturelles avant la lettre: Trois lignes françaises, de la Révolution au Front populaire," in *Sociologie de l'art: Colloque internationale, Marseille, 13–14 juin 1985* (Paris: Documentation Française, 1986), pp. 23–30.

1. The State and the Uses of Patronage

1. On attitudes toward art in court and other official circles, see Robert Rosenblum, *Transformations in Late Eighteenth Century Art* (Princeton: Princeton University Press, 1967), pp. 50–106; *French Painting 1774–1830: The Age of Revolution,* catalogue of an exhibition at the Grand Palais, Paris,

the Detroit Institute of Arts, and the Metropolitan Museum of Art, New York, 1974–1975, especially Frederick J. Cummings, "Painting under Louis XVI 1774–1789," pp. 31–43, and the critique of this exhibition in Carol Duncan, "Neutralizing 'the Age of Revolution,'" *Artforum* 14, no. 4 (December 1975): 46–54. On the philosophes see James Leith, *The Idea of Art as Propaganda in France, 1750–1799: A Study in the History of Ideas*, University of Toronto Romance Series, 8 (Toronto: University of Toronto Press, 1965); on the Academy, radicals, and David, see Thomas E. Crow, *Painters and Public Life in Eighteenth-Century Paris* (New Haven: Yale University Press, 1985). On the Revolution, François Benoit, *L'art français sous la révolution et l'empire: Les doctrines, les idées, les goûts* (Paris: Société Française d'Edition d'Art, 1897) is still useful.

2. Louis Hautecoeur, *Les beaux-arts en France: Passé et avenir* (Paris: Picard, 1948), pp. 49–62, provides a general survey and stresses the essential continuities; on Louis-Philippe, see Léon Rosenthal, *Du romantisme au réalisme: Essai sur l'évolution de la peinture en France* (Paris: H. Laurens, 1914), pp. 10–16, and Michael Marrinan, *Painting Politics for Louis-Philippe: Art and Ideology in Orléanist France* (New Haven: Yale University Press, 1988); on the Napoleons, see Benoit, *L'art français*, pp. 166–167; Pierre Angrand, "L'état mécène: Période autoritaire du Second Empire (1851–1860)," *GBA*, 6th ser., 71 (January–June 1968): 303–305; Jean-Marie Moulin, "The Second Empire: Art and Society," in *The Second Empire 1852–1870: Art in France under Napoléon III*, catalogue of an exhibition at the Philadelphia Museum of Art, the Detroit Institute of Art, and the Grand Palais, Paris, 1978–1979, p. 12; and Patricia Mainardi, *Art and Politics of the Second Empire: The Universal Expositions of 1855 and 1867* (New Haven: Yale University Press, 1987), pp. 33–47, 123–127.

3. The classic expression of this view is that of Jacques-Louis David in a report to the Convention of 25 brumaire year 2, quoted at length in Hautecoeur, *Beaux-arts*, p. 50. On its influence through the Directory, the Consulate, and the Empire, see Benoit, *L'art français*, pp. 154–177. For several Third Republic expressions of these views, see L. de Ronchaud, "De l'encouragement des beaux-arts par l'Etat," *La nouvelle revue*, 7th year, 33 (March–April 1885): 130–136; Antonin Proust, *L'art sous la République* (Paris: Bibliothèque-Charpentier, 1892), pp. i–iv, 1–3; Georges Trouillot, *ACD/D* 1894 (2), Report 907, 28 July 1894: 768.

4. The phrase is that of Couyba, *ACD/D* 1901, Report 2643, 6 July 1901: 1188. The view is put forward in, for example, the report of Maurice-Faure, *ACD/D* 1895, Report 1538, 13 July 1895: 355, and in Gustave Larroumet, *L'art et l'Etat en France* (Paris: Hachette, 1895), pp. 291–294. Hautecoeur, *Beaux-arts*, pp. 30–32, challenges Larroumet's characterization of Louis XIV's cultural patronage as "artistic absolutism."

5. The formulation is Hautecoeur's, *Beaux-arts*, p. 86, but it is similar to

that of de Ronchaud, "Encouragement," p. 136; Proust, *L'art,* pp. 3–5, who draws a direct link between his efforts as minister of arts in 1881 and those of the Revolution; and Pierre Vaisse, "La troisième république et les peintres: Recherches sur les rapports des pouvoirs publics et de la peinture en France de 1870 à 1914" (Thèse de Doctorat d'Etat, Université de Paris IV, 1980), pp. 137–168; see also Benoit, *L'art français,* pp. 157–196, 228–239.

6. On bureaucracy during and after the Revolution, see Clive H. Church, *Revolution and Red Tape: The French Ministerial Bureaucracy, 1770–1850* (Oxford: Clarendon Press of Oxford University Press, 1981); Guy Thuillier, *Témoins de l'administration,* L'Administration Nouvelle (Paris: Berger-Levrault, 1967), pp. 21–95.

7. The report is reprinted in part in Fernand Engerand, "Les musées de province," *Revue hebdomadaire,* 2nd ser., 5, no. 4 (16 March 1901): 358–359; the decree in, among others, Paul Dupré and Gustave Ollendorff, *Traité de l'administration des beaux-arts,* 2 vols. (Paris: Paul Dupont, 1885), 2: 113–114. Dupré and Ollendorff, like most authorities prior to the 1960s, give the date as 14 fructidor year 8 (i.e., 1800 instead of 1801), an error traceable at least as far back as L. Clément de Ris, *Les musées de province,* 2 vols. (Paris: Jules Renouard, 1859, 1861), 1: 4–5. The documents themselves, in AN, AFIV 41, Plaquette 233, leave no doubt that the year 9 cited in more recent sources is correct.

8. Théodore Gudin's *Devotion of Captain Desse* (1829, Salon of 1831), for example, went to Bordeaux, home port of the captain whose heroism the painting celebrates; see *French Painting 1774–1830,* no. 92, pp. 475–477, ill. pp. 28, 300.

9. Hautecoeur, *Beaux-arts,* pp. 39–49; Proust, *L'art,* pp. 2–3; Vaisse, "Troisième république," pp. 58–59; see also AN, F^{21} 4711, a useful "Tableau synoptique de l'organisation et du personnel de l'Administration des beaux-arts, depuis 1792 jusqu'en 1874," and a typewritten history covering the period from 1664 to 1929, "Administration des beaux-arts." During the July Monarchy official purchases were made by the Interior Ministry; during the Second Empire, though the fine arts division functioned as part of the civil list, the imperial family purchased works for its own collections separately from the official state purchases. The Comte de Nieuwerkerke, Directeur Général des Musées from 1849 and Surintendant des Beaux-Arts from 1863 to 1869, essentially controlled the organization of the Salon (though the juries only to varying degrees) and all official purchases. See Geneviève Lacambre and Joseph Rishel, "Painting," in *The Second Empire,* pp. 243–248.

10. On the relative paucity of state cultural spending overall, see Paul Gerbod, "L'action culturelle de l'Etat au XIXe siècle (à travers les divers chapitres du budget général)," *Revue historique* 270 (1983): 389–401.

11. The greater fluctuation in the proportions of commissioned and purchased sculpture probably resulted from the more variable need for sculptures for building projects. For example, most of the commissioned sculptures paid for in 1864 were destined for projects approaching completion in Paris (AN, AD$^{XVIII^F}$ 811).

12. Rosenthal, *Du romantisme,* pp. 38–61; Harrison C. White and Cynthia A. White, *Canvases and Careers: Institutional Change in the French Painting World* (New York: John Wiley and Sons, 1965), pp. 27–33, 44–54, 63–70, 84–98, though their discussion of Second Empire official purchases, based on insufficient information, is inaccurate; Anne Coffin Hanson, *Manet and the Modern Tradition* (New Haven: Yale University Press, 1977, 1979), pp. 5–7; Geneviève Lacambre, "Les institutions du Second Empire et le Salon des Refusés," in Francis Haskell, ed., *Saloni, gallerie, musei e loro Influenza sullo sviluppo dell'arte dei secoli XIX e XX, Atti del XXIV Congresso C.I.H.A., Bologna 1979* (Bologna: CLUEB, 1981), pp. 163–175; Jon Whiteley, "Exhibitions of Contemporary Painting in London and Paris, 1760–1860," in Haskell, ed., *Saloni,* pp. 69–87.

13. Historians and contemporary critics often mention Ingres's absence from the Salons, the latter, with the exception of Baudelaire, usually in unfavorable terms: see Rosenthal, *Du romantisme,* p. 47; Charles Baudelaire, *Art in Paris 1845–1862: Salons and Other Exhibitions,* trans. and ed. Jonathan Mayne (Ithaca: Cornell University Press, 1981), pp. 37–38. On Millet, see Alexandra R. Murphy, Susan Fleming, et al., *Jean-François Millet,* catalogue of an exhibition at the Museum of Fine Arts, Boston, 1984, pp. ix–xviii, 231–259; Robert L. Herbert, *Jean-François Millet,* catalogue of an exhibition at the Grand Palais, Paris, 1975 (in French), and at the Hayward Gallery, London, 1976 (in English, slightly abridged).

14. In the first decade of the Third Republic, the last in which the Salons were under official state sponsorship, juries, acting on instructions from the Fine Arts Administration, reacted against this growth in size, and the exhibitions at first were smaller, before they rose to unprecedented heights in 1879 and 1880; see Vaisse, "Troisième république," pp. 267–274.

15. On the Second Empire and speculation, see Alain Plessis, *De la fête impériale au mur des fédérés, 1852–1871,* Nouvelle Histoire de la France Contemporaine, 9 (Paris: Seuil, 1973), pp. 80–112; Theodore Zeldin, *France 1848–1945,* 2 vols. (Oxford: Clarendon Press of Oxford University Press, 1973, 1977), 1:82–83, 555–557. On bourgeois art patronage as the frame for state action see Moulin, "The Second Empire"; Albert Boime, "Entrepreneurial Patronage in Nineteenth-Century France," in Edward C. Carter II, Robert Forster, and Joseph N. Moody, eds., *Enterprise and Entrepreneurs in Nineteenth- and Twentieth-Century France* (Baltimore: Johns Hopkins University Press, 1976), pp. 137–207.

16. Vaisse, "Troisième république," pp. 436–448; Geneviève Lacambre,

"Introduction," in her *Le Musée du Luxembourg en 1874: Peintures*, catalogue of an exhibition at the Grand Palais, Paris, 1974. See also the historical introductions to the various catalogues of the Luxembourg published between 1824 and 1890: Musée du Luxembourg, *Notice des peintures, sculptures et dessins de l'école modern du Musée national du Luxembourg*, particularly that of 1873 by Philippe de Chennevières, pp. v–xii, which quotes from earlier introductions.

17. AN, F²¹ 2197, Maire de Grenoble to Ministre de l'Intérieur, 25 April 1850; AN, F²¹ 445, Maire de Dijon to Ministre de la Maison de l'Empereur et des Beaux-Arts, 20 June 1866.

18. AMB, 1436 R 7, Gilbert to ?, 26 May 1897. In the Rouen case, the sculptor Léopold Bernstamm offered a drastic reduction in the price of his bust of Flaubert if the state would guarantee placement in the Luxembourg. When the state demurred, citing the principle that it never made such commitments, the city offered to pay half the (higher) purchase price, and the work went to Rouen. See AN, F²¹ 2278, Kaempfen (Directeur des Musées Nationaux) to Ministre de l'Instruction Publique et des Beaux-Arts, undated (late October 1900); note, Cabinet du Ministre, 11 November 1900; Préfet de la Seine-Inférieure, Rouen, to Ministre, 15 January 1901.

19. Figures on Luxembourg paintings from Musée du Luxembourg, *Notice*, 1860 (number of works in 1860) and 1873, p. ix (works added in 1863).

20. On the Luxembourg's character as a "musée de passage," see Chennevières, in Musée du Luxembourg, *Notice*, 1873, p. x; Comte de Nieuwerkerke, "Rapport au Ministre de la Maison de l'Empereur et des Beaux-Arts sur la situation des musées impériaux," *GBA*, 1st ser., 15 (July–December 1863): 102.

21. For parliamentary criticism of conditions in the Luxembourg, see, e.g., Tirard, *Rapport* 1877, 2nd session, no. 179 (6 December 1877), *JO CD/A*, 22 December 1877, p. 8621: "The painting galleries are increasingly inadequate"; G. Berger, *ACD/D* 1896 (2), Report 2041, 13 July 1896: 206; and a comment in the debate that paintings in the Luxembourg were decaying, *ACD/DP* 1896e, 28 November 1896: 653. In his report on the fine arts budget for 1901 (*ACD/D* 1900, Report 1857, 10 July 1900: 1840–1843), the deputy Berger presented an extensive program for the reconstruction of the Luxembourg drawn up by its curator, Léonce Bénédite. The situation of the Luxembourg was also discussed in the debates on the fine arts budgets in 1900, 1902, and 1903.

22. *CAC* 1 (1862–1863): 143; P. de Chennevières, "Au Luxembourg," in his *Souvenirs d'un directeur des beaux-arts*, 5 vols. (Paris: L'artiste, 1883–1889), 2:37; AN, F²¹ 47, Blanc to Ségé, 27 November 1872, quoted in Lacambre, *Le Musée du Luxembourg*, p. 9.

23. On Second Empire claims to authority, in the particular context of

the salons, see Achille Fould's "Address to the Prize-Winners of the 1857 Salon," repr. and trans. in Linda Nochlin, ed., *Realism and Tradition in Art, 1848–1900: Sources and Documents* (Englewood Cliffs, N.J.: Prentice-Hall, 1966), pp. 3–4; on criticism of the government, see Mainardi, *Art and Politics,* and, e.g., Edmond About, *Salon de 1866* (Paris: Hachette, 1867), pp. 6–9.

24. Once again Edmond About provides a representative view; he writes of the state's purchases in "Le Salon de 1868," *Revue des deux mondes,* 2nd ser., 75 (1868): 718–719: "Quelques-unes de ces oeuvres traversent le Musée de Luxembourg, qui est devenu un lieu de passage, et vont ensuite chercher l'ombre dans les départemens [*sic*] éloignés. On assure que plusieurs sont enfouies aussitôt que livrées, parce qu'elles feraient peu d'honneur au goût des bureaucrates qui les choisissent." I am grateful to Patricia Mainardi for bringing this passage to my attention.

25. See, among others, Cecil Gould, *Trophy of Conquest: The Musée Napoléon and the Creation of the Louvre* (London: Faber and Faber, 1965), pp. 24–42, 91–96; Charles Saunier, *Les conquêtes artistiques de la révolution et de l'empire* (Paris: Renouard/H. Laurens, 1902), pp. 25–42; Marie-Louise Blumer, "La Commission pour la recherche des objets de sciences et arts en Italie (1796–1797)," *La Révolution française* 87 (1934): 62–88, 124–148.

26. Marie-Louise Blumer, "Catalogue des peintures transportées d'Italie en France," *Bulletin de la Société de l'histoire de l'art française* (1936): 347–348; Gould, *Trophy,* pp. 91–96, 116–130; Saunier, *Conquêtes artistiques,* pp. 85–105.

27. Gould, *Trophy,* pp. 70–71; Saunier, *Conquêtes artistiques,* p. 24. The chronology in Christiane Aulanier, *Histoire du Palais et du Musée du Louvre: Index général des tomes* (Paris: Editions des Musées Nationaux, 1968), indicates that the Grande Galerie, centerpiece of the early museum, was entirely closed between 1796 and 1799, partially closed until 1801, and then completely closed again between 1805 and 1810.

28. AN, AFIV 41, Plaquette 233.

29. Gould, *Trophy,* p. 77, gives the figure of 846 paintings; on restorations, Engerand, "Musées de province," p. 358.

30. For example, in the great festival of 8–9 thermidor year 6 (27–28 July 1798), celebrating the arrival in Paris of the last convoys of art treasures from Italy; see Blumer, "La Commission," pp. 237–250; Gould, *Trophy,* pp. 65–66; Saunier, *Conquêtes artistiques,* pp. 35–38.

31. On such distributions, see Gould, *Trophy,* pp. 79–80.

32. All in AN, AFIV 41, Plaquette 233; this passage also cited in Engerand, "Musées de province," p. 358.

33. AN, AFIV 69.

34. On Napoleon's overall policy toward the provinces, the development of the prefectoral system, and other means used to encourage loyalty,

see Louis Bergeron, *L'épisode napoléonien: Aspects intérieurs, 1799–1815,* Nouvelle Histoire de la France Contemporaine, 4 (Paris: Seuil, 1972), pp. 32–50.

35. AN, AFIV 41, Plaquette 233. Though cahiers in AN, F^{21} 4909 and F^{21} 4500 indicate that Rouen received its first shipment of paintings in the year 9 (unlikely, but Rouen could have gotten them within a year or two thereafter) and that Caen received its first share in 1804, neither museum opened to the public until 1809: see Ch. de Beaurepaire, "Notice historique sur le musée de peinture de la ville de Rouen," *Précis analytique des travaux de l'Académie des sciences, belles-lettres et arts de Rouen* (1852–1853): 406, and Clément de Ris, *Musées de province,* 1:143.

36. T. J. Clark, *Image of the People: Gustave Courbet and the Second French Republic, 1848–1851* (Greenwich, Conn.: New York Graphic Society, 1973), pp. 69–74. On Blanc's first tenure as director of fine arts, see Clark, *The Absolute Bourgeois: Artists and Politics in France, 1848–1851* (Greenwich, Conn.: New York Graphic Society, 1973), pp. 52–61.

37. The collection is now housed in the Musée du Petit Palais in Avignon, which opened in 1976. See "Préface" and "La Collection Campana" in Avignon, Musée du Petit Palais, *Peinture italienne,* 2nd ed., by Michel Laclotte and Elisabeth Mognetti, Inventaire des Collections Publiques Françaises, 21 (Paris: Réunion des Musées Nationaux, 1977); Salomon Reinach, "Esquisse d'une histoire de la collection Campana," *Revue archéologique,* 4th ser., 4 (July–December 1904): 179–200, 363–384; ibid. 5 (January–June 1905): 57–92, 208–240, 343–364; Maurice Besnier, "La collection Campana et les musées de province," *Revue archéologique,* 4th ser., 7 (January–June 1906): 423–460.

38. AN, F^{21} 4505, report of Henry Houssaye, 20 July 1879. The envoi is registered in the cahier in AN, F^{21} 4500.

39. Reports in AN, F^{21} 4505: "no organization as a museum," report on Pontoise, 20 October 1879; also reports on nonmuseums in Falaise (25 August 1879), Laval (25 October 1879), which had received ten envois in the 1850s and twelve in the 1860s, and Senlis (1879). The envois are recorded in cahiers in AN, F^{21} 4500, 4909, and 4910.

40. AN, F^{21} 443, correspondence between Maire and Sous-Préfet, Brest, Préfet, Finistère, and Ministre, August–September 1863.

41. On the 1851 circular, see AMB, 1434 R 4, Préfet Gironde to Maire de Bordeaux, 11 August 1851. Requests for catalogues or lists of works were made, for example, to the following cities: Marseilles (AN, F^{21} 447, Directeur des Beaux-Arts to Maire, 9 September 1863); Bourges (AN, F^{21} 443, Préfet Cher to Ministre, 25 September 1863); and Caen (AN, F^{21} 443, Préfet Calvados to Ministre, 14 August 1863).

42. Clément de Ris, *Musées de province,* 2:87; for similar comments on Marseilles, if anything even more damning, see. J. C. L. Dubosc de Pes-

quidoux, *Voyage artistique en France* (Paris: Michel Lévy Frères, 1857), p. 299. Marseilles received twenty-four works of art in the fifties and sixties, plus eighteen from the Campana collection; its new museum building was not completed until 1869. Figures on envois from cahiers in AN, F²¹ 4500 and 4910.

43. Quoted in Clément de Ris, *Musées de province*, 2:318; envoi figures from cahier, AN, F²¹ 4500.

44. AN, F²¹ 4500 and 4910, cahiers. In this respect the government was merely following the precedent established by previous governments: Nancy had received Delacroix's *Death of Charles the Bold at the Battle of Nancy* in 1829, Bordeaux Antoine-Jean Gros's *Landing of the Duchess of Angoulême at Pauillac* in 1820.

45. For a favorable comment on this notion, see Clément de Ris, *Musées de province*, 1:84.

46. AN, F²¹ 437, Commission du Muséum de la Ville de Calais to Directeur-Général des Musées, 20 August 1864, reply 1 September 1864; see also Préfet Aude to Ministre d'Etat, 14 July 1857, about the omission of Carcassonne; an envoi was announced 17 August 1857.

47. AN, F²¹ 437, Ministre d'Etat to Préfet Gironde, 20 March 1852. Bordeaux did eventually receive the painting, somewhat earlier than usual; see letter of 5 June 1852. On the emperor's birthday as determining date, see F²¹ 443, undated note (1861) for the Ministre on a request from Caen that an envoi be speeded up for a local exposition; the exception was granted in this case, but it was clearly an exception.

48. Categories from Charles Blanc, Directeur des Beaux-Arts, to Ministre de l'Instruction Publique et des Beaux-Arts, August 1872, reprinted in *CAC* 10 (1872): 334–337. Blanc himself listed only the museums he included in the first two categories. Although cities might complain about their category, usually because a nearby rival had been classified higher, Blanc made clear that the categories were only a matter of convenience: on, e.g., Niort versus Poitiers, see Angrand, *Histoire des musées*, 1:121–122.

49. Figures on envois from cahiers, AN F²¹ 4500 and 4909; figures on requests compiled from correspondence in AN, F²¹ 437, 443 (Bordeaux); 439, 447 (Marseilles); 2200, 451 (Roanne, Rouen).

50. AN, F²¹ 437, Hugot, Député to Chappuis, Maire de Colmar, 8 May 1851. Obviously the mayor himself was not terribly astute, but the historian can be grateful for his naiveté in enclosing this letter with his own request to the minister. Such enclosures were not in themselves uncommon—local officials often enclosed notes from influential Paris patrons supporting their requests—but in general the enclosures did not contain tactical advice.

51. AN, F²¹ 443, Alphonse Dumilâtre to Surintendant des Beaux-Arts, 11 November 1867, and reply, 2 December 1867.

52. AMB, 1438 R 1, comment of Emile Faget, Adjoint au Maire de Bordeaux, Délégué aux Beaux-Arts, Extrait des Délibérations du Conseil Municipal de Bordeaux, 5 May 1872.

53. David Thomson, *Democracy in France,* 5th ed. (London: Oxford University Press, 1969), pp. 91–110; Michel Crozier, *The Bureaucratic Phenomenon* (Chicago: University of Chicago Press, 1964), pp. 213–227, 251–263; Guy Thuillier, *Bureaucratie et bureaucrates en France au XIXe siècle,* Ecole Pratique des Hautes Etudes, IVe Section, Centre de Recherches d'Histoire et de Philologie: Hautes Etudes Médiévales et Modernes, 38 (Geneva: Droz, 1980), pp. 114–133, 316–333.

54. Although the imperial project was never officially announced, a number of cities submitted requests for these works in the spring of 1870: see, e.g., AN, F²¹ 447, Maire de Marseille to Ministre de la Maison de l'Empereur et des Beaux-Arts, 6 April 1870, and copy of reply, 3 May 1870 (original in AMM, 57 R 5) explaining that the distribution is still being planned; there is a similar reply to the Maire de Bordeaux, 20 May 1870, in AN F²¹ 458. The interpellation of the minister by one of his eventual successors, Agénor Bardoux, is in *JO CD,* 22 March 1872, pp. 2021–2022; the minister commented that numerous deputies had raised the issue with him privately.

55. AN, F²¹ 494, "Rapport au Président de la République," n.d., reprinted in *CAC* 11 (1872): 333–334. The Fine Arts Administration distributed works from the Louvre reserves throughout the remainder of the nineteenth century and beginning around 1890 also sent works from the Luxembourg to the provinces.

56. See Table 4. For the Campana distribution the government had, according to the *Chronique des arts et de la curiosité* 1 (1862–1863): 142, divided museums into three classes of importance. The first category included 17 museums (compared to 14 in 1872), the second 19 (28), and the third 31 (the Third Republic expanded this category considerably, to about 100). Unfortunately the article does not list the museums in each category.

57. *CAC* 11 (1872): 336, 334. Blanc's very idiomatic phrase reads "Les aspirations de la province et le goût de plus en plus vif que s'y manifeste pour tous les progrès de l'art."

58. Chennevières, "Charles Blanc," in his *Souvenirs* 1:90–97; Vaisse, "Troisième république," pp. 508–510.

59. AN, F²¹ 462, Blanc to Nanteuil, 11 November 1872; see also AMD, 4 R I (uncatalogued series), Dossier Nanteuil.

60. The museum's director responded, reasonably enough, that no one in Marseilles would have thought of this possibility if Blanc himself had not brought it up; Blanc eventually acquiesced. Extensive correspondence in AN, F²¹ 466 and 485; in AMM, 57 R 5; and in MM, NS/C 1872–1876, especially AN, F²¹ 466; Préfet Bouches-du-Rhône to Ministre, 13 October

1872, Adjoint au Maire de Marseille, Délégué aux Beaux-Arts, to Blanc, 14 November 1872, Blanc to Clapier, 16 November 1872; and MM, NS/C 1872–1876, Bouillon-Landais, Directeur, to Maire de Marseille, 23 December 1872.

61. *CAC* 11 (1872): 334; *JO* CD, 28 July 1874, pp. 5309–5310: proposal of de Tillancourt and a favorable response from the Sous-Secrétaire d'Etat de l'Instruction Publique et des Beaux-Arts.

62. In the parliamentary discussion of the fine arts budget for 1903, Roger Ballu, a deputy and former Inspecteur des Beaux-Arts (his direct responsibilities had not included provincial museums) charged that the Fine Arts Administration was engaged in the practice of systematically transferring masterpieces from the collections of provincial museums to the Louvre: *ACD/DP,* 1903 (1), 3 February 1903: 510. He cited no definitive evidence to support this charge, and I have found none in the archives; the minister, Jacques Chaumié, while responding to most of Roger Ballu's comments, did not bother to reply to this charge.

63. Envois registered in cahiers, AN, F²¹ 4909 and 4910. Inspectors discovered that these museums did not exist in 1879–1880; AN, F²¹ 4505, reports of 17 July 1879 (Montélimar), 13 September 1879 (Pont-Audémer), 10 October 1879 (Mont-de-Marsan), and 11 June 1880 (Vervins, which at least had one or two of the trappings of a museum, including a checklist and a minimal budget it shared with the town library).

64. AN, F²¹ 4500, 4909, 4910, cahiers. On Quimper, which consistently requested works the government was happy to send it, see Angrand, *Histoire des musées,* 1:67–74.

65. See, for example, AN, F²¹ 4509, copy of a letter of 22 February 1884 from Etienne Arago, curator of the Luxembourg, to the mayor of his native Perpignan about the envois the latter had requested: "the administration . . . has decided to make its gifts proportionate to the *sacrifices* that municipalities impose on themselves."

66. AN, F²¹ 2210, Sadi-Carnot to Directeur des Beaux-Arts, 26 July 1885; Sadi-Carnot had also written a letter to the Ministre on 23 July in which he referred to the city's *sacrifices.*

67. AN, F²¹ 2216, Bouillon-Landais to Directeur des Beaux-Arts, 22 July 1883; F²¹ 471, Maire de Rouen to Sous-Secrétaire d'Etat des Beaux-Arts, 29 October 1880.

68. AN, F²¹ 2250, Rapport au Ministre de l'Instruction Publique, des Beaux-Arts, et des Cultes, signed Roger Marx, 15 June 1897.

69. Envoi figures from cahiers in AN, F²¹ 4500 and 4909, and reports on Bordeaux (27 October 1879) and Montpellier (25 November 1879), AN, F²¹ 4505.

70. Correspondence in AN, F²¹ 4508 (1885) and F²¹ 4512 (1895); AN F²¹ 4500, 4909, 4910, cahiers. Among other class 1 museums, Montpellier

received ten envois and Nantes nine in the 1880s, Lyons thirty and Marseilles thirty-two in the 1890s.

71. *JO* CD, 17 December 1884, p. 2823.

72. AN, F²¹ 2223, Directeur des Beaux-Arts to Ministre, November 1886.

73. On this principle, which had as another ramification the state's adherence to a "neutral" purchasing policy, see Vaisse, "Troisième république," pp. 430, 434.

74. AN, F²¹ 471, Ministre to Maire de Rouen, 28 October 1872. In the original draft, the sentence began, "I should moreover not conceal from you that because of the small number of sculptures acquired each year by the state," but another hand marked in the margin "This is not clever! The Adm[inistrati]on should never accuse itself."

75. AMD, 4 R I, CC/CD 1891–1892, Conservateur Adjoint to Maire, 6 July 1892.

76. For two typical examples, Rochefort and Cahors, see Angrand, *Histoire des musées,* 1:142–145, 2:9–18.

77. AN, F²¹ 466, Maire de Marseille to Sous-Secrétaire d'Etat des Beaux-Arts, 30 June 1879, marginalia.

78. AN, F²¹ 2236, Chef du Bureau de l'Enseignement et des Musées to Commissaire des Expositions des Beaux-Arts, 9 June 1899; F²¹ 2270, Bigard-Fabre (Chef de Bureau) to Directeur des Beaux-Arts, 5 February 1902, cases involving Bordeaux and Dijon.

79. AN, F²¹ 2210, Ministre to Gustave Denis, Sénateur, 13 February 1886.

80. Class 1 museums chosen for comparison were Amiens, Bordeaux, Caen, Dijon, Grenoble, Lille, Lyons, Marseilles, Montpellier, Nantes, and Rouen; artists drawn from cahiers in AN, F²¹ 4500 and 4909, and confirmed in catalogues where possible. Material on the Luxembourg drawn from Musée du Luxembourg, *Notice,* 1880 and 1890.

81. AN, F²¹ 2216, internal note, 20 February 1890.

82. See, for example, de Ronchaud, "Encouragement," pp. 132–134, 147, 158–159. Parliamentary calls for "l'unité des arts" effectively meant encouraging purchases of decorative arts; see, for example, the comments of Pierre Merlou in the report on the fine arts budget for 1894, *ACD/D* 1893 (2), Report 907, 26 June 1893: 375, and the call of Georges Berger for more government purchases of decorative arts, *ACD/DP* 1895 (1), 16 February 1895: 447–448. On the need for government support for the graphic arts, see the comments of Georges Leygues, *ACD/DP* 1890e, 22 November 1890: 613.

83. AN, F²¹ 2242, Directeur des Beaux-Arts to Directeur des Musées Nationaux, 10 June 1896.

84. AN, F²¹ 443, Maire de Bordeaux to Ministre, 31 August 1864;

AMB, 1434 R 6, draft of this letter with changes, also T. Scott, Président de la Société des Amis des Arts de Bordeaux to Maire Adjoint (?), "Mardi matin" [early August 1864].

85. AMB, 1436 R 7, Vallet, Conservateur du Musée to Maire de Bordeaux, 3 October 1890, 9 February 1897, and 3 August 1892.

86. Chennevières's offer (actually recalling an offer made just prior to the outbreak of the Franco-Prussian War) to the Préfet des Bouches-du-Rhône, 23 April 1877, is in ADBdR, 4 T 50; he mentions the dimensions of the picture. The report of the Conservateur, Bouillon-Landais, to the Maire, 14 May 1877, is in AMM, 57 R 5; the eventual refusal, Préfet to Ministre, 31 May 1877, is in AN, F^{21} 477. The sizes of the "smallest" pictures cited by Bouillon-Landais are approximately sixteen to twenty square feet.

87. Angrand, *Histoire des musées,* passim.

88. AN, F^{21} 2210, Maire Adjoint de Dijon to Ministre, 28 June 1882.

89. De Ronchaud, "Encouragement," p. 152; Engerand, "Musées de province," p. 359; Larroumet, *L'art et l'Etat,* p. 25. Larroumet goes on to say that "the departments receive the paintings they deserve," somewhat disingenously blaming the low quality on the requests of deputies. On About, see note 24.

90. According to the cahiers in AN, F^{21} 4500, 4909, and 4910, there were 84 joint purchases between the late 1880s and 1914; this amounted to less than 2 percent of the total envois for that period (4,687), and less than 3 percent of the envois of painting and sculpture (3,019). Of the 84 joint purchases, 71.4 percent represented purchases with museums of classes 1, 2, and 3; only one purchase with a museum of class 5 or 6. For praise of joint purchases, see Larroumet, *L'art et l'Etat,* pp. 26–27; Dujardin-Beaumetz, *ACD/D* 1899, Report 1134, 4 July 1899: 2631.

91. There is extensive correspondence on Dijon's efforts to add a "Musée Rude" to its museum in AN, F^{21} 2242, 1891–1895; of particular interest is the letter explaining the Fine Arts Administration's inability to offer more assistance, Directeur des Beaux-Arts to Conservateur du Musée de Dijon, 12 March 1894. On Marseilles's request for assistance in building a Puget gallery, AN, F^{21} 2250, 1899–1900, and F^{21} 2275, May–September 1905; for the Louvre's resistance, Directeur des Musées Nationaux to Sous-Secrétaire d'Etat des Beaux-Arts, 1 August 1905.

92. The best source on these matters is Vaisse's chapter "L'abandon des salons," in "Troisième république," pp. 259–346.

93. Larroumet, *L'art et l'Etat,* p. 10. See also Dujardin-Beaumetz's perceptive comments on the development of the art market, *ACD/D* 1899, Report 1134, 4 July 1899: 2596–2597, and Simyan's praise for avant-garde artists who had been excluded from the salons, *ACD/D* 1902e, Report 613, 8 December 1902: 850–851.

94. See Vaisse, "Troisième république," pp. 399–406. He calculates that by 1908 only a quarter of the state's purchases were made at the Salon des Artistes Français, the descendant of the old official salon.

95. *ACD/D* 1890 (2), Report 792, 5 July 1890: 755; *ACD/DP,* 1890e, 30 November 1890: 634–635.

96. On the desirability of impartiality, see *ACD/D* 1892 (2), Report 2271, 7 July 1892: 513–514; 1894 (2), Report 907, 28 July 1897: 777; 1898e, Report 496, 12 December 1898: 503–504; 1907, Report 1238, 11 July 1907: 1621–1622; Larroumet, *L'art et l'Etat,* pp. 18–21.

97. On exhibitions of purchased works: *ACD/D* 1896 (2), Report 2041, 11 July 1896: 199; *ACD/D* 1897 (1), Report 2698, 20 July 1897: 1854; *ACD/DP* 1903 (1), 3 February 1903: 509 (national tour); on the institution of annual exhibitions of purchases, see Vaisse, "Troisième république," pp. 452–453. On democratization and expansion of the system: *ACD/D* 1899, Report 1134, 4 July 1899: 2619–2621 (Dujardin-Beaumetz); *ACD/D* 1903, Report 1203, 4 July 1903: 1308.

98. On solicitations: *ACD/D* 1902e, Report 613, 6 December 1902: 860; *ACD/D* 1906, Report 344, 13 July 1906: 1623 (the reporter, Couyba, expressed skepticism about artists voting on purchases); *ACD/D* 1907, Report 1238, 11 July 1907: 1622. The more extensive proposal was also made by Dujardin-Beaumetz, *ACD/DP* 1891e, 12 November 1891: 311–312; see also *ACD/D* 1899, Report 1134, 4 July 1899: 2620.

99. De Ronchaud, "Encouragement," p. 153.

100. Lacambre, *Le Musée du Luxembourg,* p. 10.

101. John Rewald, who generally criticizes the government for its lack of support for the impressionists, notes that the first substantial purchase of their paintings by the dealer Paul Durand-Ruel allowed the impressionists to avoid submitting works to the Salon of 1872: *The History of Impressionism,* 4th ed., rev. (New York: Museum of Modern Art, 1973), pp. 271–272. For the most recent scholarship on the impressionist exhibitions, see *The New Painting: Impressionism 1874–1886,* catalogue of an exhibition at the National Gallery of Art, Washington, and the Fine Arts Museum of San Francisco, 1986.

102. White and White, *Canvases and Careers,* pp. 94–102, 111–152; Boime, "Entrepreneurial Patronage," pp. 165–173, 184–191. Vaisse, "Troisième république," pp. 458–459, observes that the stalwarts of academicism, in its narrowest sense—Bonnat, Baudry, Bouguereau, Cabanel, Gérôme, and Meissonnier—obtained very little direct patronage from the state after 1870, partially because of their association with the cultural policies of the Second Empire but also because of their prices. On American purchases of pompier art, see Lillian M. C. Randall, ed., *The Diary of George Lucas: An American Agent in Paris, 1857–1909,* 2 vols. (Princeton: Princeton University Press, 1979), especially the introduction, 1:3–32.

103. *JO* CD, 17 December 1884, pp. 2823–2824.

104. *ACD/DP* 1890e, 22 November 1890: 628; *ACD/DP* 1895 (1), 16 February 1895: 454.

105. *ACD/D* 1906, Report 344, 13 July 1906: 1623.

106. J. Paul-Boncour, *Art et démocratie* (Paris: Ollendorff, 1912), p. 100. See also *ACD/D* 1902e, Report 613, 8 December 1902: 849–851, Simyan's criticism of the government for letting great impressionist works escape from France's patrimony; *ACD/D* 1903, Report 1203, 4 July 1903: 1308, a similar lament.

107. Among the works in which such attitudes appear are Michel Hoog, *L'art d'aujourd'hui et son public,* Collection "Vivre son temps" (Paris: Editions Ouvrières, 1967), pp. 13–14; Jeanne Laurent, *Arts et pouvoirs en France de 1793 à 1981: Histoire d'une démission artistique,* Université de Saint-Etienne, Travaux, 34 (Saint-Etienne: CIEREC, 1982), p. 9 and passim; and Charles Rosen and Henri Zerner, *Romanticism and Realism: The Mythology of Nineteenth-Century Art* (New York: Viking, 1984), pp. 206, 231–232. See also Vaisse, "Troisième république," pp. 1–16.

108. See the denial of the fine arts director, Henry Roujon, of a deputy's charge that the state "bestows all its favors" on the Academy, *ACD/DP* 1900e, 7 December 1900: 750; see also Vaisse, "Troisième république," pp. 1–16; Albert Boime, *The Academy and French Painting in the Nineteenth Century* (London: Phaidon, 1971); idem, "The Second Empire's Official Realism," in Gabriel P. Weisberg, ed., *The European Realist Tradition* (Bloomington: Indiana University Press, 1982), pp. 45–49, 97–100; Marie-Claude Genet-Delacroix, "Vies d'artistes: Art académique, art officiel et art libre en France à la fin du XIXe siècle," *Revue d'histoire moderne et contemporaine* 33 (1986): 40–43.

109. Boime, *The Academy,* pp. 15, 19–20; Vaisse, "Troisième république," pp. 174–183.

110. Laurent, *Arts et pouvoirs,* p. 53.

111. Generically, nineteenth-century history painting included not only depictions of the great events of ancient, medieval, and modern history but also scenes drawn from literature, including drama (e.g., Shakespeare), poetry (Hugo), and fiction (from Scott to Flaubert), and from biblical events and religious allegories.

112. See Marrinan, *Painting Politics,* passim; Hanson, *Manet,* pp. 103–104; Linda Nochlin, *Realism,* Style and Civilization (Harmondsworth: Penguin, 1971), pp. 23–55; Boime, "Realism," pp. 51–52, 85–95; Robert Rosenblum and H. W. Janson, *Nineteenth-Century Art* (New York: Abrams, 1984), pp. 354–357. On the difficulty of categorizing pictures solely from written evidence, see Anne Coffin Hanson, "Manet's Subject Matter and a Source of Popular Imagery," *Museum Studies* 3 (1969): 63–64.

113. Patricia Mainardi, "The Death of History Painting in France,

1867," *GBA* (1982): 219–226; idem, *Art and Politics*, pp. 154–174, 187–193; White and White, *Canvases and Careers*, pp. 90–92; Lacambre and Rishel, "Painting," pp. 245–246; Hanson, "Manet's Subject Matter," pp. 63–64, 78.

114. Boime, *Academy*, pp. 16–18, briefly summarizes these developments. He calls the artists involved members of a "juste milieu."

115. On this kind of picture, see Rosen and Zerner, "The Ideology of the Licked Surface," in their *Romanticism and Realism*, pp. 205–232.

116. Vaisse, "Troisième république," pp. 97–99; Georges Lafenestre, "Collection Desfosses," in his *Artistes et amateurs*, Les Idées, Les Faits, et Les Oeuvres (Paris: Société d'Edition Artistique, 1899); see especially his praise of a Sisley, pp. 339–340. Among Marx's works, see especially his *Maîtres d'hier et d'aujourd'hui*, 2nd ed. (Paris: Calmann-Lévy, 1914), with chapters on Rodin, Fantin-Latour, Renoir, Monet, Morisot, and Gauguin, among others.

117. The Renoir was a commission: see C. Sterling and H. Adhémar, *Musée national du Louvre. Peintures: Ecole française, XIXe siècle*, 4 vols. (Paris: Editions des Musées Nationaux, 1958–1961), vol. 4, no. 1600. On acquisitions between 1900 and 1914 see purchase lists in *ACD/D* 1904: 1393–1394 (Redon); 1905: 1207–1208 (Picabia, Matisse, Marquet, Sebilleau); 1907: 1646–1648 (Signac); 1909: 1918–1919 (Luce, Villon); and Vaisse, "Troisième république," pp. 449–450, 489–496 (Sisley, Vuillard, Denis, Signac).

118. Rosen and Zerner, *Romanticism and Realism*, p. 218.

119. Vaisse, "Troisième république," pp. 98–99; Larroumet, *L'art et l'Etat*, pp. 6–27, 294–298.

120. AMB, 1436 R 2, Maire to Ministre de l'Instruction Publique et des Beaux-Arts, 23 August 1926, and reply (in the negative) from Directeur des Beaux-Arts, 8 September 1926.

121. AN, F[21] 4512, inspection report, dated Marseilles, 17 March 1895; the curator, Paul Guigou, also mentioned the artist Louise Breslau.

122. For example, Marseilles joined with the state to purchase Frédéric Montenard's *Coup de Mistral in the Mediterranean*, and the government had sent one Montenard painting to the Luxembourg in 1890 and another to Marseilles in 1895; see AN, F[21] 4909, cahier. Bordeaux also bought a painting by Raffaelli, who had exhibited with the impressionists and constitutes one of the clearest cases of an artist who assimilated many of impressionism's formal qualities and pictorial concerns without ever fully adopting its aesthetic outlook or stalwart independence; he had a painting in the Luxembourg from 1886 to 1893, when it was sent to Lyons. See Bordeaux, *Catalogue*, 1910, no. 557, and Musée du Luxembourg, *Notice*, 1890, p. 37, no. 211. Provincial museum acquisitions will be discussed more fully in Part II.

123. The first major bequest, the major impressionist collection left by

Gustave Caillebotte on his death in 1892, remains controversial; for the latest debate, see Pierre Vaisse, "Le legs Caillebotte d'après les documents," *Bulletin de la Société de l'histoire de l'art français* (1983): 201–208; Marie Berhant, "Le legs Caillebotte, vérités et contre-vérités," ibid., 209–223. On the Moreau-Nélaton and Camondo collections, see R. Koechlin et al., "La donation Etienne Moreau-Nélaton," *Bulletin de la Société de l'histoire de l'art français* (1927): 118–152; Musée National du Louvre, *Catalogue de la Collection Isaac de Camondo* (Paris: Braun, n.d. [before 1921]). On subscriptions, see Rewald, *History of Impressionism*, pp. 553–554; *Edouard Manet 1832–1883*, catalogue of an exhibition at the Grand Palais, Paris, and the Metropolitan Museum of Art, New York, 1983, p. 183, and *Gustave Courbet (1819–1877)*, catalogue of an exhibition at the Grand Palais, Paris, and the Royal Academy, London, 1977–1978, p. 243. On purchased works, see, for example, *Centenaire de l'Impressionisme*, catalogue of an exhibition at the Grand Palais, Paris, 1974, pp. 138, 170, on Monet's *Femmes au jardin*, bought for the Luxembourg from the artist for 200,000 francs in 1921, and Berthe Morisot's *La berceuse*, bought for the Louvre for 300,000 francs in 1930.

2. Inspectors, Inspections, and Norms

1. AN, F^{21} 562, Report, Guillaume, Directeur-Général des Beaux-Arts, to Bardoux, Ministre de l'Instruction Publique et des Beaux-Arts, 1 February 1879.

2. ADSM, 4 T 219, Ministre de l'Intérieur to Préfet, 21 January 1813; AN, F^{21} 2198, Ministre de l'Intérieur to Préfet Hérault, 12 April 1817.

3. ADBdR, 4 T 50, Circular, Ministre de l'Intérieur to Préfets, 3 August 1821.

4. *CAC* 1 (1862–1863): 142; on Houssaye's appointment, which is described as a "sinécure créée pour lui," see P. Larousse, *Grand dictionnaire universel du XIXe siècle*, 17 vols. (Paris: Larousse, 1866–1877), 9:419.

5. The circular, Ministre de l'Intérieur to Préfets, 4 August 1851, can be found in ADBdR, 4 T 50, Dossier 5, and in AMB, 1434 R 4, where it is summarized in Préfet Gironde to Maire de Bordeaux, 11 August 1851. Requests for catalogues or inventories were made, for example, to Caen (AN, F^{21} 443, original missing, reply Préfet Calvados to Ministre, 22 August 1863), Marseilles (F^{21} 447, Directeur-Général des Musées to Maire de Marseille, 9 September 1863, and Calais (see Chapter 1, note 46).

6. During the Second Empire, the fine arts bureaucracy was housed in the Ministère de l'Intérieur until 1853, the Ministère d'Etat (1853–1863), the Ministère de la Maison de l'Empereur et des Beaux-Arts (1863–1870), the short-lived Ministère des Lettres, Sciences, et Arts, and then again the Maison de l'Empereur in the last weeks of the regime. With the abolition of the civil list immediately after the founding of the Republic on 4 Sep-

tember 1870, the Fine Arts Administration came to rest in the Ministère de l'Instruction Publique et des Beaux-Arts. See also Chapter 1, note 9.

7. AN, F²¹ 562, Guillaume report of 1 February 1879. Curiously, the report did not mention a precedent that soon received much emphasis from the Fine Arts Administration: the decree law of 25 March 1852, which specified that museum curators had to be named by the prefect on "presentation" (preliminary selection) by the mayor.

8. AN, F²¹ 562, report of 1 February 1879. In a ministerial circular to prefects of 26 April 1881, AN, F²¹ 4500 (also in *JO,* 28 April 1881, pp. 2341–2342), the undersecretary of state, Edmond Turquet, said only that the question of the 1839 ordinances' applicability to museums was under study, and he did not cite it as an authority.

9. According to the circular of 26 April 1881 in AN, F²¹ 4500, and to Lockroy's report on the fine arts budget for 1881, *JO,* 10 July 1880, p. 8428.

10. See Katherine Auspitz, *The Radical Bourgeoisie: The Ligue de l'enseignement and the Origins of the Third Republic, 1866–1885* (Cambridge: Cambridge University Press, 1982), pp. 46–48, 123–126, 136–139, 157–162; Jean-Marie Mayeur, *Les débuts de la IIIe République, 1871–1898,* Nouvelle Histoire de la France Contemporaine, 10 (Paris: Seuil, 1973), pp. 111–119; and, more generally, Sanford Elwitt, *The Making of the Third Republic: Class and Politics in France, 1868–1884* (Baton Rouge: Louisiana State University Press, 1975), pp. 170–185.

11. Some of these ideas can be found in d'Osmoy's report on the fine arts budget for 1877, *JO* CD/A, 12 August 1876, p. 6303; in that of Lockroy on the 1882 budget, *JO* CD/A, May 1881, pp. 843–844; in Proust, *L'art sous la République,* pp. i–ii, 5–7, 26–28, 107–111; and in Larroumet, *L'art et l'Etat en France,* pp. 291–296; cf. P. Vaisse, "Troisième république," pp. 115–168; Marie-Claude Genet-Delacroix, "Esthétique officielle et art national sous la IIIe République," *Le mouvement social,* no. 131 (April–June 1985): 105–120. Proust, among others, recognized that these ideas owed much to the tradition of the French Revolution, but republican leaders and ideologues could still consider such concepts "new" by virtue of their break with the practices of the Second Empire and their adaptation to a new industrial age.

12. Georges Lafenestre, "Le Marquis de Chennevières," in his *Artistes et amateurs,* pp. 268–269; Henry Roujon, "Le Marquis de Chennevières," in his *Artistes et amis des arts* (Paris: Hachette, 1912), pp. 18–20; Antoine Schnapper, "Philippe de Chennevières et la province," *Bulletin de la Société de l'histoire de l'art français* (1972): 33; P. de Chennevières, "Les musées de province," *GBA,* 1st ser., 18 (January–June 1865): 121–129.

13. Lafenestre, "Chennevières," pp. 276–277; Roujon, "Chennevières," pp. 28–29. Lafenestre refers to the republicanism of Fine Arts Administration officials (including himself) on p. 269.

14. On Chennevières's views, see his "Les musées de province," pp. 128–

130; Lafenestre, "Chennevières," pp. 278–279. On legitimist nostalgia and decentralization, see A. J. Tudesq, "La décentralisation et la droite en France au XIXe siècle," in *La décentralisation, VIe colloque d'histoire organisé par la faculté des Lettres et des Sciences humaines d'Aix-en-Provence, les 1er et 2 décembre 1961* (Aix-en-Provence: Ophrys, 1964), pp. 56–58, 65–66; Robert R. Locke, *French Legitimists and the Politics of Moral Order in the Early Third Republic* (Princeton: Princeton University Press, 1974), pp. 156–157, 197–198. Locke observes that after the Commune the legitimists' traditional hostility to the centralized state was considerably tempered by their fear of revolution and disorder.

15. Lafenestre credits Chennevières with a strong interest in artistic education but notes that the crucial report on the subject was written by Guillaume in Chennevières's name. On Guillaume, see Henry Roujon, "Eugène Guillaume," *Artistes et amis des arts*, pp. 131–132, and Vaisse, "Troisième république," pp. 80–81.

16. AN, F²¹ 562, report of 1 February 1879 and decree of appointment of same date. Houssaye got this assignment after seeking, through contacts, the more lucrative and more permanent position of Inspecteur des Beaux-Arts; see AN, F²¹ 562, Turquet to Mme. Edmond Adam, 17 April 1879.

17. AN, F²¹ 562, undated documents. Curiously, there was no zone for the Gare Saint-Lazare.

18. Of these only 44 of Baignières's and 43 of Houssaye's have survived in the archives, together with 7 of 9 submitted by the third inspector, Arthur Gentil. Figures compiled from lists in AN, F²¹ 562, correspondence in F²¹ 4910, and reports in F²¹ 4505, which also contain the dates used to reconstruct the inspectors' schedules.

19. AN, F²¹ 562, report of 1 February 1879 (Guillaume); F²¹ 4910, letter of 18 November 1879 (Turquet).

20. Although Houssaye's report has not survived in the archives, it is largely reproduced in an anonymous report of 23 pages, entitled "Les musées de province: Étude" (henceforth "Les musées"), in AN, F²¹ 4909, and in Houssaye's "Les musées de province, leur origine et leur organisation," *Revue des deux mondes*, 3rd ser., 38 (1880): 546–565.

21. Houssaye, "Les musées de province," pp. 556, 559.

22. Ibid., p. 565. His wording is cited exactly, though with a few additions, in AN, F²¹ 4909, "Les musées," pp. 15–16.

23. Houssaye, "Les musées de province," pp. 562–565, emphasis in original. See also AN, F²¹ 4909, "Les musées," pp. 16–18.

24. Bardoux's *projet de loi* of 1878 was never passed, and though Turquet's circular of 26 April 1881 suggested that he was working on such a bill, none was presented to Parliament between the date of the circular and November 1881, when Turquet was replaced by Antonin Proust as head of the short-lived Ministère des Arts in the Gambetta government.

25. For example in AN, F²¹ 4508, Chef du Bureau des Musées, des Sous-

criptions, et de l'Inventaire to Préfet Isère, 7 July 1881: "[Museums] . . . will commend themselves as much through the quality of their installation as through the intelligent care given to their conservation"; these distinctions would help create a "new classification" of museums eligible for envois.

26. AN, F²¹ 4510, letter of 18 June 1885.

27. A handwritten copy of the circular, seven pages long, is in AN, F²¹ 4500. The circular was also published in *JO,* 24 April 1881, pp. 2341–2342.

28. Circular in AN, F²¹ 4500.

29. Correspondence in AN, F²¹ 4910. The curators were Alphonse Chassant of Evreux, who reported on museums in the Eure, and Anatole Faugère-Dubourg of Nérac, who covered the Gers, the Dordogne, and the Haute-Garonne.

30. AN, F²¹ 4910, report, with a cover letter to Turquet (by then out of office) of 28 November 1881. The museums covered included two, Amiens and Arras, left out of the original inspection.

31. In 1881 Turquet had to reassure one of the ad hoc inspectors, an Arlesian named Estrangin, both that the state had the right to conduct such inquiries and that municipal officials usually greeted inspectors with all possible courtesy (AN, F²¹ 4910, letter of 2 March 1881). He did not state what may have seemed obvious, that whatever their fears or resentment of state interference, local officials also saw inspection visits as a chance to press their particular requests on the government, and they thus had every reason to be polite.

32. AN, F²¹ 4910, Dayot to Sous-Secrétaire d'Etat, 28 August 1885. The reply of 3 September sent the requested letters of introduction to the authorities.

33. *JO* CD, 17 December 1884, p. 2824.

34. The report, "Rapport à M. le Ministre de l'Instruction Publique, des Beaux-Arts et des Cultes, sur l'organisation de l'Inspection des Musées," and subsequent decree, both of 13 January 1887, are reprinted in *CMP,* pp. 326–329 (the report is misdated 13 June). A copy of the circular, addressed to the Maire de Dijon, dated 20 January 1887, and signed for the minister by Kaempfen, can be found in AMD, DNC/Rapports des Inspecteurs.

35. *JO CD/A,* 28 November 1878, pp. 11,122–11,123. The creation of the Inspection de l'Enseignement du Dessin actually occasioned a heated dispute in the discussion of the fine arts budget between the minister, Bardoux, and the *rapporteur* of the budget, Antonin Proust, who believed that an inspectorate was superfluous until the government actually implemented its program to promote artistic education; Bardoux maintained that inspections on their own could be useful. See *JO* CD, 29 November 1878, pp. 11,177–11,178.

36. See *ACD/D* 1900, Report 1857, 10 July 1900: 1810; *ACD/D* 1903,

Report 1203, July 1903: 1281, lists six painters, four architects, a sculptor, and an engraver; on salaries, *JO* CD/A, July 1882, p. 1799; AN, ADXVIIIF 1225, Min. *CD* 1885.

37. *ACD/D* 1896 (2), Report 2041, 11 July 1896: 185.

38. Kaempfen's report, 13 January 1887, *CMP*, pp. 326–328; *ACD/D* 1896 (2), Report 2041, 11 July 1896: 185.

39. *ACD/D* 1905, Report 2669, 13 July 1905: 1166–1172. This figure, however, includes art courses in *écoles primaires supérieures,* which were added to the inspection load only from 1905. Without them, the average was 100 institutions per district, with the same average number of museums, 23, in each case (earlier figures from *ACD/D* 1904, Report 1953, 13 July 1904: 1367).

40. *ACD/D* 1905, Report 2669, 13 July 1905: 1165; *ACD/D* 1904, Report 1953, 13 July 1904: 1367 (on timing of inspections); *ACD/D* 1900, Report 1857, 10 July 1900: 1810.

41. *ACD/D* 1900, Report 1857, 10 July 1900: 1810. In 1904 one "inspecteur principal" received 3,400 francs per annum, the eight "inspecteurs ordinaires" 3,300 each, and three "inspecteurs adjoints" 2,000 apiece. The principal inspector also received traveling expenses of 20 francs per day, the others 12 francs a day per man, sums the reporter pronounced inadequate: *ACD/D* 1904, Report 1953, 13 July 1904: 1367.

42. For previous reports lamenting low pay, see *ACD/D* 1894 (2), Report 907, 28 July 1894: 769; *ACD/D* 1903, Report 1203, July 1903: 1282, and reports of 1896, 1900, and 1904 already cited.

43. AN, F^{21} 2278, letter, Minet, Conservateur, to Ministre, 18 March 1909.

44. There are handwritten specimen forms in AN, F^{21} 562; the printed forms, with of course the information they contain, are in F^{21} 4505.

45. Michel Foucault, *The Order of Things: An Archeology of the Human Sciences* (New York: Pantheon, 1971), pp. 42–44, 206–208, 246–249; quotation from p. 248.

46. On bourgeois culture as an elite culture, see Maurice Crubellier, *Histoire culturelle de la France, XIXe–XXe siècle* (Paris: Armand Colin, 1974), pp. 105–120; on classification and standards in the provinces, compare Robert Fox, "Learning, Politics and Polite Culture in Provincial France: The Sociétés Savantes in the Nineteenth Century," in Donald N. Baker and Patrick J. Harrigan, eds., *The Making of Frenchmen: Current Directions in the History of Education in France, 1679–1979* (Waterloo, Ont.: Historical Reflections Press, 1980), pp. 543–564.

47. On Montpellier, see above, note 2. On the question of how new this ideology really was in relation to ideas about the state and the arts, see Chapter 1.

48. AN, F^{21} 562, draft of letter, Turquet to Inspecteurs, 23 April 1879.

49. These criteria, with varying degrees of emphasis, underlay much of the administration's correspondence with provincial museums in the years 1883–1885, for example in AN, F²¹ 4508, Directeur des Beaux-Arts to Préfet Rhône, 28 August 1883. All the criteria are spelled out in the following letters from the Directeur des Beaux-Arts: F²¹ 4509, to Préfet Meurthe-et-Moselle, about Nancy, 11 November 1884; F²¹ 4510, to Préfet Aveyron, about Rodez, 15 February 1884; to Préfet Loire, about Saint-Etienne, 2 July 1884; to Préfet Yonne, about Tonnerre, 15 July 1885.

50. AN, F²¹ 4510, Directeur des Beaux-Arts to Préfet Aveyron, 15 February 1884: "in thus concerning itself with the adequate installation of provincial museums, the state is simply acting as a good proprietor."

51. Cf. AN, F²¹ 4509, Directeur des Beaux-Arts to Préfet Loiret, 1 June 1883 ("consulter"); F²¹ 4508, Directeur des Beaux-Arts to Préfet Rhône, 28 August 1883 ("approbation"); for an example of a controversial appointment shunted off to Paris by Bordeaux in 1899, see extensive correspondence in F²¹ 4511. What might be regarded as the government's definitive statement on the subject, a ministerial circular to prefects of 14 August 1890 (copy in ADCdO, 33 T 1a; also reprinted in *CMP*, pp. 335–336), stresses the 1852 decree, making future envois conditional on its observance, but leaves the administration's role somewhat murky, relying on the "consulter" formula.

52. Many examples of these forms can be found in the following series in the Archives Nationales: F²¹ 4506–4511, 1881 through 1890; F²¹ 4511–4514, 1891–1900; F²¹ 4514–4517, 1901–1910; for examples of post–1900 forms, see F²¹ 4515 (stationery), reports on Dijon, 1902; and F²¹ 4516, reports on Nantes, 1905 (stationery) and Rouen, 1906 (short form).

53. A few examples: AN, F²¹ 4509, Bouchet-Doumenq's 1890 report on Nice, noting many mediocre works; F²¹ 4510, Pillet's report the same year on Saint-Dié (Vosges), paintings "d'un faible intérêt"; F²¹ 4514, Fournereau's 1895 report on Troyes, with a distinguished collection, more notable for sculpture than for painting. Inspectors' considerations of quality will be discussed later in this section.

54. The 1887 form printed questions on even-numbered pages, with spaces for curators to record the desired information, and left each odd-numbered page blank, with the heading "Observations de l'Inspection relatives aux déclarations ci-contre." On the 1890 form, the curator was asked to provide information on budgets and personnel in tables on the cover page, with the rest left blank for the inspector's "appréciations" of the museum's building, administration, and installation. The 1895 questionnaire divided each page (after the tables on page 1) into three columns: "Questions," "Réponses à Faire par MM. les Conservateurs," and "Observations de l'Inspecteur."

55. In the debate over the establishment of the Inspection de l'Enseigne-

ment du Dessin in 1878 (*JO* CD, 29 November 1878, pp. 11,179–11,180). Proust, implying that artists domiciled in the various districts would not be sufficiently objective, advocated Paris-based inspectors; Bardoux said the ministry would take the best candidates wherever it found them. Later discussions of train fares for the inspectors' trips (*ACD/D* 1903, Report 1203, 4 July 1903: 1282) indicate that the corps of inspectors was normally resident in Paris.

56. AN, F²¹ 4505, report of 1 November 1879.

57. *CAC,* 2 February 1906, p. 33.

58. AN, F²¹ 4516, report of 20 June 1902.

59. AN, F²¹ 4508, report of 1887; F²¹ 4516, reports of 31 March 1901, 4 April 1903, 2 April 1907.

60. AN, F²¹ 4505, report of 4 April 1880.

61. AN, F²¹ 4505, report of 14 July 1879; see also F²¹ 4511, favorable reports of 1881 and 1887 on the locally oriented collection in Vire (Calvados).

62. AN, F²¹ 4508, report of 1887 on Lyons; see also F²¹ 4510, Lucien Charvet's 1887 report on installation of native metalwork in Saint-Etienne.

63. AN, F²¹ 4513 (among others), question under "Titre III. Collections," "III. Inventaires-Catalogues," which included questions about installation.

64. AN, F²¹ 4512, report of 1895.

65. AN, F²¹ 4514, report of 1895; there was a similar case in Saint-Omer (Pas-de-Calais): F²¹ 4510, reports of 26 February 1887 and 2 March 1890.

66. AN, F²¹ 4509, report of Dauban, 1887, and letter, Ministre de l'Instruction Publique et des Beaux-Arts to Préfet Loire-Inférieure, 12 April 1890. Construction began the following year, and a report in 1903, three years after the completion of the new building, indicated ample space available for new acquisitions (F²¹ 4516). See also Angrand, *Histoire des musées,* 1 : 107–108.

67. AN, F²¹ 4509, letter, Maire Nancy to Préfet Meurthe-et-Moselle, 17 December 1884, and reports of Pillet, 1887 and 1890.

68. AN, F²¹ 4516, report of Louis Leydet, 1909.

69. For example, the 1862 fire in Bordeaux received front-page coverage in the newspaper *Le sémaphore de Marseille,* 18 June 1862.

70. 13 of 90: Figures compiled from reports in AN, F²¹ 4505.

71. The article appeared in the *Moniteur du Calvados,* 21 June 1896; letter, Directeur des Beaux-Arts to Hirsch, Inspecteur, 6 July 1896, Hirsch's report, 10 July 1896, and regular inspection report for 1896, all in AN, F²¹ 4512. On the serious fire in the museum in 1906, see *CMP,* pp. 59–60.

72. Extensive correspondence in AN, F²¹ 4512 (1880s) and F²¹ 4514 (1890s); see also below.

73. The exact percentages, compiled from figures in AN, F²¹ 4505, were

separate buildings 26.8%, town halls, 35.4%, other buildings 37.8%. The building was considered separate if the only other occupant was a library or other artistic collection but not a natural history museum. Distinct wings of larger buildings, like the museum in Blois, which was part of the château, were counted as if they were separate.

74. On Dijon see Chapter 1, note 70; on Saint-Lô, AN, F^{21} 4510, report of Bayard de la Vingtrie, 1887. Proximity to a theater was regarded as nearly as dangerous, since theaters, prior to the spread of electricity, were notorious firetraps. See, for example, Pillet's 1887 report on Saint-Dié (Vosges), also in F^{21} 4510.

75. AN, F^{21} 4505, reports of 13 July 1879 (Châlon) and of 12 October 1879 (Pau); F^{21} 4510, report of 31 March 1887 on Saint-Etienne; F^{21} 4511, reports of 1887 and 1891 on Valence; F^{21} 4514, report of 1895 on Tulle. The same report on Tulle, and the one cited in note 74 about Saint-Lô, contain the inspectors' urgings against new envois.

76. AN, F^{21} 4514, correspondence from 1897–1899. Bureaucratic obstruction from the Public Buildings Authority seems ultimately to have frustrated the project. Rouen also consulted the administration on the construction of its new museum, and Chennevières set up an advisory committee in 1876 to provide the desired advice (correspondence in AN, F^{21} 471); see Chapter 5.

77. AN, F^{21} 4510.

78. AN, F^{21} 4505, report of 30 July 1879; report of 13 October 1879 on Tarbes.

79. AN, F^{21} 4516, clippings from *La libre parole,* 22 October 1900, and *L'intransigeant,* 19 October 1900; correspondence between Bigard-Fabre, Chef de la Division de l'Enseignement et des Travaux d'Art, Roujon, Directeur des Beaux-Arts, Roger Marx, Inspecteur en Chef des Musées de Province, and Préfet Gard, November–December 1901; report of Charvet, 1 March 1901.

80. The city shortly thereafter announced a competition for a 300,000-franc project to reconstruct the building on the same site. The administration, in the person of Roger Marx, continued to offer behind-the-scenes assistance, principally in supporting the project before the Commission des Bâtiments Civils. AN, F^{21} 4516, Charvet to Directeur des Beaux-Arts, 27 April 1901 (emphasis in original), and extensive correspondence from Marx, mostly 1903.

81. Examples from the first inspection reports, AN, F^{21} 4505: a librarian, the curator in Carpentras, who felt incapable of cataloguing paintings (report of 18 July 1879); the curator in Valence, of whom Houssaye wrote, "[he] would confuse a Venetian picture with a Flemish" (16 July 1879); the "curators" in Bernay and Dinan, who had sold their collections to the city in exchange for a life annuity (12 July and 23 October 1879).

Inspectors occasionally did praise curators whose "zeal" or "competence" impressed them, for example in 1887 in Mâcon (F²¹ 4509) and Saint-Etienne (F²¹ 4510).

82. The lack of a curator was cited in the museums of Rodez (AN, F²¹ 4510), Directeur des Beaux-Arts to Préfet Aveyron, 15 February 1884) and Saint-Lô (ibid., Directeur to Préfet Manche, 4 June 1884). Inspectors objected to restrictions on curatorial authority in Lille (F²¹ 4508, report of 1890), Nantes (F²¹ 4509, Directeur to Préfet Loire-Inférieure, 10 March 1885, and report of 1887), and Le Puy (ibid., correspondence of 1884–1885); see also Angrand, *Histoire des musées*, 3:49–57, on a commission structure in Agen.

83. *CMP*, p. 336. Another circular, of 23 December 1896, reiterated the administration's policy on restorations; a copy can be found in ADCdO, 33 T 1a, and the circular is reprinted in *CMP*, pp. 336–337.

84. AN, F²¹ 4516, report of 1909; clipping from *Journal des artistes*, 5 May 1901, and letter, Marx to Directeur des Beaux-Arts, 11 May 1901, containing the threat.

85. AN, F²¹ 4505, report of 21 July 1879; F²¹ 4512, report of 1895 on Grenoble.

86. AN, F²¹ 4505, report of 25 May 1879.

87. AN, F²¹ 4509, report of Dauban, 1890, and F²¹ 4513, report of Bouchet-Doumenq, 1895 (on Poitiers); F²¹ 4516, reports of Tronchet, 1902, and Leydet, 1909 (on Nancy).

88. AN, F²¹ 4509, report of 15 March 1890 (Marseilles); report of 1890 (Montpellier). The idea of printing facsimiles of artists' signatures was fairly common in the larger museums and was, for example, adopted in the 1908 catalogue of the Marseilles museum.

89. AN, F²¹ 4510, Directeur des Beaux-Arts to Préfet Côte-d'Or, 20 March 1885. Other offers of subsidies included the museums in Le Puy (for installation as well as for a catalogue, F²¹ 4509, Directeur des Beaux-Arts to Préfet Haute-Loire, 20 March 1883) and Marseilles (F²¹ 4516, report of Charvet, 16 March 1902).

90. AN, F²¹ 4509, Directeur des Beaux-Arts to Maire Nîmes, 9 April 1890.

91. F²¹ 4510, report on Saint-Etienne, 1887; see also AN, F²¹ 4509, report on Orléans, 1890, described as both cramped and not well lit.

92. AN, F²¹ 4910, report of Emile Cardon, with cover letter to the Ministre, pp. 20–21.

93. AN, F²¹ 4516, report of Paul Steck, 22 February 1906.

94. AN, F²¹ 4510, report of 1887.

95. AN, F²¹ 4512, report of 1895.

96. AN, F²¹ 4509, report on Nice, 1890; F²¹ 4514, report on Vendôme, 30 May 1895; F²¹ 4510, report on Soissons, 1887.

97. AN, F²¹ 4910, report of 9 February 1890. Hirsch, however, reporting on the museum in Bordeaux in 1887 (F²¹ 4507), expressed reservations about "a certain 'viney' red, much too light, which has the effect of tarnishing and darkening the paintings." He noted, however, that some galleries in the Louvre were also painted this color.

98. See, for example, AN, F²¹ 2278, R. Marx to Ministre de l'Instruction Publique et des Beaux-Arts, 13 December 1902, in which he expressed little concern about faulty attributions, the major point of a private citizen's letter about the Rouen museum, and much more about a matter of secondary concern in the letter, works supposedly in poor condition.

99. AN, F²¹ 4509, report of 1887 (Paray-le-Monial); F²¹ 4510, report of 10 April 1887 (Saintes); see also Pillet in an 1890 report on Saint-Dié: "The museum contains only very few pictures, which are of little interest" (also in F²¹ 4510).

100. AN, F²¹ 4507, report of 10 April 1887; F²¹ 4508, report of 1887 (Grenoble).

101. AN, F²¹ 4510, report of 1887.

102. Engerand, "Musées de province," p. 363.

103. For example, in his report on Toulouse of 30 July 1879 (AN, F²¹ 4505), Houssaye criticized the museum for relegating over two hundred works to storage, even though he admitted that conditions in the (closed) *réserves* were superior to those in the public galleries (passage cited in Chapter 1).

104. Houssaye, "Les musées de province," p. 565.

105. AN, F²¹ 4909, "Les musées," p. 16; AN, F²¹ 4505, "Extrait d'une lettre de M. Peraldi, Conservateur du Musée, à Ajaccio, correspondant du Comité des Sociétés des Bx. Arts des Dépts.," 27 February 1880.

106. AN, F²¹ 4510, report of 31 May 1887.

107. See text at note 94.

108. MD, IX (Correspondance Diverse, 1892−1927), letter, Joliet, Conservateur, to Beylard, 5 July 1906.

109. AN, F²¹ 4514, report of 7 March 1895; see also F²¹ 4510, Charvet report of 31 May 1887 on Salins.

110. AN, F²¹ 4510, report of 14 May 1890.

111. *CMP,* p. 25. The report cited excessive humidity, heat in the summer, the risk of fire, inadequate light, and lack of space.

112. AN, F²¹ 4509, report of 1887. Pillet praised the museum for having the sense—unlike the Louvre, he specifically noted—to rotate works between storage and public display.

113. AN, F²¹ 4511, correspondence between Directeur des Beaux-Arts, Préfet Marne, and Liénard, Conservateur, October 1883−February 1884; statement of art association in *Délibérations du Conseil municipal* (extrait), 2 April 1884; and reports of Pillet, 1887 and 1890.

114. AN, F²¹ 4514, Chenevier, Conservateur to Ministre, 15 September 1894; list of paintings damaged, 2 October 1894; report of Roger Marx, 20 October 1894.

115. AN, F²¹ 4512, report of 15 April 1895. The report condemned the museum's installation, catalogue, and fire safety measures and blamed these deficiencies on the curator.

116. AN, F²¹ 4510, letter concerning Saintes, undated but probably late 1884–early 1885; also Sous-Secrétaire d'Etat des Beaux-Arts to Préfet Yonne, about Tonnerre, 15 July 1885: "Indeed, one could not reasonably require that all the conditions I have just described to you be carried out with the same strictness. Clearly, for example, there could be no question of insisting on allocating an entire building for the installation of these collections."

117. CMP, p. 326.

118. AN, F²¹ 4512, Directeur des Beaux-Arts to Préfet Aude, undated (early June 1896). In the discussions of the Commission des Musées de Province in 1907, Marx flatly declared that the administration did not have the funds to reclaim envois from a major museum: CMP SCA, 23 October 1907, p. 292.

119. AN, F²¹ 4510, Directeur des Beaux-Arts to Préfet Charente-Inférieure, 1884–1885.

120. AN, F²¹ 4511, report of Liénard, Conservateur, 18 May 1881; threat in Directeur des Beaux-Arts to Préfet Marne, 9 February 1884; bordereau summarizing the situation, April 1884.

121. For example, AN, F²¹ 4505, report of Baignières on the museum in Pontoise, 20 October 1879: "It has no organization as a museum, and is delaying spending any money to do so until the Fine Arts Administration sends it some canvases and some sculpture"; F²¹ 4511, Charvet's comment after a highly critical report on the museum in Vienne (Isère): "The last word that mayors utter when an inspector takes leave of them is always a request for envois. He in turn strongly advises them to install their collections well, for only this can encourage the administration to entrust new works of art to them." For other such cases, see Angrand, Histoire des musées, 3:9–18, 62–67.

122. By 1906, in fact, the head of the Direction des Beaux-Arts was admitting that he received very few requests for works of art, and that some works, particularly sculptures, were actually difficult to dispose of. See comments of Dujardin-Beaumetz, CMP SP, 30 October 1907, p. 274.

123. ACD/D 1899, Report 1134, 4 July 1899: 2631; ACD/D 1903, Report 1203, 4 July 1903: 1321.

124. ACD/DP 1900e, 7 December 1900: 746.

125. Cited in CMP, p. 18.

126. ACD/D 1901, Report 2643, 6 July 1901: 1252; ACD/D 1907, Report 1238, 11 July 1907: 1652.

127. Engerand, "Musées de province," pp. 368–369; the text of this article, with only minor emendations, was also the basis for his proposal for a special commission on provincial museums, ACD/D 1905, Report 2313, 16 March 1905: 299–302; ACD/D 1901, Report 2643, 6 July 1901: 1252. Bardoux's "Projet de loi pour la conservation des monuments historiques et des objets d'art" is in JO CD/A, 4 July 1878, pp. 7528–7529; on Turquet's intentions of presenting such legislation, see note 24.

128. The concepts of *personnalité civile,* which falls under the more general rubric of *personne morale,* and of *éstablissement public* or *établissement d'utilité publique* have distinct legal meanings; see *Dictionnaire de droit,* 2nd ed., 2 vols. (Paris: Dalloz, 1966), 1:736–740, 2:300. But the "Décret relatif à la personnalité civile des Musées départementaux" of 30 September 1906 (*JO,* 10 October 1906, p. 6837, reprinted in *CMP,* pp. 6–9, and *CAC,* 20 October 1906, pp. 275–276) refers to the museum granted the *personnalité civile* as an "établissement public," and the decree awarding this status was to be "rendu en la forme ordinaire des reconnaissances d'utilité publique."

129. "Proposition de loi portant création d'une caisse des bâtiments d'instruction publique," ASCD/D 1879 (5), Chambre report 1415, 24 May 1879: 216–220; "Rapport . . . concernant . . . la création d'une caisse spéciale intitulée: caisse de dotation des musées nationaux," ASCD/D 1881 (2), Chambre report 3911, 11 July 1881: 681–682; "Proposition de loi sur la création d'une caisse des musées destinée à faciliter les acquisitions d'oeuvres d'art," ACD/D 1890 (1), Report 576, 20 May 1890: 720–721; "Proposition de loi ayant pour objet la création d'une caisse des musées de l'Etat," ACD/D 1894 (2), Report 661, 31 May 1890: 230. Only the 1879 and 1890 proposals specifically mentioned provincial museums, and when the *caisse des musées nationaux* was finally established in 1895, it benefited only the national museums.

130. "Musées de province: Il faut faire appel à l'opinion publique," editorial by Henry Clouzot, *Bulletin de l'art ancien et moderne,* 16 December 1905, p. 305.

131. Engerand's proposal is in ACD/D 1905, Report 2313, 16 March 1905: 299–303; Dujardin-Beaumetz's report to the minister proposing establishment of the commission, reprinted in *CMP,* pp. 1–4; list of members, *CMP,* pp. 235–237. The commission also included two members of the government in addition to Dujardin-Beaumetz and three members without listed profession.

132. Praise for Engerand's proposals: *Bulletin de l'art,* 22 April 1905, pp. 126–127; *CAC,* 15 April 1905, p. 113; praise for Dujardin-Beaumetz's action: *La dépêche [de Toulouse?],* 26 July 1905, and *Le petit journal,* 26 June 1905 (where the establishment of the commission was reported as a reliable rumor), clippings in AN, F^{21} 4500.

133. Dujardin-Beaumetz's report to the minister, reprinted in *CMP,* p. 3.

134. *CMP* SP, 12 July 1905, pp. 237–242.

135. See comments of Léon Bruman on *personnalité civile* as a financial remedy, ibid., p. 240.

136. *CMP* SCL, 4 November 1905, p. 280.

137. AN, F²¹ 4516, report of Bayard on Lyons, 3 March 1908. For the actual decree, see above, note 128.

138. *CMP*, pp. 9–10. The three museums were those of Auch (Gers), Bagnols-sur-Cèze (Gard), and Wassy (Haute-Marne).

139. *CMP*, pp. 10–14, on concerns involved in drafting of the "Avant-projet de décret portant règlement des conditions de fonctionnement des musées départementaux et municipaux, dépositaires des collections de l'Etat"; on reasons the arts subcommission limited itself to "voeux," and list of them, pp. 14–15, 227–228.

140. Marx's comments on curators in *CMP* SCL, 4 April 1906, p. 279; on the state's assistance to provincial museums, *CMP* SCA, 23 October 1907, p. 292, and similar comments from an inspector, Steck, p. 300.

141. This *voeu* did, however, provoke the objection of Louis Gonse that "you are asking for the creation of new museums when we lack the means to maintain those that exist," *CMP* SCA, 23 October 1907, pp. 303–305.

142. *CMP* SCA, 23 October 1907, p. 295; cf. Engerand, "Musées de province," p. 373, and AN, F²¹ 4909, "Les musées."

143. Draft provision in *CMP*, p. 13, final wording, p. 230; discussion of the clause in *CMP* SCL, 6 April 1906, pp. 285–6, and in *CMP* SP, 25 October 1907, pp. 245–253.

144. *CMP* SCL, 6 April 1906, pp. 286–288.

145. *CMP* SCA, 23 October 1907, pp. 295–299; emphasis in original. It was this discussion that led to the adoption of the *voeu*, proposed by a writer, Frantz Jourdain, on a lottery to benefit museums.

146. *CMP* SP, 30 October 1907, pp. 275–277.

147. The administration split on a related issue as well, the *voeu*, supported by Marx and Lapauze, that the Ecole du Louvre fulfill the intent of the decree establishing it in 1884 and institute courses on museum administration. Théophile Homolle, director of national museums and of the Ecole, was dubious but in the end promised to make the attempt. See *CMP* SCA, 23 October 1907, pp. 305–307; *CMP* SP, 30 October 1907, p. 273.

148. *CMP*, p. 14. On the educational clause, see *CMP* SCL, 4 November 1905, p. 283, and 6 April 1906, pp. 288–289; *CMP* SP, 30 October 1907, p. 266.

149. *CMP* SP, 30 October 1907, pp. 260–262, 266–267. In these arguments and in a related comment from a senator, Lintilhac, ibid., p. 269, lay the seeds of two important post–1945 reforms. Since 1945 provincial museums have been divided into two categories corresponding roughly to the degree of curatorial expertise they require, and the state subsidizes the

salaries of the most qualified curators, who do in fact pass a national examination.

150. *CMP* SC, 30 October 1907, pp. 265–271.

151. Ibid., p. 268 (Bayet's proposal); the final text can be found in *CMP*, p. 231.

152. There was some discussion in the commission on this point; Lapauze read from the 1852 decree to demonstrate that it in no way required prefects to consult the minister about their choices (*CMP* SP, 30 October 1907, p. 262). The 1910 decree, requiring only approval of (two or three) *candidates'* qualifications, did not technically change this provision, but in practice this amounted to review (and usually approval) of the chosen candidate.

153. In 1916, for example, the "Commission d'examen des titres des candidats aux postes de Conservateur des Musées de province" on its own initiative approved the appointment of Gaston Joliet, an elderly former prefect and brother of the curator, as assistant curator of the Dijon museum; with the administration's tacit approval, he had already been serving as acting curator during his brother's illness. See ADCdO, 33 T 2, Sous-Secrétaire d'Etat to Préfet Côte d'Or, and other correspondence.

154. *CMP* SCA, 23 October 1907, p. 292.

155. *CMP* SCA, pp. 293, 296–298, 302–303 (importance of additional funds for work on catalogues, new construction, and the *Inventaire des richesses de l'art de la France*). Roger Marx repeated his point in *CMP* SP, 30 October 1907, p. 275.

156. *CMP* SP, 30 October 1907, pp. 273–274. Dujardin-Beaumetz qualified his support with the observation that he doubted whether the cabinet would approve it.

157. *ACD/DP* 1908e, 11 November 1908: 593–595; *ACD/D* 1909, report 2758, 22 July 1909: 1927.

Introduction to Part II

1. *ACD/D* 1903, Report 1203, 4 July 1903: 1321.

2. This is one of the major starting points of David Pinkney's *Decisive Years in France, 1840–1847* (Princeton: Princeton University Press, 1986); see especially pp. 5–6. Pinkney endorses the views of A. J. Tudesq, whose magisterial *Les grands notables en France (1840–1849): Etude historique d'une psychologie sociale*, 2 vols. (Paris: Presses Universitaires de France, 1964), emphasizes the diversity of the July Monarchy elite and treats the 1840s as a period of transition at all levels of society. But Tudesq, while insisting on a large measure of regional diversity in terms of the continuity of the elite, also makes clear the general importance of lineage and of the leisure afforded by a landed income to the *notables* exercising local leadership in

1840: see *Les grands notables,* 1:101−114, 321−334, and on Rouen, Bordeaux, and Dijon, 1:267−271, 293−301, 316−318.

3. Museums in Formation, 1791−1850

1. Douglas, *How Institutions Think,* p. 63; on the founding of provincial museums in general, see Edouard Pommier, "Naissance des musées de province," in Pierre Nora, ed., *Les lieux de mémoire,* vol. II: *La nation,* 3 books (Paris: Gallimard, 1986), book 2, pp. 451−495; on ideology and the early Louvre, see idem, "Idéologie et musée à l'époque révolutionnaire," in Michel Vovelle, ed., *Les images de la Révolution française, Actes du colloque des 25−26−27 oct. 1985 tenu en Sorbonne* (Paris: Publications de la Sorbonne, 1988), pp. 57−78.

2. Henri de la Ville de Mirmont, *Histoire du Musée de Bordeaux,* vol. 1: *Les origines: Histoire du musée pendant le Consulat, l'Empire et la Restauration* (Bordeaux: Feret, 1899), p. 12 (only volume published, henceforth cited as Mirmont, *Histoire*); "Introduction," in Dijon, Musée Municipal, *Catalogue historique et déscriptif du Musée de Dijon: Peintures, sculptures, dessins, antiquités* (Dijon: Lamarche, 1869), pp. vii−viii (henceforth cited as Dijon 1869); Pierre Quarré, "Le Musée de Dijon: Sa formation, son développement," *Mémoires de l'Académie des sciences, arts et belles-lettres de Dijon* (1947−1953): 144−147; Pommier, "Naissance," in Nora, *La nation,* 2:462−464.

3. Gould, *Trophy,* pp. 18−23; Saunier, *Conquêtes artistiques,* pp. 9−16; Benoit, *L'art français,* pp. 110−111; L. Réau, *Histoire du vandalisme: Les monuments détruits de l'art français,* 2 vols. (Paris: Hachette, 1954), vol. 1: *Du haut Moyen Age au XIXe siècle,* pp. 384−385.

4. David, "Second Rapport sur la nécessité de la suppression de la Commission du Muséum, fait au nom des Comités d'instruction publique et des finances," 27 nivôse year 2 (16 January 1794), in Alexandre Tuetey and Jean Guiffrey, eds., *La Commission du Muséum et la création du Musée du Louvre (1792−1793),* Archives de l'art français, n.s. 3 (Paris: J. Schémit, 1909), p. 371.

5. In Nora, *La nation,* 2:479−482.

6. For a summary of the *instructions* sent out from Paris, see France, Commission des Monuments, *Procès-verbaux,* ed. Louis Tuetey, 2 vols., *Nouvelles archives de l'art français,* 3rd ser., 17−18 (1901−1902), 17:viii−ix and, on the most important such *Instruction,* sent out after the decree of 8 pluviôse year 2, France, Commission Temporaire des Arts, *Procès-verbaux,* ed. Louis Tuetey, 2 vols., Collection des documents inédits sur l'histoire de France (Paris: Imprimerie Nationale, 1912, 1917), 1:xiv−xix. There is a particularly interesting "Projet d'instruction pour hâter les établissemens de bibliothèques et de Muséums," dated 13 November 1792, in Commission des Monuments, *Nouvelles archives,* 17:306−309, but the Committee of Public Instruction seems never to have acted on it.

7. On this decree and the measures preceding it, see Pommier, "Naissance," in Nora, *La nation*, 2:472–477. Pommier places particular emphasis on a decree of 24 October 1793, of which the pluviôse decree was a followup; it served to establish the principles that localities would remain responsible for their own patrimonies and that no centralized redistribution of works of art would take place.

8. Charles de Beaurepaire, "Notes historiques sur le Musée de peinture de la ville de Rouen," *Précis analytique des travaux de l'Académie des sciences, belles-lettres et arts de Rouen* (1852–1853): 390–393, referring to inventorying efforts carried out pursuant to decrees of the National Assembly in 1790 and 1791; Mirmont, *Histoire*, p. 19; E. Bouillon-Landais, *Catalogue des objets composant la collection du Musée de Marseille, précédé d'un essai historique sur le musée* (Marseilles: Marius Olive, 1876), pp. 9–10 (henceforth cited as Marseilles 1876).

9. De Beaurepaire, "Notes historiques," pp. 390–400, 403–405.

10. Dijon 1869, pp. viii–xi; Quarré, "Musée de Dijon," pp. 147–150. It should be noted that the department sold off most of the paintings originating in religious houses and kept for the museum most of those coming from the private collections of émigrés.

11. Mirmont, *Histoire*, pp. 20–31.

12. Marseilles 1876, pp. 10–15.

13. Ibid., pp. 16–19; ADBdR, 4 T 50, Administrateurs du Musée to Citoyens Administrateurs du Département des Bouches-du-Rhône, 4 ventôse year 7, and "Séance publique pour l'inauguration du Musée national," *procès-verbal*.

14. ADBdR, 4 T 50, Administrateurs du Musée to Préfet, 14 floréal year 8 (3 May 1800). There are similar letters in ibid., 23 germinal year 8 (13 April 1800, just days after Delacroix's arrival), and frimaire year 9 (November 1800).

15. Marseilles 1876, pp. 19–21; ADBdR, 4 T 50, Chef de la 2e Division de la Préfecture to Préfet, 8 prairial year 8 (27 May 1800).

16. ADBdR, 4 T 50, Guenin to Préfet (?), 8 fructidor year 11 (27 August 1803).

17. Marseilles 1876, pp. 11–12; Pierre Lacour and Jules Delpit, *Catalogue des tableaux, statues, etc. du Musée de Bordeaux* (Bordeaux: Duviella, 1855), pp. 17–18 (henceforth cited as Bordeaux 1855); see also Mirmont, *Histoire*, pp. 45–67.

18. Quarré, "Musée de Dijon," p. 149; idem, "Préface," in Alain Roy, *Les envois de l'Etat au Musée de Dijon (1803–1815)*, Ville de Dijon et Association des Publications près l'Université de Strasbourg (Paris: Ophrys, 1980), p. 9; Marseilles 1876, p. 23; Mirmont, *Histoire*, pp. 30–31; de Beaurepaire, "Notes historiques," pp. 443–444 (on restitutions to churches and émigrés).

19. De Beaurepaire, "Notes historiques," pp. 407–443; Emile Minet,

Musée de Rouen: Catalogue des ouvrages de peinture, dessin, sculpture et d'architecture (Rouen: Girieud, 1911), pp. 66–115 (henceforth cited as Rouen 1911). The 1911 catalogue does not give provenance for works acquired prior to 1803; it is therefore impossible to be certain whether works without provenance not also listed in de Beaurepaire came from revolutionary confiscations. This is, however, a reasonable assumption in most cases. On specific paintings see Dijon, Musée des Beaux-Arts, *Catalogue des peintures françaises* (Dijon, 1968), henceforth cited as Dijon 1968, nos. 37, 61, 90, 314, 323, 324; and Rouen 1911, nos. 489, 506, 591–611, 691, 693, 732, 733, 787, 788.

20. Among other major cities, Toulouse had established a Muséum du Midi de la République as early as fructidor year 3 (August 1795), with collections from the former royal painting academy as well as from émigrés and former religious houses; see Clément de Ris, *Les musées de province*, 2:280–282.

21. AN, AFIV 41, report of Chaptal, Ministre de l'Intérieur, 13 fructidor year 9.

22. Mirmont, *Histoire*, p. 73, states that when the first shipment of twenty-nine paintings arrived in Bordeaux, on 8 floréal year 11 (22 April 1803), Rennes, Tours, Marseilles, Montpellier, and Rouen had already received their initial allotments. According to Roy, *Envois*, pp. 15–16, the first twenty-seven paintings accorded to Dijon left Paris on 12 vendémiaire year 12 (3 October 1803) and arrived in Dijon two weeks later.

23. Quarré, "Musée de Dijon," p. 163. The original museum was located in what was then the eastern wing of the Palais des Etats; the two galleries were essentially spurs running to the east of this wing toward the Sainte Chapelle, demolished at about the same time, and the celebrated medieval ducal kitchens, which are still standing.

24. Thibaudeau, speech of 25 germinal year 12 (15 April 1804), cited in Marseilles 1876, pp. 21–24: "Il faut malheureusement donner congé à Terpsichore mais les arts utiles doivent avoir la préférence"; on delays in Dijon, see Roy, *Envois*, p. 16.

25. De Beaurepaire, "Notes historiques," p. 406; ADSM, 4 T 219, Maire de Rouen to Préfet Seine-Inférieure, 26 March 1808.

26. Bordeaux 1855, pp. 18–20; Mirmont, *Histoire*, pp. 38, 82–87, 133–149.

27. Paul Robert, *Dictionnaire alphabétique et analogique de la langue française: Les mots et les associations d'idées*, 7 vols. (Paris: Robert, 1970), 4:551–552; *Grand Larousse de la langue française*, 7 vols. (Paris: Larousse, 1955), 4:3524; Bordeaux 1855, p. 17; Mirmont, *Histoire*, p. 13.

28. L. de Lanzac de Laborie, *Paris sous Napoléon*, 8 vols. (Paris: Plon-Nourrit, 1905–1913), vol. 8: *Spectacles et musées*, p. 237; Gould, *Trophy*, p. 87.

NOTES TO PAGES 106 – 109 · 299

29. Marseilles 1876, pp. 21–25; ADBdR, 4 T 50, Guenin to Préfet Bouches-du-Rhône, 8 fructidor year 11 (26 August 1803), referring to the "Musée national de Marseille."

30. Mirmont, *Histoire,* pp. 38, 151–153.

31. Robert, *Dictionnaire,* 4:552, gives only the approximate date of "end of the eighteenth century" for the association of "Muséum" with natural history museums. The natural history museum in Paris, formerly called the Jardin des Plantes, acquired the name Muséum in 1793. The Paris Muséum is a research institution whose professional staff have the title "professeur," but provincial natural history museums without such research components are also called "muséums."

32. AMB, 1434 R 1, Lacour to Maire, 12 March 1811, and Monbalon to Maire, 19 March 1811; see also Mirmont, *Histoire,* pp. 186–190.

33. AMB, 1434 R 1, Lacour to Maire, 2 February 1818, defending himself against complaints made to the prefect; see also Mirmont, *Histoire,* pp. 267, 295–297.

34. Mirmont, *Histoire,* pp. 273, 305–314; Bordeaux 1855, p. 25; AMB, 1434 R 1, Lacour to Maire, 5 May 1820.

35. Mirmont, *Histoire,* pp. 316, 320–321. The city's official name for its art museum remained Galerie des Tableaux throughout the nineteenth century, but common usage soon sanctioned Lacour's insistence on "Musée," beginning with the first catalogue, published in the fall of 1821: *Notice des tableaux et des figures exposés au Musée de la ville.*

36. H. Berthélemy, "Les institutions municipales en France: Leur évolution au cours du XIXe siècle," *Verfassung und Verwaltungsorganisation der Städte,* 7: *England–Frankreich–Nordamerika. Schriften des Vereins für Social-politik* 123 (1906): 212.

37. De Beaurepaire, "Notes historiques," p. 406; ADSM, 4 T 219, Descamps to Préfet, 15 January 1808; Préfet to Maire, 10 March 1808, and reply, 26 March 1808.

38. ADSM, 4 T 219, Préfet to Ministre de l'Intérieur, 12 December 1812, and replies, 21 January and 18 February 1813; ADSM, 2 OP 1538/52, Ministre de l'Intérieur (Acting) to Préfet, 29 September 1815.

39. The bill for the purchase and restoration of pictures was 55,880 francs, for construction work 123,270 francs, of which 51,389 was for the museum, the remainder for the library; of the total sum of 179,150 francs due, the city had paid 32,004 francs (ADSM, 2 OP 1538/52, Ministre de l'Intérieur to Préfet, 29 September 1815).

40. Marseilles 1876, p. 25; Mirmont, *Histoire,* pp. 182, 231. Since Aubert served until 1845 and Lacour until 1859, there was no further opportunity for state intervention in these cities under the old statute.

41. Quarré, "Musée de Dijon," pp. 151–152; ADCdO, 33 T 2, Ministre de l'Intérieur to Préfet Côte d'Or, 27 July 1817, naming Févret de Saint-

Mémin curator, and Thiers to Préfet, 5 March 1835, on ministerial approval of curatorial appointments.

42. Cited in Dijon 1869, p. xiv.

43. On the eighteenth-century origins of art schools and their broad ideological purposes, see Pommier, "Naissance," in Nora, *La nation*, 2: 455–459.

44. AMB, 1434 R 1, Lacour to Maire, 8 August 1811. See also Mirmont, *Histoire*, pp. 191–192.

45. Mirmont, *Histoire*, p. 16.

46. AMB, 1434 R 1, Lacour to Maire, undated but 1822 from context.

47. AMM, 57 R 2, Aubert to Maire, 16 August 1824.

48. Quarré, "Musée de Dijon," pp. 151–152; MD III, note headed "Améliorations," 1819. On Févret de Saint-Mémin, see P. Quarré, "Charles-Balthazar-Julien Févret de Saint-Mémin: Sa vie et son oeuvre," in *Un descendant d'une grande famille de parlementaires bourguignons: Charles-Balthazar-Julien Févret de Saint-Mémin, artiste, archéologue, conservateur du Musée de Dijon*, catalogue of an exhibition at the Musée des Beaux-Arts, Dijon, 1965, pp. 5–21.

49. ADCdO, 33 T 2, Maire Dijon to Préfet Côte d'Or, 3 January 1831.

50. AMM, 57 R 2, Comte de Lanisse to Maire Marseille, describing the intentions of a third party, 18 June 1819.

51. MM, NS/C 1810–1849, Maire Adjoint to Conservateur, 22 July 1837 (concerning graffiti), Maire to Conservateur, 1 December 1838 (concerning refuse); AMM, 57 R 2, Conservateur to Maire, 29 June 1837 (stone throwing).

52. AMB, 1434 R 2, eight art students to Maire, 30 March 1841; Lacour to Maire, 24 November 1842.

53. AMM, 57 R 2, Conservateur to Maire, 28 June 1838; AMM, 57 R 3, Giraud, artist, to Maire, 19 February 1848; MM, NS/C 1810–1849, Maire to Conservateur, 10 March and 26 October 1848.

54. AMB, 1434 R 1, Lacour to Maire, 28 January 1832; AMM, 57 R 2, Aubert to Maire, 20 August 1834; AMD, 4 R I, DNC/CC, Févret de Saint-Mémin to Maire, 4 June 1839.

55. AMM, 57 R 2, Aubert to Maire, 25 April 1843. Correspondence in MM, NS/C 1810–1849 indicates at least sixteen meetings between 1818 and 1824, including, among others, those of the Société de Bienfaisance, the Société Royale de Médicine, and the district electoral college. Electoral assemblies were even more frequent during the July Monarchy.

56. AMM, 57 R 2, Aubert to Maire, August 1824, a general plea that functions unrelated to the museum be held elsewhere; MM, NS/C 1810–1849, Maire to Aubert, 16 August 1824. The reply contains an 1866 annotation by Bouillon-Landais, who had become curator in 1865, noting that the problem would finally be solved when the new museum building, then under construction, was completed.

57. Th. Ricaud, *Le Musée de peinture et de sculpture de Bordeaux de 1830 à 1870* (Bordeaux: Bière, 1938), pp. 124–125; Bordeaux 1855, p. 33; on Lacour's views of the old museum galleries, see AMB, 1434 R 1, Lacour to Maire, 28 January 1832.

58. Paul Mantz, "Les musées de province: I. Le Musée de Bordeaux," *L'artiste*, 4th ser., 8 (1846–1847): 52. See also Arsène Houssaye, "Les musées de province: Le Musée de Bordeaux," *Moniteur universel* (1858): 375, and Lacour's proposal for a new museum, AMB, 1434 R 2, Lacour to Maire, 29 November 1842.

59. Ricaud, *Musée de peinture et de sculpture*, pp. 125–127.

60. AMM, 57 R 2, Aubert to Maire, 14 March and 4 June 1836.

61. AMD, 4 R I, DNC/CC, Févret de Saint-Mémin to Maire, 7 March 1840.

62. AMB, 1434 R 2, Lacour to Maire, 28 January 1832, 24 November 1842.

63. MM, NS/C 1810–1849, Maire to Conservateur, 28 July 1818; AMM, 57 R 2, Maire to Conservateur, 25 April 1834.

64. AMM, 57 R 3, Dassy to Maire, 13 August and 5 October 1846. A marginal note on the second letter indicates that the city intended to review Aubert's budgets to determine how much should go to the museum and how much to the art school.

65. AMM, 57 R 2, Aubert to Maire, 12 November 1825 and 5 January 1826, concerning restoration of a portrait of an archbishop; Aubert to Maire, 1 February 1839, claiming a bonus for restoration work as standard practice; MM, NS/C 1810–1849, Maire to Aubert, 28 November 1839, directing him to see to the transportation of a painting to a church; ADSM, 4 T 219, Note, 1827, on bonus to Descamps for restoration work.

66. AMB, 1434 R 1, Lacour to Maire, undated (1822).

67. AMM, 57 R 2, Aubert to Maire, 30 December 1839; Aubert to Maire, 4 July 1845, on lack of opportunity to follow Paris market.

68. ADSM, 4 T 219, Préfet to Court, 10 April 1853. This dossier contains extensive correspondence on at least seven candidates for the curatorship; the general tone of the letters makes clear that the city was seeking an artist of note, and with local roots. One candidate wrote the prefect that the mayor had expressed an interest in him as "an artist from Normandy, the most important condition desired by the City Council" (Paul de Saint-Martin to Préfet, 15 March 1853).

69. ADSM, 4 T 219, A. Darcel, Paris to Préfet, 4 March 1853: "The municipality's inclination, I still believe, would be to make this position a kind of retirement pension for one of the former city drawing professors."

70. ADSM, 4 T 219, A. Darcel to Préfet, 4 March 1853 (on Rouen); AMM, 57 R 4, J. Tassy to Maire, 20 August 1847, marginalia.

71. For a survey of early catalogues, covering up to the year 1821, see Mirmont, *Histoire*, pp. 349–350. The earliest catalogue in Rouen dates

from 1809, in Bordeaux from 1821, and in Dijon from the early 1820s. The first substantial catalogues date from 1834 in Dijon (*Notice des objets d'arts exposés au Musée de Dijon, et catalogue général de tous ceux qui dépendent de cet établissement,* 224 pp., divided by school) and from 1837 in Rouen (*Catalogue des objets d'art exposés au Musée de Rouen, augmenté de notices sur la vie et les ouvrages des principaux maîtres de chaque école, ainsi que sur les Personnages célèbres dont les Portraits figurent dans la Collection,* 164 pp.), but not until 1855 in Bordeaux and 1876 in Marseilles.

72. Bordeaux 1855, pp. 2–4.

73. Ibid., p. 5.

74. Clément de Ris, *Musées de province,* 1:116–117. He was discussing attributions in the 1837 catalogue.

75. Houssaye, "Musées de province: Bordeaux," pp. 355–356.

76. Clément de Ris, *Musées de province,* 1:140–142, 2:27, 140. The catalogues under discussion dated from 1850 in Dijon and from 1844 in Marseilles.

77. Ibid., 1:142, 2:28.

78. Various sources indicate the following days and hours for individual museums: Bordeaux, 1818, open to the public Thursdays and the first Sunday of each month, closed in winter (AMB, 1434 R 1, Lacour to Maire, 2 February 1818); Bordeaux, 1821, open to the public Saturdays and Sundays, closed Fridays for cleaning, open to artists and foreigners all other times (Mirmont, *Histoire,* p. 316); Dijon, 1842, Sundays, 12 to 2, foreigners every day (Dijon, Musée Municipal, *Notice des objets d'arts exposés au Musée de Dijon, et catalogue général de tous ceux qui dépendent de cet établissement,* Dijon: Victor Lagier, 1842, p. 2); Marseilles, 1832, public hours Sundays and holidays, Saturdays cleaning, artists and foreigners all other days, 9–4; Marseilles, 1838, Sunday hours listed as 11–3 (AMM, 57 R 2, "Règlement pour le Musée et l'Ecole de Dessin de la Ville de Marseille," 1832, and Aubert to Maire, 29 April 1838); Rouen, 1844, Sundays and Thursdays, 10–4 (Edouard Frère, *Guide du voyageur en Normandie,* Rouen: Le Brument, 1844, p. 52).

79. Stendhal, *Mémoires d'un touriste,* ed. V. Del Litto, 3 vols., La Découverte (Paris: François Maspéro, 1981, orig. pub. 1838), 1:96; AMB, 1434 R 3, Cuvillier to Maire, 21 May 1846.

80. AMM, 57 R 2, "Règlement," 1832, p. 15; Mantz, "Musées de province: I. Musée de Bordeaux," p. 49.

81. Mirmont, *Histoire,* pp. 315–316, on public interest in envois on recent history; AMM, 57 R 2, Favre, a private citizen, to Maire, 29 August 1818, on the public's "plus sainte enthousiasme" at seeing the recently arrived Gérard portrait of Louis XVIII.

82. AMB, 1434 R 1, Lacour to Maire, 2 February 1818. The Rouen museum from its opening had a "homme de peine" whose functions

included "to keep an eye on the visitors and prevent them from touching the paintings" (ADSM, 4 T 219, Maire to Préfet, 26 March 1808).

83. ADCdO, 33 T 3, "Règlement sur la police intérieure du Musée de tableaux et de sculptures de la ville de Dijon," 1847; this *règlement* also included a checking requirement, as did the 1855 Bordeaux catalogue. On barriers, see AMM, 57 R 3, 13 August 1846, Dassy to Maire; and Clément de Ris, *Musées de province*, 1:208, praising Nantes for substituting wooden barriers for the normal metal ones.

84. Stendhal, *Mémoires d'un touriste,* 3: *Journal d'un voyage dans le midi de la France,* p. 151.

85. J. C. L. Dubosc de Pesquidoux, *Voyage artistique en France* (Paris: Michel Lévy Frères, 1857), p. 299.

86. Mantz, "Musées de province: I. Musée de Bordeaux," p. 49. Houssaye, "Musées de province: Bordeaux," p. 375, also refers to the inadequate light in Bordeaux.

87. On the disorder in Bordeaux, see Houssaye, "Musées de province: Bordeaux," p. 355: "The museum seems to have been arranged at random; the various schools are jumbled together."

88. Stendhal, *Mémoires d'un touriste,* 1:96–97.

89. Ibid., 3:157–158.

90. Dubosc de Pesquidoux, *Voyage,* pp. 116, 157–160, 213–218, 304; Clément de Ris, *Musées de province,* 1:120, 2:175, 178–179, 318; Stendhal, *Mémoires d'un touriste,* 3:151–152, 155; Houssaye, "Musées de province: Bordeaux," p. 362.

4. Museums in Transition, 1850–1870

1. Berthélemy, "Les institutions municipales," pp. 181–205; Félix Ponteil, *Les institutions de la France de 1814 à 1870,* Histoire des Institutions (Paris: Presses Universitaires de France, 1966), pp. 160–162; Paul Leroy-Beaulieu, *L'administration locale en France et en Angleterre* (Paris: Guillaumin, 1872), pp. 89–94, 99–101.

2. Leroy-Beaulieu, *L'administration locale,* p. 89; Ponteil, *Les institutions de la France,* pp. 378–379; Berthélemy, "Les institutions municipales," p. 213.

3. See Guy Thuillier, "Pour une histoire du quotidien administratif au XIXe siècle," *Revue administrative* 29 (1976): 247–252, and his series of course summaries, "Histoire de l'administration française au XIXe siècle," *Annuaire de l'Ecole pratique des hautes etudes, 4e Section* 109 (1976–1977): 851–857; 110 (1977–1978): 903–912; 111 (1978–1979): 773–784.

4. AMM, 57 R 3, Maire to Dassy, 8 March 1856.

5. See, for example, AMM, 57 R 4, "Règlement du Musée et de l'Ecole des Beaux-Arts de Marseille"; this *règlement* was drafted by Rougemont,

the Adjoint Délégué aux Beaux-Arts, in 1864: see MM, NS/C 1850–1871, Rougemont to Maire, 24 March 1864.

6. The criticism of Gué in relation to the proposed drafting of a new catalogue will be discussed below. On Gué's alliance with the *adjoint,* Troye, during the affair, see AMB, 1434 R 7, Gué to Potié, a city hall official, 29 March 1868. More generally, there is correspondence from Lacour in 1858, and from Gué in 1859, to the then *adjoint* (AMB, 1434 R 5), and from Rougemont to the curator and Jeanron, director of the art school, in 1866 (AMM, 57 R 3).

7. MD III, memorandum headed "Mr. Ziégler, peintre d'Histoire, Chevalier de la Légion d'Honneur"; Quarré, "Musée de Dijon," pp. 154–155.

8. ADSM, 4 T 219, Nieuwerkerke to Préfet, 15 March 1853; ADCdO, 33 T 2, Ministre to Maire, 20 November 1862. The director of the Rouen art school, Gustave Morin, did not become curator of the museum until 1865, on the death of the artist chosen in 1853, Joseph-Désiré Court.

9. ADCdO, 33 T 2, Ministre to Maire, 20 November 1862; Préfet Côte d'Or to Ministre de l'Intérieur, 22 December 1855, and to Ministre d'Etat (Achille Fould), 24 December 1855 and 20 January 1856; Maire to Préfet, 20 August 1856, on appointment of Pérignon and Devillebichot; MD IV, Devillebichot to Pérignon, 18 September 1856.

10. AMD, 4 R I, DNC/Journal du Musée, 1856–1861; MD IV, "Journal du Musée," May 1861–June 1863; Pérignon (in Paris) to Devillebichot, 30 January 1859, on a disciplinary matter relating to copyists; Devillebichot to Pérignon, 25 January 1859; AMD, 4 R I, DNC/CC 1851–1879, Pérignon to Maire, 5 May 1860.

11. Ricaud, *Musée de peinture et de sculpture,* pp. 121–122.

12. AMB, 1434 R 6, Charroppin to Maire, 26 October 1864.

13. AMB, 1434 R 6, Gué to Maire, 14 September 1863; emphasis added.

14. AMB, 1434 R 6, Gué to Maire, 19 May 1864; Gué to Sourget, Maire Adjoint Délégué aux Beaux-Arts, undated but 1864 from context. On the restorer, Duclos, see AMB, 1434 R 2, Lacour to Maire, 20 June 1842, 1434 R 3, Lacour to Maire, 14 May 1847, on his appointment and salary; 1434 R 5, Lacour to Maître, Secrétaire Général de la Ville, 14 January 1855, and Gué to Maire, 29 April 1859, on Duclos's picture dealing.

15. AMB, 1434 R 7, Gué to Maire, 25 August 1868.

16. AMB, 1434 R 7, Gué to Potié, 29 March and 19 June 1868.

17. Gilbert Sigaux, *Histoire du tourisme* (Geneva: Editions Rencontre, 1965), pp. 64, 66, 71; René Duchet, *Le tourisme à travers les âges: Sa place dans la vie moderne* (Paris: Vigot Frères, 1949), pp. 111–112, 136–137; Jean Falaize, "L'épopée du rail," in *Histoire des chemins de fer en France* (Paris: Presses Modernes, 1964), pp. 32–37; Pierre Dauzet, *Le siècle des chemins de fer en France (1821–1938)* (Fontenay-les-Roses: Bellenand, 1948), pp. 27–29, 35–41; Henry Peyret, *Histoire des chemins de fer en France et dans le*

monde (Paris: Société d'Editions Françaises et Internationales, 1949), pp. 194−199.

18. Pinkney, *Decisive Years in France*, pp. 33−39, 54−58; Falaize, "L'épopée," pp. 38−49, 58−59; Dauzet, *Le siècle des chemins de fer*, pp. 43−48, 52−63, 84−116; Peyret, *Histoire des chemins de fer*, pp. 119−225; Gras, ed., *Histoire de Dijon*, pp. 272−273; Edouard Baratier, ed., *Histoire de Marseille*, Univers de la France et des Pays Francophones: Histoire des Villes (Toulouse: Privat, 1973), p. 332; Louis Desgraves et Georges Dupeux, eds., *Bordeaux au XIXe siècle* (Bordeaux: Delmas/Fédération Historique du Sud-Ouest, 1969), pp. 211−212.

19. John Pudney, *The Thomas Cook Story* (London: Michael Joseph, 1953), pp. 112, 121, 130−133; Sigaux, *Histoire du tourisme*, p. 79.

20. Duchet, *Le tourisme à travers les âges*, p. 114; Jean Mistler, *La librairie Hachette de 1826 à nos jours* (Paris: Hachette, 1964), pp. 257, 259n; Edouard Frère, *Guide du voyageur en Normandie, ou Description historique, pittoresque, monumentale et statistique . . .* (Rouen: Le Brument, 1844).

21. Mistler, *La librairie Hachette*, pp. 121−136; on the controversy over Hachette's monopoly, see also Gustave Charpentier, *Du monopole de MM. Hachette et Cie pour la vente des livres dans les gares des chemins de fer* (Paris, 1861).

22. Mistler, *La librairie Hachette*, pp. 124, 257−258, 260; L. Viardot, *Les musées de France—Paris* (Paris: Maison, 1855; 2nd ed., Hachette, 1860). Viardot's titles, like the other non-Joanne volumes Hachette had purchased, were gradually dropped from Hachette's list as the Joanne series expanded.

23. Mistler, *La librairie Hachette*, pp. 259−262; Duchet, *Le tourisme à travers les âges*, p. 137; *An Historical Notice upon the Establishment of Messrs. Hachette & Co.* (Paris: [Hachette?], 1876), pp. 41−44; *Grande collection de guides et d'itinéraires pour les voyageurs, dirigée par Adolphe Joanne,* promotional brochure, 1864, bound in with the Library of Congress copy of A. Joanne, *Les environs de Paris illustrés, itinéraire descriptif et historique* (Paris: Hachette, 1856).

24. Marc Boyer, *Le tourisme* (Paris: Seuil, 1972), pp. 134−136; Jean Cassou, "Du voyage au tourisme," *Communications*, no. 10 (1967): 25−29.

25. Mistler, *La librairie Hachette*, p. 260. Joanne's *Itinéraire général de la France: Normandie* (Paris: Hachette, 1866), pp. 60−62, for example, provided a lengthy description of "the paintings that, for various reasons, have seemed to us to offer the greatest interest" in the Rouen museum, and occasionally took issue with both the catalogue's enthusiasms and its attributions.

26. Boyer, *Le tourisme*, pp. 133, 137−146; Duchet, *Le tourisme à travers les âges*, pp. 144−148; Louis Burnet, *Villégiature et tourisme sur les côtes de France*, Bibliothèque des Guides Bleus (Paris: Hachette, 1963), pp. 253, 259, 413, 420−421.

27. AMB, 1434 R 6, Maire to Gué, 3 November 1860, 22 October 1864; MM, NS/C 1850–1871, Maire to Conservateur, 3 August 1858.

28. AMB, 1434 R 6, Charroppin to Maire, 26 October 1864.

29. MD IV, Devillebichot and Pérignon to Maire, 26 June 1857 and 2 April 1858; Pérignon to Maire, 16 July 1859; AMD, 4 R I, DNC/CC 1851–1879, Pérignon to Maire, 5 May 1860.

30. AMD, 4 R I, DNC/Journal du Musée, entries for 14 May 1857 and 9 March 1860; AMM, 57 R 4, Jeanron to Maire, 21 June 1865.

31. *Annuaire des artistes et des amateurs* 1 (1860): vii–viii, 308–310.

32. Charles Blanc, "Introduction," *GBA* 1 (January–March 1860): 5–15.

33. Léon Lagrange, "Des Sociétés des amis des arts en France: Leur origine, leur état actuel, leur avenir," *GBA* 10 (April–June 1861): 111–113, 158–160.

34. Lagrange, "Des Sociétés," *GBA* 9 (January–March 1861): 295–301; 10:29–32. The book is *Des Sociétés des amis des arts en France* (Paris: J. Claye, 1861).

35. Mirmont, *Histoire*, pp. 340–341, 510–512, 516–522. Lagrange, though he mentions a short-lived society in Avignon (*GBA* 10:33), presents the society founded in Bordeaux in 1851 as though it had no precedents (*GBA* 10:42).

36. Lagrange, "Des Sociétés," *GBA* 10:33, 37–42, 102–110.

37. SAB *CR* 1 (1851–1852), pp. 2–3: "favoriser le progrès des arts à Bordeaux, et en propager le goût."

38. Lagrange, "Des Sociétés," *GBA* 10:163–164.

39. AMD, 4 R I, DNC/CC 1851–1879, Conservateur to Maire, 3 April 1858; AMM, 57 R 3, Marcotte, Président, Société Artistique des Bouches-du-Rhône, to Maire, 27 August 1856, and extensive marginalia.

40. See, for example, AMM, 57 R 3, Marcotte to Maire, 7 January 1853, explaining the value of such purchases and citing precedents in other cities; Lagrange, "Des Sociétés," *GBA* 10:36.

41. The only exception I have found in extensive research on association statutes is the Société des Amis des Arts de l'Ain, in Bourg-en-Bresse, whose 1879 statutes allowed its administrative board to set a commission of up to 10 percent on sales. See Société des Amis des Arts de l'Ain, *Statuts* (Bourg: Villefranche, 1879), Art. 6.

42. MD IV, Pérignon to Maire, undated but 1858 from context: "Elle montrerait par là, aux artistes qui ont été invité à concourir à l'éclat de notre exposition, que l'appel qui leur a été fait était dans un but sérieux et réel de prendre part aux encouragements si nécessaires à leur travaux." Pérignon's somewhat awkward syntax has been modified in the translation.

43. Cf. Raymonde Moulin, "Les bourgeois amis des art: Les expositions des beaux-arts en province, 1885–1887," *Revue française de sociologie* 17 (1976): 406.

44. In 1857 the gap had narrowed, but still amounted to a power of ten: *amateurs* 56 works for 18,284 francs, average 326.5 francs; society 43 works for 25,060 francs, average 582.8 francs; the city 5,000 francs for Félix Ziem's *Banks of the Amstel*. Figures from SAB *CR* 3 (1853), 6 (1857).

45. SAB *CR* 3 (1853), pp. 5–6; Lagrange, "Des Sociétés," *GBA* 10.

46. AMM, 57 R 4, Gabriel to Maire, 11 November 1865.

47. Lagrange, "Des Sociétés," *GBA* 10:162.

48. SAB *CR* 10 (1861), p. 7.

49. SAB *CR* 8 (1859), p. 3; they went on to say that the poor business climate at the time of the Crimean War bore most of the responsibility.

50. AMM, 57 R 4, Extrait des Registres des Délibérations du Conseil Municipal de la Ville de Marseille (hereafter abbreviated CM Extrait), 27 February 1863, explaining the annual appropriation; Clapier to Maire, 30 October 1864; Gabriel (Clapier's successor) to Maire, 11 November 1865; CM Extrait, 11 March 1864, on 1864 purchases. The city's reply to these criticisms will be discussed later in this chapter.

51. AMB, 1434 R 1, Henry Guillot to Maire, 12 February 1813; see also Mirmont, *Histoire,* pp. 191–192.

52. AMM, 57 R 2, Auguste Robineau to Maire, 14 and 17 February 1823 and 8 October 1825; AMB, 1434 R 3, Bertrand to Maire (?), 10 September 1848.

53. AMM, 57 R 3, Marquis de Brisselin to Maire, 30 December 1844.

54. AMM, 57 R 2, CM Extrait, 19 February 1838; AMM, 57 R 3, Meiffredy to Maire, 17 November 1846, and marginal summary of reply.

55. AMB, 1434 R 2, Lacour to Maire, 18 July 1842.

56. AMB, 1434 R 1, Lacour to Maire, 1822; Mirmont, *Histoire,* pp. 363–385; Bordeaux 1855, pp. 27–31.

57. AMM, 57 R 2, Aubert to Maire, 2 May 1845. Also AMM, 57 R 3, Loubon (Directeur de l'Ecole de Dessin) to Maire, 2 September 1847, and reply, 7 September, about the former's efforts to obtain envois for the museum.

58. AMB, 1434 R 3, excerpt from *L'indicateur,* 13 December 1846, describing city council meeting of 11 December; despite a renewed promise from the Minister of the Interior in October 1848, nothing seems to have come of this promise.

59. AMD, 4 R I, DNC/Journal du Musée, entry for 20 March 1859.

60. AMB, 1434 R 4, Lacour to Maire, 31 May 1850; AMM, 57 R 4, *Règlement,* 1864, Art. 13; also comments of Rougemont on a letter from Courajod, Lyons, to Maire, 12 May 1864 (on solicitations from out of town) and on a letter from a dealer, Angely, to Maire, 14 March 1865 (on commercialization).

61. AMM, 57 R 4, Loubon to Maire, 25 May 1862.

62. AMD, 4 R I, DNC/Journal du Musée, entry for 21 June 1861; compare Bordeaux 1855, p. 9: "For how can the history of the arts or of litera-

ture be known and understood without the study of the mediocrities that have preceded, accompanied, or followed the production of masterpieces?"; AMB, 1434 R 7, Gué to Maire, 13 December 1867.

63. AMM, 57 R 3, Curé Orange to Maire, 13 February 1857. E. Bénézit, *Dictionnaire critique et documentaire des peintres . . .* , new ed., 10 vols. (Paris: Gründ, 1976), 8:667, 678, 9:161, gives the following prices for paintings by these artists sold between 1840 and 1869: Raphael, 19,685 to 155,000 francs, mean around 40,000; Rembrandt, 21,000 to 155,000 francs, mean around 40,000; Rubens, 61,950 to 187,000 francs, mean around 110,000.

64. The Millet, as will be discussed later in this chapter, was sent to the exhibitions in both Bordeaux and Marseilles. The catalogues of the Société des Amis des Arts de Bordeaux, *Explication des Ouvrages . . . dans la Galerie de la Société des Amis des Arts de Bordeaux, [date]*, do not contain prices, but the collection of these catalogues in the Bibliothèque Municipale de Bordeaux contains numerous indications of prices in the hand of the donor, Charles Marrionneau, an artist and member of the society. The following are a few examples of prices that reputable artists, most of them with state purchases to their credit, were asking at Bordeaux exhibitions; the *average* price paid by private collectors at that exhibition is in parentheses. For 1856 (474), Théodore Rousseau, 1,200 francs for *Après la pluie* (high for a landscape); 1858 (597), Corot, 5,000 francs for *Les baigneuses* (bought by the city); 1865 (446), Millet, 6,000 francs for *Une tondeuse de moutons*, 4,000 for *La naissance d'un veau;* 1867 (408), Lehmann (a member of the Institut), 12,000 francs for *Le repos;* at this exhibition, however, there were seven private purchases of 2,000 francs or more. As a postscript, it might be noted that Edouard Manet asked rather more than might have been expected for a controversial young artist with only one honorable mention to his credit: 1,500 francs for *Enfant portant un épée* in 1862; 2,000 for *Jeune femme jouant de la guitare* in 1865.

65. MD III, and MM, NS/C 1850–1871, Jury, Coiffeur to Conservateur, 23 January 1857. Examples of envois in this period, all far larger than any of the works bought by cities: to Marseilles, Bin, *Prométhée enchaîné* (1869), 18 feet 4 inches by 14 feet; to Bordeaux, Gigoux, *Cléopâtre après la bataille d'Actium* (1855), 12 feet 8 inches by 21 feet 3.5 inches; Tabar, *Episode de la campagne d'Egypte* (1857), 14 feet 9 inches by 12 feet 1 inch. See Marseilles 1876, nos. 11 and 19, and Emile Vallet, *Catalogue des tableaux, sculptures, gravures, dessins exposés dans les galeries du Musée de Bordeaux* (Bordeaux: G. Gounouilhou, 1881), henceforth cited as Bordeaux 1881, nos. 484 and 621.

66. AMB, 1434 R 6, Gué to Maire, 10 March 1863; he also mentioned its merit and subject matter. The works are Bordeaux 1881, nos. 338 and 633.

67. AMB, 1434 R 6, statement (draft) of Commission de l'Instruction

Publique et des Arts, undated but probably early 1865; Ricaud, *Musée de peinture et de sculpture*, pp. 101–112; see also Jean Cavignac, ed., *Actes Notariés concernant Lodi-Martin Duffour-Dubergier, Maire de Bordeaux, Président du Conseil Général de la Gironde (1797–1860)*, Réceuil d'Etudes et de Documents pour servir à l'histoire du département de la Gironde et des départements voisins, 2 (Bordeaux: Archives Départementales de la Gironde, 1982).

68. These figures count the fifteen paintings acquired from the Robert Brown collection in 1860 as one purchase.

69. AMB, 1434 R 6, Note, 30 March 1861, on an article in *La Gironde* of this date; on the Brown purchase, see Ricaud, *Musée de peinture et de sculpture*, pp. 95–98.

70. AMM, 57 R 4, CM Extrait, 12 April 1867; on the criticism, see text at note 50.

71. AMM, 57 R 5, marginal comment of Rougemont on letter, Comte de Coustin to Maire, 28 February 1870, observing that the city made purchases (of works it had been able to examine) only once a year; AMM, 57 R 4, Landelle to Maire, 14 April 1863, complaining of delays and sloppy procedures concerning the purchase of his *Women of Jerusalem,* and a similar complaint from the secretary of the Société Artistique, 10 March 1868.

72. AMB, 1434 R 6, Gué to Maire, 10 March 1863, concerning purchase of two paintings by Alaux le Romain; 1434 R 7, Gué to Maire, 2 March 1868, concerning purchase of two Guérin paintings.

73. AMM, 57 R 4, CM Extrait, 13 July 1866; CM Extrait, 29 April 1868, on the Moretto. On the Bordeaux works mentioned (Bordeaux 1881, nos. 304, 314, 500, 501), see Ricaud, *Musée de peinture et de sculpture*, pp. 72, 114–115, and AMB, 1434 R 5, Lacour to Maître, Secrétaire-Général, 14 March 1856, and 1434 R 7, Gué to Maire, 2 March 1868.

74. MD IV, Pérignon to Maire, undated but 1858 from context; Gué's statement, quoted in a Conseil Municipal discussion of 27 May 1861, is cited in Ricaud, *Musée de peinture et de sculpture*, p. 119.

75. See the definition of history painting in Chapter 1, note 111.

76. A comparison with Table 6 reveals slight but clear differences between state purchases in this period and those of Bordeaux and Marseilles. Roughly, the cities reversed the proportions of state purchases devoted to history and genre, while acquiring a comparable share of landscapes.

77. AMB, 12 D 57, City Council discussion of 25 May 1868, comments of Emile Fourcand; see also Ricaud, *Musée de peinture et de sculpture*, p. 169.

78. AMB, 12 D 51, City Council discussion of 8 May 1865; see also Ricaud, *Musée de peinture et de sculpture*, p. 154.

79. Ricaud, *Musée de peinture et de sculpture*, p. 142; AMM, 57 R 4, CM Extrait, 12 April 1867.

80. AMB, 12 D 53, City Council discussion of 16 April 1866. The notion of a realist "school," which most scholars today consider at best misleading, was fairly common at the time.

81. AMB, 12 D 53, City Council discussion of 16 April 1866. Ricaud's account of the price dispute, *Musée de peinture et de sculpture,* pp. 158−159, has some notable gaps and gives erroneous date references for several meetings.

82. AMM, 57 R 4, CM Extrait, 25 June 1869. Rougement claimed that, unlike Courbet, "Millet seeks effect and prestige in style and imagination." See also Sherman, "The Bourgeoisie, Cultural Appropriation, and the Art Museum," p. 47.

83. AMM, 57 R 4, CM Extrait, 31 March 1865.

84. AMM, 57 R 4, CM Extraits, 12 April 1867, 29 April 1868.

85. AMM, 57 R 4, CM Extrait, 25 June 1869.

86. Letter from Scott, Président, Société des Amis des Arts to Maire, 2 May 1860, cited in AMB, 12 D 42, City Council discussion of 7 May 1860, also in Ricaud, *Musée de peinture et de sculpture,* p. 99; AMB, 12 D 49, City Council discussion of 2 April 1864, after an inconclusive discussion, on 30 March (in 12 D 48).

87. On the Curzon, see Ricaud, *Musée de peinture et de sculpture,* p. 153; on the Corot, AMB, 13 D 31, letter from Président to Maire, 31 May 1858, also cited in Ricaud, p. 77.

88. AMM, 57 R 4, CM Extraits, 25 June 1869 (Millet), 29 April 1868 (Ulmann), 31 March 1865 (Viot, Beaume). He also praised Beaume for not confusing spiritual "grandeur" with material size.

89. Report of the mayor, Antoine Gautier, 10 March 1856, summarized in Ricaud, *Musée de peinture et de sculpture,* pp. 67−68.

90. On the influence of the society's officers, see AMB, 1434 R 6, Charroppin to Maire, 29 March 1864, informing him of Bouguereau's price for *Une bacchante* and congratulating him on the city's choice.

91. AMM, 57 R 4, CM Extraits, 4 March 1870, 27 February 1863, and 29 April 1868.

92. AMB, 1434 R 8, Charroppin to Maire, 17 May 1870, and CM Extrait, 27 May 1870.

93. AMB, 1434 R 7, Beausse, employé Hôtel de Ville and Guichard, Bordeaux to Maire, 8 October 1868: "the acquisition of new treasures in order to preserve for the Bordeaux museum the first rank it already holds" (this was a purchase solicitation); Gué to Maire, early May 1862, quoted in Ricaud, *Musée de peinture et de sculpture,* p. 139.

94. AMM, 57 R 4, CM Extrait, 4 March 1870. Since Regnault was killed in the Franco-Prussian War in January 1871 at the age of 27, it is impossible to know whether the bright expectations for his future would have been

fulfilled. The Prix de Rome, which he had won in 1866, cannot be taken as an infallible indicator of future stardom, even by the standards of the time.

5. Museums in Construction, 1860−1890

1. See, for example, AMM, 57 R 4, Jeanron (Directeur de l'Ecole des Beaux-Arts) to Maire, 21 June 1865, saying that installation of the museum's latest acquisitions had forced him to place well-known works in storage; AMB, 1434 R 8, Gué to Maire, 7 January 1870, with a similar report.

2. AMM, 101 M 1, CM Extrait, 7 April 1862.

3. ADSM, 2 OP 1538/52, CM Extrait, 7 April 1854.

4. *La Gironde,* 14 June 1868, and *Courrier de la Gironde,* 15 June 1868; AMB, 1434 R 7, Gué to Maire, 19 June 1868; see Chapter 4. Both the *Courrier* and the *Gironde* could be characterized as opposition newspapers, the former Orleanist, the latter republican.

5. AMM, 101 M 1, CM Extrait, 7 April 1862; ADSM, 2 OP 1538/52, Rouen, Conseil Municipal, "Proposition de M. E. Nétien, Maire de Rouen, pour la construction d'un Musée de Peinture," 20 February 1874, pp. 5−6, cited in CM Rouen Extrait, report of Barthelemy, 7 April 1876.

6. AMB, M 12, "Rapport sur le Projet de Construction du Musée, présenté à la Commission Municipale le 28 août 1874, par M. P. Deloysnes," p. 4.

7. AMM, 101 M 1, CM Extrait, 7 April 1862; ADSM, 2 OP 1538/52, "Proposition de M. E. Nétien," 1874, p. 5; AMB, M 12, "Rapport sur le Projet," 1874, p. 18.

8. *Nouvelliste de Rouen,* 7 May 1877: "a monument worthy at the same time of our city and of the incomparable treasures it is called upon to house"; *Courrier de la Gironde,* 18 October 1881: "in a monument worthy of our city"; *Petit rouennais,* 20 February 1880: "the opening of a museum at last truly worthy of our artistic treasures"; AMB, 1435 R 1, Rapport Trimestriel, Vallet, Conservateur, to Maire, 23 August 1881: "a museum truly worthy of a great city like Bordeaux."

9. David Pinkney has convincingly pointed to the 1840s as a crucial period of economic transformation in France (*Decisive Years in France,* pp. 23−49), but cities with different economic structures and at different stages of development were confronting similar physical and social problems in the 1850s and 1860s.

10. Pierre Guiral and Paul Amargier, *Histoire de Marseille* (Paris: Mazarine, 1983), pp. 223−224, 242−248, 262−264; Baratier, ed., *Histoire de Marseille,* pp. 327−333, 341−350; Louis Girard, "La politique des grands travaux à Marseille sous le Second Empire," in Chambre de Commerce de

Marseille, *Marseille sous le Second Empire: Exposition, conférences, colloque organisé à l'occasion du centenaire du Palais de la Bourse, 10–26 novembre 1960* (Paris: Plon, 1961), pp. 78–79, 87; William H. Sewell, Jr., *Structure and Mobility: The Men and Women of Marseille, 1820–1870* (Cambridge: Cambridge University Press, 1985), pp. 1–4, 18–34, 38–43.

11. Michel Mollat, ed., *Histoire de Rouen*, Univers de la France et des Pays Francophones: Histoire des Villes (Toulouse: Privat, 1979), pp. 319–340.

12. Charles Higounet, ed., *Histoire de Bordeaux*, Univers de la France et des Pays Francophones: Histoire des Villes (Toulouse: Privat, 1980), pp. 289–297, 305–320: the section on 1815–1939 by Pierre Guillaume is entitled "Le temps de l'immobilisme"; Desgraves and Dupeux, eds., *Bordeaux au XIXe siècle*, pp. 179–209.

13. For a discussion of the conceptual bases of urban planning in nineteenth-century France, see Maurice Agulhon et al., *La ville de l'âge industriel: Le cycle haussmannien*, Histoire de la France Urbaine, 4 (Paris: Seuil, 1983), pp. 93–105.

14. A. Bailleux de Marisy, "La ville de Marseille: Ses finances, ses travaux publics," *Revue des deux mondes* 64 (July–August 1866): 620–652; Raoul Busquet and Pierre Guiral, *Histoire de Marseille*, new ed. (Paris: Robert Laffont, 1978), pp. 341–343, 351–353; Baratier, ed., *Histoire de Marseille*, pp. 333, 351; Sewell, *Structure and Mobility*, pp. 33–35, 107–109; Girard, "La politique des grands travaux," pp. 75–88.

15. Mollat, ed., *Histoire de Rouen*, pp. 308–318.

16. Higounet, ed., *Histoire de Bordeaux*, pp. 256–265; Dupeux and Desgraves, eds., *Bordeaux au XIXe siècle*, pp. 211–238.

17. On "Haussmannisation," see Agulhon et al., *La ville*, pp. 75–117; David H. Pinkney, *Napoleon III and the Rebuilding of Paris* (Princeton: Princeton University Press, 1958); and for a more general survey, Louis Hautecoeur, *Histoire de l'architecture classique en France*, 7 vols. (Paris: Picard, 1943–1957), vol. 7: *La fin de l'architecture classique, 1848–1900*, pp. 20–75, 85–93.

18. On the eclipse of the *notables* see Pinkney, *Decisive Years in France*, pp. 61–62, although he places this development in the context of centralization. On the late July Monarchy as the period in which a commercial bourgeoisie, with some representation of industrial capital (in Rouen the lines were blurred) acceded to *political* power at the local level, see Jean-Pierre Chaline, in Mollat, ed., *Histoire de Rouen*, especially pp. 361–365, and in his own monograph, *Bourgeois de Rouen*, especially pp. 87–90, 372–373. Chaline himself plays down the significance of this shift for social or political attitudes, but that does not rule out an impact on *urbanisme*. On a similar shift in Bordeaux, also in the July Monarchy, see Dupeux and Desgraves, *Bordeaux au XIXe siècle*, pp. 70–78; on Marseilles, see Agulhon

et al., *La ville,* pp. 485–490; on Reims and Saint-Etienne, cf. Gordon, *Merchants and Capitalists.*

19. Chaline, *Bourgeois de Rouen,* pp. 359–370.

20. For a lucid discussion of these charges, see ibid., pp. 371–381; idem, "Le milieu culturel rouennais au temps de Flaubert," in Université de Rouen, Institut de Littérature Française, Centre d'Art, Esthétique, et Littérature, *Flaubert et Maupassant, écrivains normands* (Paris: Presses Universitaires de France, 1981), pp. 17–25.

21. Cited in Guiral and Amargier, *Histoire de Marseille,* pp. 253–254; on Marseilles's "misères monumentales," see also M. Chaumelin, "Projet d'une salle de concert et d'expositions," *Tribune artistique et littéraire du Midi* 3 (1859): 248–252; and idem, "La bourse de Marseille," *Tribune* 4 (1860): 239–245.

22. Chaumelin, "La bourse de Marseille," *Tribune* 4 (1860): 239.

23. *Gazette du Midi* (Marseilles), 13 August 1869.

24. Etienne Parrocel, "Le Palais de Longchamp," *Nouvelliste de Marseille,* 12 August 1869; Agulhon et al., *La ville,* pp. 582–583; on mayors, Paul Masson, ed., *Les Bouches-du-Rhône: Encyclopédie départementale,* 15 vols. (Marseilles: Archives Départementales des Bouches-du-Rhône, 1913–1933), vol. 11: *Biographies,* pp. 73, 263–264, 375–376, 475–476. On the political role of the city council during the Second Empire, see Norbert Rouland, *Le conseil municipal marseillais et sa politique de la IIe à la IIIe République (1848–1875)* (Aix-en-Provence: Edisud, 1974), pp. 231–248.

25. *Une question de propriété artistique: La vérité sur le Palais de Longchamp* (Paris: Ducher, 1884), pp. 19–20, 25–27 (hereafter cited as *La vérité*); E. Parrocel, *L'art dans le Midi: Célébrités marseillaises–Marseille et ses édifices–architectes et ingénieurs du XIXe siècle,* 4 vols. (Marseilles: E. Chatagnier, 1884), 4:2–3; AMM, 101 M 1, CM Extraits, 12 April 1847, 31 May 1847, 14 February 1848, 18 May 1854, 18 September 1859 (inclusion of an art museum in the plans).

26. AMM, 101 M 1, CM Extrait, 7 April 1862. The two sides were in fact presenting differing notions of the limits of the city: the Boulevard Longchamp at this time was identifiably urban, but what lay beyond it was only slowly becoming so. See Liliane Kaercher, "Cercles et sociétés à Marseille" (Thèse de 3e cycle, Université de Paris I, 1981), pp. 213–215.

27. AMM, 101 M 1, CM Extrait, 7 April 1862.

28. AMM, 101 M 1, CM Extrait, 19 September 1859; "Projet du Monument à élever sur le Plateau de Longchamp" (Espérandieu), 31 December 1861; *La vérité,* pp. 32–37, 43–49 (text of the advisory committee's report), 56.

29. *La vérité,* 2nd. ed., rev., 1900, takes Espérandieu's side in the dispute, but accurately reproduces most of the important documents in the case, with the unfortunate exception of the architectural drawings, not all of

which have survived. The main stages of the controversy were an unsuccessful lawsuit brought by Bartholdi in Marseilles in 1864–1866, a decision from the Conseil d'Etat in 1873 that Bartholdi was entitled to further payment from the city for his work (see also *CAC*, 15 March 1873, pp. 98–99), and press reports, prompted by Bartholdi's friends, in 1874, 1883, and 1897 (see also press clippings in ADBdR, 4 T 50). The 1914 Joanne guide to Provence, Gaston Beauvais, *Provence,* Collection des Guides-Joanne (Paris: Hachette, 1914), p. 257, connects Bartholdi with the Palais de Longchamp.

30. Final figures from *Nouvelliste de Marseille,* 13 August 1869; original estimates from AMM, 101 M 1, "Projet du Monument," 31 December 1861; on municipal indebtedness, see Bailleux de Marisy, "La ville de Marseille," pp. 643–649, and more generally, Louis Girard, *La politique des travaux publics du Second Empire* (Paris: Colin, 1952), especially pp. 330–348.

31. AMM, 101 M 1, CM Extraits, 7 April 1862 and 4 November 1864.

32. AMM, 101 M 1, CM Extraits, 4 November 1866 and 15 July 1870 (on final accounting); on members of the city council and their politics, Masson, ed., *Les Bouches-du-Rhône,* 11:15, 190–192, 218, 281–283, biographies of Henri Amat, Augustin Fabre (not a member of the opposition), Adolphe Fraissinet, and Labadié.

33. Jean Stock, "Le Palais des Arts," *Petit marseillais,* 14 August 1869; *Gazette du Midi,* 13 August 1869; *Courrier de Marseille,* 15 August 1869. The view that the Palais de Longchamp was far superior to public buildings constructed earlier in Marseilles seems to have been a common one: see, for example, Bailleux de Marisy, "La ville de Marseille," p. 639.

34. Bernex's speech reprinted in *Gazette du Midi,* 19 and 20 August 1869; Louis Brès, *Le Palais de Longchamp* (Marseilles: Barlatier, 1869), p. 28.

35. ADSM, 2 OP 1538/52, "Ville de Rouen, Avant-Projet de Musée-Bibliothèque," 20 June 1873; "Proposition de M. E. Nétien," 20 February 1874; Rouen CM Extrait, 7 April 1876.

36. CMR, 7 April 1876, pp. 210–215; on Chennevières's commission, ADSM, 2 OP 1538/52, CM Extrait, 7 April 1876; AN, F[21] 471, Maire to Directeur, 12 April and 27 May 1876, Directeur to Maire, 24 May 1876; *Journal de Rouen,* 30 May 1876, an article signed "A.D.," undoubtedly Alfred Darcel, a member of the commission, on its findings.

37. ADSM, 2 OP 1538/52, CM Extrait, 7 April 1876; *Journal de Rouen,* 7 May 1877.

38. ADSM, 2 OP 1538/52, CM Extrait, 9 February 1877; according to documents in this dossier, the Conseil d'Etat approved the loan in April 1878, the Ministry of the Interior granted the declaration of *utilité publique* in August 1878, and hearings on expropriations were held from June 1879 through January 1880. Construction of the curator's lodgings began in the spring of 1880, that of the main sections of the second phase not until 1882.

39. Alfred Darcel, "Feuilleton," *Journal de Rouen*, 19 February 1880; *Petit rouennais*, 20 February 1880.

40. Mayor's speech reprinted in *Journal de Rouen*, 20 February 1880.

41. *Journal de Rouen*, 19–20 February 1880; *Nouvelliste de Rouen*, 19–20 February 1880; *Petit rouennais*, 20 February 1880.

42. *Petit rouennais*, 17 December 1880; *Journal de Rouen*, 18 December 1880. The *Journal*'s response to a letter in another newspaper appears less surprising in that the letter writer, whose views the *Petit rouennais* declined to endorse, had mentioned the *Journal* by name.

43. Mayor's speech reprinted in *La Gironde*, 27 May 1875. The government appointed all mayors until 1882, but Pelleport-Burète's predecessor and successor, Emile Fourcand, had been an elected member of the city council, whereas Pelleport-Burète was not.

44. *Courrier de la Gironde*, 27 May 1875, p. 2; *La Gironde*, 27 May 1875, p. 3.

45. Pre-1870 efforts to construct a museum are summarized in Ricaud, *Musée de peinture et de sculpture*, pp. 123–136, 162–164, and in AMB, M 12, "Rapport sur le Projet," 28 August 1874, pp. 4–13.

46. AMB, 8303 M 9, CM Extrait, 8 April 1864, also cited in Ricaud, *Musée de peinture et de sculpture*, p. 134. The architectural plans for this project are in AMB, 8303 M 9 and 8303 M 10.

47. AMB, 8303 M 10, "Rapport de M. G. Henry Brochon au Conseil Municipal," 16 April 1866; M 12, "Rapport sur le Projet," 28 August 1874, pp. 10–11; Ricaud, *Musée de peinture et de sculpture*, pp. 162–164.

48. Philippe Burty, "L'Exposition de Bordeaux," *GBA* 18 (January–June 1865): 466; *Courrier de la Gironde*, 15 June 1868 (see also Chapter 4); AMB, M 12, "Rapport sur le Projet," 28 August 1874, pp. 11–13; Ricaud, *Musée de peinture et de sculpture*, pp. 175–177.

49. On the fire in the city hall, to which the museum had returned a few months before, see AMB, 1432 R 1, particularly a letter, Gué to Maire, 12 December 1870, describing the damage, and subsequent reports of the committee of artists and members of the Société des Amis des Arts supervising the restoration of damaged works. Sixteen paintings were completely destroyed, including a Champaigne and a Luca Giordano; a further fifteen sustained damage beyond the point of restoration over a large portion of their surfaces, including Delacroix's *Lion Hunt*, of which only a fragment now remains. Another forty-seven were less seriously damaged. See also Ricaud, *Musée de peinture et de sculpture*, pp. 178–180.

50. AMB, M 12, "Rapport sur le Projet," 28 August 1874, pp. 12, 17–23.

51. Ibid., 28 August 1874, pp. 13–15; plans from the 1874 project are reproduced in Jean Pinçon, "La construction du musée de peinture et de

sculpture de Bordeaux," *Revue historique de Bordeaux et du département de la Gironde,* n.s., 22 (1973): 89–102. The 1862 project had included an art school, but not the library; the 1874 design left out the art school.

52. AMB, M 12, "Rapport sur le Projet," pp. 19–22.

53. Ibid., p. 19; mayor's speech in *La Gironde,* 27 May 1875.

54. *Courrier de la Gironde,* 15 October 1881. The critic's marvelous term "enlaidissement" loses all its resonance in a correct English translation; only the term "uglification" conveys its full force.

55. *La Gironde,* 23 June 1881 (on a preliminary visit as the museum was being installed) and 14 October 1881.

56. AMB, M 12, "Rapport sur le Projet," 28 August 1874, p. 24; ADSM, 2 OP 1538/52, "Proposition de M. E. Nétien," 20 February 1874, pp. 12–13; on Marseilles, see above, note 26.

57. Brès, *Le Palais de Longchamp,* pp. 5–6; Bernex speech in *Gazette du Midi,* 19 August 1869.

58. *La Gironde,* 27 May 1875; MM, NS/C 1872–1876, Secrétaire-Général to Conservateur, 4 June 1872.

59. Bernex speech in *Gazette du Midi,* 19 August 1869; characterization of the "fête populaire" in *Courrier de Marseille,* 16–17 August 1869.

60. *Nouvelliste de Marseille,* 13 August 1869. On the character of the district in 1851, see Sewell, *Structure and Mobility,* pp. 115, 121, and on the 1870s as a period of development and gentrification, see Kaercher, "Cercles et sociétés à Marseille," pp. 214–215. The Chartreux district to the east of Longchamp remained socially diverse for a longer period of time, with both working-class and petit-bourgeois inhabitants late into the century.

61. *La Gironde,* 27 May 1875; on social segregation as a new phenomenon in Bordeaux and as a purpose of Haussmannisation, see Higounet, ed., *Histoire de Bordeaux,* pp. 256–258.

62. There is extensive documentation on the expropriation procedures in Rouen, including petitions from the occupants, in ADSM, 2 OP 1538/52.

63. Mollat, ed., *Histoire de Rouen,* pp. 308–318; Chaline, *Bourgeois de Rouen,* pp. 161–170, 184–187.

64. ADSM, 2 OP 1538/52, "Proposition de M. E. Nétien," 20 February 1874, p. 13; Brès, *Le Palais de Longchamp,* p. 28. The use of the word "milieu" indicates, in my judgment, the notion of a *kind* of place, or atmosphere, rather than this specific place ("lieu") which, as Brès himself pointed out, had not previously been a wealthy area.

65. AMM, 101 M 1, CM Extrait, 7 April 1862; AMB, M 12, "Rapport sur le Projet," 28 August 1874.

66. The term "dragée," or sugar coating, appears in AMM, 101 M 1, CM Extrait, 7 April 1862.

67. "Pensées sur la ville, arts de la ville," in Agulhon et al., *La ville,*

pp. 204–205; AMM, 101 M 1, CM Extrait, 4 November 1866; *Gazette du Midi,* 20 August 1869.

68. AMM, 57 R 5, Conservateur to Maire, 17 December 1875, and Commissaire de Police, 12e Arrondissement to Commissaire Central, 23 December 1875; MM, NS/C 1881–1884, Conservateur to Maire, 8 June 1881; MM, NS/C 1889–1892, Maire Adjoint à la Police to Conservateur, 8 July 1891.

69. See Choay, in Agulhon et al., *La ville,* pp. 216–220; on the main architectural styles and their exponents, Hautecoeur, *La fin de l'architecture classique,* pp. 121–205, 287–305.

70. ADSM, 2 OP 1538/52, CM Extrait, 7 April 1876; for Sauvageot's own description of his study of lighting systems, see ibid., "Ville de Rouen, Avant-Projet du Musée-Bibliothèque," 20 June 1873.

71. On the early design history of the art museum, see Helmut Seling, "The Genesis of the Art Museum," *Architectural Review* 141 (1967): 103–114, and Nikolaus Pevsner's expansion on it in *A History of Building Types,* Bollingen Series 35, A. W. Mellon Lectures in the Fine Arts 19 (Princeton: Princeton University Press, 1976), pp. 111–128; on the Alte Pinakothek, ibid., pp. 129–130. On inspectors' advocacy of skylights, see, for example, AN, F^{21} 4910, report on Soissons, 1887.

72. AMM, 101 M 1, CM Extrait, 4 November 1866.

73. *Courrier de Marseille,* 15 August 1869, and *Gazette du Midi,* 13 August 1869 (ancient Greece); Brès, *Le Palais de Longchamp,* p. 9 (Renaissance); *Nouvelliste,* 13 August 1869 (French Renaissance); on eclectic architecture, Agulhon et al., *La ville,* pp. 189–191; Hauteceour, *La fin de l'architecture classique,* pp. 135–205.

74. Barthes, *Mythologies,* pp. 199–213.

75. *Courrier de Marseille,* 15 August 1869; *Gazette du Midi,* 13 August 1869.

76. On the fence, AMM, 101 M 1, CM Extrait, 4 November 1866, comments of Martin, and *Gazette du Midi,* 13 August 1869; on Barye sculptures, ibid. and Brès, *Le Palais de Longchamp,* p. 18.

77. *Le sémaphore de Marseille,* 29 July 1869. All of the newspapers and pamphlets provide some description of the statuary; the most detailed are in Parrocel's articles in the *Nouvelliste,* 13 and 14 August 1869, and in his later book, *L'art dans le Midi,* 4:57–60, as well as in Brès, *Le Palais de Longchamp,* pp. 11–18, who comments on the symbolism of the horn of plenty. For a similar but more elaborate reading of this symbolism, see Denise Jasmin, "Le Palais Longchamp et ses images," *Provence historique* 31 (1981): 223–235.

78. *Courrier,* 16–17 August 1869; on liters per second, see Brès, *Le Palais de Longchamp,* p. 10; *Gazette du Midi,* 13 August 1869. On the centrality of

the château d'eau, AMM, 101 M 1, CM Extrait, 7 April 1862: "Since the arrival of the waters of the Durance should be the dominant subject, the principal motif of this great project . . ."; *Le sémaphore de Marseille,* 29 July 1869.

79. There are a number of brief but informative articles, generously illustrated, on water supply, water towers, and fountains in the issue of *Monuments historiques* devoted to "L'eau douce": no. 122 (August–September 1982); see particularly Dominique Jarassé, "La ville et les jeux d'eaux au XIXe siècle," pp. 74–77, with a reference to and a photograph of the Palais de Longchamp.

80. *La Gironde,* 23 June 1881, 27 May 1875; on the eighteenth century in Bordeaux's collective memory, Higounet, ed., *Histoire de Bordeaux,* p. 255.

81. ADSM, 2 OP 1538/52, Report, Commission d'Architecture de la Seine-Inférieure, 30 June 1876; speech of Barrabé, mayor, reprinted in *Journal de Rouen,* 20 February 1880.

82. On the plans, see Pelleport-Burète's speech, *La Gironde,* 27 May 1875; on the busts constructed, Pinçon, "La construction," pp. 93–94.

83. On the sculptural program, ADSM, 2 OP 1538/52, CM Extrait, 12 April 1878; on removal of the Flaubert bust, CMR, 24 July 1908, p. 248.

84. There are letters protesting the lack of commissions for local sculptors in the *Petit rouennais,* 13 May 1882 and 7 June 1882; for a similar comment on the Marseilles commissions, see Parrocel, "Le Palais de Longchamp II," *Nouvelliste de Marseille,* 13 August 1869. On the standardization of the ancillary sculpture, see, for example, ADSM, 2 OP 1538/52, contract bid of Benjamin Guilloux, 28 January 1879, for interior ornamentation.

85. An earlier, influential, example was Henri Labrouste's Bibliothèque Sainte-Geneviève in Paris, completed in 1850, though the idea for such inscriptions went back to Boullée and others in the late eighteenth century: see Neil Levine, "The Romantic Idea of Architectural Legibility: Henri Labrouste and the Neo-Grec," in Arthur Drexler, ed., *The Architecture of the Ecole des Beaux-Arts* (New York: Museum of Modern Art, 1977), pp. 325–357. The Palais de Longchamp bears a certain superficial resemblance to the Sainte-Geneviève, not only in the inscriptions but in the disposition of the interior stairways, but it lacks Labrouste's assertive formula expression of structure.

86. Brès, *Le Palais de Longchamp,* p. 20, describing the stairway: "the approach of an artistic sanctuary"; *Petit rouennais,* 20 February 1880: "we have a fine temple." On the symbolism of museum spaces, see Duncan and Wallach, "Universal Survey Museum," pp. 448–469.

87. See Pincon, "La construction," p. 92.

88. AMB, 1440 R 1, Vallet to Maire, 25 March 1881.

89. On Puvis, see *Puvis de Chavannes 1824–1898,* catalogue of an exhibi-

tion at the Grand Palais, Paris, and the National Gallery of Canada, Ottawa, 1976–1977 (French and English versions; further references to the French), and Richard J. Wattenmaker, *Puvis de Chavannes and the Modern Tradition*, rev. ed., catalogue of an exhibition at the Art Gallery of Ontario, Toronto, 1975; Jacques Foucart-Banville, *La génèse des peintures murales de Puvis de Chavannes au Musée de Picardie*, Annales du Centre Régional de Documentation Pédagogique d'Amiens (Amiens: C.N.D.P., 1976).

90. Brès, *Le Palais de Longchamp*, pp. 20–21; Parrocel, in *Nouvelliste de Marseille*, 15 August 1869, and reprinted, with additions, in *L'art dans le Midi*, 4:109–115. Parrocel describes the initial critical reaction, but see also *Puvis de Chavannes*, pp. 97–98.

91. ADSM, 4 T 219, Extrait des procès-verbaux des délibérations du Conseil Général de la Seine-Inférieure, April 1889: "une place magistrale parmi les peintres qui se livrent aux travaux décoratifs."

92. CMR, 17 February 1888, pp. 55–56.

93. On the importance of stillness in Puvis's art, see the influential comments of George Heard Hamilton, *Painting and Sculpture in Europe 1880–1940*, Pelican History of Art (Baltimore: Penguin, 1967), pp. 45–46.

94. The decorative program in the Lyons museum, completed in 1886, similarly and explicitly links an idealized vision of art with specific references to the modern city: see *Puvis de Chavannes*, pp. 193–196.

95. Pierre Vaisse discusses the Toulouse program in detail in his "Troisième république."

96. On Puvis de Chavannes as "peintre de *mur*," see Jacques Foucart, "Préface," in *Puvis de Chavannes 1824–1898*, pp. 18–20.

97. Félix Jahyer, "Salon de 1869 (Suite)—La Peinture," *Tribune* 13 (1869): 60.

98. Parrocel, *L'art dans le Midi*, 4:108; *Nouvelliste de Rouen*, 19 February 1880.

99. On the concept of cultural encoding and the idea of the code as class-based, see Bourdieu, *La distinction*, pp. i–viii.

100. Museum and city officials, moreover, consistently distinguished in the late nineteenth century between detailed, scholarly, descriptive catalogues and more summary "catalogues de vulgarisation," essentially checklists, destined for a wider public, from which such material as Puvis's explanation of the Lyons mural program would likely be excluded. See, for example, the discussion in the Rouen city council, CMR, 21 December 1888, pp. 861–862.

101. The classic fictional example, the wedding party's visit to the Louvre in Zola's *L'assommoir*, comes to mind in this context: *Oeuvres complètes*, ed. Henri Mitterand, 15 vols. (Paris: Cercle du Livre Précieux, 1966–1969), 3:657–660. But the Louvre was not designed as a museum, and its intimidating qualities derive in large part from its labyrinthine

layout and colossal size, and only secondarily from elements deliberately conceived in the design of the museum.

6. The Museum and the Institution of Culture, 1870–1914

1. Douglas, *How Institutions Think,* p. 98; AMB, 1435 R 2, Reports of 17 October 1890 and 3 December 1894.

2. R. Moulin, "Champ artistique et société industrielle capitaliste," in *Science et conscience de la société: Mélanges en l'honneur de Raymond Aron,* 2 vols. (Paris: Calmann-Lévy, 1971), 2:194.

3. Barthes, *Mythologies,* pp. 230–233; CMB, 24 April 1903, p. 119, comments of Lauga. See also AMB, 1438 R 1, CM Extrait, 15 May 1891, report of Beaudin on an exhibition purchase, referring to the committee's discussions as much more "du domaine de l'art que du domaine adminis-tratif"; 1438 R 3, CM Extrait, 12 March 1901, comments of Lauga similar to those in 1903.

4. MM, NS/C 1850–1871, Decree of 12 July 1871, which also contains list of members; AMB, 1438 R 1, report of Sourget, *adjoint,* 27 January 1875.

5. Dates of founding of advisory committees: Marseilles 1871 (following the appointment of an ad hoc committee on installation in 1869), Bordeaux 1874, Rouen 1879. On composition of the commissions, see, e.g., RBM, June 1896, p. 88, May–June 1900, p. 60; AMB, 1438 R 3, Procès-Verbal de la Commission Consultative, 25 March 1902.

6. AMD, 4 R I, DNC/CC 1880–1890, Mazeau, Conseiller Municipal, to Maire, 26 June 1888, and Gleize, Conservateur, to Maire, 30 June 1888; CMB, 30 March 1904, pp. 140–141.

7. MD IX, Thévenot to Joliet, Conservateur, 29 December 1894 (year unclear); on Darcel's role, see CMR, 30 November 1883, pp. 680–681; "Extrait du rapport général sur les services municipaux pendant l'année 1889," 1 May 1890, p. 379; "Extrait du rapport . . . 1890," 1 May 1891, p. 426; 5 June 1891, pp. 472–473.

8. On procedures in Marseilles, AMM, 57 R 5, 22 August 1876, Con-servateur to Maire, and 22 November 1876, Jules de Magy to Maire; de Magy was an artist disgruntled with the slowness of the procedures. Bouillon-Landais's complaint about the committee and proposal to abolish it are in MM, NS/C 1881–1884, Conservateur to Maire, 16 December 1882. On the earlier battle see MM, NS/C 1850–1871, copy of a letter from Rougemont to Maire, 24 March 1864, with later marginalia in Bouillon-Landais's hand: "I had all of that [the old lines of authority] done away with in 1870 because it would have meant the complete annihilation of the museum and the curator—it is in the curator's interest to defend the position he occupies and to extend its prerogatives."

9. Biographies of Guigou (1865–1896, curator 1894–1896) and Auquier (1863–1908, curator 1896–1908) in Masson, ed., *Les Bouches-du-Rhône*, 7:35–36, 255–256; on Guigou's work as a critic, AN, F²¹ 4512, Préfet Bouches-du-Rhône to Ministre, 30 April 1894. Cabrit's appointment in 1899 culminated a competition so intense and politically delicate that the mayor left the choice between three finalists to the fine arts director; see file in AN, F²¹ 4511. On his social activities, quarterly reports in AMB, 1435 R 2.

10. On the Joliets, see Quarré, "Musée de Dijon," pp. 155–156. The minutes of the Dijon commission are in MD VI (1892–1927) and AMD, 4 R I 3–4; Joliet set the agenda for the meetings, and commission members rarely voiced any objections to his proposals.

11. Two city councillors in Bordeaux, Baysselance and Duc, made suggestions to this effect in 1886 and 1889: CMB, 2 July 1886, p. 103; AMB, 1438 R I, CM Extrait, 21 May 1889.

12. CMR, 12 August and 9 December 1887, pp. 578–580, 802–809. The other association, the Société des Amis des Arts, bitterly opposed this decision, largely because its own activities focused exclusively on exhibition purchases. Its deliberations for the period are in BMR, MSS. mm 107.

13. CMR, 9 December 1887, p. 808; 12 August 1887, p. 579.

14. CMR, 9 December 1887, pp. 805–806.

15. CMR, 10 February 1893, pp. 80–82.

16. Press criticism of the official Rouen salon: *Petit rouennais,* 30 September 1891, 14 May 1903; *Dépêche de Rouen et de la Normandie,* 9 June 1909; favorable comments on other exhibitions, including dealers' shows: *Journal de Rouen,* 10 December 1895, 18 December 1897, 14 June 1903; *Dépêche,* 27 November and 17 December 1909. The city's decision to leave the organization of the local salon to the Société des Amis des Arts is in CMR, 14 April 1899, pp. 120–121; the only exhibition under this regime took place in 1903. On the city's resumption of responsibility for the salon, CMR, 29 December 1905, pp. 475–476; despite a hefty municipal subsidy, the exhibition left the association with a deficit of over 2,300 francs (see minutes for general meeting of 5 June 1905, BMR, MSS. mm 107).

17. AMB, 1438 R 3, CM Extrait, 30 March 1898.

18. Ibid.

19. Ibid.; AMB, 1438 R 3, CM Extrait, 12 March 1901; the first work purchased at another exhibition was the not very radical *Salon of Marie Antoinette, Versailles* by Maurice Lobre, bought at the salon of the Société d'Artistes Girondins: see AMB, 1438 R 3, CM Extrait, 5 January 1900. On later purchases at the exhibition of an artists' group called "L'Atelier," CMB, 11 May 1906, pp. 102–103; 27 March 1908, p. 107.

20. Douglas, *How Institutions Think,* p. 108.

21. AMB, 1438 R I, reports of Sourget, of Faget, and of Commission

Consultative, 27 January 1875. *La Gironde* also praised the Luminais, 23 April 1875.

22. *Journal de Rouen,* 7 October 1880; AMB, 1438 R 1, Vallet to Maire, 3 April 1885; Auguin to Soulé, *adjoint,* 3 April 1887.

23. AMB, 1438 R 1, clipping from *Courrier de la Gironde,* date not given.

24. *Journal de Rouen,* 4 October 1897; *Petit rouennais,* 2 October 1897.

25. AMB, 1438 R 3, clippings from *La Gironde,* 31 March 1903, and *La république nouvelle,* 15 April 1903, whence the citation; CM Extrait, 8 July 1902, as well as various other correspondence and press clippings. *Danaë* was not an especially large painting (100 by 127 centimeters, roughly three and a quarter by four feet), but it was nonetheless larger than most paintings the city was buying at the time.

26. AMB, 1438 R 1, Vallet to Maire, 4 October 1890. Press comments from unidentified clipping in the same file.

27. AMB, 1438 R 3, CM Extraits, 25 March and 3 April 1892.

28. See *Petit rouennais,* 7 November 1897 (referring to Fréchon specifically as an impressionist); *Journal de Rouen,* 25 May 1903. Dubosc also used this article to praise Fréchon in terms similar to those employed in the earlier *Petit rouennais* article.

29. On the Puget collecting policy, AN, F^{21} 2275, Auquier to Sous-Secrétaire d'Etat des Beaux-Arts, 15 May 1905; on plans to devote a room to the display of Puget works, AMM, 57 R 5, Conservateur to Maire, 22 September 1877; offers of sale of purported Puget sculptures, in MM, NS/C 1881–1884.

30. On Rude and his *Hebe,* see Peter Fusco and H. W. Janson, eds., *The Romantics to Rodin: French Nineteenth-Century Sculpture from North American Collections,* catalogue of an exhibition at the Los Angeles County Museum of Art, the Minneapolis Institute of Arts, the Detroit Institute of Arts, and the Indianapolis Museum of Art, 1980–1981, no. 213, pp. 351–356; on Dijon's acquisition of works by Rude, AN, F^{21} 2242, Maire de Dijon to Directeur des Beaux-Arts, 24 March 1891; on the Prud'hon portrait, ADCdO, 33 T 4a, CM Extraits, 8 and 16 March 1882.

31. On purchases of prints by Drouyn, see especially AMB, 1438 R 1, CM Extrait, 30 November 1888; on his work in general, Frédérique Portelli-Zavialoff, *Léo Drouyn 1816–1896: Dessins-Gravures-Peintures,* catalogue of an exhibition at the Archives Municipales de Bordeaux, 1973.

32. On Delacroix as effective native son, see SAB *CR* 1851–1852, p. 5; on *The Lion Hunt,* Bordeaux 1881, p. 148; AMB, 1438 R 1, Vallet to Soulé, *adjoint,* 7 June 1886.

33. On acquisitions of Géricault, CMR, 12 May 1876, pp. 282–284, 24 July 1908, p. 427; Comité Consultatif des Beaux-Arts, Séance, 4 June 1901, RBM, May–June 1901, pp. 48–49.

34. AMB, 1436 R 1, Vallet to Maire, 18 August 1890; 1435 R 2, report of Cabrit, 10 March 1900.

35. AMB, 1436 R 1, Leroi to Maire, 5 October 1888. There are examples of Rothschild gifts in AMD, 4 R I, DNC/CC 1891–1892, Leroi to Maire, 11 October 1891 (including the Rodin); MM, NS/C 1893–1894, copy by Guigou of letter from Leroi, 30 July 1894; CMR, 7 October 1892, p. 779, 11 August 1893, pp. 661–662, 12 October 1894, p. 392, 18 October 1895, p. 419, 24 July 1896, p. 310.

36. AMB, 1435 R 2, report of Vallet, 7 July 1893.

37. On conditions of the Trimolet bequest, ADCdO, 33 T 4a, CM Extraits, 10 October 1878 and 21 July 1882, and the collection inventory, AMD, 4 R I 2; see also Quarré, "Musée de Dijon," pp. 161–162, and Joseph Comyns Carr, *Art in Provincial France: Letters Written during the Summer of 1882 to the Manchester Guardian* (London: Remington, 1883), pp. 118–121. On the Grangier Collection, MD V, "Rapport du Conservateur du Musée, Année 1907."

38. CMR, 5 June 1891, pp. 472–473 (on Loutrel gift); RBM, April–May 1898, p. 76; *Journel de Rouen,* 20 December 1897 and 26 April 1898 (on the Marjolin-Scheffer collection); on the Dutuit family, see Chaline, *Bourgeois de Rouen,* pp. 110–114, 234–238.

39. Depeaux to Maire, 24 May 1909, cited in CMR, 28 May 1909, p. 210. See also *Dépêche de Rouen et de la Normandie,* 29 May 1909.

40. RBM, October–November 1909, pp. 138–139 (includes biographical information on Depeaux). On the opening ceremonies, see also *Journal de Rouen,* 14–15 November 1909; *Dépêche de Rouen et de la Normandie,* 14 November 1909.

41. CMR, 27 July 1877, p. 515, comments of Loiseau.

42. AMM, 57 R 5, Conservateur to Maire, 14 July 1873: "Nos collections doivent tendre à s'épurer"; AMB, 1440 R 2, report of Vallet on the new museum installation, 3 August 1878, suggesting a gradual "épuration" (purge) as conditions dictated; 1435 R 2, quarterly report, 7 December 1892, indicating that an effective purge had taken place.

43. See, on this point, the well-documented article by Dominique Poulot, "L'invention de la bonne volonté culturelle: L'image du musée au XIXe siècle," *Le mouvement social,* no. 131 (April–June 1985), especially pp. 46–47, 62–64.

44. [P.] Bouillon-Landais, *Coup d'oeil sur le Musée de Marseille* (Marseilles: H. Seren, 1867), p. 4.

45. *Journel de Rouen,* 20 February 1880.

46. CMR, 27 July 1877, p. 515; AMB, 1435 R 2, Rapport trimestriel, 5 December 1891; CMB, 9 May 1911, p. 152, report of Lamargue.

47. Crow, *Painters and Public Life,* p. 5; emphasis in original.

48. MM, NS/C 1850–1871, minutes of meeting of 2 July 1869; AMB, 1440 R 2, report of Vallet, 3 August 1878.

49. *Journal de Rouen,* 19–20 February 1880.

50. AMB, 1440 R 2, report of 3 August 1878.

51. 19–20 February 1880, passim. Bouillon-Landais anticipated a space of about ten centimeters, or approximately four inches, between paintings (*Coup d'oeil,* p. 14); Jules Adeline observed that the Rouen installation helped to show the works to advantage inasmuch as "the frames do not touch" (*Nouvelliste de Rouen,* 19 February 1880).

52. AMD, 4 R I, DNC/CD 1898–1903, Joliet to Maire, 15 June 1903; AMB, 1440 R 2, report of 3 August 1878.

53. *Journal de Rouen,* 19 February 1880.

54. AMB, 1440 R 2, report of 3 August 1878.

55. Bouillon-Landais, *Coup d'oeil,* pp. 13–15; *Journal de Rouen,* 19 February 1880.

56. *Journal de Rouen,* 19 February 1880; AMB, 1440 R 2, report of 3 August 1878.

57. *Journal de Rouen,* 19 February 1880.

58. Installations reconstructed from the accounts of Darcel in the *Journal de Rouen,* 19–20 February 1880, and of Adeline in the *Nouvelliste de Rouen,* 19 February 1880, which also contains floor plans.

59. *Journal de Rouen,* 20 February 1880.

60. Ibid.; *Nouvelliste de Rouen,* 19 February 1880.

61. MM, NS/C 1850–1871, draft notice in Bouillon-Landais's hand, 26 May 1870; NS/C 1872–1876, Conservateur to Maire, 3 January 1873; AMM, 57 R 5, Conservateur to Maire, 20 December 1876; AMB, 1435 R I, report of Vallet, 17 July 1882.

62. AMD, 4 R I, DNC/CC 1881–1890, CM Extrait, 4 December 1885; Gleize to Maire, 15 February 1886.

63. MD V, "Rapport du Conservateur du Musée, année 1899." Joliet mentioned the gradual placement of labels in his annual reports for 1895, 1896, and 1897, then virtually every year from 1900 on.

64. *Nouvelliste de Rouen,* 19 February 1880.

65. On this division as a commonplace in nineteenth-century conceptions of the museum, and its reflection in various texts, notably catalogues, see Poulot, "L'image du musée," pp. 57–59.

66. MM, NS/C 1872–1876, Econome de la Ville to Maire, 14 May 1872; on the cleaning schedule, AMM, 57 R 5, Conservateur to Maire, 18 May and 5 July 1870; AMB, 1431 R 2, Conservateur to Maire, 6 April 1881.

67. MM, NS/C 1893–1894, Conservateur to Maire, 2 June 1894. In the same dossier there is a letter from Bouillon-Landais to his successor, dated 9 July 1894, expressing his concern about cleanliness and also about safety,

saying that the hanging of the pictures required regular checking to prevent them from falling on visitors' heads!

68. MM V, "Rapport du Conservateur," 1898; "Rapport . . . année 1904."

69. MM V, "Rapport du Conservateur du Musée sur sa gestion (Année 1895)."

70. ADCdO, 33 T 3, Ville de Dijon, "Règlement sur la Police Intérieure du Musée de Dijon," 18 October 1887; Rouen, "Règlement de Police Intérieure du Musée de Peinture," reprinted in *Journal de Rouen,* 5 May 1881.

71. AMB, 1431 R 2, Vallet to Maire, 6 April 1881 (draft *règlement* marked up to reflect final version); ADBdR, 4 T 50/VI, "Extrait des Registres des Arrêtés de la Ville de Marseille," 11 April 1870.

72. Dijon Règlement 1887; Rouen Règlement 1881; AMB, 1431 R 2, Draft, 6 April 1881.

73. MD IX, Joanne to Joliet, 20 November 1899; also letters of 23 March 1895, 2 November 1899, and 5 November 1901, and replies.

74. Dominique Poulot, "La visite au musée: Un loisir édifiant au XIXe siècle," *GBA,* 6th ser., 101 (January–June 1983): 188–190.

75. CMR, 28 July 1882, p. 454.

76. AMD, 4 R I, DNC/CC 1893–1897, Charles Masson to Maire, 13 October 1894.

77. Ibid., draft of reply from Maire by Joliet, 18 October 1894; the questionnaire and responses are in MD XIV.

78. Cf. Douglas, *How Institutions Think,* p. 76: "Too much interpretation can be put upon positive statements about what behavior is most honored. Much clearer evidence comes from studying aversion. The rules for avoiding reprehensible behavior and purifying after disapproved contact are more clearly known and easier to elicit . . . Institutional influences become apparent through a focus on unthinkables and unmemorables, events that we can note at the same time as we observe them slipping beyond recall."

79. Gay, *Bourgeois Experience,* 1:379–399, especially pp. 379–382.

80. Recorded in *CMP,* p. 20; cited in Zeldin, *France 1848–1945,* 2:451. For some appropriately trenchant comments on the misleading uses to which Zeldin puts this example, see Poulot, "L'image du musée," p. 36.

81. AN, F[21] 4516, report of Tronchet, 1902; Marx to Directeur des Beaux-Arts, 12 September 1907, draft for Directeur to Tronchet, 16 September 1902. Marx may have been thinking only of Vaucouleurs, which is also in Lorraine.

82. AMB, 1438 R 1, Vallet to Maire, 14 May 1882. On the Antigna, see Chapter 4, note 78.

83. AMD, 4 R I, DNC/CC 1871–1880, Gleize to Maire, 13 January 1879.

84. *Nouvelliste de Rouen,* 5 October 1882; *Journal de Rouen,* 6 October 1882.

85. Berger, *Ways of Seeing,* pp. 11, 45–64.

86. AMM, 57 R 5, Conservateur to Maire, 18 March 1876 (draft in MM, NS/C 1872–1876), 28 August 1878.

87. AMM, 57 R 5, Conservateur to Maire, 6 December 1875 (draft in MM, NS/C 1872–1876).

88. MM, NS/C 1889–1892, "Amateur" to Conservateur, 30 May 1890. "Bordelle" is now a common French term for a situation of complete disorder; the ellipsis in the original ("ce sera un B . . .") suggests that the writer may have been thinking of the word's original meaning.

89. CMR, 3 June 1881, p. 338; AN, F^{21} 2236, Maire to Directeur, 23 October 1897.

90. *CAC,* 7 September 1907, p. 277; 12 September 1908, p. 305; 19 October 1907, p. 301.

91. MM, NS/C 1893–1894, Léonce Bénédite, Conservateur Luxembourg, to Guigou, 14 July 1894, offering advice on security measures following a theft in the museum; MD V, annual reports for 1900 (asking for a study of security measures), 1901 (requesting two additional guards), 1905–1906 and 1907 (installation of burglar alarms), 1911 (modifications to French windows).

92. ADCdO, 33 T 3, Dijon Règlement 1887, art. 10; ADBdR, 4 T 50/VI, Marseille Règlement 1870, art. 9; AMB, 1431 R 2, Draft Règlement 1881.

93. AMB, 1435 R 2, report of 12 February 1899, first summarizing the new regulation.

94. See, for example, an editorial in *CAC,* 16 December 1905, p. 325, criticizing an artist for taking up too much space while painting in the Louvre, although the journal was at pains not to generalize from this case.

95. ADCdO, 33 T 3, Dijon Règlement 1891, art. 7, requiring a five centime fee (previous *règlements* did not mention a fee); *Journal de Rouen,* 5 May 1881, Rouen Règlement 1881: fee and optional except for wet umbrellas.

96. MM, NS/C 1881–1884, Conservateur to Maire (draft), 10 December 1881.

97. AMB, 1431 R 2, Maire adjoint to Conservateur, 13 December 1881; clipping from *Petite Gironde,* 6 November 1888.

98. CMR, 8 July 1881, p. 423. The subject also came up briefly in the session of 23 April 1880, p. 257.

99. *Petit rouennais,* 5 June and 15 October 1882.

100. AN, F^{21} 2223, E. Brunel to Ministre, 18 August 1887; reply from Directeur des Beaux-Arts, 23 August 1887.

101. *Petit rouennais,* 5 June 1882.

102. 50, rue d'Ernemont; see Chaline, *Bourgeois de Rouen,* p. 168.

103. René-Marie Cazals, *Essai historique, anecdotique sur le parapluie, l'ombrelle et la canne, et sur leur fabrication* (Paris, 1844), pp. 32–33; L. O. Uzanne, *Les ornements de la femme: L'éventail–l'ombrelle–le gant–le manchon,* Petites Monographies d'Art (Paris: Librairies-Imprimeries Réunies, 1892; orig. pub. 1883), pp. 179–190 (also discusses men's umbrellas); T. S. Crawford, *A History of the Umbrella* (Newton Abbot: David and Charles, 1970), pp. 136–142, 162–163. Both Uzanne and Crawford cite the anonymous 1841 tract *Physiologie du parapluie par deux cochers de fiacre* as seminal in the identification of umbrellas with social status; among other things, it called for the abolition of checkroom fees.

104. Zola, *Oeuvres complètes,* ed. Henri Mitterand, 15 vols. (Paris: Cercle du Livre Précieux, 1966–1969), 3:657–660.

105. L. O. Uzanne, *Fashion in Paris: The Various Phases of Feminine Taste and Aesthetics from 1797 to 1897,* trans. Mary Lloyd (London: Heinemann, 1897), passim; *Grand dictionnaire universel du XIXe siècle,* 17 vols. (Paris: Larousse, 1866–1877), 12:198.

106. Crozier, *Bureaucratic Phenomenon,* pp. 210–227, 237–238.

107. AMB, 1431 R 2, Conservateur to Maire, 13 November 1888; CMR, 14 November 1890, p. 921, 13 February 1891, p. 54.

108. AMD, 4 R I, DNC/CC 1891–1892, CM Extrait, 27 June 1890; MD XII, "Rapport sur la question des entrées payantes au musée de Dijon," 19 February 1904.

109. Actually the museum in Evreux (Eure) had since 1881 charged a fee of fifty centimes, except for Sundays all year and Thursdays from April to October, but it was a relatively unimportant museum, and this measure attracted little attention. A copy of its 1881 *règlement* is in MD XII.

110. The estimate for 1904 was derived as follows: 6,139 (the actual number of paid admissions from April 16 through the end of the year) divided by 8.5 (number of months under the system), multiplied by 12, result 8,667. The actual figure for the complete year 1906 was 7,176.

111. AMM, 57 R 5, Conservateur to Maire, 11 December 1875; MM, NS/C 1893–1894, Conservateur to Maire, 2 June 1894; AMB, 1435 R 2, report of Cabrit, 25 January 1903; MD V, "Rapport . . . 1901."

112. AN, F²¹ 4512, report on Grenoble; F²¹ 4513, report on Perpignan; F²¹ 4514, report on Toulon.

113. Statements on the purposes of admission fees can be found in CMR, 25 March 1898, pp. 63–64 (keeping the museum open seven days a week); minutes of Comité Consultatif meeting, 5 May 1899, in RBM, April–May 1899, pp. 61–62 (new acquisitions); MD XII, CM Extrait, 15 March 1904, pp. 134–138 (guards' salaries, additional guards, maintenance).

114. MD XII, CM Extrait, 15 March 1904, pp. 134–138; also "Rapport

sur la question des entrées," 19 February 1904, and Conservateur to ?, 18 November 1899, when the proposal first came up.

115. CMR, 17 December 1897, pp. 538–540.

116. MD XII, CM Extrait, 15 March 1904, pp. 136–137; CM Extrait, 23 March 1904, pp. 150–151.

117. MD XII, "Rapport sur la question," 19 February 1904.

118. AN, F²¹ 4513, Ministre Instruction Publique et Beaux-Arts to Ministre Intérieur, undated draft (early-mid February 1898).

119. CMR, 25 March 1898, pp. 63–64; minutes of Comité Consultatif, 31 October 1898, in RBM, October–November 1898, p. 183.

120. MD XII, Conservateur to Maire, 18 November 1899; MD V, "Rapport du Conservateur du Musée—Année 1903."

121. *Journal de Rouen*, 16 December 1897.

122. CMR, 25 March 1898, p. 63.

123. CMR, 17 December 1897, p. 538: "All of us occasionally receive friends from the country. Now, when they come to Rouen, we often take them to the museum"; MD V, CM Extrait, 15 March 1903, p. 137: "A goodly number of Dijon families bring friends or relatives to the museum on days it is not open to the public."

124. *CAC*, 27 January 1907; 11 November 1907.

125. MD XII, letters from Conservateurs, 1904–1907, Musée Historique Lorrain, Nancy; Musée Calvet, Avignon; Muséum d'Histoire Naturelle, Marseille; Conservateur Grenoble to Joliet, 8 November 1904.

126. Poulot, "La visite," p. 195. In his later article, "L'image du musée," pp. 49–53, Poulot offers several additional visit "types," including the "often repeated . . . cultural visit" as well as "regular attendance" for professional and scholarly purposes, but these could reasonably be assimilated to his two basic categories. Though it is impossible to determine precisely the relative importance of each kind of visit, Poulot's reliance on anecdotal information may have led him to underestimate the numerical weight of regular casual visitors.

127. AMB, 1435 R 2, reports of Cabrit, 10 July 1903 (fair day), 10 March 1900, 27 April 1905, 21 October 1906 (school groups); AMD, 4 R I, DNC/CD 1898–1903, J. Trémeau, Ecole des Filles, Autun, to Conservateur, 12 July 1901; 4 R I, DNC/CD 1904–1910, Econome, Lycée Carnot to Conservateur, July 1907 (school groups); MM, NS/C 1889–1892, Maire Adjoint to Conservateur, 21 August 1889 (Algerians), NS/C 1893–1894, Conservateur to Maire, 30 September 1893 (Russians).

128. Poulot, "La visite," pp. 193–195, discusses the presence of the "new middle class" and democratization, the latter with respect to "musées cantonaux," overtly pedagogical small-town museums founded during the Third Republic. These were very different in character and in purpose from

the major municipal museums, and their collections were not confined to the fine arts.

129. AMB, 1435 R 2, report of Cabrit, 10 March 1900; 19 April 1901.

130. *Journal de Rouen*, 14 November 1909.

131. See, for example, the critical comments of the philosopher Nelson Goodman, "The End of the Museum?" in his *On Mind and Other Matters* (Cambridge, Mass.: Harvard University Press, 1984), pp. 174–187.

132. Jean-Paul Sartre, *La nausée,* Collection Folio (Paris: Gallimard, 1972, orig. pub. 1938), pp. 120, 129–130.

Conclusion

1. J.-K. Huysmans, *L'oblat* (Paris: Plon, 1911, orig. pub. 1903), p. 220.

2. On the curators' association and on expanded tourism, see Fernand Guey, "Origine et destinée des musées de province," *Cahiers de la république des lettres, des sciences, et des arts,* no. 13 (1931): 330. Guey was at the time curator of the Rouen museum.

3. See Guey, "Origine et destinée," pp. 330–332; Quarré, "Musée de Dijon," pp. 166–168.

4. On the ordinance of 13 July 1945, see Georges Poisson, *Les musées de France,* 3rd ed., Que sais-je? 447 (Paris: Presses Universitaires de France, 1976), pp. 12–14.

5. The 1984 law on decentralization, part of a whole package of reform legislation implemented by the socialist governments of the day, abolished the category of *musée classé* but not the status of their curators, who are chosen by mutual agreement of the Direction des Musées de France and the city concerned. Cities are responsible for the salaries of additional curators and the rest of the museum's salary and operation expenses.

6. This summary is based on my consultation of correspondence between the Directeur des Musées de France, the mayor of Rouen, and the Rouen curator in the "collections" files of the Musée des Beaux-Arts, Rouen.

7. For a more detailed survey of recent state cultural policy, with particular attention to the effects of decentralization, see Erhard Friedberg and Philippe Urfalino, "La décentralisation culturelle au service de la culture nationale," in *Sociologie de l'art: Colloque international, Marseille, 13–14 juin 1985* (Paris: Documentation Française, 1986), pp. 11–21.

8. On recent exhibitions of contemporary art in Europe, see Jean-Marc Poinsot, "Les grandes expositions: Esquisse d'une typologie," *Cahiers du Musée national d'art moderne,* nos. 17–18 (1986): 122–146.

9. The pioneering work of this kind, to which I do not mean my strictures to apply, is, of course, Pierre Bourdieu and Alain Darbel, *L'amour de*

l'art: Les musées d'art européens et leur public, 2nd rev. ed. (Paris: Minuit, 1969); on the limitations of more recent surveys, see the analysis of Nathalie Heinich, "La sociologie et les publics de l'art," in *Sociologie de l'art,* pp. 267–278.

10. Harris, "Gilded Age Revisited," pp. 545–564; Paul J. DiMaggio, "Cultural Entrepreneurship in Nineteenth-Century Boston: The Creation of an Organizational Base for High Culture in America," *Media, Culture and Society* 4 (1982): 33–50; Zolberg, "Tensions of Mission in American Art Museums," p. 184.

11. For insight into this trend, see Brian Wallis, "Institutions Trust Institutions," and Hans Haacke, "Museums, Managers of Consciousness," in Wallis, ed., *Hans Haacke: Unfinished Business* (New York and Cambridge, Mass.: New Museum of Contemporary Art and M.I.T. Press, 1986), pp. 50–59, 60–72.

Index

Italic type indicates page on which illustration appears.

About, Edmond, 272n24

Academicism, 48–49, 147

Acquisitions, joint (state-municipal), 43, 199–200, 281n122

Acquisitions, municipal: and local elites, 94, 210–211; at local exhibitions, 134, 195–198; practices, 137–140, 143–145, 193, 195–197; character of, 147–152, 198–202, 202–205; purposes of, 152, 196, 198, 210–211, 241. *See also* Donations; Museum picture, concept of

Acquisitions, state: practices, 18–20, 269n9, 309n76; character of, 45, 52–53. *See also* Cultural policy, state; Envois; Envoi system; Salons, Paris

Adeline, Jules, 190, 216, 217–218

Administration. *See* Advisory committees; Bureaucracy; Curators; Regulations, museum

Admission: hours, 117–118, 230, 232, 302n78; fees, 229–230, 232–235, 241

Advisory committees, 140, 193–194, 212

Alaux, Jean, 143

Amateurs, 123, 131; defined, 115; and municipal acquisitions, 151–152, 193

Amiens: Musée de Picardie, 75, 185

Angrand, Charles: *The Rouen Museum in 1880*, 213, *214*, 215

Annuaire des artistes et des amateurs, 131

Antigna, Jean-Pierre Alexandre, 143; *Mirror of the Woods*, *148*, 149, 151, 221

Architecture. *See* Museums: buildings

Art associations, 132–135. *See also* Exhibitions, provincial; *and specific cities*

Art education: as purpose of museums, 18, 106, 109, 211–212; as state objective, 59, 64; art schools, linked to museums, 109–110, 115, 123–124

Art en province, L', 5

Art market, 141; and state policy, 41, 46–47; expansion of, and provincial exhibitions, 131, 134. *See also* Acquisitions *entries;* Salons, Paris

Artists: and museum officials, 111, 114; as museum public, 130, 225–226; and provincial exhibitions, 135–136, 141; local ties to museums, 202–205. *See also* Curators

Aubert, Augustin, 109, 110, 111, 113, 114, 139

Auguin, Louis, 198

Auquier, Philippe, 36, 194

Avant-garde. *See* Cultural policy, state

Avignon: Musée du Petit Palais, 243, 273n37

Aynard, Edouard, 47, 88

Baignières, Arthur, 60, 69

Ballu, Roger, 276n62

Bardoux, Agénor, 55, 59, 285n35

Barrabé, Alexandre, 167

Barthes, Roland, 5, 10, 177–179, 193

Bartholdi, Auguste, 162, 163, 182, 183

Barye, Antoine Louis, 134, 179, 190
Bayard de la Vingtrie, J.-M., 70–71
Benner, Emmanuel: *Bathers, 222,*
 222–223
Berger, Georges, 64–65
Berger, John, 2, 223
Bernex, Théodore, 161, 164, 165, 173
Bibliothèque Sainte-Geneviève (Paris),
 318n85
Blanc, Charles, 23, 33, 131–132
Bonheur, Auguste: *Souvenir des Pyré-
 nées,* 152
Bonheur, Rosa, 203
Bordeaux: Société des Amis des Arts,
 132, 133, 134, 145, 151, 197; social
 and urban development of, 157–158,
 159, 174; exhibitions, 321n19
Bordeaux, Musée des Beaux-Arts de:
 envois to, 30–31, 36, 42, 105; condi-
 tions in, 77, 111–112, 113, 119, 155;
 origins and early years of, 101, 105,
 107–108; collections of, 102,
 138–139; projects for, 112, 168–170;
 catalogues, 115–116, 117, 125, 129,
 243; visitors to, 129, 224–225; acqui-
 sitions for, 143–145, 149–150,
 196–197, 198–200, 205; fires in, 155,
 170; design and construction of,
 170–171, 181; reactions to, 171–172;
 site of, 173, 174; installation and
 decoration of, 180, 182, 184–185,
 291n97
Bouguereau, William, 46, 136, 237;
 The Return of Tobias, 146, 147; *The
 Day of the Dead,* 147; *Une bacchante,*
 151
Bouillon-Landais, Paul, 173; as admin-
 istrator, 194, 215, 217, 218; views of,
 211–212, 226; and visitors, 223, 224,
 231
Boulanger, Louis, 21, 214; *Agony of
 Mazeppa,* 216
Bourdieu, Pierre, 5
Bourgeois, Léon, 45
Bourgeoisie: as urban elite, 5, 94, 160,
 238; as museum public, 95–96,
 228–229, 235–237; defined, 266n15

Brandenburg, Albert, 171, 208
Brascassat, Jacques, 139
Brès, Louis, 172–173, 175, 176, 185–187
Brittany, 29, 35
Brochon, Henry, 169
Bureaucracy, 13, 51, 122–123, 282n6.
 See also Cultural policy, state
Burguet, Charles, 170, 180

Cabrit, Jean, 194, 207; and visitors,
 231, 236–237
Caillebotte, Gustave, 281n123
Camondo, Isaac de, 52
Campana, Giampietro: collection of,
 27–28, 243
Carr, J. Comyns, 91, 93
Catalogues, 115–117, 191, 301n71;
 standards for, 74–75, 129. *See also
 specific cities*
Cavelier, Jules: *La Durance, 178,*
 179–180, 190
Chaline, Jean-Pierre, 160
Chaptal, Jean-Antoine, 18, 25–26,
 103–104
Charroppin, Adolphe, 125, 129
Charvet, Lucien, 73, 75, 79, 81
Chaumelin, Marius, 160, 161
Checking. *See* Regulations, museum
Chennevières, Philippe de, 23, 58–59,
 166–167
Chronique des arts et de la curiosité, 131,
 225, 234–235
Clapier, Alexandre, 34, 137
Classification. *See* Museums: standards
 of comparison for
Clément de Ris, Louis, 116–117
Cogniet, Léon: *Tintoretto Painting His
 Dead Daughter, 134, 135*
Commission des Musées de Province,
 84–89
Compiègne: Musée Vivenel, 69
Cook, Thomas, 127
Corot, Camille, 216; *Bath of Diana,*
 149, 151
Courbet, Gustave, 136; *After Dinner at
 Ornans,* 27; *The Painter's Studio,* 52;
 Stag in a Stream, 150

Courrier de la Gironde, 168, 171
Court, Joseph-Désiré, 42, 114; *Boissy d'Anglas at the Convention,* 216
Couyba, Charles, 47, 84, 86
Crow, Thomas, 212
Crozier, Michel, 229
Cultural history, character of, 8–10
Cultural policy, state, 13, 17, 239–240; in early Third Republic, 32–33, 57–58; and avant-garde, 51; grants to provincial museums, 75, 88–89, 243; post-World War II, 242. *See also* Commission des Musées de Province; Envoi system; Inspections; Museums: standards of comparison for
Curators: appointment of, and state, 67, 109, 287n51, 295nn152,153; qualifications of, 71, 114–115, 123, 194–195, 237–238; training of, 73–74, 86–88, 243; role of, 113–115, 123, 125–126, 194, 242, 243; artists as, 114–115

Darcel, Alfred, 194, 212, 301nn69,70; and new Rouen museum, 167, 212–216; and Rouen collections, 198, 208, 223
Dassy, Joseph, 114, 123
Daubigny, Charles-François, 149, 216
Dauzats, Adrien, 194
David, Jacques-Louis, 18, 98
Decentralization. *See* Provinces, French
Decorative arts (as envois), 39
Delacroix, Charles, 102
Delacroix, Eugène, 18, 28, 136, 205; *Boissy d'Anglas at the Convention,* 205; *Justice of Trajan,* 216
Delaunay, Jules: *Ophelia,* 198
Deloysnes, Paul, 156, 170, 171, 175
Delpit, Jules, 115–116, 125
Depeaux, François, 209, 237
Descamps, Jean-Baptiste, 105, 108
Devillebichot, Jean-Auguste, 124, 130, 139, 140
Devosge, François, 110, 205; and origins of Dijon museum, 97, 100;

works of, in Dijon collection, 120, 205
Dijon: socio-economic background, 7
Dijon, Musée des Beaux-Arts de: conditions in, 36, 72, 111, 218; envois to, 36, 104; origins and early years of, 97, 100, 104, 113; acquisitions and collections, 103, 203–205, 209; regulations and fees in, 118, 232–234; visitors to, 118, 119, 230–231, 232–234; Salle des Gardes, 119, 120; catalogues and labels, 124, 217; expansion and installation of, 130, 218–219
Donations, 194, 207, 208. *See also* Acquisitions *entries;* Advisory committees
Douglas, Mary, 9–10, 97, 192, 198, 220
Drouyn, Léo, 205
Dubosc, Georges, 202
Dubosc de Pesquidoux, Léonce de, 119, 120
Duffour-Dubergier, Lodi-Martin, 143, 182
Dujardin-Beaumetz, Henri, 45, 83, 84, 87, 278n93
Duncan, Carol, 3, 4
Duran, Carolus: *Danaë,* 199, 199–200
Durance, La (Cavelier), *178,* 179–180

Engerand, Fernand, 43, 78, 84, 89
Envois: responses to, 24, 41–42; character of, 29–30, 49–50
Envoi system, 25–27, 103–104; purposes of, 14, 16–18, 25, 89; and artistic quality, 24, 39, 40, 47; and state policy, 30, 37–38, 61–62, 86–87; workings of, 30–32, 36–37, 292nn121,122. *See also* Inspections; Museums: standards of comparison for
Espérandieu, Henri, 162–164, 165
Exhibitions, provincial, 133–136, 195–197

Fauquet, Ernest, 187, 195, 196, 220, 224, 227
Févret de Saint-Mémin, Charles-Balthazar de, 110, 113, 120, 124

Fire hazards, 36, 55, 56, 69, 71–72, 81, 155

Flaubert, Gustave, 183

Foucault, Michel, 9, 65

Fourcand, Emile, 169, 171

Fréchon, Charles: *Spring Leaves,* 200, *203*

Fructidor year 9, decree of, 18, 25, 103. *See also* Envoi system

Gardens. *See* Parks

Garnier, Charles, 176

Gay, Peter, 221

Gazette des Beaux-Arts, 131

Géricault, Théodore, 205, 216

Girodet de Trioson, Anne-Louis de, 145

Gironde, La, 168, 171–172

Gleize, Emile, 194, 217, 222

Gomot, Hippolyte, 37, 47, 63

Grenoble, Musée des Beaux-Arts de, 29, 70, 76

Gros, Antoine-Jean, 145

Gué, Oscar, 124–126, 155; and visitors, 129; and acquisitions, 141, 143, 147, 152

Guenin, Joachim, 101, 102

Guidebooks. *See* Tourism

Guigou, Paul, 194, 218, 281n121

Guillaume, Eugène, 55, 59

Hachette, Louis: "Bibliothèque des Chemins de Fer," 128

Harris, Neil, 3, 245

Haussmann, Baron Georges Eugène, 159

Honnorat, Jean-François, 123, 161, 162

Houssaye, Arsène, 117

Houssaye, Henri, 59, 60–61, 69, 78–79

Huysmans, Joris-Karl: *L'oblat,* 240

Impressionists: state purchases of, 46, 51, 281n123; local attitudes toward, 52, 198, 200, 202, 209

Ingres, Jean-Auguste-Dominique, 18, 20, 28, 216

Inspection des Musées des Départements, 63–64, 243. *See also* Inspectors

Inspections, 55–56, 60, 62–63; purposes of, 14, 63, 67; and envoi system, 35, 82. *See also* Museums: standards of comparison for

Inspectorate of Provincial Museums. *See* Inspection des Musées de Province

Inspectors, 64–65; attitudes of, 60, 76–77, 240, 287n55; role of, 78–79, 89, 240. *See also* Charvet, Lucien; Marx, Roger; Pillet, Jules

Installation, 208–209, 212–216, 242

Jeanron, Philippe-Auguste, 27, 130

Joanne, Adolphe: *Itinéraire générale de la France,* 128, 129

Joanne, Paul, 219

Joliet, Albert, 194–195, 232; on installation, 213, 217, 218–219; and visitors, 220, 231, 233–234, 236

Joliet, Gaston, 294n153

Journal de Rouen, 167–168, 234

Kaempfen, Albert, 61

Klenze, Leo von, 177

Labadié, Alexandre, 165

Labels, 74–75, 216–218. *See also* Installation

Labrouste, Henri, 162, 318n85

Lacaze, Marquis de, 114, 138–139

Lacour, Pierre (father), 101, 102, 107, 109

Lacour, Pierre (son), 182; and early museums, 102, 107, 109–110, 113; as administrator, 111, 112, 114; and catalogues, 115–116, 125; and visitors, 118; and acquisitions, 138–139

Lacroix, Paul, 131

Lafenestre, Georges, 50

Lagrange, Léon, 132, 134, 135

Larousse, Pierre, 229

Larroumet, Gustave, 11, 43, 44

Laurens, Jean-Paul: *Alone,* 222
La Ville de Mirmont, Henri de, 109,
196–197, 203
Leblond, Auguste, 209
Le Breton, Gaston, 205
Le Carpentier, Charles-Louis, 100
Legros, Alphonse: *Ex-Voto,* 240
Lemire, Abbé, 83
Lemonnier, A. C. G., 100, 108
Lenoir, Alexandre, 128
Leroi, Paul, 207
Loir, Luigi: *Flood Tide of the Seine,
Paris,* 202, *204*
Loubon, Emile, 114, 140
Louvre, Ecole du (Paris), 243, 294n147
Louvre, Musée du, 25, 98; in cultural
policy, 33, 40, 53; as model, 68–69,
240, 241; and visitors, 227, 228,
319n101
Luxembourg, Musée du: character of,
and cultural policy, 21–23, 38–39,
53, 272n24; and major provincial
museums, 38, 240–241, 271n18
Lynch, Comte de, 106
Lyon, Musée des Beaux-Arts de, 36,
69, 235, 319n94

Manet, Edouard, 308n64; *Olympia,* 52
Mantz, Paul, 118, 119, 125, 126
Marrionneau, Charles, 308n64
Marseille, Musée des Beaux-Arts de:
envois to, 30, 42,104; catalogues, 75,
106; origins and early years of,
101–102, 104, 113; conditions in,
111–112, 119, 155, 218; visitors to,
129, 223–224, 236; acquisitions for,
137, 144–145, 149–150, 203; design
and construction of, 161–165, *164,*
177; reactions to, 165, 179; site of,
173; decoration of, 179–180, 183,
184, 185–187
Marseilles: Société Artistique des
Bouches-du-Rhône, 136–137, 145;
social and urban development of, 157,
158–159, 160, 173
Marx, Roger, 36, 50, 74, 84–89, 221

Massé, Alfred, 93
Maupas, Charlemagne-Emile de, 161
Mémoires d'un touriste (Stendhal), 118,
119–120, 129
Mérimée, Prosper, 128
Millet, Jean-François, 20, 136; *La
bouillie,* 141, *142,* 149–150, 151
Monet, Claude, 46, 52, 202
Montpellier: Musée Fabre, 69, 75
Moreau-Nélaton, Etienne, 52
Morse, Samuel F. B.: *Gallery of the
Louvre,* 213
Moulin, Raymonde, 193
Munich: Alte Pinakothek, 177
Musée des Copies project. *See* Charles
Blanc
Museum picture, concept of, 150–151,
197–198. *See also* Acquisitions,
municipal
Museums: as symbol and metaphor, 1,
154–155; historiography of, 2–4;
standards of comparison for, 33,
66–68, 69, 71, 81–82; collections,
origins and character of, 102–103,
119–120, 240; early terminology for,
105–106; buildings, symbolism of,
121–122, 156, 176–179, 180–181; in
United States, 244–245. *See also*
Catalogues; Louvre, Musée du; Lux-
embourg, Musée du; *and specific cities*

Nancy, Musée des Beaux-Arts de, 72,
74, 221
Nanteuil, Celestin, 34
Nétien, Etienne, 156, 166, 175
Nieuwerkerke, Comte Alfred-Emilien
de, 27, 123, 269n9
Nîmes, Musée des Beaux-Arts de, 73
Nudity. *See* Sexuality

Onfroy, Jules, 161, 163

Palais de Longchamp. *See* Marseille,
Musée des Beaux-Arts de
Pannini, Giovanni-Paolo, 213
Paris. *See* Louvre, Musée du; Luxem-

Paris (*continued*)
 bourg, Musée du; Provinces, French;
 Salons, Paris
Parks, as sites for museums, 175–176
Parrocel, Etienne, 185–187, 190
Paul-Boncour, Joseph, 48
Pelleport-Burète, Vicomte de, 168, 171,
 173, 174, 180
Périé, Georges, 197
Pérignon, Alexis, 124, 134, 135, 139,
 147
Personnalité civile, 84–86
Petit, Léonce, 149
Petit rouennais, 167–168, 227–228
Pillet, Jules, 71, 80–81
Pinkney, David, 295n2, 311n9
Poulot, Dominique, 220, 236
Preservation, museums and, 98–100,
 102, 128–129
Proust, Antonin, 283n11, 285n35
Provinces, French: and Paris, 6, 8;
 decentralization and, 25–26, 122,
 244, 329n5. *See also* Regionalism
Prud'hon, Pierre-Paul: *Portrait of
 Georges Anthony*, 205, 206
Public. *See* Artists; Bourgeoisie; Regu-
 lations, museum; Visitors
Puget, Pierre, 44, 203
Puvis de Chavannes, Pierre, 185,
 188–190; *Marseilles, Gateway to the
 Orient*, 185–187, 186; *Marseilles,
 Greek Colony*, 185–187, 186; *Inter
 Artes et Naturam*, 187–188, 188–189,
 190

Quarré, Pierre, 195

Regionalism: in collections, 69, 103,
 197, 241
Regnault, Henri: *Judith and Holofernes*,
 151–152
Regulations, museum, 118, 219;
 checking, 226–229
Renoir, Auguste, 51
Revolution, French: and origins of
 museums, 24–25, 97–100, 103

Reynaud, François: *The End of the Day
 (Abruzzi)*, 150–151
Rodin, Auguste, 207
Roll, Alfred, 52; *Self-Portrait*, 200
Ronchaud, Louis de, 43, 45
Rothschild, Baron Alphonse de, 207
Rouen: exhibitions, 195; art associa-
 tions, 196; social and urban develop-
 ment of, 157, 159, 174
Rouen, Musée des Beaux-Arts de: en-
 vois to, 30, 35; design and construc-
 tion of, 36, 166–167, 180–181, 182;
 conditions in, 76, 155; installation of,
 76, 214, 215–216; origins and early
 years of, 100, 104–105, 108; collec-
 tions of, 103, 116, 209–210; reactions
 to, 167–168; site of, 174; decoration
 of, 181, 182–183, 187–188; acquisi-
 tions for, 195–196, 199, 200–202, 205;
 regulations and fees in, 227–228, 232–
 234; visitors to, 230–231
Rougemont (Marseilles official), 140,
 145, 149, 150–152, 162
Roujon, Henry, 40, 233
Rouvière, Balthazar, 161, 162
Roux, Marius, 154, 155, 162
Rude, François, 44, 203

Salons, local. *See* Exhibitions,
 provincial
Salons, Paris, 20, 22–23, 41, 44, 196,
 270n14. *See also* Art market; Acquisi-
 tions; Cultural policy, state
Sartre, Jean-Paul, 238
Sauvageot, Louis, 166, 168, 176, 181
Serre, Michel, 120
Serres, Antony: *The Sentence of Joan of
 Arc*, 147
Sexuality: as issue in museums, 149,
 221–224
Sisley, Alfred, 51
Sluter, Klaus, 119
Smith, Alfred: *Quais of Bordeaux, Eve-
 ning*, 200, 202
Sociétés des Amis des Arts. *See* Art
 associations; *and specific cities*

Sourget, Adrien, 168, 198
Stendhal (Henri Beyle): *Mémoires d'un touriste,* 118, 119–120, 129

Thibaudeau, Antoine, 104
Third Republic, French. *See* Cultural policy, state
Toulouse, Musée des Beaux-Arts de, 73, 298n20
Tourism, 126–128, 129, 220, 241–242
Tournès, Etienne: *Young Woman Undressing,* 200, *201*
Tournon-Simiane, Philippe de, 107
Travel. *See* Tourism
Turquet, Edmond, 44, 57, 62, 66, 285n31

Umbrellas: significance of, for bourgeoisie, 228–229. *See also* Regulations, museum
Urban planning, 158–160. *See also* specific cities

Vallet, Emile: and acquisitions, 42, 198, 200, 221; and new Bordeaux museum, 185, 212–213, 215; as administrator, 192, 217, 218; and donations, 207, 208; views of, 212, 225–226, 229
Vandalism, 223, 224–225, 235
Vaudoyer, Léon, 162, 163
Verdrel, Charles, 159, 174
Verdun, Musée de, 81
Vernet, Horace, 143
Villot, Frédéric, 117
Viollet-le-Duc, Eugène, 166, 176
Visitors, 172, 220; behavior and habits of, 117–118, 219, 230–231, 236; tourists as, 129, 236; social composition of, 175, 244; numbers of, 230–231

Wallach, Alan, 3, 4

Ziégler, Jules, 123, 124
Zola, Emile: *L'assommoir,* 228, 319n101
Zolberg, Vera, 245